THE DRAWINGS OF HENRI MATISSE

John Elderfield

THE DRAWINGS OF HENRI MATISSE

Introduction by John Golding
Catalog by Magdalena Dabrowski

With 220 illustrations

THAMES AND HUDSON

Published in association with

THE MUSEUM OF MODERN ART, NEW YORK *and the* ARTS COUNCIL OF GREAT BRITAIN

Published on the occasion of the exhibition "The Drawings of Henri Matisse" (1984–85), organized by the Arts Council of Great Britain with the collaboration of The Museum of Modern Art, New York

Edited by Magdalena Dabrowski, John Elderfield, Catherine Lampert and Nikos Stangos

First published in the USA in 1985 by Thames and Hudson Inc.,
500 Fifth Avenue, New York, New York 10110

Library of Congress Catalog Card Number 84–50423

Printed and bound in Great Britain by Balding + Mansell Limited, Wisbech, Cambs.

CONTENTS

FOREWORD TO THE EXHIBITION

The Arts Council announced in the catalogue for the Matisse retrospective which opened the Hayward Gallery in 1968 its intention to devote a separate exhibition to Matisse's sculpture, drawings and prints in two or three years' time. In the event, it was not till thirteen years later that the painter and art historian John Golding, one of the selectors of London's Picasso exhibition, was asked to choose 150 drawings by Matisse to be shown in an exhibition with the sculpture. During the last three years Dr Golding has re-visited important collections, spoken to colleagues and made new contacts. His discerning judgment among Matisse's large legacy and his devoted pursuit of drawings of 'strength and beauty' has been invaluable.

At an early stage, the Arts Council of Great Britain approached John Elderfield, Director of the Department of Drawings at The Museum of Modern Art, author of two important works on Matisse and a collaborator on several Arts Council exhibitions since 1974, to write the catalogue text. This led to the agreement to show the drawings also in the new galleries of The Museum of Modern Art (the sculptures had been the subject of an exhibition there in 1972). Surprisingly this exhibition is the first major show devoted to this aspect of Matisse's inventive genius in either New York or London.

The collaboration between the Arts Council and The Museum of Modern Art has been extensive and gratifying. It has involved not only practical matters but an exchange of ideas between Dr Golding, Dr Elderfield and Catherine Lampert, the exhibition organizer, about the selection and on approaches to the owners of important works. John Elderfield's distinguished text adds to our knowledge of Matisse's deepest artistic ambitions and to our understanding of the subtle qualities of individual masterpieces. In his introduction John Golding perceptively weighs the role of drawing – especially as opposed to colour – in Matisse's art. We are particularly grateful for the scholarly, lively notes on the works which Magdalena Dabrowski, Assistant Curator in the Department of Drawings at The Museum of Modern Art, prepared for this catalogue.

In addition to seeking works which represent Matisse's finest achievement as a draughtsman over his sixty-year working life, we looked for examples of various techniques and for essential themes, such as the 'Plumed Hats' and the line drawings known as *Themes and Variations*. A special objective of Dr Golding was to 'give a glimpse of the

artist's mind and sensibilities at work.' Consulting others whose opinion is widely respected including, as well as those listed below, the indispensable advice of Dominique Fourcade and Victor Carlson, it seemed there was almost a consensus among specialists about what constitutes Matisse's 'master drawings' (several here have never been published or exhibited before). For certain aspects there were more marvellous works available than gallery space would allow, and we had to decline generous offers. At the same time we wish to thank several lenders who treasure unique drawings and who have exceptionally agreed to their inclusion in this exhibition.

We are particularly indebted to Matisse's family; they have taken a personal interest in all aspects of the exhibition. Our deepest gratitude goes to Pierre and Marie-Gaetana Matisse, Mme Marie Matisse, M. Gérard Matisse, M. Claude Duthuit and to his late mother Mme Marguerite Duthuit, who early on endorsed our plans, and to Mme Jacqueline Monnier. The superb collections of Matisse's work at the Musée National d'Art Moderne, Paris, and the Musée Matisse, Nice-Cimiez, both of which have received donations from the estate, were drawn upon to a large extent and we appreciate greatly their generosity. The help of Isabelle Monod-Fontaine, author of the essay in the parallel volume on Matisse's sculpture, is especially appreciated. The Baltimore Museum of Art kindly allowed many irreplaceable drawings in the Cone Collection to travel. Other museums in France, Denmark, Canada, Japan, Britain and the United States as well as numerous private collectors have parted with precious drawings. We are grateful for the great generosity and interest of curators and owners who have gone out of their way to collaborate.

The Arts Council, The Museum of Modern Art and Dr Golding gratefully acknowledge the important help of Mr William R. Acquavella, Mlle Colette Audibert, Mr Jacob Bean, Mr Heinz Berggruen, Mr John Berggruen, Mr Ernst Beyeler, M. Dominique Bozo, The Honourable Mrs Camilla Cazalet, Mme Ethel de Croisset, Mme Lydia Delectorskaya, Mr Michael Dollard, Mr Erik Fischer, Mr Jack Flam, Mr Xavier Fourcade, Sir Lawrence Gowing, Mr John Hallmark-Neff, Miss Anne d'Harnoncourt, the late Dr Harold Joachim, Mr John Kasmin, M. Hubert Landais, Mr William S. Lieberman, Mlle Isabelle Monod-Fontaine, Mr Conrad Oberhuber, Mr Stuart Preston, Mr John Richardson, Mr Duncan Robinson, Mr John Rosenfield, Mr William Rubin, Mrs Angelica Zander Rudenstine, M. Pierre Schneider, Mrs Ester Sparks Sprague, Mr Nikos Stangos, Mr Robert Stoppenbach, Mme Dominique Szymusiak, Mr Eugene V. Thaw, M. Germain Viatte, Mme Dina Vierny, Mme Hélène Vincent, Mr Leslie Waddington, Mr Nicholas Watkins, Mr Alan Wilkinson.

JOANNA DREW, Director of Art, Arts Council of Great Britain
RICHARD E. OLDENBURG, Director, The Museum of Modern Art

LENDERS TO THE EXHIBITION

Canada

Ottawa National Gallery of Canada/Galerie nationale du Canada
Toronto Art Gallery of Ontario
 Mr and Mrs Alfred C. Cowen
 Sam and Ayala Zacks Collection

Denmark

Copenhagen The Royal Museum of Fine Arts

France

Bordeaux Musée des Beaux-Arts
Grenoble Musée de Peinture
Nice-Cimiez Musée Henri Matisse
Paris Musée National d'Art Moderne. Centre Georges Pompidou

Japan

Kurashiki (Okayama) Ohara Museum of Art

Switzerland

Basel Collection Ernst Beyeler
Lucerne Rosengart Collection

United Kingdom

London Courtauld Institute Galleries. Courtauld Collection
 Kasmin Ltd
Manchester Whitworth Art Gallery, University of Manchester
Sutton Scotney Fondation Capa/Sutton Manor Arts Centre

USA

Baltimore	The Baltimore Museum of Art: The Cone Collection
Cambridge	Fogg Art Museum, Harvard University
Chicago	The Art Institute of Chicago
	Dr and Mrs Martin L. Gecht
Indiana	Mr and Mrs Richard Selle
Lexington	Collection J. R. Gaines
New Haven	Yale University Art Gallery
New York	The Metropolitan Museum of Art
	The Museum of Modern Art
	Mr Julian J. Aberbach
	Mr and Mrs William R. Acquavella
	Bragaline Collection
	Collection Marshall Cogan
	Mr and Mrs Nathan L. Halpern
	Collection Dr and Mrs Arthur E. Kahn
	Mr Pierre Matisse
	Pierre Matisse Gallery
	Mr John Rewald
	Mr and Mrs Eugene V. Thaw
Palm Springs	Louise E. Steinberg
Philadelphia	Philadelphia Museum of Art
San Francisco	San Francisco Museum of Modern Art

Private collections

INTRODUCTION by John Golding

'*L'éternel conflit du dessin et de la couleur dans un même individu.*'[1] HENRI MATISSE

Although Matisse had been a dedicated and assiduous draughtsman since his earliest student days, in his 'Notes of a Painter' of 1908, the first and still the most celebrated of his extended statements about the aims and the nature of his art, he had surprisingly little to say about the role of drawing. Colour, he makes it very clear, is his paramount concern and his most important means of expression. More or less concurrently, however, some less public but equally revealing pronouncements were being made by Matisse to his students and recorded by one of them.[2] In these, significantly enough, the introductory and also the longest passages were devoted to drawing. Drawing, Matisse appears to suggest, is the cardinal discipline through which, as he later affirmed more explicitly, the artist could 'gain possession' of his subject, and which must be at the basis of his first endeavours. Through this discipline and this possession would come release of the artistic personality. 'Drawing', he said to encourage and stimulate his students, 'is like making an expressive gesture with the advantage of permanence.' Subsequently he was to state: 'It is only after years of preparation that the young artist should touch colour – not colour used descriptively that is, but as a means of personal expression.'[3]

If certain passages of the 'Notes of a Painter' might be seen as an encouragement to the spectator to accept Matisse's painting at its very splendid face value (and possibly this helps to explain why even today, when the literature on Matisse has become so extensive, his art has still not been accorded the formal and critical analysis it deserves), late in life Matisse was worried that the hedonism of his art, its apparent effortlessness, would encourage new generations of artists to take the short cuts which he himself had so rigorously eschewed. In an open letter of 1948 he wrote: 'I have always tried to hide my own efforts and wanted my work to have the lightness and joyousness of a springtime which never lets anyone suspect the labours it has cost. So I am afraid that the young, seeing in my work only the apparent facility and negligence in the drawing will use this as an excuse for dispensing with certain efforts which I believe necessary.'[4] Now he asserts the primacy of drawing when he goes on to say: 'I believe study by means of drawing to be essential. If drawing belongs to the realm of the Spirit and colour to that of the Senses, you must first draw to cultivate the Spirit and to be able to lead colour through the paths of the Spirit.'

Earlier, in 1937, in a short article entitled simply 'Divagations',[5] which begins by quoting Ingres' celebrated aphorism, 'le dessin est la probité de l'art' (a concept which Matisse professes not quite to understand), Matisse made the point that as teachers, great artists are incapable of passing on the deepest truths or secrets of their work because their profoundest gifts are in a sense something beyond and outside them. He expressed the same view in his book *Jazz* where he asked himself the rhetorical question, 'Do I believe in God?', to which he had answered, 'Yes, when I am working.' And if colour – 'cette magie', as Matisse used to refer to it – was always what Matisse cared for most and what he ultimately regarded as the most exalted aspect of his art, it was also a factor which in the last analysis, and despite the formidable powers of his intellect, he could never really analyse or explain; it was the intangible that was outside himself. Drawing, on the other hand, he was much more prepared to accept as the expression of his own personality. In his 'Notes of a Painter on his Drawing' of 1939 he wrote: 'I have always seen drawing not as the exercise of a particular skill, but above all as a means of expression of ultimate feelings and states of mind, but a means that is condensed in order to give more simplicity and spontaneity to the expression which should be conveyed directly to the spirit of the spectator.'[6].

Many of Matisse's canvases do indeed appear effortless in their execution, and most of the large, important paintings (some of which were worked over a period of years) appear so completely resolved in their formal and colouristic perfection that we cease to analyse or question the means by which they were achieved. The drawings, on the other hand, often invite a more direct involvement in the creative process. When a painting was progressing unsatisfactorily, certain areas, and often the whole surface, were wiped down and redone; but in the final work the traces of this activity have almost always been obliterated. Yet throughout his career (and most particularly in the late 1930s and early 1940s) Matisse executed drawings which bear the marks of endless erasures, cancellations and emendations. Conversely in many of the quickly executed pure line drawings we feel our way into the artist's mind by the way in which we instinctively follow and identify with the sure, rhythmic notations of his hand. Matisse's output as a draughtsman was immense and he seems to have destroyed relatively little;[7] because of this his drawings inevitably vary quite astonishingly in quality, but this appears not to have bothered him. It might perhaps be fair to say that, in a way that the paintings are not, the drawings are his artistic autobiography. The drawings that are assembled here were chosen primarily because of their strength and beauty, and to illustrate the various phases of his long career and the varied drawing media and techniques in which Matisse worked. But many are also included to give a glimpse of the artist's mind and sensibilities at work. A final, quick sketch of a famous model, for example, shows her drawing on a cigarette at the end of what one feels must have been a lengthy working session. In the *Themes and Variations* series he examines the formal properties of a still-life in a very different

way from that in which he responds to the graceful movements of a young model as she turns and shifts. There is a contrast between the way in which he contemplates the unchanging beauty of the model and the curiosity and affectionate humour with which he examines the fleeting expressions on the face of a favourite grandchild.

Fauvism, the first of the new pictorial twentieth-century movements and the one which brought Matisse to fame as its leader, was primarily a colouristic revolution. But Matisse stepped over the limits of Divisionism and into his new role as revolutionary painter largely because he felt that the disciplines of working in a Divisionist idiom involved suppressing the emotive properties of line and the musical flow of linear arabesque in favour of an overall activation of the surface of the canvas in terms of colour touches more or less equivalent in size. Fauvism, Matisse more than once observed, represented for him 'the return to the purity of means',[8] and 'the purity of means' he defined as 'the assertion of expression through colour'. But the release, or partial release, of colour from its traditional representational or descriptive role involved and was quickened by a corresponding freedom in the use of line. Of his move from Divisionism into Fauvism Matisse once said, 'from then onwards I was able to compose my paintings by drawing in such a way that I united arabesque and colour.'[9] And with Fauvism his draughtsmanship now partook of some of the same autonomy as his colour. 'With what is called Fauvism and succeeding movements', he said, 'came expression through drawing, contour, lines and their directions.'[10] The variety of his linear configurations and of his mark-making during the period, within the confines of a single work, was never to be equalled or repeated in any of his subsequent production.

Nor was this all: Matisse had previously learnt as much, if not more, from the Divisionist sketch as from the Divisionist painting, for the simple reason that in their paintings the Divisionists were forced to grade out their pure colours into tints in the areas where they met, whereas in their sketches, which allow a lot of white ground to come through, each colour mark or touch stood much more purely for itself and acted upon the others around it in a much more independent and autonomous fashion. So too in Matisse's drawings of the Divisionist period and even more pronouncedly in the succeeding Fauve years, the paper support takes on a new importance as a screen or field of light against which the graphic lines, marks and hatchings may act. The importance of the support (whether it was canvas or paper), both as a source of light and as pure, living tissue, was to be fundamental to Matisse's art henceforth.

'With Fauvism came the exaltation of colour; with Cubism, precision of drawing.'[11] It is perhaps not surprising that it was in 1913 and above all in the years between 1914 and 1916, when the Cubists (and in particular Picasso and Gris, whose careers, unlike those of so many of their contemporaries, had not been interrupted or cut short by the

war) were increasingly introducing colour into their paintings, that Matisse felt the need to assess for himself the achievements of the movement. It was the search to formulate a concept of colour to complement their complex and highly abstracted approach to line and form that led the Cubists to the invention of *papier collé*, and so subsequently to new compositional procedures. Matisse, on the other hand, tended initially to ignore the colouristic implications of their work and to concentrate immediately on new methods of pictorial structure, possibly because, in a very different way from the Cubists, he had already won a high degree of autonomy for colour in his Fauvist works. He spoke of reworking the most purely Cubist of all his own canvases, the *Still-life after de Heem* of 1915–16, 'according to modern methods of construction.'[12] And it was in part at least the encounter with Cubism and the experiments with 'modern methods of construction' that endowed his paintings of the period with a new sense of grandeur and of spatial complexity and precision. The debt to Cubism is summed up in the great Chicago *Bathers by a River*, basically a work of 1916–17, although it was begun much earlier. Its bold and original compositional effects were almost certainly achieved by experimenting with cut paper attached to the canvas support, and in this respect it looks forward to Matisse's paper cut-outs of the 1940s, works which he saw as uniting drawing and colour in a totally new way.

In his drawings, as he himself remarked, the Cubist experience led to a new sense of structure and economy, and this reduction, combined with the freedom and variety of mark-marking of his Fauve period was to prepare for his final concept of drawing as a form of pictorial sign language. More immediately, a study of the drawings of the war years provides us with insights into his attitude to Cubism – an attitude that is concealed in the finished paintings. Characteristically, he did not accept the new procedures without a struggle; some of the most angular and severe of his drawings are superimposed over the ghosts of elaborately worked naturalistic images which have been erased and cancelled, honed down to an essential scaffolding or structure, often with a pronounced emphasis on vertical and horizontal axes, softened only slightly by mediating diagonals. 'Now I draw according to my feelings, not according to anatomy', Matisse said in 1913,[13] and a careful study of some of the Cubist drawings shows him doing both. Much of the graphic work of the period deals with the single portrait head or three-quarter-length figure – possibly only a familiar or well-studied visual certainty would allow for so much ultimate linear reduction and abstraction. Just as Picasso's output at this time shows him working simultaneously in an abstracted, Cubist idiom, and a neo-classical manner, some of Matisse's most Cubist drawings are complemented by works of a heightened realism and meticulousness of observation that he was never again to attempt.

The more detailed, naturalistic drawings of the late war years, and the fine, evolved pencil drawings of 1919 (these include some of the drawings of the famous 'Plumed Hat' series) form a prelude to the

drawings of the 1920s, many of them executed at Nice; Matisse had
been visiting the city since 1916 and from 1921 onwards was to spend half
the year there. The most characteristic of the drawings of the Nice
period (a term used to cover or describe most of the work of the
decade) are perhaps the very finished works in charcoal and estompe,
although, as had been his custom almost from the very start, Matisse
continued to work simultaneously in the widest possible range of pure
drawing media and techniques, often in single working sessions from
an individual model. As Dominique Fourcade has pointed out,[14]
Matisse's drawings were seldom actual studies for paintings, and even
when they are preparatory to a painting of the same subject they were
almost invariably conceived and executed as drawings in their own
right. But now, during the 1920s, when Matisse had reverted to a more
naturalistic idiom in his painting, tending to make use of smaller
formats and also of a more descriptive kind of lighting with a
consequent emphasis on tonal values of light and dark, his drawing
came closer to his painting than ever before. In 1929 he was able to
state: 'My drawing represents a painting executed with restricted
means'[15] (although with his loyalty towards colour he felt he had to
qualify the statement by adding that a painting was somehow 'fuller').
These are perhaps the most accessible of all Matisse's drawings, and
they speak for themselves. Most typically they show women seated or
reclining in interiors that are bathed in a soft, filtered Mediterranean
light; sometimes they are glimpsed on balconies; frequently they are
depicted as costumed odalisques. Everywhere there is the decorative
arabesque, endlessly varied, supple and expressive. Matisse was
subsequently to assert on several occasions that it was only with the
heroic canvases of the war years, when he had learnt to use black as
colour that he had emerged as a true colourist (an extraordinary
statement in view of the colouristic splendours that had preceded
them); and in these drawings, too, the blacks and the intense darks are
charged with light and the implication of colour.

The year 1930 marked a turning point in Matisse's art and
particularly in his activity as a draughtsman. He was commissioned by
the publisher Skira to illustrate a volume of Mallarmé's poetry, and at
the end of the same year Albert C. Barnes, by now his greatest
American patron, invited him to execute a mural decoration for his
private art gallery at Merion, Pennsylvania. The Mallarmé com-
mission resulted in the first and one of the most ambitious and
beautiful of all the books illustrated by Matisse. The maquette for the
book, now in the possession of the Baltimore Museum of Art, once
again allows us to follow Matisse's working methods. The first
preliminary studies are mostly in pencil – some are fairly elaborate,
while others are more tentative and exploratory; but, as they evolve
they become increasingly simplified and subtle. The final illustrations
were rendered as etchings in pure, reduced but flowing lines, and as
such they form a prelude to the pen drawings mostly in black ink on
white paper which were begun towards the middle of the decade, and
which Matisse was to value as amongst his greatest achievements. In

1939 he wrote: 'My line drawing is the purest and most direct translation of my emotion. The simplification of the medium allows for that.'[16] Matisse also insisted that not only were the drawings more complete and weighty than they might appear at first sight but that they generated light – and this was not simply a question of the white support being so much in evidence, for he talks of his line as 'modelling' the light behind it – and even a sensation of colour, the beginning, perhaps of his subsequent obsession with white as colour. As with the Mallarmé illustrations, these drawings were almost invariably preceded by more laboured and evolved studies in what Matisse described as 'a less rigorous medium'[17] (charcoal, estompe or pencil). Because the line drawings in ink allow for no corrections, they are the most uneven in quality in all Matisse's graphic output, but they can be superb, and a mere handful of the best would consolidate Matisse's reputation as one of the greatest draughtsmen of all times.

The Barnes murals affected Matisse's draughtsmanship in a different way. To begin with, the nature of the commission and the siting of the murals called for a new boldness of approach and one which led to a new reductiveness in his art, which was to be simultaneously monumental and yet decorative in its emphasis. Matisse was to remember how, strolling about in front of the vast surfaces to be covered, he did not know quite how to approach the project; a cord hanging in front of a fanlight in the enormous studio that he had taken to execute the commission cast a giant curved shadow on the surface of the blank canvas and encouraged him to lay down his first great, sweeping arabesque. The original lay-in of the design was purely linear, but subsequently the composition was further evolved and modified by the addition and subtraction of cut paper attached to the support, a technique which undoubtedly made Matisse more aware than ever before of an interaction between outline and colour. The iconography of some of the large mythical subjects that followed (the three variants of the *Faun and Nymph* for example, of which two are included here) arises from his book illustration, but other large drawings, such as the two-figure composition now in Tokyo, are derived directly from the Barnes mural, and all owe much of their breadth and grandeur of treatment to the project. Inevitably, also, the new monumentality touches much of the smaller works on paper as well. In the second half of the decade the pure line drawings are complemented by blacker, heavier drawings, often more experimental in feeling, in which the charcoal has been smudged and manipulated in such a way that some of the cloudier areas seem to dissociate themselves from the linear contours of the subject, creating a sensation of atmospheric light that is as rich, but more ambiguous than that which characterizes the earlier charcoal pieces of the Nice period.

If Matisse's illness and subsequent operation in the early months of 1941 represented a personal tragedy – he was to remain a semi-invalid for the rest of his life – they channelled his drawing into new and ever deeper waters. Confined to his bed for many of his waking as well as his

15

sleeping hours, drawing, for obvious reasons, became increasingly paramount as a means of expression. In April 1942 he was able to write to his son Pierre, 'For a year now I've been making an enormous effort in drawing. I say effort but that's a mistake, because what has occurred is a "floraison" after fifty years of effort.'[18] It was in 1941 that Matisse accepted an invitation to illustrate Ronsard's *Florilèges des amours*, a project that was to result in the most exquisite of all his graphic accompaniment to poetry. The most immediate results of his 'floraison', however, were to be seen in the volume entitled *Dessins: Thèmes et variations*, which was published by Fabiani in 1943, and was accompanied by an important text by Louis Aragon. The *Themes and Variations* in fact simply give a new dimension and emphasis to his earlier working methods, but they constitute an important category of work within his output as a draughtsman and many of them make it very clear that after his illness, when he had faced the prospect of non-existence, he saw the world and all things visual in a new and miraculous light. Now preliminary, highly worked charcoal drawings of his subject were executed, often over three or four fairly lengthy sessions. Each of these was succeeded by shorter bouts of work in which he executed variants of the original subject or motif in pure line drawings (these could be in pen or pencil), often at great speed. During these bursts of activity Matisse worked in complete silence and often glanced at his subject only from time to time. In this they differed from the pure line drawings of the 1930s, and despite the beauty of individual sheets, ideally the drawings need to be seen in the series to which they belong. Matisse spoke of the automatic element involved – 'je suis conduit, je ne conduis pas'[19] – and of the necessity to 'empty' his mind before he began the variations. Yet it is perhaps in these more than in any of his other works on paper that we witness in effect a very great draughtsman thinking out loud, commenting on the creative process.

There is absolutely no doubt at all that by now Matisse's draughtsmanship was in advance of his activities as a colourist. In a letter of 1940 to Bonnard he had already written, 'I have found a kind of draughtsmanship that, after some preliminary works, achieves a spontaneity that releases entirely what I feel. . . . But a drawing by a colourist is not a painting. I must try to find an equivalent for it in colour. That is what I can't bring off.'[20] The solution was to come through an investigation of the possibilities of *découpage*, the cutting and manipulation of coloured paper, and most directly through the execution of *Jazz* commissioned by Tériade in 1942 though not published until 1947. In the text to *Jazz* (which was reproduced in his own handwriting and which, although intended by Matisse to have a purely visual function, does in fact provide wonderful insights into the workings of his mind), Matisse wrote, under the heading of *Drawing with Scissors*: 'To cut to the quick in colour reminds me of a sculptor carving in stone.' Later he was to say, '*papier découpé* allows me to draw in colour. It is for me a matter of simplification. Instead of drawing a contour and filling it with colour – one process modifying another – I draw directly

into colour, which is more accurately gauged through not being modified or transposed. This simplification guarantees a precision in the union of the two means which become simply one.'[21]

During the first half of 1948 Matisse produced his last great oil paintings. For the rest of the year he was working on cut-outs – some on a very large scale – and on large thickly brushed ink drawings, a series that had been begun in 1947, and which he saw with total justification as being of equal importance with the works on canvas. The year 1949 saw the most intensive work on the Chapel of the Rosary at Vence, a work which by now he was coming to regard as his culminating masterpiece. I believe that one of the reasons the Chapel meant so much to Matisse was that he saw it as a means of combining his colouristic achievements with his newly won conviction that his draughtsmanship could be equally telling and potent. Colour in the interior of the chapel is etherialized through being embodied exclusively in stained glass which lives and dies with the natural light of day. In a sense Matisse here unites the two lights with which he had been obsessed throughout his life: natural, shifting light and light produced artificially through colour.

Of the Chapel he said, 'I tell the stories in black and white, on the walls. The sun playing on the windows does the rest.'[22] The means by which he told the stories on the wall were by now almost brutally simplified, although these images also have about them, unquestionably, a quality of extraordinary spiritual intensity. Their reductiveness, and Matisse's whole final conception of draughtsmanship, were irrevocably bound up with his by now obsessive need to create what he called 'signs', a concept that he had first talked about (in print at least) towards the end of the 1930s, significantly enough in his 'Notes of a Painter on his Drawing'. In a conversation with Aragon soon after his illness Matisse said, 'The importance of an artist is to be measured by the number of signs he has introduced into the language of art. . . . The sign may have a religious, priestly or liturgical character or simply an artistic one.'[23] By the time that he had completed his work on the Chapel, not only had drawing and painting become synonymous in many of the related works, but by now the graphic 'sign' had also become as 'full' and as charged with meaning as the coloured image.

Matisse's obsession with the creation of a pictorial sign language can be traced back through the *Themes and Variations* to their antecedents and counterparts in the heavily worked and corrected charcoals and the abbreviated, fast-flowing line drawings of the 1930s. If the concept seems less applicable to the more naturalistic and highly worked products of the 1920s, a closer examination of many of these reveals that the flowers and the arabesques embedded in the draperies and wallpapers which surround and envelop the figures often seem to echo or impersonate their identities in a more abstract language. Certainly the reductiveness of the Cubist drawings, and behind them the vitality and variety of the mark-makings of the Fauve period seem very directly relevant to the creation of new graphic signs, as does Matisse's fascination with the broken and repeated contours of

Cézanne and the rhythmic strokes and hatchings of Van Gogh; and in this context even his early fascination with the linear properties of Japanese and other oriental art forms takes on a new meaning. In his old age all things visual had become for him touched by that property of magic which earlier he had ascribed primarily to colour. He said, 'Each thing has its own sign. This marks the artist's progress in the knowledge and expression of the world, a saving of time, the briefest possible indication of the character of a thing. The sign . . .'[24]

NOTES

1 In a letter to André Rouveyre, 6 October 1941.

2 'Notes by Sarah Stein', 1908, published by Alfred H. Barr under the title 'A Great Artist Speaks to his Students', in *Matisse: His Art and His Public* (New York: The Museum of Modern Art, 1951).

3 Letter to Henry Clifford, published as a preface to the Matisse retrospective exhibition held at the Philadelphia Museum of Art in 1948.

4 Ibid.; trans. Jack D. Flam, *Matisse on Art* (London: Phaidon, 1973).

5 *Verve*, vol. I, no. I, December 1937.

6 *Le Point*, Paris, no. 21, July 1939.

7 Many early sketches were destroyed in 1936 (see Victor I. Carlson's introduction to *Matisse as a Draughtsman*, The Baltimore Museum of Art, 1971); but mostly it seems to have been Matisse's custom to preserve even his most casual drawings.

8 'The Purity of Means' (statement to Tériade), *Minotaure*, Paris, no. 15, October 1936.

9 Quoted in Gaston Diehl, *Henri Matisse* (Paris: Pierre Tisné, 1954).

10 'On Modernism and Tradition', *The Studio*, London, IX, no. 50, May 1935.

11 'Matisse Speaks' (interview with Tériade), in Flam, *Matisse on Art* (note 4, above).

12 Ibid.

13 Clara T. MacChesney, 'A Talk with Matisse, Leader of Post Impressionists', *New York Times Magazine*, 9 March 1913.

14 Preface to *Henri Matisse. Dessins et sculpture* (Paris: Musée National d'Art Moderne, Centre Georges Pompidou, 1975).

15 'Rôle et modalités de la couleur', 1945, in Dominique Fourcade, *Henri Matisse. Ecrits et propos sur l'art* (Paris: Hermann, 1972); trans. Flam, *Matisse on Art* (note 4, above).

16 'Notes d'un peintre sur son dessin', 1939, in Fourcade, *Henri Matisse* (note 15, above).

17 Ibid.

18 Quoted in Barr, *Matisse: His Art and His Public* (note 2, above).

19 Louis Aragon, 'Matisse-en-France', in Henri Matisse, *Dessins: Thèmes et variations* (Paris: Fabiani, 1943); reprinted in *Henri Matisse. A Novel*, trans. Jean Stewart (London: Collins, 1972).

20 'Correspondence Matisse-Bonnard 1925/46', *La Nouvelle Revue Française*, Paris, xviii, July–August 1970.

21 'Propos de Henri Matisse' (interview with André Léjard), *Amis de l'art*, Paris, no. 2, October 1951.

22 Quoted in Norbert Calmels, *Matisse, La Chapelle du Rosaire des Dominicaines de Vence, et de l'Espoir* (Gordes: Morel, 1975).

23 Quoted in Aragon, 'Matisse-en-France' (note 19, above).

24 Ibid.

THE DRAWINGS OF HENRI MATISSE by John Elderfield

1 · Epiphanies

By an epiphany, he meant a sudden spiritual manifestation,
whether in the vulgarity of speech or of gesture or in a memorable
phase of the mind itself. He believed that it was for the man of
letters to record these epiphanies with extreme care, seeing that
they themselves are the most delicate and evanescent of moments.
JAMES JOYCE, *Stephen Hero*

Writing in 1954, the year of his death, on the subject of portraits, Matisse remembered an experience that had occurred more than half a century before.[1] He did not say when exactly it took place. Given the date when he was writing, he could not reasonably be expected to remember that – especially since a part of the point of his story has to do with the collapsing in on itself of chronological time. All that he can tell us is that he was 'still a pupil occupied with "traditional" drawing, anxious to believe in the rules of the school.' But the experience itself he vividly recalled – and recorded with extreme care. 'The revelation at the post-office' was how he described it, the oxymoron laconically reminding us that his was a romantic, instinctive sensibility within a 'modern', mechanical age. Matisse's own realization of this fact is another part of the point of the story, which begins with Matisse in a post-office in Picardy, thinking about his mother, and waiting for a telephone call . . .

> To pass the time [he wrote] I picked up a telegraph form lying on a table, and used the pen to draw on it a woman's head. I drew without thinking of what I was doing, my pen going by itself, and I was surprised to recognize my mother's face . . . I was struck by the revelations of my pen, and I saw that the mind which is composing should keep a sort of virginity for certain chosen elements, and reject what is offered by reasoning.

This rejection of reasoning was, in fact, the third of its kind that Matisse recorded when discussing his early career. The first belongs to his very beginnings as an artist. In the summer of 1890, when he was twenty, Matisse was convalescing after an attack of appendicitis and his mother gave him a paintbox to keep him from being bored. 'When I started to paint,' he wrote of his first efforts, 'I felt transported into a kind of paradise. . . . In everyday life I was usually bored and vexed by

the things that people were always telling me I must do. Starting to paint I felt gloriously free, quiet and alone.'² Since 1889, Matisse had been working as a law clerk in Saint-Quentin (where he had earlier attended the local *lycée*; he was from Picardy), and had begun to take early-morning drawing classes at the Ecole Quentin-Latour, making detailed studies of casts of antique sculpture.³ The revelation of painting for the first time suggested a kind of freedom: not only from the drudgery of the law office but also from that of the cold, dark mornings drawing at the art school. Drawing was literal copying. It was submission to learned rules. But to paint was to be 'gloriously free'.

The second rejection of reason for instinct came two years later, and it too was a rejection of academic drawing. In the winter of 1891–92, now determined to be an artist, Matisse left Saint-Quentin for Paris. But rather than immediately launching on a career as a painter, he enrolled for a course of twenty lessons in drawing from antique casts under the famous Adolphe William Bouguereau at the Académie Julian. This is often explained as being the price that Matisse had to pay to placate his father, who vigorously opposed his son's giving up a legal career. However, it also tells of Matisse's own acceptance of the fact that learning to draw was the necessary, traditional way of training to be a painter. Despite the contempt that he felt for Bouguereau's teaching, Matisse obviously felt that the patient study of drawing, however onerous, was simply necessary.⁴ Why else was it that no sooner than he had left Bouguereau in disgust, as he did in 1892, that he applied for admission to the Ecole des Beaux-Arts; and, rejected the first time, went there as an unofficial student to improve his skills until finally accepted in 1895?

Such persistence is not the behaviour of someone acting against their will; indeed, not of someone merely fulfilling the demands of convention. More even than that, Matisse – for all he wrote and spoke against academic teaching – was committed to the idea that the methodical study of earlier art and then of nature, through the practice of learning to draw from these sources, was the essential grounding of an artist. His early studies from the antique 'didn't produce pleasant drawings', he readily acknowledged, 'but drawings revealing intense efforts.' And yet, they 'were afterwards recognized as profitable'.⁵ The Beaux-Arts instruction 'is deadly for young artists'.⁶ The teachers are 'pompous ignoramuses'.⁷ And yet, he insists, sounding just like an academician himself, 'I believe study by means of drawing to be essential. . . . It is only after years of preparation that the young artist should touch colour.'⁸

But the reason he gave to justify this belief not only explains his own early patient academic study; it also reveals the precise point of principle on which Matisse and his academic teachers could never agree:

The painter who is just beginning thinks that he is painting from the heart. The artist who has completed his development also

thinks that he is painting from the heart. Only the latter is right, because his training and his discipline allow him to accept impulses from within, which he can in part control.

It is not enough to naively paint from the heart – to be transported into the 'kind of paradise' that the first taste of painting can open. Training is necessary: not, however, to learn the principles of correct draughtsmanship, but to acquire the discipline that will allow the artist to receive, and record, impulses deriving from feeling rather than merely from observation. 'If I have confidence in my hand that draws,' Matisse wrote in 1947, 'it is because I was training it to serve me, I never allowed it to dominate my feeling.'[9] The painter who is just beginning becomes the *artist* who has completed his development only with this particular kind of training.

Bouguereau, certainly, was not the one to provide it. He said to Matisse: 'You'll never learn how to draw.'[10] Much later, Matisse recalled this statement, but with an unexpected twist, when he quoted with approval what Toulouse-Lautrec reputedly had said towards the end of his life: 'At last, I don't know how to draw.' 'That means', Matisse commented, 'he had found his true line, his true drawing, his own draughtsman's language. That also meant that he had left the means used *to learn to draw*.'[11] In 1892, when Matisse left the Académie Julian, he left the means used to learn to draw. The exact perfection of Bouguereau was deadening. So was that of his deputy, Gabriel Ferrier, who allowed Matisse to begin life drawing. 'I did my utmost to depict the emotion that the sight of the female body gave me', he said.[12] But 'all that was not actually observed in nature, all that derived from feeling or memory was scorned and condemned as bogus.'[13]

Once again, it was painting that revealed an alternative to this all too literal, rule-bound world. Returning to Picardy in early 1892, Matisse visited the museum at Lille and there was especially impressed by Goya's *Les Jeunes* and *Les Vieilles*, paintings then thought to have been pendants but now established as having been made some seven or eight years apart.[14] The former harmonious and charming, the latter raw and almost expressionist, they must have offered Matisse a powerful object lesson in the adaptation of artistic language to the depiction of emotion, not merely of appearance. In any event, he returned to the mill of instruction for yet a third time, applying for admission to the Ecole des Beaux-Arts.[15] Refused, he registered in October of 1892 for evening classes at the Ecole des Arts Décoratifs (where he met Albert Marquet), while following the general procedure of would-be Beaux-Arts students: drawing independently in the Cour Yvon, the glass-roofed court of the school, in the hope of attracting the favourable attention of one of the professors and thus be invited to work in his atelier. It was Matisse's good fortune to attract the notice of Gustave Moreau.

'He taught us to discipline our will without any preconceived method; to have respect for a certain interior vision'.[16] These words on Moreau by another of his students, Georges Rouault, perfectly

summarize the two aspects of Moreau's teaching that Matisse most welcomed. It was while a student under Moreau that Matisse sufficiently improved his skills, judged by traditional Beaux-Arts standards, finally to pass (in February of 1895) the examination that gained him official acceptance to the school.[17] But far more important to Matisse than this, and far more relevant to what follows, was Moreau's insistence on a kind of discipline guided not by any external notion of objectivity – 'Don't dispute "objective truth" with nature', he advised Rouault[18] – but by 'interior vision'; that is to say, by the search for self-expression.

Matisse continued to draw from the antique. Indeed, he added to his studies of the art of the past by making copies in the Louvre. But under Moreau, copying was not a process of acquiring technical skills – 'photographic fact is only documentation, information', he insisted[19] – instead, it was a way of studying the past. (And when Matisse affirmed the importance of years of drawing for the young painter, he did not talk of learning to draw but of 'study by means of drawing'.)[20] Thinking about this in retrospect, Matisse realized that 'it was almost a revolutionary attitude on Moreau's part to send us off to the Louvre at a time when official art, doomed to the vilest pastiches, and living art, given over to plein-air painting, seemed to have joined forces to keep us away.'[21] In retrospect, it does indeed seem that Matisse was thus shielded not only from debased academic art but also from modern art. His was a willingly protracted education that avoided contemporary suggestion, trusting only on the examples of the past – and on himself until he had begun to find his own language.

'I have never avoided the influence of others,' he said to Apollinaire in 1907. 'I would have considered this a cowardice and a lack of sincerity towards myself. I believe that the personality of the artist develops and asserts itself through the struggles it has to go through when pitted against other personalities.'[22] But he picked his own battles, and did so extremely methodically. He knew how to be influenced, and the struggles of the mid 1890s were mainly with traditional drawing.

The studies that Matisse made under Bouguereau and Ferrier in 1891–92, such as L'Homme – académie (p. 137), have been described as a compromise between academic idealization and realistic definition. This is indeed true. We sense a curious imbalance in Matisse's attempt both to present a cleanly articulated set of formal relationships in the disposition of trunk and limbs and to convey the sagging weight of the elderly model. The area of rib-cage, stomach and hip is hardly convincing. Far more germane, however, to the conception of this sheet is the way that Matisse has used both idealization and realism to try to achieve a sense of inner, organic coherence for his subject as he observed it. The bas-relief effect may be no more than Matisse's inability to model in the round. And yet, the obsessive attention afforded to the interior of the trunk, and the way that the varying pressure of the contour drawing always turns into the figure to enclose it as if within a sense of grasp, combine to enforce the isolation of the figure as something almost hypnotically observed from a fixed

viewpoint. The reality of the figure, it seems, exists uniquely in the eyes of the artist, through which he imagines his hold on the isolated image.

The interiority of the figure is similarly stressed. Matisse has attempted to render its inner organic coherence by searching out its muscular and fleshy structure. At this stage, 'anatomical exactitude' is pursued as a way of revealing the internal character of the model. Later, he would attempt to discover the model's 'essential qualities', and therefore 'penetrate amid the lines of the face those which suggest the deep gravity which persists in every human being.'[23] Matisse's strengthening of the folds of the stomach, so that they clumsily detach themselves from the body, is certainly a mark of ineptness. But it is also evidence of a dissatisfaction with detail, and of an attempt to summarize, from details, the essential qualities of the model. 'I found myself or my artistic personality', he told Apollinaire, 'by looking over my earliest works. They rarely deceive.'[24]

How he continued is very much to the point here. In his earliest works, he said, he 'found something that was always the same and which at first glance I thought to be monotonous repetition. It was the mark of my personality which appeared the same no matter what different states of mind I happened to have passed through.' Returning to this theme later (referring to his copies at the Louvre), he added: 'What is believed to be boldness was only awkwardness. So liberty is really the impossibility of following the path which everyone usually takes and following the one which your talents make you take.'[25]

In effect, Matisse guarded the awkwardness of his early work. While his contemporaries were inheriting the skill and sophistication of the nineteenth century, his own technical ability was extremely rudimentary and his own artistic models were entirely traditional.[26] Instinctively, he seemed to have recognized that the truth of his own vision required these things. This might appear an extremely unusual judgment on the work of an artist renowned as the twentieth-century master of fluid and graceful drawing, and I will need to return to it later. Suffice to say for the moment that when Matisse had gained such a reputation, he was very careful to point out that his 'apparent facility' should not be taken as an excuse by students 'for dispensing with certain efforts which I believe necessary' and that if his work did look fluid and easy it was only because he tried, after his formative years, 'to hide my own efforts ... [and] never let anyone suspect the labours it has cost.'[27] Technical proficiency as such was deemed dangerous. Playing the violin, 'I wanted to acquire too rich a technique, and I killed my feeling.'[28] 'When an artist or student draws a nude figure with painstaking care, the result is drawing, and not emotion.'[29]

Drawing itself was not to be studied; drawing was a means of study. And drawing itself was not the aim of such study; its aim was the revelation of emotion. Moreau's teaching reinforced this message: self-expression. And it reinforced too, and justified, Matisse's suspicion

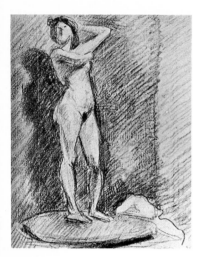

1 *Figure Study.* c.1895

of technical dexterity. 'Gustave Moreau loved to repeat', he recalled, '"The more imperfect the means, the more the sensibility manifests itself." And didn't Cézanne also say: "It is necessary to work with coarse means?"'[30] (If Matisse, under Moreau, began by shielding himself from modern art, it was Moreau who prepared for his modernism within that shield.)

The few Matisse drawings that can safely be attributed to his tenure with Moreau show the same artist concerned with the interiority of the body, but now with it as a whole image whose unity is hardly compromised by internal detail. The shaded density of the earlier figure is transposed to the setting. Engaging the whole spread of the sheet allows a new kind of collaboration between image and support. The latter more than merely forms the ground: it shapes and articulates what it contains, whose very containment, and frozen immobility, is all the more telling for the energy that surrounds it. The figure, though weighty, is strangely deprived of some of its weight, to read – for all its harsh and strident contours – like a pool of calm that has been excavated within some particularly resistant hard stone, for the contours that bound it belong as much to the ground as to the image itself.

The figure, of course, is articulated from within. Its internal wholeness is manifested not only by its silhouette but by balanced tensions and movements, summarily described. 'The mechanics of construction', he would tell his students in 1908, 'is the establishment of oppositions which create the equilibrium of the directions.'[31] Also: 'Express by masses in relation to one another, and large sweeps of line in interrelation. One must determine the characteristic form of the different parts of the body and the direction of the contours which will give this form.' And, more specifically – almost, it seems, remembering the construction of this particular work: 'In this sketch, commencing with the clash of the black hair, although your entire figure is in gradation from it, you must close your harmony with another chord – say the line of the foot.' The arbitrary reinforcement of contour below the model's right foot in this drawing closes the harmony in precisely this way.

Many of the remarks recorded by Sarah Stein and others in Matisse's school have to do with the analysis and simplification of form. They are required reading for an understanding of Matisse's own early drawings, for they condense, in effect, those elements of Matisse's own education in drawing that he himself found valuable. His overriding message is the creation of unity, of wholeness. His advice on how to achieve it concentrates on these three broad practical points.

First, sheer visual perception: how to see and to understand the structure of the model, which he described most often with building analogies. A foot is a bridge. A leg is like a flying buttress. Forearms are like cords. The parts must be firmly fitted together as when a carpenter constructs a house. Second, empathetic and metaphorical analysis. Assume the posture of the model, the better to understand it.

24

Notice how the calf of a particular model's leg resembles a vase, and how another's torso suggests an egg, and how 'these folded hands are lying there quietly like the hoop-handle of a basket that has been gradually lowered upon its body to a place of rest.' Third, the importance of linear simplification. 'One must always search for the desire of the line, where it wishes to enter or where to die away.' Lines cannot exist alone. One line brings another in counterpoint, and together they create volume. Never forget the constructional lines that describe the principal axes: 'All the lines must close around a centre; otherwise your drawing cannot exist as a unit, for these fleeing lines carry the attention away'.

Some of Matisse's statements do sound like the 'handy rules' that he later condemned teachers for giving their students, and few of them are particularly original. The point, however, is that they are, by and large, simplified versions of standard academic drawing practice combined with an attempt on Matisse's part to express, in practical terms, his belief that independence of vision was indeed possible within the context of extremely traditional study. He quoted to his students in 1908 (not quite accurately) a sentence from Courbet: 'I have simply wished to assert the reasoned and independent feeling of my own individuality within a total knowledge of tradition.'[32] And that, in short, was the aim of his drawing – then, earlier, and later.

As is well known, Moreau directed his students not only to the Louvre but to sketch in the streets of Paris. 'In effect,' said Matisse, 'it's there that I learned to draw.'[33] Following Delacroix's injunction that an artist should learn to note quickly a fleeting gesture, he drew, with Marquet, the silhouettes of passers-by. 'We were trying . . . to discipline our line. We were forcing ourselves to discover quickly what was characteristic in a gesture, in an attitude.'[34] The simplification of means, concern with the characteristic within the fugitive: both were central to Matisse's drawing – indoors as well as out – while he studied with Moreau. Some pen and brush sketches in the Musée Matisse at Le Cateau-Cambrésis, as well as some hasty pencil drawings from the artist's estate, are evidence of Matisse's work on the streets of Paris (though some certainly postdate his Moreau studies).[35] Most drawings of this type, however, Matisse later deliberately destroyed.[36] If he indeed did learn to draw in this way, and purified his line by the practice of working at speed, the result of this learning – the record of a fleeting impression – did not finally satisfy him. True, concern with the characteristic within the fugitive was common to his indoor and outdoor work. But to discover what was characteristic in a gesture was finally very far removed indeed from discovering the characteristic architecture of a model, such as he was beginning to do in Moreau's studio.

Thus far, the progress of Matisse's art is the progress of a draughtsman. From 1896, however, the painter leads the way. His summer 1896 paintings in Brittany; *La Desserte* and associated works of 1897; the experience of Impressionism; then Matisse's extended marriage trip to London, Corsica and Toulouse in 1898–99, when

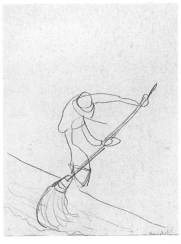

2 *The Sweeper.* 1901–02

25

colour in his painting took on a positive reality of its own: these leave his drawings (judging, at least, from the few that we know from this period) very far behind. By the time of the Corsican landscapes, Matisse was drawing in paint itself, in thick bands and streaks of vivid, lively paint. For the first time, his art was truly uninhibited, truly his own. All this was a revelation, 'a love of the materials of painting for their own sake.'[37] It was like the original experience of painting, back in 1890.

But still Matisse worried about achieving the proper discipline to be an artist. Without that, he would not truly be painting from the heart. And as he worried, he continued to draw. Returning to Paris in 1899, he returned to the Ecole des Beaux-Arts. But Moreau had died and been succeeded by Fernand Cormon. Matisse was asked to leave. He tried to go back to the Académie Julian but the other students took his studies for jokes and again he had to leave. Then, he enrolled in a private studio where Eugène Carrière came once a week to offer criticisms. (It was there he met André Derain.) But that studio closed for want of students, so Matisse and his friends hired a model themselves. Once again, we find Matisse, in reaction to a moment of liberation with regard to painting, turning obsessively back to drawing as if to prove to himself that the liberation just experienced can be reconciled, through drawing, with tradition.

Though probably drawn in 1900, after he had left working with Carrière, the beautiful *Standing Nude Model* (p. 140) with its softly vaporous ambience is certainly reminiscent of that artist.[38] But the same kind of 'architectural' construction that was evident in the earlier Moreau study is manifested in this work too. The body turns in on itself even as it raises its hand to balance that turning. Matisse is absorbed in the sensate, functioning aspect of the body.[39] Its identity stamps the identity of the drawing. For as in that earlier drawing, Matisse is preoccupied by the presence of the body within the ground – and, with an estompe used as an eraser, he rubs its identity out of a prepared charcoal ground before adding heavier charcoal accents to specify 'the equilibrium of the directions' within the figure and along its enclosing contours.[40]

The greater degree of finish within this work is interesting for this reason. Matisse took some drawings to Rodin for criticism (probably in 1899) and was horrified to be told that he had 'facility of hand' ('which wasn't true', he insisted) and that he would be advised to do detailed drawings.[41] He had, in fact, already come to the conclusion that he should try to make more detailed drawings (once again, Matisse's conservatism asserting itself) – but 'the right kind of detailed drawings':

Because, if I could get the simple things (which are so difficult) right, first, then I could go on to the complex details; I should have achieved what I was after: the realization of my own reactions.

To be told by Rodin that he had 'facility of hand' when he was struggling for simplification was certainly disheartening. But – as he

realized afterwards — his whole approach, his 'work-discipline', was already opposite to Rodin's. Rodin worked individually on details of the body then sought to combine them. 'Already', wrote Matisse, 'I could only envisage the general architecture of a work of mine, replacing explanatory details by a living and suggestive synthesis.'

This, he said, he did not quite realize at the time — 'for I was quite modest and each day brought its revelation.' One was that of Cézanne, whose work reinforced for Matisse his belief in the necessary wholeness of the body in his art. But the most important of these revelations, in many ways, was what he described as 'the revelation of the interest to be had in the study of portraits', which he began making in 1899.[42] And this revelation took place when Matisse was in a post-office in Picardy, waiting for a telephone call, and thinking of his mother.

Matisse, we recall, 'drew without thinking' an image of his mother's face. Still occupied with 'traditional' drawing and even now anxious to believe in the rules he had been taught — indeed, having returned to more detailed drawing — he was amazed by the revelations of his pen and 'saw that the mind which is composing should keep a sort of virginity for certain chosen elements, and reject what is offered by reasoning.'[43]

His artistic training had been in 'the dead part of tradition, in which all that derived from feeling or memory was scorned and condemned as bogus.' He had already, in part at least, surpassed that: 'Before the revelation at the post-office, I used to begin my study by a kind of schematic indication, coolly conscious, showing the sources of the interest which the model moved me to interpret.' He is referring, presumably, both to the studies under Moreau and more finished ones, like that made after his work with Carrière. In either case, cool analysis of the structure of the model, expressed in 'a kind of schematic indication', preceded elaboration to greater or lesser degree.

> But after this experience, the preliminary tracing I have just mentioned was modified right from the beginning. Having cleaned and emptied my mind of all preconceived ideas, I traced this preliminary outline with a hand completely given over to my unconscious sensations which sprang from the model. I was careful not to introduce into this representation any conscious observation, or any correction of physical error.

After that, 'reason takes charge, holding things in check and makes it possible to have new ideas using the initial drawing as a springboard.' But 'the almost unconscious transcription of the meaning of the model is the initial act of every work of art, particularly of a portrait.'

For the moment, let us be satisfied with noting these three things: first, Matisse's virtual identification of feeling and memory; second, the idea of drawing as the tracing of sensations springing from the model; and third, that this takes place in a virgin mind emptied of preoccupations. The question now can be asked: What was this revelation and what does it mean for Matisse's drawing?

Matisse's first portraits (p. 138) come as a shock when compared to any of his previous drawings. We are suddenly in the presence of a modern artist. Technically, they separate themselves from what came earlier. With the exception of some of the swiftly drawn street scenes, the medium of pen, brush and ink had not been used before — certainly not within a studio setting. These drawings, in effect, bring together the spontaneity and vividness of quickly sketching the 'characteristic in a gesture' and the preoccupation with architectonic wholeness of the academic drawings. It was, I suggest, 'the revelation at the post-office' that allowed these two strands to be combined; and in the following way.

The lessons of sketching in the street were, first, that with a disciplined line the artist's perception of what was characteristic in a gesture could be quickly recorded, and second, that when dealing with subjects in motion, the speed of the drawing minimized the necessity of remembering the gesture. But sketching in the street also, I think, made it evident to Matisse that drawing was indeed not only a matter of observation but of memory: of recording, in fact, not what was seen 'out there' — for that probably had passed before the pen touched the paper; rather, what had been stamped in the mind. The act of drawing was that of remembering.

Drawing from the model does not seem to be quite the same. Since even his time at the Académie Julian, Matisse had wanted not merely to record the appearance of the model but to depict the emotion it produced on him. Under Moreau, he eventually began to do so by means of architectonic simplification: by searching for the continuity of the whole image as a separate, constructed thing, distanced and whole by the estrangement of the act of seeing, and by giving its wholeness coolly and consciously, through schematic indications of the sources of interest within the model, which were then developed and elaborated to varying degrees. To work like this was gradually to reveal the wholeness of the image, to draw out its characteristic identity in the act of working.

Suddenly, however, to find himself producing the identity of a remembered face without any observation at all — which was 'the revelation at the post-office' — was surely to realize that the characteristic identities of immobile as well as mobile subjects were to be discovered through memory: that rather than their existing 'out there', distanced by sight, and whole in their separation from the artist, they, somehow, were 'on the inside'. Things were indeed accessible to sight, and yet their characteristic identities were not accessible to coolly analytical observation. They stamped themselves in the mind, and the act of drawing was that of reproducing not the model, certainly, nor even — it now appeared — the consciously observed 'sources of the interest which the model moved me to interpret', but an image that existed in the artist's mind. (The figures in the drawings around 1900 seem suddenly closer than any before.)

'Feeling or memory' had been 'scorned and condemned as bogus.' It now appeared that feeling and memory were very closely related and

that they were at the very heart of drawing. To record a characteristic image was to record the artist's feeling before his subject, to remember that feeling, which is to say, to excerpt it from the passing of time.

Drawing from an immobile object would seem to be a simpler proposition than drawing from outside nature, in this one crucial respect: nature has a tendency to move, however imperceptibly, while immobile objects, by definition, stand still. And yet, to any very careful observer, immobile objects do move; if not in space (with the movement of that observer's head or even eye) in time, and for such an observer, the act of recording the object comes down, in effect, to trying to record the present while it is taking place before it can slip into the past and be lost forever. By this I mean: experience of observation (not even of drawing) will show that fixed concentration on an object may appear to suspend time and hold it in the eternal present, but with the slightest lapse of concentration, backward time jumps (in reverse, like a clock that poises for a moment at each minute mark before it lurches forward) and a new (and later) observation has to begin ... which means: unless the memory of that first concentrated observation can be preserved, a new sensation before the object occurs (if not, a new object itself).[44]

Matisse would tell his students to look at the model, then 'close your eyes and hold the vision, and then do the work with your own sensibility.'[45] The model, he insisted, 'must not be made to agree with a preconceived theory or effect. It must impress you, awaken in you an emotion, which in turn you seek to express. You must forget all your ideas, all your theories before the subject.'[46] With the mind thus cleaned and emptied of preconceived ideas, the subject is experienced, and drawing is the record of that experience, of the 'unconscious sensations which sprang from the model.' To remember these is to make a drawing.

In order to clean his mind of *a priori* feelings — 'of all influences which prevented me from seeing nature from my own personal view'[47] — Matisse, around 1900, apparently copied from photographs.[48] Photography, for him, showed things that were 'devoid of feeling'. To copy a photograph, he said, 'kept me within the limits of the visible features of the model.' He was forcing himself 'to make the greatest resemblance possible';[49] and by resemblance he does not mean an objective, realistic copy, rather something whose own internal relationships are equivalent to those in the observed, experienced source. Working from photographs, he realized later, was 'an error' (why, will be considered later) — 'but what a lot of things I learned from it!'[50] Photography, in fact, presented Matisse with images not only 'devoid of feeling' but also stopped in time. Matisse's drawings around 1900 are far indeed from photographic representations. But they do give the impression of stopped time: of energized matter somehow frozen in a moment in their animated hatchings. The function of these hatchings, moreover, is curious: volume as such is indicated by areas of blank, white paper; concavities and spaces by strokes of the brush and pen. This led Matisse's fellow students — with

whom he was sharing his models – to remark that he was making a 'negative' (in the photographic sense) of what he saw.[51]

These ink drawings fall into two general categories: those, like the *Self-portrait, Smoking Pipe* (p. 138), composed of networks of dense, scribbly pen hatchings; and those, like *Standing Nude* (p. 142), more broadly drawn with directional strokes, with clearer contrasts of black and white, and often using a brush as well as a pen. The first known drawing of the set, a portrait of Madame Matisse dated 3 January 1899,[52] combines both approaches, but thereafter they seem to have been separated one from the other. Both reflect the impetuousness of Matisse's somewhat earlier paintings. The former group is generally related to his studies in Neo-Impressionism, as well as to his contemporaneous first etchings;[53] the latter to his admiration for Van Gogh and for Cézanne.

The great breakthrough of Matisse's painting in 1898 was the freedom of his touch from the specific description of objects. Reckless cascades of brushstrokes 'contained within them, independently of the objects that they served to represent, the power to affect the feelings.'[54] While his drawings were still patiently built up part by part to discover the structure of the model, these paintings were spontaneously coding the world through the tangible symbols of strokes and lines of paint. It seems almost as if drawing and painting had changed places. Drawing, the form of pictorial art potentially closest to pure feeling, was a deliberated artisanal procedure, while painting was virtually drawing in paint. The ink drawings of 1900 restore drawing to its pioneering position in Matisse's art, a position that had been lost around 1896. They do so by co-opting to drawing the lessons of Matisse's impetuous paintings and the lessons of the modern artists he had been admiring – and this was possible once drawing was conceived as principally the record of feeling, with its aim to capture the vividness of emotional response that a subject aroused. That was the point of the paintings. Now it was the point of the drawings too.

In the *Self-portrait, Smoking Pipe*, no attempt is made to analogize the nature of flesh or of clothing. The same dense hatching runs through the whole sheet just as broken spots and flecks of paint do in many of the Neo-Impressionist paintings. And as in those paintings, the *vibrato* (as Matisse called it) of light and dark touches does not so much imitate light as create it. The advantage of working in ink was that it emphasized contrasts which produced what Jean Puy, his colleague at this time, called 'the maximum resonance on the eye.'[55] The hatching of the *Self-portrait, Smoking Pipe* may indeed derive from traditional tonal modelling, and resemble it, but it clings to the surface, which it reveals through its interstices, and generates light 'through the opposition of colors' in their most rudimentary contrasting states.[56]

This approach is developed in the more broadly drawn works of this period. Large, boldly contrasted zones of black and white resonate against each other to generate images that are entirely antinaturalistic – for their identities cannot be disentangled from the coarse means

that created them – yet which hold as live constructions in a way previously unknown in Matisse's drawings. The *Standing Nude* (p. 142) is close in pose to the charcoal and estompe *Standing Nude Model* (p. 140) and similarly turns in on itself as a condensed whole. Its tangibility, however, is the tangibility of the trenchant marks of the pen that press around it, that partake of its density, and that expose the blankness of the sheet itself as the image of its exposure. Such marks clearly reflect Matisse's study of Van Gogh's drawings (one of which he purchased in this period) – of Van Gogh's coding of the observed world into symbolic, shorthand graphic devices laid bare on the white sheet without a trace of connecting tonal tissue to cohere them, but only the continuity of the surface and the insistent rhythms of the marks themselves.[57]

But even more than Van Gogh, Cézanne lies behind these drawings. It was Cézanne who taught Matisse that drawing could be purely 'a relationship of contrasts or simply the relationship between two tones, black and white.'[58] Cézanne, more than any other early modern artist, specifically addressed the question of how to preserve the wholeness and tangibility of objects yet fix them irrevocably to the flat resistant surface of modern pictorial art, and in so doing worried the enclosing contours of objects to find a way of allowing the eye to pass through them, while yet maintaining their authority. This too became Matisse's problem in the years around 1900, and while Cézanne's solution was not Matisse's, Matisse's would have been unthinkable without Cézanne's example.

In Cézanne's drawings, contrasts of tonality are so exaggerated as virtually to empty volumes of shading and compress it into the interstices between them. Volume is identified with the flat whiteness of the sheet, and is articulated by proxy, as it were, from the outside. 'Line and modelling', Cézanne insisted, 'do not exist.'[59] Traditionally, line is the symbolic, conventional component of drawings and shading the illusionistic component, which individualizes the conceptual, making it tangibly real. Cézanne, however, made the symbolic component of drawing (line) the sceptical substitute for its illusionistic component (tonality): sceptical, because line in Cézanne's drawings is allowed neither a conceptual, contouring function nor an individualizing one. It neither makes images nor identifies forms. Rather, it expresses in its discontinuity the inherent difficulty of representing the unseen three-dimensionality of objects in the world. It hovers away from forms, both connecting and separating, and is a kind of lost-and-found drawing that lets objects elide one into the next and into the surrounding space but keeps them whole just the same.[60]

Matisse's contrasts are an exaggeration of Cézanne's. They too conflate the functions of line and of shading and truly are neither of these things. Cézanne, especially in his *Bathers* compositions, had used shading outside contours in order to embed his figures into the picture surface. The heavy strokes of the pen in Matisse's *Standing Nude* (p. 142) build obsessively around contours that are detached from the figure

3 Paul Cézanne, *Three Bathers*. 1879—82

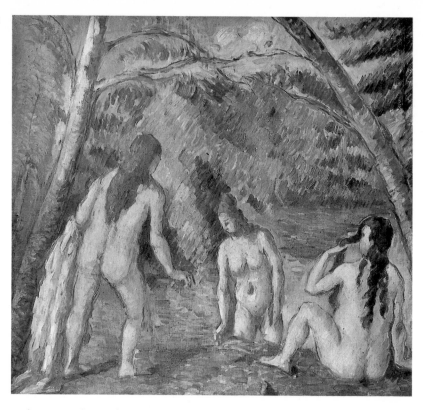

and exist only as the interior edges of an inky corporeal substance –
not shadow but materialized space – that thrusts aggressively away
from the blind spot created by the figure. With hindsight we might
claim that the drawings in Moreau's studio anticipate such an effect,
but truly nothing in Matisse's earlier work quite prepares us for the
sharp feeling of 'nowness', the sheerly instantaneous presence that
this remarkable image conveys. It is indeed as if the density and
concentration of a sudden vivid remembrance has been projected
onto the page.

 In a brilliant discussion of Romanticism, Northrop Frye disting-
uished between the empirical attitude to reality, in which the
inductive sciences begin, where 'reality is, first of all "out there,"
whatever happens to it afterwards' and a 'purely formalizing or
constructive aspect of mind, where reality is something brought into
being by the act of construction.'[61] Matisse is an inheritor of
Romanticism in emphasizing the reality-constructive power of the
mind. The 'outside' world 'yields importance and priority to the inner
world, in fact derives its poetic significance at least from it', says Frye of
the Romantics, adding this sentence from Coleridge's *Notebooks* which
could well have come from Matisse too: 'I seem rather to be seeking, as
it were *asking* for, a symbolic language for something within me that
already and forever exists, than observing anything new.'[62] 'Nature is
on the inside': if the subject of drawing or painting is conceived of as
'out there', separate from the artist, it simply cannot be represented

except in a fugitive way. But once it is understood that the subject is actually received 'on the inside' – indeed, that only 'on the inside' does it truly exist – then that certainly can be represented in such a way as to defeat the corrosiveness of time.

'Since things and my body are made of the same stuff,' wrote Merleau-Ponty, 'vision must somehow take place in them; their manifest visibility must be repeated in the body by a secret visibility. "Nature is on the inside," says Cézanne. ["If Cézanne is right, I am right," Matisse says.][63] Quality, light, color, depth, which are there before us, are there only because they awaken an echo in our body and because the body welcomes them.'[64] Cézanne (and Merleau-Ponty) and Matisse inherit from Romanticism its internalizing of reality, which is, as Frye points out, a by-product of the internalizing of the creative impulse itself.[65] All of which means that nature conforms to an internal image of itself which defies those aspects of its external image that might dispel the integrity of what is 'on the inside'.

'He had no hesitation about introducing extreme and wholly artificial elements in his pictures', remembers Puy of Matisse at this time.[66] For what was important now was picturing images whose very artificiality was integral to their identities. The message of Cézanne's 'coarse means' (and of Moreau's before that) turned out to be that the medium of art was exposed along with the artist's sensibility – and that the two were inseparable. There is no dissimulation in Matisse's drawing. But from this point onwards it is frank and candid (at times even to a brutal degree), and is carried by the sheer urgency of his vision – which is also to say by the objective, disinterested way it was manifested. Around 1900, however, Matisse's urgent desire for the wholeness of the bodily image found itself, for the first time, in potential conflict with the objective character of his own now modern art. Which is to say, the physical identity of the body and the physical substance of art itself seemed bound for collision. The implications of this would be profound in the years that followed. We should therefore re-examine some of his early drawings in this light.

The *Self-portrait, Smoking Pipe* (p. 138) is hatched in a heated form of traditional modelling – or so it appears at first sight, until we notice how the scribbled marks mass up in places against the contours of the head: 'they are like bees swarming round the form', Pierre Courthion said, and his description is even more appropriate to some less completely filled sheets from the same time (p. 141).[67] They are not shadows, but serve as opposing spatial weights that push and pull the image to settle it into the ground. They also corrode the figure from the ground, or threaten to. Also highly arbitrary is the way that the hatching down the right side of the sheet carries over the figure from the ground, tending to join the two into one zone that appears closer to us than does the left side of the work. Matisse was doing something very similar to this in his contemporaneous paintings: forcing different parts of the ground to occupy different positions in space.[68] The materialized space that surrounds the more broadly rendered drawing, *Standing Nude* (p. 142), similarly reads as if in different locations

on each side of the figure; in this case because it clings to the two sides of the figure, which are themselves in different spatial locations. Something similar to this is also to be found in Matisse's paintings of this period.[69]

Matisse, even from the period of the drawings made in Moreau's studio, tended to align the depicted backgrounds of his drawings with the flat plane of the sheet. (Around 1900 this became characteristic of his paintings too.) This placed the depicted subjects in a curiously ambiguous spatial position, somehow in limbo between the background and the support on which they were drawn. The result of this is to challenge the human identity of the subject, for its tangible presence in space is thus put in doubt.[70] Matisse seems to have welcomed the sense of artificiality that this provided – for it removed the subject to a purely pictorial existence – but also to have felt uncomfortable with the withdrawal from humanity it implied. His pictorial warping of the back plane, including his use of 'false shadows', was important to open enough space for the figure to exist in a human dimension.

We see the source of this warping effect in the academic drawings, where the edges of highlighted forms grade off into areas of dark space and where accents along the contours work, not descriptively but functionally, in adjusting the figure against the ground. In the *Standing Nude Model* (p. 140) for example, Matisse uses shadow to create room for the model to stand, and illogically reinforces the line of both thighs (for they cannot equally be in shadow given how the rest of the figure is illuminated) to force them simultaneously away from the setting. But if, as a result of these devices, the model does not actually float in front of the surface, she seems as if prised from it – and would tip forward toward us had not Matisse firmly anchored her head to the top of the sheet.

To his students Matisse said: 'A shaded drawing requires shading in the background to prevent its looking like a silhouette cut out and pasted on white paper.'[71] In the ink drawings, the shading surrounding the figures opens space and fits them into the background, and, while it tends to silhouette them, there are always enough marks within the bodies of the figures to prevent them looking like cut-out silhouettes. However, in works like the *Standing Nude*, the continuity that the eye recognizes between the whiteness of the body's interior and that of the perimeter sheet forces the shading between these two zones to read as if hollowed. But its boldness also makes it appear as if on the surface, which produces an unsettling ambivalence (shuttling our attention between surface and depth) that is part of the drama of the work. It is as if the figure has been impressed into the sheet's surface, which buckles under its pressure. The physical identity of the bodily image and the physical substance of the surface are opposed.

In works like *Self-portrait, Smoking Pipe*, Matisse allows victory to the surface; similarly so in *Still-life with a Chocolatière* (p. 139). But the result of this is to render the identities of these images ambiguous: they tend to dissolve into the ground. Maintaining the identity of images produced

an unsettling spatial ambivalence because the identity of the surface had now to be acknowledged. But since there was now no going back to images distanced in space – for drawing was no longer about the 'out there' – the only alternative, it seemed, was to risk loss of the wholeness of things. After being so careful and cautious for so long, Matisse had finally allowed the demands of emotion to dominate his handling, only to find that the medium itself was opposing his control. As he explained later, he knew that he was being carried forward by an impulse 'quite alien' in its recklessness, and yet he also knew that it was the reality of art itself that he had to trust: 'I knew that I had found my true path ... [but] there was something frightening in feeling so certain and knowing that there was no turning back.'[72]

Certainly in drawing, the most doggedly, carefully nurtured and slowly developed of Matisse's arts at this time, there was no possibility of retreat. And with his drawing poised at this moment of crisis, Matisse let it rest. There are hardly any known drawings after the series in ink that ended around 1903, until the Fauve drawings of 1905. Matisse continued to worry the ambivalence of figure and ground in his paintings, which came increasingly to depend on drawing to a more traditional degree than those drawn in paint just prior to 1900. Now, painting was controlled by drawing again. By 1903, Matisse was consolidating in his painting, and had checked his recklessness in order to preserve wholeness for the images it contained. And he was now making sculpture too.

The function of sculpture for Matisse both paralleled that of drawing (his first ambitious sculptures exactly coincided with his first ambitious modern drawings) and could substitute for it – in the following ways. First, it too was a study medium for painting. It was 'a complementary study [to painting] to put my ideas in order.'[73] 'That is to say, it was done for the purpose of organization, to put order into my feelings, and find a style to suit me.'[74] Second, it too dealt with the limits of shaped volumes and how they abut into the surrounding space as well as contain whole images. Third, it specifically addressed the relation of containing drawing to physical touch, for in Matisse's sculptures 'his touch ... becomes his line, is his draftsmanship.'[75] And fourth, it addressed – far more directly than any other aspect of his work – the question of how visually distanced from the observer are the whole images he made: being 'real' things, they belong in the world in a way that images in drawings or paintings do not. In his early sculptures, Matisse used 'real' volumes and masses to investigate how to contain the wholeness of figures – how to make images with a compactness and self-sufficiency that crucially depended upon the adjustment of their contours to the space around them. It was as if he had to study images physically away from the flatness of pictorial art, in order to achieve that union of the physical and the pictorial he desired. They had to be physically whole, but they also had to be visual things if they were to find a place in pictorial art. Matisse therefore consciously 'models the figure seen at a distance', as William Tucker

puts it.[76] With few exceptions, he makes small, graspable sculptures, but so broadly abstracted that their physicality is withdrawn from our grasp. The sculpture 'is made as if felt near by the hand ... and is seen far by the eye', and largely achieves this effect because volume serves the demands of internal linear rhythms; solid, simplified volume is drawn as it is amassed, to produce centralized images like tree-trunks or, more often, like intertwined branches. When his work was once compared to Maillol's, he replied: 'Maillol, like the Antique masters, proceeds by volume. I am concerned with the arabesque ...'[77]

'A drawing is a sculpture,' he told his students, 'but it has the advantage that it can be viewed closely enough for one to detect suggestions of form that must be much more definitely expressed in a sculpture which must carry from a distance.'[78] Soon, the arabesques of his drawings would remember their sculptural derivations, and their contours the mass of the bodies the sculptural contours bounded. But first, the opposite tendency of his early impetuous drawings reasserted itself. Matisse's modernity, already in 1900 bolder and more responsive to the 'coarse media' of his art than anything to be found in any of his contemporaries, was fully unchained. Study, it seemed, could only go on so long. As Lawrence Gowing has remarked, Matisse had been separately studying the elements of art in order to find 'a way out of conventions that had long ago ceased to govern the *avant garde*.'[79] It is indeed odd to find Matisse saying, even in 1951: 'All my life I have been influenced by the opinion current at the time I first began to paint ... "render observations made from nature"; "copy nature stupidly"' and that his whole career was a reaction to this opinion: a search for 'means of expression beyond the literal copy – such as Divisionism and Fauvism.'[80] By 1900, literal copying was not a live issue in avant-garde art. In 1905, when Fauvism was created, it was simply an anachronism. Most artists (and not just artists), it seems, are prisoners of their first maturity. In a curious way, Matisse was a rebellious, unwilling prisoner of his immaturity. He always remained a student – unable to relax, unable to stop thinking of art as study, even when it was clear that it was coming 'from the heart'. But at Collioure in 1905, the presence of André Derain, ten years younger than Matisse and determined to be at the very forefront of the avant-garde, both unsettled Matisse and unlocked from him a kind of modernity so extreme as to alter decisively the steady momentum of his art and to dissolve that wholeness of imagery that he had always been striving to maintain – if only to allow its reconstitution in a radically new way; but that was not apparent at the time.

There are few truly 'Fauve' drawings, and not surprisingly, for Fauvism was, in one sense, antipathetic to drawing. The great pioneering movements of early modern art – Impressionism, Fauvism, Cubism – were all, in their different ways, attacks on the image-making aspect of drawing, for discrete images disrupted the continuity of the painting surface and its modern, object-like unity. Fauvism follows Impressionism, at its most extreme, in all but repudiating the two central norms of Western pictorial art since the

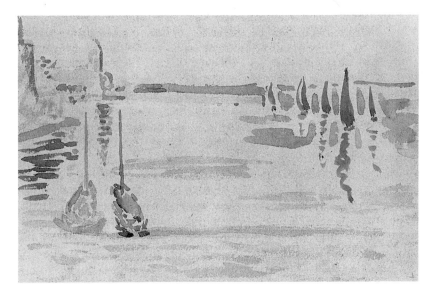

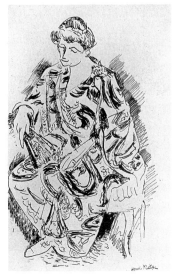

Renaissance: discrete image-making and the illusion of sculptural form. Drawing is crucial to both of these – which accounts for its traditional place at the very foundation of the visual arts. When the more radical Impressionists rendered nature in their paintings as an all-over molecular field that fractured the imagist unity of objects and narrowed value contrasts to such an extent as to squeeze volumes virtually out of existence, drawing was made homeless in advanced art and was required, in effect, to begin again. Fauvism, too, fractured the unity of things and dissolved their volumes, in dabs and dashes of high intensity pigment scattered across exposed white surfaces to generate light in the dazzling vibrations of complementary colours. Drawing as such could only exist in such works in the form of elongated patches of pigment: long, but often broken, dashes, bars and curling strips of paint. Like the Impressionists, Matisse took his art out of doors – for the first time properly since before 1900 – and found modern painting waiting for him: a molecular flux of sensations to be suspended in colour. Exceptionally, he turned to the medium of watercolour.[81] There, it seemed, a kind of drawing could be produced with a comparable all-over luminosity to the oils. Watercolour too could break up the wholeness of objects. Anything that disrupted the field of colour was intolerable.

Subjects which themselves fractured – or rather, camouflaged – volumetric forms were used on occasion by the Fauves. Matisse's *Seated Woman* of early 1905 does just that.[82] It was not, however, until the summer of 1905 at Collioure that a comparable degree of abstraction was regularly achieved without such help. Of the few drawings we know from that Collioure summer, some – like *Madame Matisse Seated* (p. 144) and the somewhat later *Le Port d'Abaill* (p. 145) – remind us of the linear armatures from which, in the paintings, colour was escaping.[83] They recall the carefully designed and compartmented Neo-

Impressionism that had produced *Luxe, calme et volupté* the previous year.[84] Others – like *Madame Matisse among Olive Trees* (p. 144) – seek a draughtsmanly equivalent of the paintings in lightly touched marks of the pen scattered across the sheet to give an all-over *vibrato* in black and white. But we notice how Matisse could not resist enclosing the figure. Landscape could be dissolved, but even in the heat of Collioure the unity of the figure was precious to him.

In drawing, the surprise of that summer is the *The Artist's Daughter, Marguerite* (p. 145). The sitter remembered it as having been drawn in 1905 at Collioure.[85] We cannot but wonder whether she is correct, for the usual attribution to 1906 is more convincing stylistically. But if it was made in 1905, it tells us that Matisse was indeed wondering what had been lost in the passion of painting. It is a careful, thoughtful and beautifully observed portrait, calmer than anything around it, indeed, more internally consistent as a portrait than any drawing preceding it. When compared with the portraits around 1900 it is curiously styleless. Though obviously modern, its means are not exaggerated as they were earlier. The exposed line that enters the falling lock of hair to the right is unusually inert and weakens that section, and Matisse's difficulty in achieving a comfortable relationship between the two eyes (some-thing we will see again) leaves the eye to the left somewhat adrift and misplaced. But the broadness of the conception carries these details to produce a highly compelling image, set assuredly within the whiteness of the sheet.

The Artist's Daughter, Marguerite hardly qualifies as a Fauve drawing. The portrait of *Jeanne Manguin* (p. 147), however, is the closest that Matisse came to producing a Fauvist drawing style. Indeed, it is the closest that Matisse's drawing has yet come to his painting. Fauvism, it suggests, was not antipathetic to drawing after all, but actually a form of drawing in paint.

At Collioure, we know, Matisse had been worried about the relationship of drawing and painting. He wrote to Signac on 14 June 1905 of the reservations he now felt about his Neo-Impressionist *Luxe, calme et volupté*. The design and the paint application were not in accord:

> In my opinion, they seem totally different, one from the other, absolutely contradictory. The one, drawing, depends on linear or sculptural plasticity; the other, painting, depends on coloured plasticity.[86]

Matisse's terms here derive very specifically from a statement quoted in Emile Bernard's July 1904 article on Cézanne, in which Cézanne links 'sculptural plasticity', an art of linear contours, to the antique and to Ingres and 'decorative plasticity', an art of colour, to the Renaissance and to Delacroix.[87] What Matisse wanted to achieve in Fauvism was to synthesize these two approaches: to resolve, in fact, the ancient conflict of drawing and colour.

In Matisse's Neo-Impressionist painting, as in Neo-Impressionism itself, drawing and colour are counterposed. Insofar as Fauvism is a development from the kind of preliminary colour sketches the Neo-

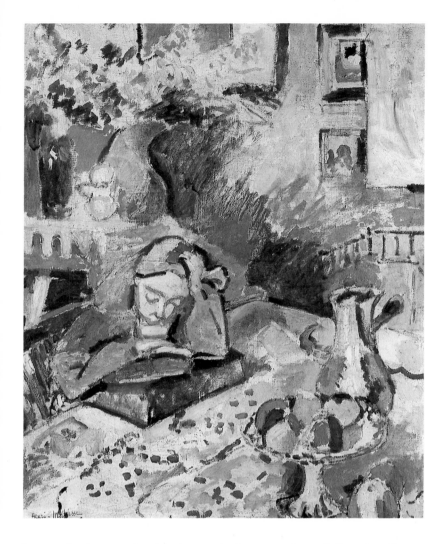

Impressionists made, it gives priority to colour.[88] But insofar as Fauvism opposes – which it does – the all-overness which Neo-Impressionism inherited from Impressionism, it makes drawing and colour as one. Both Neo-Impressionism and Fauvism separate themselves from Impressionism in that neither are painterly, *malerisch* styles, but styles that use individually set-down and unblended touches of paint. Unlike Neo-Impressionism, however, Fauvism does not use all-over, similar-sized touches. In especially the developed Fauve paintings of the winter of 1905–06, such as *Girl Reading*, to which the *Jeanne Manguin* drawing most closely relates, Matisse overturned the traditional notion (inherited and exaggerated by Impressionism and Neo-Impressionism) of relative uniform facture as necessary to a coherent art. In both painting and drawing, the sheer variety of marks, lines, spots, scribbles and summary shading is astonishing – and entirely new to Western art. Talking of the change in his art from Neo-Impressionism to Fauvism, Matisse noted: 'I was able to compose my

paintings by drawing in such a way that I united arabesque and colour.'[89] The example of Van Gogh obviously helped Matisse to this solution (and that of Gauguin would soon help him to consolidate it), but the stress on discordant facture is carried to a new extreme. Linear and decorative plasticity are united, and being united they allow Matisse at one and the same time to decompose objects and to maintain a sense of their identities. The substance and specific identity of objects is corrupted in the visual flux, but the visual flux is made permanent: the abrupt drawing in paint presumes, and does not destroy, the existence of the objects from which it derives. Matisse seems actually to rebuild the represented subject from the chaos of sensations, and in that rebuilding to discover its emotional content. This is precisely what happens in *Jeanne Manguin*.

But far from varying his handling to focus attention on psychologically expressive features like face or hands, he deflects it from them, spreading 'expression' through every part of the figure, and throughout the work. The very assertiveness of the facture assists this too. It forces attention to the surface of the drawing, holding even the contours there as they seem almost to gouge their way at times across the resistant sheet, like woodcutting tools throwing off fragments of matter, which lie scattered around them. (He was making woodcuts around this time.) They divide up space more than contain it, thereby allowing the whiteness of the sheet equal weight on either side of them. Fauvism had finally expelled from Matisse's art 'the obligation to render tonal distinctions ... it is as if the connecting tonal tissue of painting had been surgically removed to reveal its irreducible chromatic structure.'[90] In drawing, it drained figures like this one of enclosed tactile substance, allowing contrasts of black and white to read colouristically. A sense of air-filled, breathing space runs right through the whole drawing, joining figure and ground in a way that Matisse had never achieved before. Miraculously the problems of his early ink drawings had been solved. He had surrendered to the surface – as Cézanne had in his late work, from which this breathing openness derives – and, like Cézanne, had found that the white sheet of the surface became virtually a medium of existence (like air, space, light, and freedom) within which objects grow and gain their life. Where does the wholeness of this image lie but in the wholeness of the surface itself?[91]

And yet, this was so purely visual a thing as to refuse all sense of the graspable, and as such was bound to bother Matisse. 'A drawing is a sculpture' ... *Jeanne Manguin* could hardly be further from that. The great *Nude in a Folding Chair* of 1906 (fig. 7) reasserts the graspable – but, like the drawings of 1900–03, in the form of dense shadows built around the figure's contours. Matisse extended this approach in the drawings for woodcuts he made from the same model early in 1906. They co-opt to their blunt contours a sense of tangibility, seemingly drained and condensed from the now emptied bodies they contain.[92] One (p. 148, below) embeds the figure within strained linear rhythms derived from Van Gogh,[93] but regardless of their stylistic variety they all look back

to the woodcuts of Gauguin, and take from his woodcut technique that sense of images having been created by excavation, leaving behind a tough, angularized line of enclosure that 'synthesizes to itself memories of the lost bodies between.'[94]

The carving away of matter to create line was obviously a tedious process,[95] and one of this group of drawings (p. 149) was not translated into a woodcut. But Bernice Rose's suggestion, that Matisse's experience of woodcuts helped him to make of conventional contour drawing something more vividly expressive, is a reasonable one.[96] The ink drawings around 1900 had generally shied from exposed contours. Works like *Jeanne Manguin* render them almost purely optical. The drawings for woodcuts, however, retrieve for contours an abrasive physicality while allowing them to function decoratively, as flat surface patterns, at the same time. While works of this kind are certainly more conventional than *Jeanne Manguin* in returning to silhouetted figures whose silhouettes belong to the ground as much as to the figure (and in this sense recapitulate what had been achieved around 1900), they do point to something quite new in the way that Matisse no longer worries about trying to disentangle the wholeness of the bodily image from that of the ground. The bodily image rests calmly and flatly within the excited ground – a passage of quiet emptiness amidst the Fauvist *vibrato* around it – and the ground reverberates with the rhythms of the whole body. The design of the surface is generated by that of the body: it ripples away from the body until it, too, is whole.

While he was making these drawings for woodcuts, Matisse also produced a series of drawings on transfer paper for lithographs.[97] In these, pure continuous line drawing appears in his art for the first time. To see one of the lithographs beside a comparable woodcut study and a contemporary drawing (p. 148 below, figs 7, 8) is to realize that Matisse, having united linear and decorative plasticity in 1905, is now testing the linear against the decorative in different combinations. The method of the lithographs turned out to be the preferred one, as we soon shall see. Matisse was concurrently working on *Bonheur de vivre*, and the fluid linear rhythms displayed in the lithographs obviously relate to that seminal painting. At the same time, however, the drawing of the lithographs is less abstracted than that in the woodcuts – less completely decorative and closer to observed fact. Line would indeed become increasingly important, but a kind of line that escapes contemporary suggestion in a way that line in the lithographs does not.

By now, the standard academic poses of Matisse's earlier work have been replaced by more relaxed, naturalistic ones. The Fauve drawings and related prints look back in many respects – as does Fauvism itself – to the transitory, single-moment presentations of the Impressionists. The prints of women reclining in chairs; the drawing of a woman undressing, caught in arrested action removing her chemise (p. 149); *Madame Matisse Among Olive Trees* (p. 144): all these works owe much to Impressionist examples. Even *Jeanne Manguin* resonates with rhythms

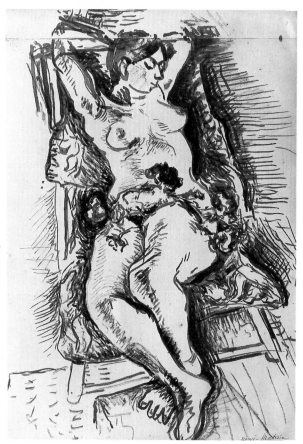

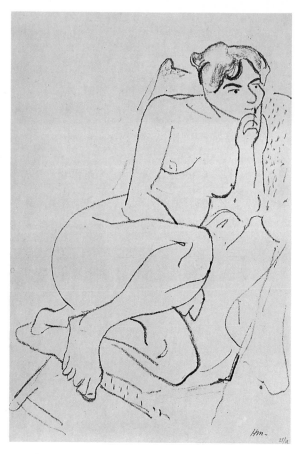

7 *Nude in a Folding Chair.* Brush and black ink. 1906

8 *Nude in a Folding Chair.* Lithograph. 1906

that evoke impermanence in their very excitement. All of these drawings pluck out a single moment from time and fix it before our eyes.

And yet, this moment is not quite some suddenly come-upon thing. The quality of silent, introspective calm in the figures reminds us that Matisse is not only fixing a temporal moment but is seeking stasis in such a moment. If time is suspended, it is not to reveal the 'characteristic in a gesture', not to give us images that themselves stand for a suddenly suspended world. The blankness of their silence is discovered in the suspension of time; yet, finally, they are not moments from nature, as with Impressionism, but moments *within* nature. We remember how Matisse insisted that his whole struggle was against the opinion current when he began to paint: 'render observations made from nature' and 'copy nature stupidly'. While the latter pointedly refers to Beaux-Arts practice, the former can apply to Impressionism as well. That too seemed alien to working from

'imagination or memory' – which meant permanence, wholeness, even within the molecular flux of the Fauvist world.

But where except the world can the imagination find its images, and what else but the world (or emotions that derive from it) can be remembered? Nothing that I (or Matisse) have said thus far is intended to suggest that Matisse did not observe the 'outside' world as part of the act of drawing or painting. He never made an 'abstract' work of art. He preferred images to abstractions, sensations to conceptions, and drew his sustenance not from the world of ideas but from the world of sensory experience. When he says, then, that his whole struggle was with the idea of rendering observations made from nature, it was, as Lawrence Gowing has noted, 'a struggle with a part of himself.'[98] The appearance of the world mattered, crucially so; it mattered as much as the physical structure of art itself – and Fauvism was the outcome of his obsession with both of these things. He found that the creation of light from simplified contrasts and the directness of pictorial method were perfectly aligned; they had (by no means incidentally) brought him, at the age of thirty-five, to the forefront of the avant-garde. But suspicions remained. Were not these suspended moments, however insulated unto themselves, too fragile, and the excitement of their handling too assertive properly to represent the wholeness of these figures that had been plucked out of time? Was not Fauvism itself as transitory a thing to the deeply conservative Matisse as being a member of the avant-garde?

Judging from what was about to happen, we might reasonably surmise that 'the anxious, the madly anxious' Matisse (as the Neo-Impressionist Cross described him)[99] indeed had suspicions of this kind. The whole Fauvist world had somehow to be ordered and calmed. 'We want something else,' Matisse would soon insist. 'We work towards serenity through simplification of ideas and of form.' [100] Drawing assumed a new importance now, for it would shape this new world. But drawing had been irrevocably altered by Fauvism to serve its purposes. 'Something else' required a new approach: 'It is a question of learning', Matisse said, '– and perhaps relearning – a linear script; then, probably after us, will come the literature.' By 'literature' he meant 'a mode of pictorial illustration'; not 'narrative description, since that is in books' but (remembering what Moreau had told him) the expression of 'interior visions'. Line drawing would be the means of ordering the world – but not a descriptive form of line drawing (such as we see, for example, in the 1906 lithographs); rather, a 'linear script'. ('Une écriture qui est celles des lignes.') With drawing of this kind, the world could be simplified into symbolic forms that had the directness and precision of words. What Matisse learns – or rather relearns – after Fauvism is the meaning of a revelation that had happened years before: not only that drawing is the transcription of unconscious sensations experienced before the model, but that the experience of such sensations constitutes a revelation, an epiphany, in itself and has to be recorded with extreme care.

2 · Signs

*I felt that I was not penetrating to the full depth of my impression,
that something more lay behind that mobility, that luminosity,
something which they seemed at once to contain and to conceal.*
 MARCEL PROUST, *Swann's Way*

Students of art history will know how Géricault's paintings of
galloping horses were 'proved' to be unreal by photography. When a
horse is completely off the ground, its legs are almost folded
underneath its body and not stretched out as they are shown by
Géricault. Why, then, do photographs tend to present horses in
motion as if they are leaping upwards and not galloping at all?

I take this question from Merleau-Ponty, who took his answer from
Rodin: 'It is the artist who is truthful, while the photograph is
mendacious; for, in reality, time never stops cold.' And Merleau-
Ponty adds: 'The photograph keeps open the instants which the
onrush of time closes up forthwith; it destroys the overtaking, the
overlapping, the "metamorphosis" (Rodin) of time.... Painting
searches not for the outside of movement but for its secret ciphers, of
which there are some still more subtle than those of which Rodin
spoke."

In Matisse's 'Notes of a Painter' of 1908, he too criticizes the
'photographic' representation of movement:

> When we capture it by surprise in a snapshot, the resulting image
> reminds us of nothing that we have seen. Movement seized while it
> is going on is meaningful to us only if we do not isolate the present
> sensation either from that which precedes it or that which follows
> it. ²

This passage comes at the end of a section in which Matisse attacks
the empirical stance of Impressionist painting. 'A rapid rendering of a
landscape', he writes, 'represents only one moment of its existence. I
prefer, by insisting upon its essential character, to risk losing charm in
order to obtain greater stability.' In this sentence, 'existence' is a
translation of Henri Bergson's term 'durée', which does not quite
mean duration but 'time' and 'existence' together. Just as a stopped
movement is untrue because never actually experienced, so is a
stopped moment. However:

> Under this succession of moments which consitutes the superficial
> existence of beings and things [in this case, Matisse uses *l'existence*],
> and which is continually modifying and transforming them, one

44

can search for a truer, more essential character, which the artist will seize so that he may give to reality a more lasting interpretation.

Just as movement has to be stopped, but not in movement, so time has to be stopped but not at one time: for if the aim is to create something lasting and stable, and since that cannot be outside time itself (for that would be unimaginable), it must be outside time's corrosiveness, at least.

Matisse is writing in 1908. And something drastically has changed. Earlier, he said, he had been satisfied with a more empirical approach (referring, presumably, to his work through the Fauve period), but was no longer. Had he been, 'I should have recorded the fugitive sensations of a moment which could not completely define my feelings and which I should barely recognize the next day.'[3] What Matisse is asking of his own art is that it persists in time as a definite record of his feelings.

This is why his earlier practice of working from photographs proved to be 'an error'. No matter how vividly he fixed his emotional response before the subject, it would be a frozen record of stopped time. Since the experience of any subject exists in time, how can one record in a fixed object – a drawing, painting or sculpture – other than one fixed and therefore fugitive moment of its existence? That question had already been answered: represent not the subject but the emotion it produces. But after Fauvism a second question arose: how to represent the emotion experienced before the subject in such a way that the represented emotion itself did not seem fugitive? Simply to record the emotional sensations received at any one moment would be to record past sensations, and as such neither lasting nor stable, therefore unrecognizable at a later time.

But how can emotional sensations be received except at the moment of experiencing the subject? For like aesthetic sensations, they come along with experience of the subject itself. That had been part of the revelation at the post-office: that 'unconscious sensations ... sprang from the model' and the mind had to be 'cleaned and emptied ... of all preconceived ideas' the better to absorb them. And yet, such sensations (again like aesthetic sensations) can grow and be clarified along with increasing familiarity with the subject. This is part of the answer to Matisse's question:

I think that one can judge the vitality and power of an artist who, after having received impressions directly from the spectacle of nature, is able to organize his sensations, to continue his work in the same frame of mind on different days, to develop these sensations; this power proves he is sufficiently master of himself to subject himself to discipline.[4]

The act of working is an act of mental discipline which preserves, develops and realizes first sensations. 'I am driven on by an idea', Matisse says, 'that I really only grasp as it grows with the picture.'[5] 'Truth and reality in art begin at the point where you cease to

understand anything you do or know, yet feel in yourself a force that becomes ... steadily stronger and more concentrated.'[6] Working clarifies feeling; more than that, it actually specifies it. Work begins 'after having received impressions directly from the spectacle of nature.'[7] 'This spectacle creates a shock in my mind. That is what I have to represent.'[8] 'My painting is finished when I rejoin the first emotion that sparked it.'[9] Working moves forward until it is finished, but only to return to the beginning and to the shock of emotion from which it began and of which it is a representation. 'At the final stage', says Matisse, 'the painter finds himself freed and his emotion exists complete in his work. He himself, in any case, is relieved of it.'[10]

Art is remembering and preserving emotion: we have heard that before. But what is different now is that art must be slowly and methodically developed – must admit time into its very construction – if it is to defeat the corrosiveness of time and shape interiorized feeling into stabilized form:

> I want to reach that state of condensation of sensations which makes a painting. I might be satisfied with a work done at one sitting, but I would soon tire of it; therefore, I prefer to rework it so that later I may recognize it as a representative of my state of mind.[11]

All of which points to a crucial modification in Matisse's understanding of drawing. Previously, the spontaneity of drawing was welcomed. Drawing was closest to pure thought and could quickly trace out the sensations springing from the subject. It provided virtually a model of that sense of instantaneousness to which painting seemed to aspire. Now, however, at least for the time being, it becomes mainly an explorative medium that prepares for painting in a more traditional way. After 1906 and until 1919, the softer, more pliable media of pencil and charcoal dominate Matisse's draughtsmanship, which serves to set down first sensations, then to analyse subjects for their characteristic expressive forms prior to their further 'condensation' in painting itself.

Matisse, however, did not work from these drawings when making his paintings, 'but from memory'.[12] He made drawings, he said, *pour me nourrir* – to strengthen my knowledge.'[13] They were the means of knowing objects, the better to remember them. 'Deep within himself ... [the artist] must have a real memory of the object and of the reactions it produces in his mind.'[14] Drawing would provide that. But since 'composition, the aim of which should be expression, is modified according to the surface to be covered',[15] it would have been inadmissible simply to transpose drawings to the canvas surface. Even in drawing itself, transposition as such was not to be tolerated:

> If I take a sheet of paper of a given size, my drawing will have a necessary relationship to its format. I would not repeat this drawing on another sheet of different proportions, for example, rectangular instead of square. Nor should I be satisfied with a mere enlargement, had I to transfer the drawing to a sheet the same shape, but

ten times larger. A drawing must have an expansive force which gives life to the things around it.

Composing the sheet, that is to say not merely realizing the image, is what makes the drawing truly expressive: 'the place occupied by the figures, the empty spaces around them, the proportions, everything has its share' in drawing as well as in painting. To possess a full knowledge of the subject means fixing it inextricably to its appointed place. 'Expression ... does not reside in passions glowing in a human face or manifested by violent movement. The entire arrangement of my picture is expressive'.

While wholeness of the kind that Matisse achieved in his paintings is only exceptionally to be found in his drawings – because drawing usually only began the process of achieving it – his drawings nevertheless take on, around 1906, along with their explorative function, a new compositional simplicity, typically comprising rhythmically unified images set barely within the sheet or emerging from earlier corrections with a severity, almost, not to be found before. For if the function of drawing was to begin to condense the sensations received from the subject, drawing was a method of filtering out those sensations which did not seem permanent.[16]

In practice this meant: avoid detail, 'exaggerate in the direction of truth',[17] and rigorously exclude any kind of expression – like 'passions glowing in a human face or manifested by violent movement' – that could hinder the idea of expression as manifested, rather, in the harmonic unity of the work of art itself. Drawings made in this way would impress in the artist's mind characteristic images, to be remembered in making the final work of art, and to be refined as they were reimagined in their new contexts.

Avoidance of detail had been a motto since the earliest years, and so, in effect, had been exaggeration in the direction of truth. But what changed from around 1906 was the character of this truth: something that required expulsion of all but the harmonious. Before considering the new kinds of drawings that Matisse began making in 1906, we must understand the nature of this desired harmony. And to do so, we should return to the question that arose after Fauvism: how to represent the emotion experienced before the subject in such a way that the represented emotion itself did not seem fugitive? Conceiving of drawing as an explorative discipline through which the emotion is clarified and made durable is part of the answer but not all of it.

The other part of the answer is to be found in Matisse's certainly most famous – and just as certainly most often misunderstood – statement on the aims of his art, from 'Notes of a Painter' of 1908:

> What I dream of is an art of balance, of purity and serenity, devoid of troubling or depressing subject matter, an art which could be for every mental worker, for the businessman as well as the man of letters, for example, a soothing, calming influence on the mind, something like a good armchair which provides relaxation from physical fatigue.[18]

This is not the manifesto of a purely hedonistic art, requiring no effort at all on the part of the observer. First of all, it is Matisse, as a 'mental worker' himself, dreaming of an art that will provide calm for his mind: an art that so fully remembers the emotion that engendered it as to provide mental relief. Second, it is Matisse explaining that art must exclude anything troubling or depressing – anything disquieting at all, anything unharmonious – if the emotion it contains is to be a calming one, for himself and potentially for others. And third, by implication, it is Matisse announcing that emotion cannot achieve durable artistic form unless it is calmed.

'There was a time', he wrote in 'Notes of a Painter', 'when I never left my paintings hanging on the wall because they reminded me of moments of over-excitement and I did not like to see them again when I was calm. Nowadays I try to put serenity into my pictures and rework them as long as I have not succeeded.'[19] The process of clarifying emotion is also the process of calming it. Art, we are told in effect, as in an earlier Romantic manifesto, has its origin in 'emotion recollected in tranquillity.' The task that Matisse therefore sets for himself is to find in nature a uniform mood of such serenity and calm[20] ('because I myself have need of peace')[21] as to make it 'representative of my state of mind'.[22] More than this, even – and here is the final, most important message of the foregoing passage – only by doing this will the artist be able to create an ideally ordered, pure world that tells of the perfect, permanent happiness of living. The luxury, indeed the voluptuousness, of nature could not be imagined except by discovery of calm at its centre, for there order and beauty are to be found.

The two great paintings whose creation decisively altered the direction of Matisse's art before and after Fauvism do indeed carry in their titles a kind of explanatory equation. *Luxe, calme et volupté* (1904–05) leads to *Bonheur de vivre* (1905–06). It was while preparing for the earlier of these paintings that Matisse's drawing style first showed signs of drastic simplification. As he transformed observed nature into an imaginary, idealized state, his line was clarified to achieve a directness that shrugs off contemporary suggestion. The little sketches that remain to us from presumably a larger body of preliminary drawn studies (we know, at least, that there was a cartoon made for the painting)[23] name the identities of figures and objects with the immediacy of words, albeit as yet not fully articulated, clumsily spoken words. They withdraw from the realm of transitory sensations to search for a more rudimentary artistic vocabulary. After *Luxe, calme et volupté* had been completed, it was clear to Matisse (who was finally dissatisfied with the picture) that if art was convincingly to represent a separate world apart, then a special order of its own had to be created for it. And after Fauvism had almost wilfully, it seems, destroyed the naturalistic order of things, stripping them of their last vestiges of tonal substance, such an order could then be created. In the absence of tonal substance, which had traditionally served to individualize things by making them tangibly real, it had to be created from line. And line, as it turned out, was the only appropriate means of providing the new order.

9 *Luxe, calme et volupté.* 1904–05

10 *Study for Luxe, calme et volupté.* 1904–05

The studies for *Bonheur de vivre* (p. 146, fig. 11) that Matisse made in the winter of 1905–06 are certainly indebted to the drawing style of Ingres, whose work was shown at the 1905 Salon d'Automne. Matisse once observed that he preferred Ingres' *Odalisque* to Manet's *Olympia* because 'the sensual and deliberately determined line of Ingres seemed to conform better to the needs of painting.'[24] Judging both from the *Bonheur de vivre* studies and from the completed work, what Matisse's painting now required was a determinedly synthetic and self-contained kind of line drawing, one that mapped out the conceptual identities of figures in unbroken contours that themselves provide a sense of continuity and therefore internal consistency for whatever it is they describe. It also required particular compositional postures for figures that would allow this linear continuity its greatest visibility. This often meant reclining figures, from whom the need to resist the effects of gravity has been removed, allowing them to be formed, with some credibility, into abstracted arabesques. The study of the piper for the foreground of the painting searches the contours of the figure for intertwining rhythms, finds them in the pliant curve of the upper leg as it curls over its passively extended, anatomically improbable companion, and in the alignment of the curve of the exposed hip to that of the left arm. The figure turns in on itself, becomes an image.[25] Likewise, the study of the flautist (p. 146). But here, Matisse establishes a firm vertical axis running from head to foot, and having drained off weight in this way, wraps the arabesque of the figure around this imaginary line. 'Ingres used a plumb line,' Matisse noticed. 'You see in his studies of standing figures this unerased line, which passes through the sternum and the inner ankle bone of the leg which bears the weight.'[26] And Matisse regularly used one too:

Around this fictive line the 'arabesque' develops. I have derived constant benefit from my use of the plumb line. The vertical is in

49

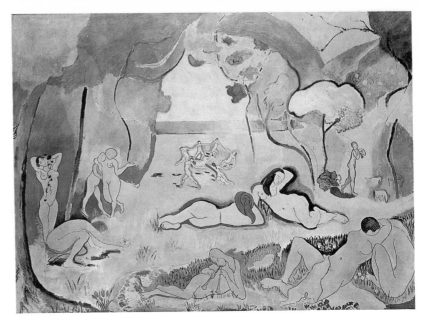

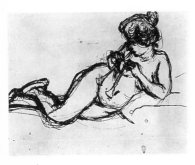

my mind. It helps give my lines a precise direction and in my quick drawings I never indicate a curve ... without a consciousness of its relationship to the vertical. ... My curves are not mad.

The soft linear continuity possible in pencil drawing gives to the flautist a sensuously swelling, organic coherence which is reinforced by the feathery internal shading. Here, the conceptual, hieratic function of line drawing is bound to a modelled illusion of tangible three-dimensional form. In the piper, by contrast, the repeated, pen-drawn contours achieve a tangibility of their very own. To say that this latter drawing is more Fauvist is certainly to make a legitimate distinction between these two works. And yet it too condenses from Fauvism a more concentrated image than Fauvism could ever allow.

These drawings for *Bonheur de vivre* are more or less contemporary with the woodcuts and lithographs discussed earlier. The thrust of the woodcuts was the creation of an abrasively physical form of contour drawing that synthesizes to itself memories of the bodily weight lost from the images the contouring contains. The method of the piper is certainly comparable – except that the analogies which Matisse finds, in the woodcut studies, between the rhythms of the body and those of the abstract lines that reverberate from it, are replaced, in the piper, by analogous, abstract lines found in the rhythms of the body itself. Whereas in the woodcut studies figure and decoration are contrasted, in the piper, figure *is* decoration.

The early 1906 lithographs approach this condition. Although they are more naturalistically conceived, the narrow 'Japanese' sheets that Matisse chose to print them on emphasize the decorative quality of their contours.[27] So does the arabesque freedom of the drawing and the elongated distortions it produces. Albert Elsen has suggested that

Matisse may well have followed Rodin's example here, in drawing without taking his eyes from the model, or with only occasional glances at the sheet.[28] He sees a similar quality in a group of four drawings[29] (e.g. *Standing Nude*), usually dated to 1908 but which should probably be reassigned to early 1906, for they show the same model as that in the lithographs and are stylistically close to these prints.

The Rodin association is indeed a sensible one. But it is not, by any means, the only one that Matisse's early 1906 drawing style calls to mind. Beside Rodin and Ingres, Gauguin was certainly influential. (We have noticed his importance for the woodcuts.) Matisse, we should notice, is turning to anti-realist linear styles in order to abstract from Fauvism a 'more lasting interpretation' of his subjects. The result of this is a shift from the Fauvist union of painting and drawing to a distinct separation of the two means. (We see this in the decorative compositions from *Bonheur de vivre* onward.) Hence, Gauguin's highly synthetic vocabulary of tough, somewhat angular lines independent of the colours used in conjunction with them was obviously of great interest to Matisse. The new emphasis on line – on linear plasticity – threatened to return Matisse to the problem that had bothered him with *Luxe, calme et volupté*: 'absolutely contradictory' forms of drawing and colour.[30] With *Bonheur de vivre* and its successors, a comparable sense of counterpoint between drawing and colour does indeed obtain. Gauguin's lesson, however, was that these two elements could be separated and yet harmonize if the drawing was abstracted, conceptual contour drawing and the colour flat and decorative.[31] The work of Puvis de Chavannes suggested a similar solution. (Looking back, in 1905, on the problem of *Luxe, calme et volupté*, Matisse had remarked: 'If only I had filled in the compartments with flat tones such as Puvis uses.'[32] And he did, of course, with *Bonheur de vivre*.) Also relevant here are a whole number of late nineteenth-century and early twentieth-century sources, from the stylized lines of Art Nouveau decoration[33] to Manet's flattened images of the 1860s set against relatively uniform grounds,[34] even to Derain's drawings, which gave freer rein to the movement of line in the Fauvist years than Matisse's did at that time.[35] What Matisse takes from all this is a two-part harmonic system of decorative colour and decorative line, in which simplified contour drawing is used as a tool for creating analogous rhythmic forms.[36] It was the controlling method of his great invented figure paintings that began with *Bonheur de vivre* and reached their first full fruition with *Music* and *Dance* in 1910.

At this point, fully realized examples of this kind of contour drawing are not to be found among Matisse's works on paper – for the simple reason that only in painting did such drawing achieve the completeness that Matisse required. Drawings, by definition for Matisse, were inherently less capable of the same concentrated expression as was painting. Of course, he made consciously complete drawings as well as primarily explorative ones – and many of the explorative ones also achieved a level of internal resolution that places them on a parallel with many of his paintings. 'Personally, I think

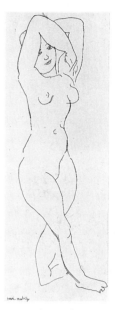

13 *Standing Nude. c.*1906

painting and drawing say the same thing', he remarked. 'A drawing is a painting made with reduced means . . . which can be totally absorbing, which can very well release the feelings of the artist just as much as the painter. But painting is obviously a thing which has more to it, which acts more strongly on the spirit.'[37] The full-scale cartoon for *Le Luxe I* that Matisse drew in 1907 is the closest that any work on paper of this period comes to using a fully developed system of rhyming contour drawing. It was preceded by notational studies similar in character to the preparatory drawings for *Luxe, calme et volupté*,[38] and the cartoon stabilizes what in these studies is only incompletely realized. But to compare the cartoon with *Le Luxe I* is to see just how more precise is Matisse's drawing in the painting. And to compare *Le Luxe I* to *Le Luxe II* is to see just how far the patient process of condensation is carried.

Signac had complained that in *Bonheur de vivre* Matisse used 'a line as thick as your thumb.'[39] Line so broadened as to read also as shape – such as we see in Matisse's studies for woodcuts – has necessarily an ambivalent function: not only as both line and shape; also as both contour and shadow, and as something both descriptive of the form it encloses and decoratively independent of that form. When, in 1906, Matisse moved towards thinner and finer lines, it might seem that he was falling back on a more traditional kind of line drawing. In fact, his post-Fauve linear style maintains a comparable ambivalence. It continues to allow him to move forward and backward between the two poles of description and abstraction. In so doing, it carries in line itself Matisse's desire to penetrate the superficial existence of things and discover their more essential character.

Linear contour drawing is, of course, essentially an antinaturalistic form, for drawn lines are symbolic and conventional. They contour the identity of things in the world, but in the world do not properly exist. In drawings of the Renaissance tradition, the conventionality of contour drawing is generally disguised, by the addition of sculptural shading and, more specifically, by the varied inflexions and densities of line itself, which evoke the illusion of internal volume, throwing up volume from void and forcing the observer to read around the line as well as the line itself. This form of line drawing had already decayed even before Matisse's career as a draughtsman began. We see, for example, in Delacroix's drawings how lines are far less inflected, are more frontal and schematic, and therefore reassert their conventional symbolic character as ciphers coding the world rather than as agents of illusionistic description.

In Matisse's *Marguerite Reading* of 1906 (p. 150), line is affirmatively frontal, extremely tense and abbreviated, and when it does reveal variety in the density of the line, this reads less as an indication of volume and more as a way of stressing those aspects of the subject deemed of greater importance, whether for the identification of the sitter or for the decorative coherence of the sheet. The openness of the linear structure, which admits continuity between inside and outside of the figure, reinforces the symbolic character of the drawing too. The lines do describe – marvellously so: bunched in the corner of the

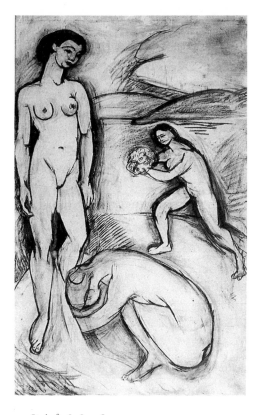

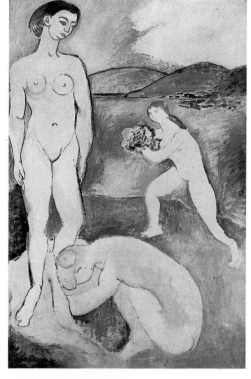

14 *Study for Le Luxe I.* 1907
15 *Le Luxe I.* 1907
16 *Le Luxe II.* 1907—08

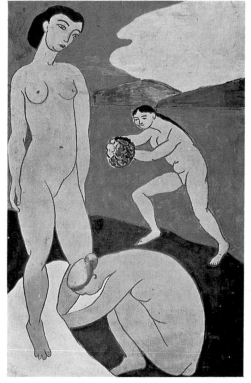

sheet, they contain and condense the youthful face of Matisse's daughter in rapt concentration. But they describe more diagrammatically than illusionistically. Like pieces of some soft flexible filament, they are separate moulded things in themselves.

Only exceptionally, in this period, did Matisse allow such openness. It was the heritage of Fauvism. After Fauvism, contours close up to produce silhouetted wholes. Even so, line always maintains its independence as a fabricated thing. Fauvism, although itself anti-naturalistic, could hardly admit continuous line drawing at all because the Fauvist method was based upon empirical observation of the world, particularly of landscape, and its translation into constructions of colour. Continuous line drawing would have tipped the balance too far towards the conceptual. Matisse's absorption in line drawing, which began when he started to work on *Bonheur de vivre*, tells of just that. The conceptual meant line drawing – and line drawing meant figures, and vice versa. Subject and means are inextricably bound. Moreover, line drawing was not only conceptual. It was also the most basic means of graphic expression and as such especially appropriate to the particular subjects that Matisse began to address. The reason why line drawing came to be Matisse's most prized form of draughtsmanship, the one form that could completely convey the essential character of his subjects, cannot be appreciated without appreciation of the kinds of subjects that engendered it.

Matisse's notion of the creation of art as remembering the shock of emotion before the subject and continuing to work until he rejoined that original emotion was enlarged, after Fauvism, in a most radical way: iconographically. As we have seen, he felt that emotion could only be made durable if it were clarified in the process of working and thereby calmed to evoke an ideal, purified order of existence. First in *Luxe, calme et volupté* and then, more definitively, in *Bonheur de vivre*, he established the geography of such an existence. His refinement of poses developed from these paintings formed the subjects of his great decorative figure compositions after *Bonheur de vivre* (and such poses regularly appear throughout his career).

These great early canvases belong to a tradition of early modern painting that recognized, and responded to, that loss of historically transmitted authority which produced modernism; not, however, by celebrating its division from the past but by attempting to repair it: by incorporating into painting a vision symbolic of the past that was so unfamiliar (because symbolic of a past never in fact experienced) as to seem genuinely new. I am thinking here, first, of certain Impressionist boating parties and of works like Seurat's *Grande Jatte*, which discover within the here-and-now a state of innocent leisure or of nobility symbolic of an arcadian past, then of the work of artists as different as Gauguin and Puvis de Chavannes, who represented arcadian states geographically or historically isolated from the here-and-now but ultimately expressive of its exigencies and emotions. In both cases, the past is brought into the present: to accredit and to authenticate the present; also to harmonize it and give to it a traditional durability.

Matisse inherits this tradition in *Luxe, calme et volupté* and *Bonheur de vivre*. An art of remembering that seeks constantly to return to first sensations seeks also, in these paintings, to return to the primacy of the distant, idealized past. In so doing, they discover an iconographical framework which allows symbolic representation of remembrance and which recalls (because the iconography is traditional) Matisse's artistic ancestry as well.

Ancestry, like tradition, refers to narrative continuity, to a sense of the wholeness of past and present as expressed in one history that confers authority on its successive manifestations. As Lionel Trilling has pointed out, the loss of belief in historically transmitted authority that marks our modern period expresses itself in a distrust of narration as a whole.[40] The narrative past having apparently lost its authenticating power for the present, narration itself – that element of a fictional work that explains how things are by explaining how they began – has fallen into disfavour. Matisse, as an early modernist, sought, in his most ambitious compositions, restoration (or reparation) of the narrative element of fictional art as part of his attempt to repair the break with the past that modernism seemed to have created. To paint imperative pictures that gave to narration a commanding role (however much the traditional forms of narration must be modified to allow it that kind of role) would be to rejoin modern art to the loftiest products of the Western tradition.

It would also be to represent the act of remembrance at the centre of each work of art. A work of art was only finished when it rejoined the first emotion that sparked it, when the first emotion had been brought out of its obscurity in the act of working: that is to say, when a sensation received in the present act of working triggered remembrance of the first emotion, thus forming a sensuous link between past and present, causing their common nature to stand out, and removing both from chronological time.[41] A comparably Proustian notion of remembrance informs the decorative figure paintings. They do not deliberately turn back the mind to the past in order to stretch out past from present. They make present and past as if one, joining them pictorially in a conceptual, hieratic but also affirmatively modern style that projects the past into the present, preserving the memory of its durability and its originality too.

'The grandeur of real art', Proust wrote, '. . . is to rediscover, grasp again and lay before us that reality from which we live so far removed and from which we become more and more separated as the formal knowledge which we substitute for it grows in thickness and imperviousness'; and this only can be achieved, he added, when we realize that 'what we call reality is a certain relationship between sensations and memories which surround us at the same time.' To grasp that is to be able finally to penetrate what surface appearances 'seemed at once to contain and conceal.' The reality being sought is not a neo-Platonic one, where objects contain timeless essences which are the only things that really or wholly exist. Matisse was too much an observer of things to accept that (as was Proust too). Rather, it is a

question of ambivalence: that Romantic sense of appearance (in Northrop Frye's words) as 'at the same time revealing and concealing reality, as clothes simultaneously reveal and conceal the naked body.'[42] In that 'certain relationship' of which Proust wrote, such a reality was to be discovered.

The relevance of this to Matisse's line drawing is as follows: only through line drawing could narrative continuity be established for the new decorative compositions. Only through line drawing could Matisse simultaneously describe reality and abstract its essential character in conceptual ciphers. And only through line drawing could he make images that would stand for the durable, original past, its purity and its calm: not only because imagery required line drawing, but also because line drawing was the purest, most original form of draughtsmanship. Talking to Apollinaire in 1907 about how he had discovered his artistic personality by looking over his earliest works (another return to the past to inform the present), he added: 'I made an effort to develop this personality by counting above all on my intuition and by returning again and again to fundamentals.'[43] An art whose subject is origins finds its particular form by a return to the fundamentals of art. In 'Notes of a Painter' of 1908, Matisse mentioned in passing that the harmony he sought was a harmony of 'signs': 'It is necessary,' he wrote, 'that the various signs I use be balanced so that they do not destroy each other.'[44] The idea of signs, which synthesize the artist's knowledge of objects, lay behind Matisse's 1909 statement that the simplification he sought required his learning 'a linear script' ('une écriture qui est celle des lignes').[45] Henceforth, sign-making became crucial to Matisse's artistic methods, and line drawing – drawing in its most primal form, drawing as naming – became Matisse's principal method of creating signs.

The primal itself affected Matisse's drawing style in this period. We have already noted the modern sources; beside them, there were certain 'primitive' ones. When, late in life, he was asked by an interviewer, 'Why are you in love with the arabesque?' he replied: 'Because it's the most synthetic way to express oneself in all one's aspects. You find it in the general outline of certain cave drawings. It is the impassioned impulse which swells these drawings.'[46]

Matisse mainly looked back to the 'primitives' of the European tradition. He praised the archaic Greek artists because they 'only worked from the basis of emotion' and because they could help one realize 'the fullness of form.'[47] The early Italian artists were valued for similar reasons. Of the Giotto frescoes at Padua, he wrote: 'I immediately understand the sentiment which emerges from it, for it is in the lines, the composition, the color.'[48] Drawings like the *Man Reclining* of c. 1909 (p. 151) would seem to be associable with his study of Greek art and the drawing of figures in paintings like *Bathers with a Turtle* (1908) with his study of Giotto.[49] Since 1906 – first in an exceptional lithograph among those done early that year (fig. 17) – Matisse had been seeking a sense of sculptural density within highly simplified, weighted contours. That was one way in which the new, purified line

drawing could be used: to bound volumes as weighty as those in Cézanne. But the flatter, more decorative option eventually predominated, and Matisse turned to yet earlier art in order to reinforce it.

In paintings like *Le Luxe I* (1907) one senses the influence equally of flat-patterned Japanese prints and of Egyptian art.[50] (The curiously tight-knit shapes of hair that Matisse started giving his figures that year seem to have come straight from Egyptian sculptures in the Louvre.) Egyptian art was praised because 'we sense in it the image of a body capable of movement and which, despite its rigidity, is animated.'[51] It was presumably for a similar reason that Matisse turned to Greek vase painting to simplify his draughtsmanship when he worked on the *Dance* (1909–10), while it was the iconic wholeness of Cycladic art that attracted him when he began *Music* (1910).[52] Reviewing these two enormous pictures in 1910, one critic noticed their borrowing from 'archaic pottery' and 'primal vases' and commented that Matisse had a 'dual personality'. 'One half of him belongs to the frenzied, American-style life of today, the other half dreams of a naive primordial structure, of the lost harmony of the soul.'[53] It was not meant to be complimentary, but it is revealing just the same.

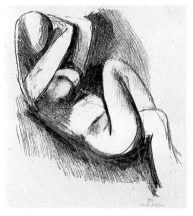

17 *Nude.* 1906

Matisse's search was for a vocabulary of expression that would allow things to be presented in their most primal form, undistorted by received opinions and interpretations. So many opinions and interpretations were consulted because 'the personality of the artist develops and asserts itself through the struggles it has to go through when pitted against other personalities.'[54] Several other sources could be enumerated for Matisse's drawing style at this time (and others, no doubt, await discovery). One more only will be mentioned here. In 1908, the Salon d'Automne included a section of 'Décorations Scolaires', children's drawings and paintings. Matisse had been looking with interest at child art in his Fauvist years. It is reasonable to assume that it too played its part in the formation of his new linear style, especially since it was something of a popular fad in Paris toward the end of the first decade of the century.[55] Like African tribal art (which also, of course, had its effect on Matisse), it was an art of origins and as such worthy of attention in the search for a new, simple, and direct method of conveying the primacy of his perception of the world. As he wrote, much later:

> The effort to see things without distortion takes something very like courage; and this courage is essential to the artist, who has to look at everything as though he saw it for the first time: he has to look at life as he did when he was a child and, if he loses that faculty, he cannot express himself in an original, that is, a personal way.[56]

In the period between 1906 and 1910, Matisse increasingly abstracted his line until it lay flatly on the surface of his paintings like some inscribed, chiselled groove between areas of resplendent, even colour. At times, it is hard, taut and muscular, holding our eye equally with the colour. At others, it seems totally disembodied: the light that is generated along the boundaries of adjacent colours erodes its visibility.

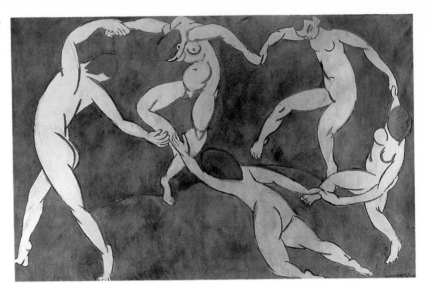

By 1911, with *The Red Studio*,[57] line is simply the absence of colour, a negative thing, present only – as in the wine-glass on the table – as a transparent vessel in which colour can float.

And yet, no matter how little the drawing of these paintings calls attention to itself, it is the means by which their astonishing colour is composed. In the great figure paintings of 1907–09, certainly, the composition of the figures is the composition of the paintings. Matisse discovers in the narrative continuity of line drawing fluid rhythms, derived from simplification of the figures, that spread through the totality of the compositions. These representatives of some ancient race, meeting for obscure reasons in bare landscapes, transmit their own self-absorption to the paintings they control. A uniformity of mood is established – at this point anxious, frightening even at times, in the unexplained drama – that runs like a charge through the wiry outlines. Then, in the two versions of *Dance* of 1909–10, a liberation occurs. The joined figures, linked in suspended animation, their whole bodies seemingly drawn, carry the frame of the picture on their shoulders and expand it with their outstretched legs. The pictorial and iconographic are fully as one. Anxiety gives way to energetic harmony as figures and painting cohere simultaneously in the form of the dance.

The second version of *Dance*, though more exact in its drawing and more vibrant in its colour than the first version, is also more frenzied.[58] John Neff has pointed out how Matisse told his friend, Maurice Sembat, that 'he regretted that *Dance* wasn't more sublime, more reposed, more nobly calm', and how Sembat wrote in 1913 of knowing a charcoal drawing in which Matisse revised the composition to achieve such an effect.[59] The great charcoal drawing which Sembat gave to Grenoble (p. 152) certainly postdates *Dance I*. If it is indeed an afterthought to both pictures, it shows us Matisse stabilizing their

composition by simplifying the form of the hill into a single curve, by straightening the limbs and bodies of the figures, at times in parallel with the edges of the sheet, and by diminishing the tension of the joined hands. The effect of this is not only, in fact, to give to the dance movement the 'solemn dignity' that Sembat says Matisse wanted: it also serves to isolate the figures and to give to them a sense of individual wholeness and tangibility that necessarily was lost in their joining, especially in the second *Dance* composition.

In Matisse's decorative compositions, linear enclosure drawing marks out the identity of figures but also flattens them abstractly to the surface in the new non-perspectival space Matisse's colour creates. Since the time of his first mature drawings, around 1900, Matisse had been testing the wholeness of the body against the wholeness of the work of art, specifically addressing the question of how to accommodate the tangibility of the whole body to that of the flat pictorial surface. In *Dance II*, the bodies form the pictorial surface. They maintain their wholeness as they establish its wholeness. But they give up their tangibility to do so. The charcoal drawing of *Dance* attempts to restore it to them.

In 1909, when he painted *Dance I*, Matisse was working on the first of his *Back* reliefs.[60] Preparatory studies of models resting against the panelled wall of his new studio at Issy-les-Moulineaux − like the *Standing Nude Seen from the Back* of 1909 (p. 151) − show him returning to a method of drawing somewhat similar to that of around 1900 in order to flatten pictorially the bulk of the body against the surface. But whereas before the surface seemed capable of warping to accommodate the body, now − being identified with the frontally disposed panelling − it remains obdurately in place, refuses to give, and the body seems limp and exhausted by the impossible pressure put upon it. The older kind of tangible wholeness is, for the moment at least, unobtainable.

But, perhaps, from those very marks and creases that appeared in the body as if crushed against the surface a new form of tangibility could be recovered. That was the lesson of the first *Back*, and it was progressively clarified in those that followed. Matisse again turned to sculpture to test on physical objects the abstractness he was achieving in painting. For a similar reason, he turned to making drawings with a new urgency. The disembodied linear vocabulary of the paintings needed to be confronted with the shapes of observed things, and the idealized anatomies of the figures they contained with more prosaic forms of human life. And as in the sculptures so in the drawings, Matisse's theme is now the physical reconstruction of bodies from their abstracted parts, the making of credible beings from the most artificial of means: metaphoric connections, formal analogies, compounded rhythmic sequences. In the charcoal drawing of *Dance*, the figures are constructed, part by part, from separate linear units. This method Matisse began to apply to observed subjects. To confront the model with the purified language of drawing itself and discover in that confrontation a logic of representation that would endow things with

their own internal life: that was the basis for the great sequence of drawings that shortly began.

The *Girl with Tulips* of 1910 (p. 153) is a new kind of Matisse drawing. To a greater extent than ever before the subject is drawn and redrawn until it conforms to an internal image of itself which defies the contingencies of mere appearance. The lightly drawn, shield-like form in the top left corner is the clue to the theme of the work. It summarizes the shape of the tulip leaves, is repeated in the drawing of the girl's collar, and is also the whole shape of her head. These analogous forms comprise a growing vertical axis that rises to the facing but profile eye, and from this axis bloom the swerving lines that bend from the shoulders and serpentine down to the tulip-shaped hands. The tapered form of the torso is itself a version of the same module, as well as an amplification of the pot from which the plant grows. Figure and plant grow together as one organism to that magnificently impassive head, which culminates what must be one of Matisse's, and this century's, greatest drawings. We see how he worried the features of the face until he established the conflation of profile and three-quarter views (as daring as anything in Cubism, and far more understated), and how concerned he was to return from the head the movement that rises there. Hence, those external guide lines that drop to the shoulders and draw in the whole figure, within a now-inverted form of the basic module, to produce a single, dense image of continuous as well as continual growth.[61]

We see here, very specifically, how Matisse discovers the metaphoric unity of the figure in the act of drawing. Since the act of drawing is affirmatively explorative, it had to be performed using the softer media of charcoal or pencil. Besides allowing the necessary linear continuity, they enabled Matisse to work longer on his drawings, to produce more fully realized drawings that yet would seem spontaneous. And from around 1910, Matisse increasingly allows us to see in his drawings, at one and the same time, a picture of his exploration of the model and of the result. We know that the finalized image we see has been discovered in the act of working. 'This image', Matisse wrote, 'is revealed to me as though each stroke of charcoal erased from the glass some of the mist which until then had prevented me from seeing it.'[62]

This statement comes from a discussion that Matisse wrote in the very last year of his life, on how he made portraits. While his methods undoubtedly had changed in a number of respects by then, what he says about working with charcoal seems exactly appropriate to his earlier work too.

He would begin 'with no preconceived ideas' so that 'everything should come to him in the same way that in a landscape all the scents of the countryside come to him', then work extremely freely until 'a more or less precise image' gradually appeared. At this point, the first sitting would be ended, to allow 'a kind of unconscious mental fermentation process' during which he would 'mentally reorganize' his drawing. Beginning the next session, he would therefore sense,

beyond 'the haze of this uncertain image' already drawn, 'a structure of solid lines'. This structure served to release his imagination, and henceforth his imagination would 'come both from the structure and directly from the model'. Now, he said, 'the model is no more to me than a particular theme from which the forces of lines or values grow out which widen my limited horizon.' As a result, 'the conclusions made during the first confrontation fade to reveal the most important features, the living substance of the work.' By this time, artist and model are more at ease in each other's company and, as the sittings continue, 'flashes of insight arise, which while appearing more or less rough, are the expression of the intimate exchange between the artist and his model. Drawings containing all the subtle observations made during the work arise from a fermentation within, like bubbles in a pond.'

The *Girl with Tulips*, the great portrait of Shchukin of 1912 (p. 154), the highly abstracted 1912–13 *Study of a Nude* (p. 156), indeed the whole sequence of impressive portrait drawings in charcoal or pencil that began in 1910 and was fully established in 1913 were not all, obviously, made over several sessions in this way. The *Study of a Nude*, for example, must have been drawn quite quickly: the rhyming accents seem scattered down the length of the sheet. Without exception, however, they are drawings that look built.

In the period 1910 through 1912, when Matisse's painting was essentially a two-part procedure of drawing then tinting – for his colour was ever more thinly applied – drawings themselves gradually took on the slow constructional approach of his much earlier paintings. Drawing on paper was building and joining. Not until 1913 – by which time his painting had become more constructional – was drawing regularly as extended a building process as it was in *Girl with Tulips*. But only in the very rarest of instances do we find in drawings the pure, continuous line that appears in the painted work. We find it in occasional pen and ink drawings, but even those read as formed from additive sequences of fluid lines.[63] And increasingly more frequent are the kind of nervous staccato swerves that characterize the Shchukin portrait. *Zorah Seated* (p. 155), also of 1912, is more continuously fluid. However, it had initially been conceived as a painting and is drawn on canvas in thinly diluted oil.

Matisse, by now, seems to have so associated fluid line drawing with the liquidity of painting that it seemed inconceivable away from it. He was always particularly responsive to the character of the medium he used. The very nature of his line is crucially determined by the means by which it is applied. This not only meant that liquid substances applied by the pen had to look different to those applied by the brush. It also meant that those drawing media in which the tool is eroded in the act of working, like pencil and charcoal, produced different kinds of marks to those where the tool transfers the image-creating agent to the sheet. One might suppose that pencil would have allowed Matisse to create, on paper, an equivalent kind of continuous line drawing to that of his paintings at this time. In fact, he rarely allowed the line to

run on for that long. Both pencil and charcoal were agents of building; largely, it seems, because both were associated with tonality as well as with line (when line emerges in a clarified form it often does so from a tonal mist) and because both meant drawing with the wrist and the fingers. Thus, sequences of grouped and parallel marks were built up, and within them the character of the sitter was discovered. Both pencil and charcoal, moreover, could be erased. Matisse would increasingly rub down the charcoal and take an eraser to the first-drawn outlines, and on top of the shadow of his original drawing rebuild a new, more exact and often more abstracted representation.

In the period from 1910 until 1914, the only works on paper to use a continuous line method tend to be rather slight: certain sketches before or after paintings, certain studies for more ambitious drawings.[64] Only in 1914, when continuous line drawing had disappeared from Matisse's paintings, which now were constructed in the additive manner adumbrated by the drawings, did it – briefly – find its place in his works on paper. It did so through print-making.

In 1914, Matisse came back to print-making, which he had not touched since 1906, and found it possible there to make quick, sure drawings either directly onto surfaced copper plates for etching or in crayon on transfer paper for making lithographs. In these prints, the line skates on the surface with an ease and fluency hardly ever to be found in any previous Matisse drawing – in part, certainly, facilitated by the medium itself. The fine, incisive lines of the 1914 pen and ink drawing, *Reclining Nude* (p. 157) would seem to have been affected by the print-making experience. Likewise, the fluid brush and ink drawing, *Portrait of Marguerite* of 1915 (p. 160). Marguerite (his daughter) was the subject of two 1914 etchings.[65] The model for the reclining nude, Germaine Raynal (wife of the Cubist art critic Maurice Raynal and close friend of Juan Gris) was the subject of several etchings and lithographs done during the same year.[66] Also that year, Matisse made prints of Yvonne Landsberg.[67] A number of the impressive drawings that led eventually to the famous painting of Yvonne Landsberg have a cursive ease that directly relates them to the etchings of the same subject.

Yvonne Landsberg sat for Matisse in the spring of 1914 for a commissioned portrait drawing, whose location is now unknown.[68] After its completion, Matisse received the sitter's approval to make the oil painting. It was while he was working on it – which took until August – that he made the drawings we know. They share one thing in common: a vertical axis around which fictive line the arabesque develops. The three-quarter-length ink drawings (p. 158, above), from July, and the two portrait heads (p. 159), from August, develop their melodic rhythms around an imaginary vertical toward the left of the sheet. Both pairs of drawings are wonderfully abbreviated studies in carefully balanced, pure lines. The shift, however, from the tender delicacy of the first pair to the more generalized, harsher beauty of the second is extraordinary. It perfectly illustrates Matisse's willingness 'to risk losing charm in order to obtain greater stability.'[69] He does so not

only by simplification; also, by rearranging the focus of the arabesque. Instead of twining within the forms of the body, it locates itself along the contour of the face and unfolds in the strands of hair into the adjacent space. This would seem to support Alfred Barr's suggestion that these drawings were made after completion of the painting,[70] for the painting draws from the curves of the subject's arms and shoulders a sequence of incised, expanding lines – etched lines – that carry the architecture discovered within her body into the very substance of the ground.

The great charcoal drawing of Yvonne Landsberg (p. 158, below right) resembles an early state of the painting, as documented by a recent X-ray photograph.[71] In this tense, austere drawing, Matisse eschews the ease of the other studies for rigorous contraction of the subject into rhyming sequences of summarily modelled forms. Face, breasts and pressed-together thighs recall that 'egg-like form beautiful in volume' Matisse had told his students to look for in a particular model, back in 1908; so does the hair, which indeed 'describes a protecting curve and gives a repetition that is a completion.'[72] Joining these forms, the branch-like neck and arms – one broken abruptly at elbow and wrist, the other wrenched downwards by the sheer force of turning and pulling the charcoal back into the body – are rigid, jolting accents, yet possessed of an eloquent beauty of their own.

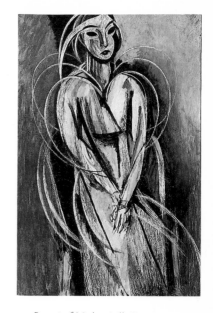

19 *Portrait of Mademoiselle Yvonne Landsberg.* 1914

This nearly painful severity persisted into the completed painting. Its inscribed branching arcs, developed from the ovals we see here, may recall the studies of magnolia buds that Matisse was drawing when he first met Yvonne Landsberg and included in an etching he made of her, for he apparently remarked that the shy, retiring nineteen-year-old reminded him of those flowers.[73] If so, the realization of the painting relates to that of the *Girl with Tulips* drawing of 1910. Matisse himself would only say that the lines were 'lines of construction',[74] and after completing the painting made another drawing of Yvonne Landsberg that summarizes them (fig. 20).[75] Referring to a painting of the following year, he uses the phrase 'the methods of modern construction.'[76] He presumably means Cubism. Whether or not we are correct in seeing the effect of Cubism – even of Futurism – in the completed painting of Yvonne Landsberg, it most certainly is to be found in other works of the period 1914–16. In his drawings, the fluid linearity that suddenly appeared in 1914 was just as suddenly expelled for a new geometric form of condensation.

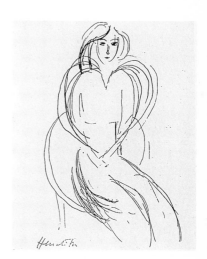

20 *Mademoiselle Landsberg.* c.1914

Writing to his friend Camoin in the autumn of 1914,[77] Matisse compared Seurat and Delacroix. He himself was like Delacroix, 'a romantic … but with a good portion of the scientific, of the rationalist.' Seurat's work was too rational, and had a 'slightly inert stability' because it showed 'objects constructed by scientific means rather than by signs coming from feeling.' Seurat's theories did produce a language of signs. For Matisse, however, emotion precluded theory. To be an artist of the imagination meant forgetting 'all your theories, all your ideas before the subject', he had told his students in 1908.[78] But he had also advised them to construct their work logically.

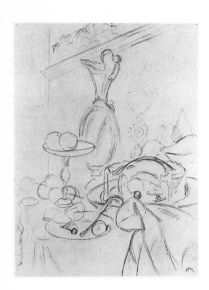

21 *Still-life after de Heem.* 1915
22 *Variation on a Still-life by de Heem.*
1915

In 1914, the 'romantic' and the 'rationalist' in Matisse were both brought to bear on the creation of signs. Emotion was to be revealed through modern methods of construction. It meant a struggle, Matisse said, 'from which I sometimes emerge the victor, but exhausted.'

The phrase, 'the methods of modern construction', was used by Matisse of his painting *Variation on a Still-life by de Heem* of 1915. Together with another 1915 painting, *Head, White and Rose,*[79] it is Matisse's most obviously Cubist-influenced work. As a student, he had made a copy of de Heem's *La Desserte* in the Louvre and presumably he worked from this copy.[80] It was entirely in character that he should take an extremely familiar, old subject on which to test the unfamiliar, new vocabulary he was now addressing.

While Matisse had of course been aware of the growth of Cubism, it was probably not until the autumn of 1913, when he re-established a studio in Paris, that he began to take a serious interest in the potential usefulness of Cubism for his own art. By then, the decorative harmonies and high spectral colour of his recent Moroccan paintings had been expelled for a new austerity. He began to create highly ambiguous figure-ground relationships within a dense painterly space, and to 'true and fair' his drawing in a more deliberated way than he had done since before Fauvism.

The appreciation among avant-garde critics like Apollinaire of the *Portrait of Madame Matisse*[81] (shown at the Salon d'Automne of 1913 and the first painting to reveal this new style) undoubtedly led to Matisse's

increasing contact with the Cubist mainstream. In the summer of 1914, Matisse encountered Juan Gris at Collioure. The discussions the two had there decisively affected Matisse's art. In the *Head, White and Rose* and the *Variation on a Still-life by de Heem*, Matisse adopted Gris' use of an imposed linear grid, each compartment of which is brought up to and woven into the architectonic unity of the picture surface. Gris himself had adopted this grid in order to examine the different parts of the subject it enclosed from different viewpoints, thereby to produce a rigorously controlled form of multi-viewpoint perspective. Matisse, in contrast, used it for the compositional order it provided. To join a simplified vocabulary of forms to an all-over pictorial structure of comparable simplification would apparently be to create an exact symbiosis of parts and whole that would tie expression to the entirety of the work. The careful drawing in Philadelphia for a section of the de Heem still-life (p. 163) repeats the forms of a more generalized sketch in the Musée Matisse at Cimiez. The elements of the still-life are condensed into rhyming ovals, circles and hard, connecting lines. Already, it tips up onto the surface of the sheet, ready for incorporation into the geometric schema of the painting.

Incorporated in the painting, however, its simplification – far from working symbiotically with that of the compositional grid – counterposes the grid, suggesting the presence of two distinct forms of reality within the one work. While the drawing that forms the details of the still-life is specific to these details, condensing from them their essential geometry, the compositional drawing hovers ambiguously between describing the general outlines of the depicted subject and fulfilling a purely pictorial, surface-organizing function. This latter kind of drawing is the closer to Cubist drawing, which depends for its force on the vitalizing conflict expressed between what is represented and the method of its representation. Competition is suggested between the 'abstract' and the 'real', and with it a duality of sensation and judgment which forces us continually to choose whether to see the elements of pictorial construction or to construct for ourselves what it is that they represent.

Matisse's early drawings, around 1900, had gained their particular tension from the dialogue offered between a readily legible subject and the independent pictorial means which made it legible. Even those works, however, manifestly derive the method of their representation from observation of the subject. Their abstraction does not compete with their realism but expresses and enlarges it. And increasingly, Matisse had turned from that particular interpretation of Cézanne's art which encouraged such shuttling of attention between subject and expressive means. The Cubists developed this interpretation to such a radical extent that art virtually escaped from its basis in observation, and embodied the world, rather, in ideational signs – signs abstracted from representation which fluctuate between abstraction and representation. Matisse, though also preoccupied with the creation of signs for objects, demanded of them an intimacy with the specific characters of the objects they signified.

As Cubism developed in the years 1909 to 1911, the two components of traditional drawing (line and shading) and therefore of their two traditionally associated functions (image-making and sculptural illusion) were gradually disengaged, eventually producing a contra-puntal system wherein line, virtually alone, carried the informational function of drawing and shading produced only a generalized kind of illusion, descriptive not of individual volumes but more of space itself. Wholeness was therefore surrendered on two counts: the wholeness of objects was surrendered in this two-part system of line and shading, and the wholeness of representation was surrendered, for the linear informational signs that fulfilled the demands of representation, alternatively (not simultaneously, because their readings alternate in the eye) fulfilled the demands of compositional coherence. Moreover, these signs appeared to float within the monochrome chiaroscuro space and around the looming sense of volume provided separately by the shading. All of this seemed irreconcilable with Matisse's art.

In these same years, 1909 to 1911, Matisse's art was indeed developing quite oppositely. True, line virtually alone carried the informational function of drawing. But it did so by expelling shading to flatten to the surface and create whole images to be filled by resplendent flat colour. Cubism had focused attention on the balance and reciprocation between the real and the abstract, between reality and art, and on their conflicting claims – which the particularly modern self-consciousness about the autonomy of art had made newly evident. Matisse, in contrast, had attempted to resolve that competition. He wanted accord, wanted to recover the balance between art and nature which modern awareness of the artificiality of art threatened to break. His art in the great decorative period is a Symbolist-derived art that rejects the dualities of Cubism for a mode in which, in Croce's words, 'the idea is no longer thinkable by itself, separate from the symbolizing represent-ation, nor is the latter representable by itself without the idea symbolized.'[82]

This conception does not change. During the period of the First World War, Matisse allows greater disharmony in his art than ever before. It is frankly disquieting at times in a way that is truly exceptional. And yet, the obsession with wholeness remains. Matisse will not surrender that. Only, and exceptionally, in the compositional drawing of works like the *Variation on a Still-life by de Heem* does he adopt a truly Cubist method of drawing where 'idea' and 'symbolizing representation' alternate functionally before the eye. Often, however, the symbolizing representation itself appears in a newly fragmented form and with a greater generality than Matisse had previously allowed. Since around 1910, his drawings had been tending in that direction in their affirmatively constructional form. But after 1913, the influence of Cubism consolidates that direction in a way that hardly was hinted at in anything that preceded it.

Matisse once described Cubism as 'a kind of descriptive realism'.[83] It had, he said, 'a function in fighting against the deliquescence of Impressionism', but 'the Cubists' investigation of the plane depended

upon reality' whereas 'in a lyric painter [referring obviously to himself], it depends upon the imagination.' Still, he conceded, 'in these days we didn't feel imprisoned in uniforms, and a bit of boldness, found in a friend's picture, belonged to everybody.' Elaborating on this on another occasion, he added: 'there was perhaps a *concordance* between my work and theirs. But perhaps they themselves were trying to find me.'[84]

This last sentence sounds simply self-serving. And yet, Cubism had indeed changed since the time that Matisse had responded to Picasso's *Demoiselles d'Avignon* in certain weighty nudes of 1907.[85] Since then, Matisse had moved quickly away from the sculptural volumes that formed the basis of Cubist analysis. Simultaneously, however, Cubism had moved; and after the Cadaqués summer of 1910, 'Picasso had pierced the closed form' (as Kahnweiler put it),[86] with the result that the looming sense of volume characteristic of earlier Analytical Cubism was replaced by a flattened linear armature spread out frontally across the surface, with abstracted elements of shading, drawn usually on either side of each linear element, floating magnetically around the armature, to open a now curiously disembodied kind of space. While still, of course, very far from what Matisse was doing, the new surface orientation of Cubism and the newly intangible sense of space that accompanied this orientation rendered a 'concordance' between it and Matisse's art possible.

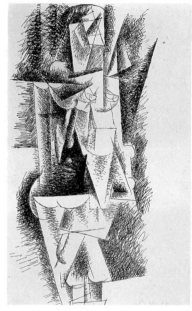

23 Pablo Picasso, *Standing Nude (Mademoiselle Léonie)*. 1911

'It is the imagination that gives depth and space to a picture', Matisse insisted,[87] when he contrasted his imaginative and the Cubists' realistic investigation of the picture plane. But then he allowed that 'the Cubists forced on the spectator's imagination a rigorously defined space between each object.' It was precisely this aspect of high Analytical Cubism that attracted him: the possibility of manipulating space with the precision, and freedom, that he had already achieved in the manipulation of colour. In the drawings of this so-called Cubist period, 1914–16, we see Matisse's simplification of forms to increasingly geometric wholes; fragmentation of these wholes into their constituent geometry; then recomposition of the fragmented elements into newly abrupt, discontinuous sign systems that imagine the identities of objects with astonishing daring, and exactness.

The formal severity of Matisse's study for the de Heem painting (p. 163) had been offset by the detailed manner of its rendering, which evokes something of the richness and sensuousness of the original still-life. In contrast, the great *La Coupe de raisin* (p. 164), also of 1915, is drastically reductive. The clean, heavily weighted line forms a sequence of thoughtfully considered arcs that stretch out the frontal, flattened image as they join to make it whole. It suggests a re-engagement with classical drawing in its simple severity. It reminds one of Matisse's long admiration of the solidity of Chardin's still-lifes. And it clearly evokes the optically distended dishes and compotiers in Cézanne's works of the 1880s.

Similar in spirit, though more abstracted, is the *Still-life with Oriental Bowl* (p. 165), again from 1915. This drawing generally relates to the 1916

paintings *Gourds* and *Still-life with Plaster Bust*.[88] Comparison with the latter work suggests that the puzzling architectural detail in the upper part of the drawing is a sculpture stand on which Matisse has placed a mirror which reflects a flower laid before it. This wonderfully concise drawing presents a pattern of analogous circular and curving forms existing as if within a purely imaginary pictorial space. Matisse said of the *Gourds* that it was 'a composition of objects which do not touch – but which all the same participate in the same *intimité*.'[89] His characterization well applies to this drawing too. The shapes of the objects are drawn with the utmost clarity: they seem stamped out onto the sheet. They are separate silhouetted wholes. And yet, their relationship is not one of isolation. As if within a magnetic field, they are suspended between attraction and repulsion, and owe their unique order to their animation of the abstract space of the sheet.

The newly monumental version of organic form that Matisse discovered in this period (and which climaxes in the great still-life paintings of 1916)[90] owes its particular density to the increased gravity of his line, but also to a change in the manner of his visual address to objects. *La Coupe de raisin* catches the subject head-on as an elemental whole and confines it to its place within the upper reaches of the flat sheet. The *Still-life with Oriental Bowl* contains a number of such primal views. One object, then the next, is searched out and conclusively fixed. Each is studied separately – in the two parts of the drawing from different points of view – and given its definitive identity. The unity of the drawing is now, in a new and ultimately Cubist way, a constructed one.

Before, he had begun with 'a clear vision of the whole' and kept that vision before him as he worked.[91] And no matter how constructional his approach became, it involved maintaince of that 'clear vision'. Hence, that sense of an instantaneously presented spatial totality offered by obviously additive drawings like the *Girl with Tulips* or the *Shchukin* portrait. Now, in the case of drawings containing more than a single identifiable image (and even, as we shall soon see, in some single-image drawings), the clear vision of the whole composition – as evidenced in the preliminary underdrawing – is no sooner established than it is surrendered. Within this general framework, and more often than not neglecting it, Matisse isolates and separately engages its constituent parts. As with Cubist drawing, the finally realized whole is an accumulation of separately studied parts and offers a temporal, durational reading in a way unlike anything that Matisse had made before. And also as with Cubist drawing, the intervals between the parts are as conclusively present as the parts themselves, for it is in those intervals that the rigorously defined space forces itself on our imagination. Of course, Matisse had always paid attention to the pictoriality of the white ground. But now it is tensely charged in quite a new way, as positive and negative areas interchange in expressive importance.

In the paintings derived from drawings of this kind, such an interchange – accentuated by the use of grounds often denser than

the objects they contain − forces contour drawing into a newly continuous relationship with Matisse's colour, for contours seem to mark the boundaries of certain absences in the ground as much as they seem to denote the presence of objects. (If, in the earlier decorative paintings, contours had seemed like inscribed channels, they now come to resemble leaded bars between areas of opaque glass − and often they simply disappear, existing only as the common boundaries of adjacent colours.) In the drawings themselves, the contour drawing echoes beyond its own enclosure the forms of the other enclosed objects and parts we see. And yet, never do such rhyming fragments evoke that sense of energies gathered into unstable fluctuating wholes such as we find in Cubist drawings. Though separately conceived, they are organized according to a unified, and stable, conception. And the stability of that conception is reinforced in their rhyming. Matisse brings Cubism into his art to achieve new flexibility. He does not surrender his art into the hands of Cubist relativity. The stability of his objects may be more anxious and the harmonies they create more disquieting. But stability and harmony remain his watchwords just the same.

Vase with Geraniums (p. 162), probably also from 1915,[92] combines the monumental rounded forms of the drawings previously discussed with contrasted geometric verticals. By this date, Matisse was using in his paintings flat upright compositional slabs, ultimately derived from the strips of *papier collé* in Analytical Cubist paintings of 1912 and from painted versions of these strips in Gris' work. The play of tonally contrasted vertical zones in this drawing certainly owes something to these same sources. Gris, in his paintings of 1913, had transposed the strips of *papier collé* into patterns of contrasting value that recapitulated the extremes of tonal shading more explicitly than did comparable works by Picasso and Braque. Gris, moreover, allowed larger and more decorative rhythms − created from these contrasting patterns − to control his paintings than Picasso or Braque did. Taken together, these two factors made Gris' work an especially available source for Matisse. In *Vase with Geraniums*, zones of tonal shading, nominally indicating shadows beside the vase and in the corner of the room, are counterposed with areas of light sheet to define the spatial relationship between the vase and its architectural setting, to fix that relationship to the geometry of the sheet, and to mobilize it pictorially − for the spatial give-and-take that the patterned contrasts provide holds the eye to the surface even as it evokes a sensation of depth.

Matisse's unrivalled ability to compose with large emphatic rhythms that divide the surface, only to carry the eye more surely across it, was enriched by studies of this kind. Gris' Cubism of 1913 had identified shifts and contrasts of tonality with shifts and contrasts of colour. The illusion of depth was produced by overlapping and juxtaposing discrete pictorial units of different value. This is the lesson that Matisse absorbs: that areas of strong tonal contrast can cling as naturally to the surface as flat areas of prismatic colour and can as readily suggest the illusion of depth − indeed, can present it with a new

sense of vigour and abstraction. The 'discontinuities of imagined space and abrupt, cadenced juxtapositions of broad vertical bands of colour'[93] of paintings like *Bathers by a River* of 1916–17 were made possible by the kind of tonal manipulation we find in this still-life drawing, and by the insistent geometric architecture discovered in drawing and redrawing even such a common object as the vase it portrays.

The imposing *Group of Trees at L'Estaque* of 1916 (p. 166) goes back to the birthplace of Cubism to find a comparable geometric order in the forms of a wintry landscape. Again, a lightly drawn first sketch has been condensed into its essential parts and the parts combined to produce a single dense image that sweeps up the height of the sheet. However, what interested Matisse most, as he wrote in 'Notes of a Painter' in 1908, was 'neither still life nor landscape, but the human figure. It is that which best permits me to express my almost religious awe towards life. . . . I penetrate amid the lines of the face those which suggest the deep gravity which persists in every human being.'[94] It was only to be expected, then, that this most experimental period of Matisse's art should climax in confrontation with the human figure. His work in drawing (as well as in painting) is no exception to this. The path that begins, in drawing, with the 1914 studies of Yvonne Landsberg leads, in 1915 and 1916, to some of the most extraordinary imaginations of the figure Matisse ever made.

Two things should be said from the start about these figures. First, they are all alike in being portraits of figures confined in their own masks. The self-absorption of the earlier decorative figures when transposed to the 'real' world turned into a moody sort of private detachment: the disillusionment of ideal beings brought roughly down to earth. When they look at us, they look not frankly, openly, disclosing themselves, but with a suspicious glance or, more often, a blank estranging stare that hides them in their own images. At times, they turn away from our gaze into their own privacy – if only to reveal, in that concealment, a curious vulnerability. Turning away suppresses emotion but shows just how close to the surface that emotion is.

Second, however, these figures are all quite unlike each other in the kinds of emotion they convey. Now that Matisse tests a highly synthetic linear vocabulary on real subjects, not imaginary ones, he proves himself to be an artist of particularized moods in a way that only the transitional decorative paintings of 1908–09 previously suggested, and they, it seems, only somewhat incidentally. These radically abstracted drawings do treat their subjects as if they were still-lifes, in a coolly analytical, detached manner, but they are not psychologically neutral, neither are they indiscriminate in the emotions they convey.

The claustrophobically muffled-up *Portrait of a Girl* (p. 161) and the *Portrait of Josette Gris*, both of 1915, show us two versions of a single, highly schematic formal vocabulary: an oval head, cut off at the top by the edge of the sheet and modified at the bottom by a semicircular chin notation, containing a somewhat tubular nose, rhymed with the rigid

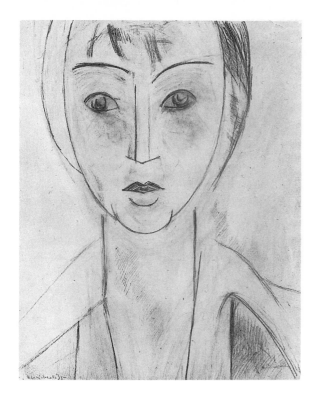

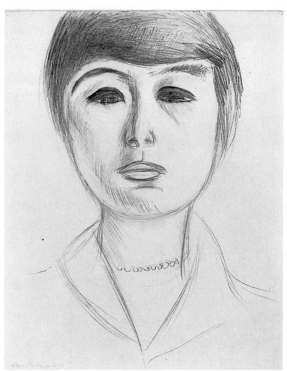

24 *Portrait of Josette Gris.* 1915
25 *Elsa Glaser.* 1914

cylinder of the neck, flattened narrow eyes, and lips that half belong to the interior organization of the face and half repeat the form of the chin below. A comparable form of analysis is applied to one version of *Greta Prozor* (p. 170; 1915–16). Common to these drawings is the way that Matisse discovers unity in formal analogy, aided here by possibilities of symmetry in the frontal pose and by his tendency to stiffen curves towards the rectilinear. (In the case of *Josette Gris*, the oval of the head is a wire folded in tension by unseen hands ready to spring back at right angles across the twin verticals of the neck from which it has been lifted.) The images unfold around an imaginary central spine – just as the second and third *Back* reliefs were doing at this time around an emphasized spine – and spread out their quiet orderly rhythms until they possess the entirety of the sheets they occupy. Matisse's displacement of the eyes in *Josette Gris* discovers a restlessness at the centre of that particularly expansive work, turning it inward again. The *Portrait of a Girl* also turns inward, but in the wrappings of the arabesque that press around her.

Neither of these works are explicitly Cubist in derivation; but they could only have been drawn at a time when in other works Matisse was throwing Cubist-derived grids up flat against the surface. No more could the monumental *Study for Portrait of Sarah Stein* of 1915–16 (p. 168), which brings this kind of portrait drawing to a triumphant climax. True, some slightly earlier, more naturalistic drawings, like the *Elsa Glaser* of 1914, anticipate the looming presence of these works and the boldness of their design. But these simply seem closer to us, pressed up

flat to the surfaces of the sheets that imprison them. The *Sarah Stein* overwhelms the sheet with the aggressive energy of a mere twenty lines. And yet, it too is finally an introverted representation, for the lines are cooled as they reach for the corners and point out the axes of the surface, revealing the geometric format of the drawing even as they reveal a curiously tender face.

An actual grid is inscribed on part of the face of another frontal, almost symmetrical portrait drawing, the *Madame Matisse* of 1915 (p. 162). This arbitrary device serves to dislocate the half of the face it occupies from the opposite, lightly shaded and vertically striated, half. An unerased guide line can clearly be seen dividing the two parts, and the point of the chin, the tip of the nose and the centre of the hat all meet it, and around it tip all the lines of the composition to and fro.

In Cubism, Matisse observed, 'the drawing and values were decomposed.'[95] In his drawing of Madame Matisse, the schematically adjusted shifts in value or tonality are independently disposed within the extremely harsh geometrical drawing, and only on this single occasion do we see the basic elements of Matisse's draughtsmanship in overt competition. The line drawing is victorious. It was by penetrating amid the lines of the face that Matisse discovered the character of the sitter. And what he found there renders the 'Cubism' which had uncovered it strangely superfluous: not only a hard, bitter rigidity, but unnerving sparks of matter that fly around the nose and the eyes in a miniature electrical storm of emotion. Matisse never made again so explicitly Cubist a drawing. Neither did he make such a disquieting one.

The two superb sheets that bring the drawings of this period to a climax, the *Eva Mudocci* of 1915 (p. 167) and *Greta Prozor* of 1915–16 (p. 169) are more drastically abstracted than any Matisse drawing we have seen thus far. They appear to be archetypal Cubist works. They take from Cubism its rectilinear design and affirmatively constructional method. Both were preceded by somewhat less abstracted versions of the same sitters[96] and both had relatively naturalistic beginnings. In each case, Matisse erased his preliminary outlines, separately examined and simplified the parts of the figure, at times from slightly shifting viewpoints, and gradually adjusted the separate linear signs until they grouped, bridged and clustered to form these astonishing open webs, seemingly suspended within the tonal matter that engendered them.

In 1916, Matisse wrote to Derain telling him he had read Henri Poincaré's *La Science et l'hypothèse* and found it contained 'such daring hypotheses, one feels quite dizzy'. He was impressed by its discussion of 'the destruction of matter. Movement exists only by means of the destruction and reconstruction of matter.'[97] Thoughts such as this undoubtedly fed what he had learned from Cubism. These drawings have literally been reconstructed from destroyed matter. And they freeze into their temporally perceived wholes the turn of a head, the movement of a body settling under its own weight. They condense from the 'succession of moments which constitutes the superficial existence of beings and things, and which is continually modifying and

transforming them . . . a truer, more essential character.'[98] In this way, they are entirely continuous with Matisse's earlier work and not Cubist drawings at all. Cubism has been absorbed.

We do read the lines in these drawings as elements both of descriptive analysis and of compositional order, as we do in Cubist drawings. But they so belong to the indomitable personalities that they make humanly present in ciphered form that they cannot be imagined away from them. We do see in these drawings a Cubist separation of means, wherein line alone carries the informational function, and shading hovers behind the transparent enclosures produced by line. And yet, the lines are condensed from the form of the shading and cannot be imagined away from that either. We do understand that the geometric web holds flat to the surface and reinforces the geometry of the sheet, as it does in Analytical Cubist drawing. But again it forms images; images that are whole, despite the discontinuity and decomposition that produced them. And, of course, we know that without the experience of Cubism these drawings could hardly have been made. Still, it was Matisse's own particular search for full knowledge of things that led him to take up 'the methods of modern construction'; and what these profound and mysterious drawings illustrate is not Cubist theory — nor theory of any kind. It is, rather, that same shock of emotional reaction before the subject which all of Matisse's drawings seek in their various ways to uncover from the obscurity of their own subjects.

'I felt there might be underneath these signs something quite different which I ought to discover, a thought which they transcribed after the manner of those hieroglyphics which one might think represented only material objects.' This is Marcel speaking, in Proust's famous novel, after he had seen the two steeples at Martinville and had felt that he was not penetrating to the full depth of his impression, 'that something more lay behind that mobility, that luminosity, something which they seemed at once to contain and conceal.' Matisse's development since Fauvism was an attempt to discover something other than the material. It had led him to the creation of imaginary wholes, linked jubilantly in a purified continuous form of drawing, only to find that they could not be transplanted whole back in the prosaic world but, there, had to be constructed individually, part from part. The result was a more daringly conceived form of drawing than he had ever produced — which is not necessarily to say more realized. But it was not, by any means, a conclusive statement. The *Portrait of a Woman* of c.1916 (p. 170) returns in one sense to the sour gravity of the charcoal study of Yvonne Landsberg (p. 158, below right), although it is more sparely abstracted as befitting its date. And yet, it also suggests a shift, albeit as yet a tentative one, toward a greater verisimilitude in the more naturalistic shading of the face. Signs penetrated appearances, but they did so at the expense of more objective, sensual knowledge of things. Knowledge of that kind had also to be possessed if the truth contained in appearances, as well as concealed by them, was to be grasped.

73

3 · Possessions

*Only the modern age, in its rebellion against society, has
discovered how rich and manifold the realm of the hidden can be
under the conditions of intimacy; but it is striking that from the
beginnings of history to our own time it has always been the bodily
part of human existence that needed to be hidden in privacy, all
things connected with the necessity of the life process itself . . .*
HANNAH ARENDT, *The Human Condition*

In 1920, when Matisse was fifty and now living in Nice for the winter
months of each year, he arranged to have published a book called
Cinquante dessins, which illustrated a large selection of drawings, almost
all done recently.[1] It was a sort of anniversary present to himself: fifty
drawings at fifty years of age.

The wording of the title page shows that Matisse both selected the
drawings and determined their sequence. They are studies from
female models, usually clothed, and most are drawn with a fine,
medium-hard pencil on dense, smooth paper, producing a light,
silvery effect, especially in those cases (which predominate) where the
figures are quite densely worked, for then they seem bathed in a
curiously unreal, disembodying light.

The *Reclining Model* of c.1919 (p. 177) is one of the more finished sheets
in the group; *A Young Girl, with Plumed Hat, in Profile* (p. 172), of the same
date, one of the more quickly drawn studies. They share an absolute
sureness – a sense of having been drawn with ease, at ease – and also a
frank delight in the sheer attractiveness of the models, and in the
confident relaxation of their poses. Whichever method Matisse adopts
– whether he draws quickly and fluently, setting down outlines with
soft, light curves and giving internal details with bunched, repeated
arabesques, or whether he continues beyond that stage, defining
contours with a harder, more carefully considered line and fixing
areas of shaded detail into patterned, opposing rhythms – in either
case, the result is candid and harmonious. In the drawing of the young
girl, the fluid play of line that bends down the left side of the sheet
spreads its freshness through the whole surface: the Renoir-like image
is almost an apparitional one.[2] In the *Reclining Nude*, the shimmer of
light across the figure suggested by Matisse's fine parallel hatching
seems to cause it to glow, relieving its solidity with a feeling of
weightless suspension. The pose of the figure helps, of course. It both
minimizes the sense of gravity affecting the figure and softens the
psychological impact of the head, thus allowing Matisse to present his
model as a tipped-up, flattened motif, spread across the sheet and
exactly describing its boundaries. In neither drawing does he enhance
the attractiveness of the model. He simply gives it; and creates from it

an independent, somewhat reticent, even solemn beauty that is as one with the luminous substance of the sheet.

Each of these drawings is typical in its own way of the changed character of Matisse's draughtsmanship in the early Nice period. The visible difficulty that Matisse had earlier in resolving his drawings has now entirely disappeared, and with it the sense either of disquiet or of heroically reconstituted harmony. Matisse had already produced as great (in fact, greater) drawings than these, but never such utterly assured ones. There are some weak sheets in *Cinquante dessins*, but the best of these drawings are truly superb. It is as if a major craftsman in the art of drawing, previously unknown, had suddenly appeared. No longer is this a 'difficult', avant-garde form of draughtsmanship; rather, an accessible, traditional and, technically, extraordinarily accomplished one. Luxury, calm and voluptuousness – and especially calm – are back in control of Matisse's art, and they are simply enjoyed as they had never been before. There is no need now, it seems, to make anything grand or elemental, anything abstract, in order to filter these qualities from the superficiality of sensations and gradually purify them. They were to be found simply by looking for them. And Matisse opens his eyes to the world around him with exclamations of delight such as he had never allowed himself to utter before. The rooms in Nice were lovely; the models were beautiful; the whole scenery was 'fake, absurd, terrific, delicious'. Matisse often forgot that it was not real, but that he had constructed it himself. In Nice, he drew, as real, the products of a wish-fulfilling imagination.

The marvellous sequence of plumed hat studies which comprise Matisse's probably most famous suite of drawings was the first great achievement of the Nice period.[4] They show a nineteen-year-old model known as Antoinette. Drawings of Antoinette dominate *Cinquante dessins*. It is a virtual anthology of her attributes and appearances. The plumed hat series is named, of course, after the extraordinary hat itself, Matisse's own creation of feathers and ribbon on a straw foundation, actually assembled on the model's head. 'The plume is seen as an ornament, a decorative element,' he told a visitor to his studio, 'but it is also a material; one can feel, so to speak, its lightness, and the down seems so soft, impalpable, one could very well be tempted to blow it away.'[5] The sheets in Detroit[6] and in New York (p. 173, below) show it with that kind of lightness, miraculously conjured at the centre of some loose, fluffy lines.

Merleau-Ponty has written of Matisse's ability 'to put in a single line both the prosaic definition of the entity [he is drawing] and the hidden operation which composes in it such softness or inertia and such force as are required to constitute it as *nude*, as *face*, as *flower*.'[7] It is precisely this marvel that we see in the plumed hat series. And there is no single definition either of the entity or of the particular qualities which compose it. In the Acquavella drawing (p. 175) and in one in Washington, DC,[8] the feathers have been transformed into a mass of curling, ornate tendrils, each somewhat like the smaller branches of certain conifers, and the looped strands of ribbon that fall from within

and around the hat — soft and relaxed in the other pair of drawings — are here crisply, vigorously rendered so that the impassive face beneath is framed by a bristle of activity. And lest we imagine that Matisse has stealthily reconstituted the form of the hat between making, say, the Detroit and the Acquavella drawings, the similarities of pose, costume and method of handling in other sections conclusively proves that this was not so.

We are presented, in effect, with a complex, but finite, set of variables which Matisse manipulates into an astonishingly rich set of possibilities. These variables include, on the one hand, those that belong to the physical form of the model herself: her gown, her pose, her expression, the way she wears her hair, the angle at which she wears the hat — things of that kind. But not the hat itself. That and the model herself, wherever she is uniquely to be found in these different disguises, is constant. And on the other hand, there is the vocabulary of Matisse's draughtsmanship: the single isolated lines that catch the tight pull of the gown across the model's breast or, now relaxed, give the drooping back of a hat rim (we see both in the Acquavella sheet); the careful parallel hatching that turns and overlaps to give the form of the face in the extraordinarily beautiful Baltimore drawing (p. 171) or that moves more quickly around the volumes to give an unusual impatience to another of these works (p. 172, right) — things of this kind. And the two sets of variables — the former, more complex than one might imagine; the latter, almost boundless — are brought together to picture this young girl dressing up as a woman. The pictorial and emotional richness of these drawings is justly celebrated.

To his visitor, and referring presumably to works like the Baltimore drawing or that in Washington, Matisse said: 'The fabric of the blouse is of a special kind; its pattern has a unique character. I want to express, at one and the same time, what is typical and what is individual, a quintessence of all I see and feel before a subject.'[9] Now, there was no single quintessence. What had been predicated but not fully realized in the Yvonne Landsberg studies of 1914 (though something comparable had been in Matisse's paintings) — multiple, equal versions of the essential character of things — has become a reality.

> You see here [continued Matisse] a whole series of drawings I did after a single detail: the lace collar around the young woman's neck. The first ones are meticulously rendered, each network, almost each thread, then I simplified more and more; in this last one, where I so to speak know the lace by heart, I use only a few rapid strokes to make it look like an ornament, an arabesque, without losing its character of being lace and this particular lace. And at the same time it is still a Matisse, isn't it?

Matisse was accustomed to discussing his work as progressive simplification, which it certainly is in the case of certain drawings in this series. However, there is no evidence to suggest that the purpose of this series was that of increasing abstraction of the subject. The

sequence in which Matisse arranged them in *Cinquante dessins* does not support this, neither does the character of the series itself. The different drawings are simply different versions of the same personality, or perhaps more accurately, versions of a multiple personality. We remember the incident of Saint-Loup's mistress in Proust who was an entirely different person to Saint-Loup than to Marcel. Just as Proust overthrows the older, classical notion of character (that a person is one despite his or her changing moods), suggesting, rather, that each person is many;[10] so now does Matisse. Knowledge of other people is relative, he tells us. The same character will look like a succession of different people; all of them have to be known.

Finally, of course, to follow the artist's own lead on this, every one of them is a Matisse. But close examination of the plumed hat series does tell us that every one of them is not the same Antoinette. Take, for example, the impatient-looking figure referred to earlier (p. 172, right) and that in the New York drawing (p. 173, below). The poses and costumes are similar. So is the general drawing style. They might well have been drawn one after the other in the same sitting. But do they show us the same girl? If the impatient figure was drawn first (which we cannot know), then obviously she has rested, removed her necklace and petticoat, put her gown back on, resettled her hat, and has sat back, relaxed, with the wide-eyed innocent expression of a mere child. Perhaps the process was exactly opposite. We cannot know. But what we are given in these two drawings is not something as simple as Antoinette surly and Antoinette glad. Beneath the common clothing are there not two quite different people? And is it not, for all their superficial similarities, the different forms of drawing that distinguish them — a certain lightness and transparency around the bodice in the New York drawing, for example, as opposed to the more heavily shaded folds in the other sheet? These derive, of course, from the slightly changed pose. But the sense of innocence that Matisse finds in the flimsier draped figure, and of posing in the other, is entirely attributable to an astonishing co-ordination of eye and hand, and mind.

Alfred Barr has observed that Matisse portrays the model 'almost as if she were an actress or mime assuming a variety of roles', and has catalogued some of her parts: 'pudgily adolescent, provincial and demure ... a cold, acquiline beauty with shadowed eyes ... alert and elegant ... languorous and seductive.'[11] There are more. And the paintings that accompanied this series of drawings show us the yet different kinds of Antoinettes oil on canvas can reveal. None of the drawings specifically prepare for the paintings, though some repeat their poses. This is a series of separate, independent creations, all finished, complete works for all the variety in draughtsmanship they reveal. And what makes possible these score or so of separate Antoinettes is the coolness with which Matisse treats so attractive a subject.

Picasso is reported to have recommended that artists choose common, ordinary subjects, and the consensus of modernism has

tended to support him. Matisse, in this period of his career, opposes that consensus — just as, earlier, his high decorative colour and flattened surfaces challenged the need for dark tonalities or heavy volumes in the creation of a profound, grave art (a misunderstanding based in linguistic ambiguity that persists even now), and just as the colour of his Nice period paintings, at times almost cosmetic, challenged the avant-garde austerity that he himself had done more than most to establish. In the 1920s, Matisse embraces attractiveness. But never is the beauty of his work directly attributable to that of his subjects. Antoinette's beauty is not enhanced.[12] Neither is it diminished, though often it seems to be contradicted by the detachment of its realization. The seductiveness of that amazing close-up study of the plumed hat itself (p. 173, above) is obviously to be found in the sheer richness of Matisse's draughtsmanship. The same is true, in different ways, of all of these sheets. Matisse, we should note, does not draw coquettes. There will be more to say about this later.

Antoinette remained Matisse's model only a year or less. Louis Aragon, whose book on Matisse was read in proof by the artist, asks: 'Could it have been because such innocence embarrassed him that Matisse kept Antoinette for so short a time?'[13] As we shall see, evocations of innocence formed one of the important themes of the 1920s. But usually it had to be discovered, not simply found. Yet in that single year, Antoinette released from Matisse some of his most memorable images, apart even from the plumed hat series itself. These include the technically astonishing study known as *Young Woman with Long Hair*[14] and a wonderful version of Antoinette asleep wearing a *gandoura*, a loosely fitting North African robe, whose stripes and folds slide frontally down the surface in one single, boldly patterned silhouetted shape, pinched in at the waist by curlicue details (p. 176). Figures resting or sleeping formed another important theme of the 1920s. So did figures exotically dressed. And Antoinette's costume-changes prepare for the more explicit exoticism about to come.

The so-called *Seated Woman* (p. 176) – this work a direct study for the extraordinarily but elusively seductive picture of Antoinette in the *Black Table*[15] – shows her in Moorish dress. Within a year or so, Matisse would begin drawing his models as if they were odalisques in some Middle-Eastern harem. One of the paintings of Antoinette shows her nude except for a transparent wrap and the ubiquitous plumed hat.[16] This too has a flavour of the exotic. So too, certainly, does that great celebration of fleshly delight, *The Artist and His Model* of 1919. (Lawrence Gowing calls it an allegory of fertility.[17]) It could well be a picture of Antoinette. Aragon claims it is an Antoinette look-alike.[18] But so is every other of her representations. That she could appear as an explicitly seductive odalisque might seem surprising after seeing the plumed hat drawings. But that is what they were leading to.

Two other images of Antoinette should briefly be mentioned before she disappears. One (p. 174, above) shows her with tied-back hair and with those strangely misaligned eyes that keep reappearing in Matisse's portrait drawings. At times, they lose contact with each

other, as they do in the *Young Woman with Long Hair*; a curious technical flaw in an otherwise highly refined drawing. Here, though equally improbable, they add a note of suspicious unease to the close-up view.

Almost without exception, Antoinette is drawn as if pressed up to the surface of the sheet. Exceptional, therefore, is the final drawing of her we shall look at (p. 174), in which she would have seemed close to us had not Matisse added a strip to the original piece of paper. As a result, she recedes – a distanced, somewhat remote figure in the spatial room of the drawing. This is not by any means the first time that Matisse draws figures away from him before abandoning them. To compare, for example, the paintings *The Piano Lesson* and *The Music Lesson* of 1916 and 1917 is to see the same.[19] In the latter painting, as in this drawing, the more 'illustrative' presentation of realist space, with figures within a spatial enclosure not pulled to the surface, expresses the artist's estrangement from what he sees. He is outside the space of the work, psychologically detached from the subject, and therefore able to set it down in physical distance from him. (The more urgent the emotional charge, the more the subject is rushed forward.)

Antoinette, we notice in this last drawing, has had her hair cut. It is bobbed in keeping with the flapper fashion then beginning to emerge, and makes her look simply like a smart young woman trying to keep up with the times. Perhaps it was this suddenly achieved contemporaneity – not innocence but its loss – that caused Matisse to stop drawing her. Or perhaps it was that she herself had changed and was therefore now out of Matisse's control. In any event, she disappeared; the first in a line to be kept only 'until the interest is exhausted',[20] then sent away.

The drawing that Matisse chose to begin *Cinquante dessins* (fig. 26) is unlike anything I have described so far. It looks like a leaf from a sketchbook and shows three standing female nudes seen from the back. They resemble earlier studies for the first *Back* relief (p. 151, above), except that they rest on their right rather than their left arms and their left arms are pulled up to behind their waists, producing a coiling movement that manages to be simultaneously graceful and expressive of physical constraint.[21] The drawing style is more summary than that of the earlier *Back* studies, but since one of the nudes rests against what seems to be the panelled wall of the Issy studio, it is tempting to conclude that this sheet also was made around 1909. That, however, is impossible, for as the panelled wall is transformed, with the rising of the eye, into an enclosing picket fence, we see above it the view of a church in a rich landscape – which is the view that Matisse saw, and painted, from his hotel window in Tangier in 1912 (fig. 27).

This harsh, ungraceful sketch was certainly an odd choice on Matisse's part with which to introduce a book of delightful, dreamy models conjured up with such ease. Turning the pages of the book, the surprise of this drawing itself is only bettered by the shock of contrast afforded by the consistently beautiful works that follow. So mischievous a frontispiece to Matisse's announcement of his new Nice style could hardly have been unconsidered.

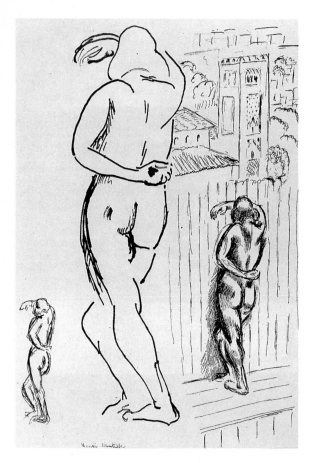
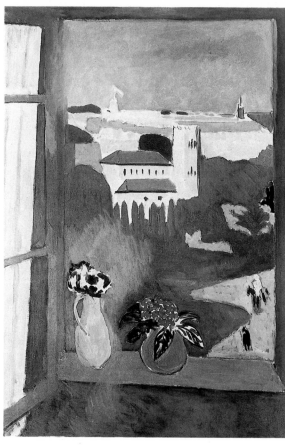

26 *Nudes Seen from the Back.* From
Cinquante dessins, 1920
27 *View from a Window, Tangier.*
1912–13

But what are the refined models of the Nice period drawings except
more civilized descendants of those clumsier creatures pinned up
against the earlier studio wall? Around 1910, Matisse had tended to stop
working from models in order to make portraits of friends and family
and other free individuals whose characters had to be realized in their
images. He is now returned to figures who can be controlled: not his
equals, almost his slaves. Their individuality, their own characters,
were important, but only as vehicles for expression of his own.

Moreover, what is, in fact, the setting at Nice, in which these models
relax and lounge, except the artist's studio in a new form, that of the
artist's home? Transposed from the primitive arcadia of the earlier
spare decorative compositions to the domesticated arcadia of these
new, increasingly ornate ones, the models are not brought into
contact with the external world. They move from one protected
environment to another, equally fenced off from disturbing sen-
sations and equally dedicated to harmonious pleasure. To work in
contact with figures in the public world had brought disquiet. To
work in the environment of the home itself, as Matisse did when he
returned to Issy in the summer of 1919, was already to escape the public
realm and have only to deal with one's household – something that

multiplies and prolongs one's own personality but does not change it as the public realm does.[22] That form of privacy could bring untroubled comfort, it seemed. And yet, the great painting he made that summer, *Tea*,[23] is uneasy despite all the relaxation of the setting. An odd drama is being played out under the dappled foliage, and only the model Antoinette is unaffected by it: she remains at ease, even slightly bored. Far better to create a new home in Nice with a paid, professional family of Antoinettes. That could be undisturbed.

So undisturbed were the new conditions that the models we see reproduced within *Cinquante dessins* have visibly relaxed when compared with those stiff figures shown in the first drawing. Those primal nudes have been domesticated and tamed, for in such a setting everything must be orderly and obedient. In Nice in the 1920s, figures are far more often clothed, even partially, than nude; and when they are nude they are either realistically drawn or there is a setting, a detail, something (even just a bracelet) to locate their worldly state. And when, very exceptionally, Matisse does draw the nude pure and abstracted, we know he has something else on his mind: that he is dreaming about the primal state that has been lost.

But that, in the end, is what the models are dreaming of, too. The view of Tangier in the background of the first of the *Cinquante dessins* is there for a purpose. It was Matisse's memory of his experience of the primal as it actually existed. As Lawrence Gowing has noted, 'Morocco bridged the gap between the reality and the dream.'[24] Matisse himself said: 'The voyages to Morocco helped me accomplish this transition, and make contact with nature again better than did the application of a lively but somewhat limiting theory, Fauvism.'[25] Nice, as Gowing puts it, 'had an analogous effect; the environment took the place of a style.'[26] The languorous Mediterranean environment; the escape from the north to closer proximity with the exotic; the cosmopolitan character of Nice itself; the ornate and oriental trappings with which Matisse decorated his apartment, and his models: all of these things contributed to an environment made in the very image of a style. The dark years of the war, and the practice of another kind of theory, had broken the spell of the Moroccan experience. Now, in Nice, the memory of that experience was systematically, precisely reconstructed.

Matisse had always possessed what the French call *la clarté française*, 'by which they mean not just "clarity" but clear-mindedness: the ability to know exactly what one is doing and why.'[27] It now was applied to rational creation of a romantic dream. The struggle of the rationalist and the romantic in himself that Matisse recorded in 1914 is therefore resolved in this surprising way. The anxious primal nudes of that first drawing in *Cinquante dessins* are excluded from the Moroccan paradise by the barrier of the studio wall. Matisse remakes his studio, which is also his home, in the image of paradise, and harmony is achieved. The clue to *Cinquante dessins*, as to many of Matisse's creations, is how it returns to the first sensation which sparked it. As a drawing, that first image is not important. As an idea, however, it is; for it

reveals to us the nature of the sensation that was to be given its tangible form.

In 1920, when *Cinquante dessins* was published and the path to be followed established, Matisse floundered for a moment, apparently unable to decide quite what his next move should be. He accepted a commission to design costumes and stage sets for Diaghilev's production of the Stravinsky-Massine ballet *Le Chant du rossignol*.[28] It was while in Monte Carlo to work on these designs that he made a vivid portrait drawing of Massine (p. 178). It is quite unlike the works in *Cinquante dessins*, as Matisse here returns to the style he had been using in 1914 just prior to the Cubist drawings. And, of course, it had to be different to how models were drawn. Massine was a public figure, not a private fantasy.

Also in 1920, Matisse spent a period at Etretat in Normandy, where he drew a curious open window (p. 179). This too is entirely unlike the *Cinquante dessins* style (and it reminds us, of course, of famous earlier paintings of a similar subject). Here, however, even on the blustery Channel coast, Matisse is starting to imagine what an artist's studio-home might be like. And the answer is decorated: swamped with ornament from top to bottom so that the world outside is contracted into a mere picture of itself, another ornament within the room. The profusely decorated interior had been created before – in paintings made after earlier contacts with the exotic; works like *The Painter's Family* of 1911.[29] Revelation always came from the East, Matisse said.[30] In 1911, Persian miniatures had shown Matisse what he called 'all the possibilities of my sensations. I could find again in nature what they should be. By its properties this art suggests a larger and truly plastic space. That helped me to get away from intimate painting.'[31] Now, it was recalled as a way back to the intimate, but to a kind of intimacy that remembered the boldness the first Eastern revelation had produced.

In 1921, Matisse established a permanent apartment in Nice, in the Place Charles Félix in the old part of the town, and there the process of building the dream truly began. That year, he again spent a period at Etretat, but thereafter, until 1930, his time was divided only between Nice and Paris, with the rarest visit elsewhere (for example, a trip to Italy in 1925). Matisse kept the Place Charles Félix apartment until 1938, when he moved to Cimiez. Its first presiding model was Henriette Darricarrère. Initially, his daughter Marguerite posed too, for Matisse's children visited regularly, especially in the early Nice years. But after Marguerite's marriage at the end of 1923, the figures we see in his work are almost always models. They idle away the day lounging beside windows and mirrors (p. 182); playing the piano or violin or guitar (pp. 182, 183), or pretending that they will (p. 181). They dress up sumptuously in rich gowns and patterned skirts, against patterned surroundings (pp. 180, 181), and they are dressed up as members of a seraglio, in low-slung ample culottes or transparent veils (p. 186), or in richly embroidered fabrics and oriental headdresses (p. 187). And they fall asleep a great deal, either singly or with friends (pp. 180, 185).

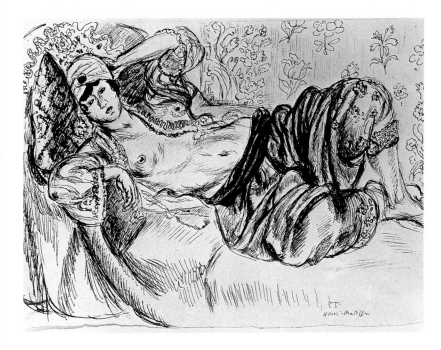

Around them, the setting is appropriately exotic, too. We see less of
it in Matisse's drawings than in his paintings, even in his prints. But we
catch glimpses of it from time to time. It is a place with heavy cushions
and couches (p. 180), with patterned textiles and ornate wallpapers and
screens (p. 182, 185). It contains, besides the usual furniture, objects
such as a brass ewer, an oriental side table or tabouret and a Moorish
chair (p. 186). Rich still-lifes of fruit and flowers stand about (p. 184).
And a large window screens it from the outside (p. 183).

All of this was utterly artificial, being constructed in exactly the
same way that an artist will construct a still-life before painting it.
Matisse was creating an ideal, imaginary, harmonious fantasy for
himself. But at the same time it was real; it was made to be real. At
which point, we reach the curious and profound paradox of the Nice
period. Art, of course, is not life. It is, by definition, artificial. Not only,
however, does this mean that making life into something artificial will
make it more congruent to art. Beyond that even: only by making life
artificial could it, in art, seem real.

Take the odalisques, for example one of the first that Matisse drew,
of around 1920–21: an indolent figure in embroidered pantaloons and
vest, with a turban on her head, reclining in a richly decorated setting.
It is the model Henriette transformed by the costume as well as the
pen into a beautiful object of pleasure. Asked in 1929 why he chose that
sort of subject, Matisse replied: 'I do odalisques in order to do nudes.
But how does one do the nude without it being artificial? And then,
because I know that they exist. I was in Morocco. I have seen them.'[32]
The nude is an artificial convention, not to be found in life as
nakedness is. In order to make it seem real in art meant finding

nakedness in life in its most artificial form. The point, however, was not just to copy Moroccan odalisques. 'Rembrandt did Biblical subjects with real Turkish materials from the bazaar, and his emotion was there. Tissot did the life of Christ with all the documents possible, and even went to Jerusalem. But his work is false and has no life of its own.'

Picking up on the very same subject as late as 1951,[33] he reiterated the Rembrandt-Tissot comparison, adding that Rembrandt's Biblical scenes are full of anachronisms but Tissot's documented ones are merely anecdotal. For an artist to draw sustenance from the past is one thing, but for him to identify with it is another: it 'disturbs the fullness of his pleasure – a bit like the man who searches, with retrospective jealousy, the past of the woman he loves.' The odalisques, then, are truly present (though not of the present). They are indeed artificial. They do make up a fantasy – but fantasy not in the sense of the incredible, not as something entirely separated from reality, but what reality can be confused with and mistaken for. And a realist style of drawing provides that. Also, and extremely importantly for Matisse, the reality of this world as drawn and painted offers a relief from normal worldly fantasy: it relieves the emotion and frees him of it in the security of its wholeness, which is far greater than that of the now excluded external world. 'As for odalisques, I had seen them in Morocco, and so was able to put them in my pictures back in France without playing make-believe.' The world in Nice was made up, but it was not make-believe. It was credible, real, whole; and when Matisse presented it in his art he presented it as the truth.

As early as 1918, he was writing to his friend Camoin on precisely this point. Comparing Gauguin and Corot, he noted that the use of firmly drawn contours produced a 'grand style' but the use of halftones was 'much closer to the truth.'[34] In Nice he abandoned his own grand style, for, had he continued with it, he told an interviewer in 1919, 'I would have finally become a mannerist. One must always guard one's freshness.... Besides, I am finding a new synthesis.' Previously, sacrifices had been made: of 'substance, spatial depth, and richness of detail. Now, I want to reunite all that, and think I am capable of it in the course of time.'[35] Once Matisse was firmly settled in Nice, the synthesis was formed.

In drawing, the great charcoal and estompe studies that dominate the years 1922 to 1924 reveal the character of that synthesis, at least in its first fully realized state. This particular medium allowed him, he said, 'to consider simultaneously the character of the model, the human expression, the quality of surrounding light, atmosphere and all that can only be expressed by drawing.'[36] The theme of these studies, then, is the synthesis of form in light.

Time and again Matisse would say that drawings should generate light. In the paintings made at Nice, colour was submitted to light: rather than producing light in the contrasts of colour, as previously, his canvases were dosed with white and the colours were joined and organized within this luminous substance. This was why charcoal and

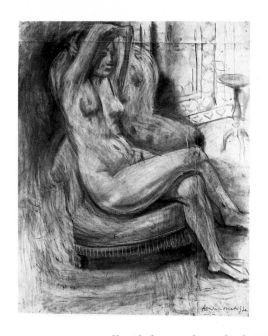

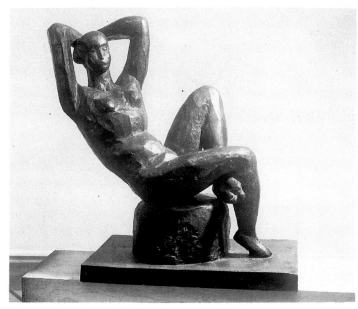

29 *Seated Nude with Arms Raised. c.*1922
30 *Large Seated Nude.* 1922–25
31 Auguste Renoir, *Portrait of Ambroise Vollard as a Toreador.* 1917

estompe – as well as lithography, which Matisse took up again in 1922 after eight years' absence from it – were especially attractive to him. Both media were particularly suited to investigation of how tonal modelling could be reconciled with his longstanding concern for the decorative flatness of the picture surface. They permitted him to create an extraordinarily wide range of soft, closely graded tones, ranging from transparent, aerated greys to dense and sooty blacks, that appear to adhere to the flatness of the sheet, and to release especially subtle effects of light from the luminous whiteness of the paper. What is more, the volumes thus created stay 'light' in feeling despite their solidity, and it was this 'light', disembodied sense of volume that he sought in his painting too.[37]

He also, in fact, sought it (as Pierre Schneider has noted) in the great sculpture of this period, the *Large Seated Nude*, begun in 1922 (again a crucial year) and completed in 1925.[38] What is probably the first important charcoal and estompe drawing of the Nice period (though it is likely to be later than the *c.*1920 date usually assigned to it),[39] the monumental *Seated Nude with Arms Raised*, prepares the pose for the sculpture as well as for a number of related paintings, drawings and prints.[40] It recalls both Matisse's early academic drawings (p. 140), where the eraser or estompe was used to remove areas of the charcoal ground and give highlights to the forms – a regular practice in this 1922–24 series – and Matisse's Cubist period drawings (pp. 167, 169) with heavily worked and altered forms. It is not an especially likeable drawing but it is a most impressive one. Nothing at all so raw appears again for a long time. But in its creation Matisse finally achieved that sense of disembodiment to which I refer.

Matisse was obviously looking for inspiration not only to Cézanne (to works like his own Cézanne *Bathers*, with their solid, weighty

29 *Seated Nude with Arms Raised. c.*1922
30 *Large Seated Nude.* 1922–25
31 Auguste Renoir, *Portrait of Ambroise Vollard as a Toreador.* 1917

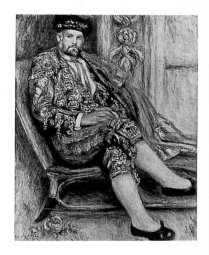

forms) but also to Renoir's late work: to paintings such as the great 1917 *Portrait of Ambroise Vollard as a Toreador*. Matisse had seen a good deal of Renoir in 1917 and 1918 and had come to rate his work even on a par with Cézanne's.[41] The 'lightened' volumes of Renoir were especially important to Matisse in the 1920s. *Seated Nude with Arms Raised* is at once solid and transparent, at once a vigorous sculptural unit and almost a ghost. The sculpture likewise loses its initial solidity, but because (as Schneider points out) the different views it offers to the spectator decompose that solidity. In drawing, the Cubist method of differing viewpoints was no longer available to Matisse, although we are given a sense of looking up at the arms and down at the legs. The solidity of the image had somehow to be tempered, but at the same time its wholeness retained. Renoir's example was therefore important. So was that of Bonnard, who Matisse also visited regularly in the late teens. Both showed Matisse how a soft southern light could give to volumes a pearlescent lustre, which is precisely what we see in his great charcoal drawings of the early 1920s.

Although the solution was new – organization with light – the problem was not. And while light turned out to be the solution, that soft Nice light needed a location, which returned Matisse to an older solution: abstract compositional construction. And this was drawn into the new synthesis he was creating. In 1918, he had written to Camoin: 'I try to assimilate the clear and complex conception of Michelangelo's construction.'[42] He had begun working at the Ecole des Arts Décoratifs in Nice, drawing and modelling from a cast of Michelangelo's Medici Tomb *Night*. He did not, he said, work 'with volume like the ancients; I am concerned with the arabesque like the Renaissance artists.'[43] The pose of the *Large Seated Nude*, its ancestors and its derivatives, is generally indebted to the Michelangelo. In the drawings too, it is the presence of the arabesque, as well as that of light, that – running through the forms of figures – makes them not objects but images. They are aesthetic rather than tangible wholes, for all the promise of palpable pleasure some of them afford.

In a photograph of Matisse's studio wall taken around 1926 (for that is the date of the lithographs it shows), we can see, pinned on the door, a photograph of a famous drawing of *Night* in the Louvre. Around it are photographs of Delacroix's *Barque of Dante* and of the Raimondi print after Raphael on which Manet's *Déjeuner sur l'herbe* was based. Both offered comparable poses of sprawling and reclining figures with heavy bodies and limbs. So did the wonderful Courbet that Matisse owned, which we see above the door. Matisse was plundering the past to help him along his way, as he admired Cézanne for doing.[44] And Cézanne, the touchstone of perseverance and quality for Matisse, was also referred to at this time. It was only to be expected, perhaps, that he should turn to Cézanne as he returned to sculptural form. Still, it comes as a surprise to realize just how much this artist was on his mind. Talking to Jacques Guenne in 1925, Matisse delivered the most impassioned of all his many panegyrics on his favourite artist.[45] Cézanne was 'a sort of god of painting.' He hesitated so long and so

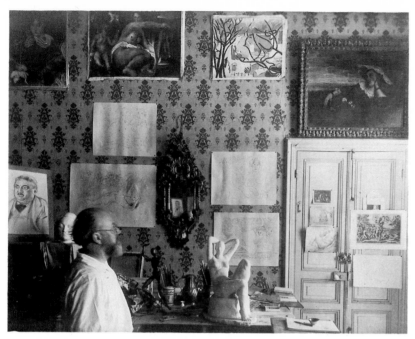

constantly because there were so many possibilities in him that 'more than anything else, he had to organize his brain.' Cézanne was a synthesist.

> In moments of doubt, when I was still searching for myself, frightened sometimes by my discoveries, I thought: 'If Cézanne is right, I am right'; because I knew that Cézanne had made no mistake. There are, you see, constructional laws in the work of Cézanne which are useful to a young painter. He had, among his greatest virtues, the merit of wanting the tones to be forces...

Matisse is referring to his own early work, and to his painting. But he must also be thinking of recent struggles, and of drawing as well as painting. The Nice period, as we shall see, was not one thing but a perpetual crisis. Throughout, Cézanne was still his touchstone; often he was his guide.

'The merit of wanting the tones to be forces.' Cézanne's painting was admired above all for its construction, and Cézanne constructed 'from the rapport of [colour] forces, likewise from black and white.'[46] That sparkling, graceful drawing of 1922, the *Seated Model with Guitar* (p. 181) has, stylistically, nothing in common with Cézanne. But it has precisely those qualities that Matisse admired in his 'god of painting'. The erased highlights fulfil structural requirements before atmospheric ones. The play of lights and darks softens the figure into a trembling luminous substance yet leaves it clear and whole. The figure melds with the ground but is solid and complete in itself. With time, and especially close up, one tends to read the drawing sequentially, as one does Cézanne drawings and paintings under similar conditions. The eye moves from volume to volume, and

volume to space, across the surface, noticing how Matisse joins objects to the surface without violating either 'the integrity of the picture surface as a flat continuum or the represented three-dimensionality of the object(s)' as he does so.[47] Objects seem to have been moved by the intensity of vision. They warp to provide a concavity for the model to sit in, and another for her guitar in front of her. But the insistent rectilinear architecture restabilizes and flattens the space at the same time. As in Cézanne's work, things order themselves before our roving eyes. Before that, however, we take it all in together at a single glance. It is 'a very solid, very complete realization.... It is rich in colour and surface, and seen at a distance it is possible to appreciate the sweep of its lines and the exceptional sobriety of its relationships.'[48]

These last words are Matisse's own description of his Cézanne *Bathers* when he gave it to the City of Paris in 1936. I do not intend to suggest that only Cézanne's influence is to be found in this drawing. Its intimacy reminds one of the artist's admiration for Corot. More explicitly Cézannist derivations appear around 1925, notably in the *Seated Figure on a Decorative Background*. The point, rather, is that Cézanne's organization of the surface through the push and pull of tonal forces was revised by Matisse even in this most un-Cézannist composition in this period of un-Cézannist sensual release.

The range in mood of these drawings follows the pattern established by the plumed hat series; that is to say, it is extraordinary. Where the *Seated Model with Guitar* is graceful and urbane, the *Reflection in the Mirror* (p. 182), a year later, is aloof; the figure ignores even her own reflection. The *Reclining Model with Flowered Robe* (p. 180), of c.1923–24, is the masterpiece of the series and one of Matisse's most splendid drawings. Victor Carlson, who knows the work well, talks of the 'rich variety of tonal relationships, from the dense black of the flowered robe (in fact, a Spanish shawl) to transparent greys indicating the thin, clinging material of the model's chemise' and of the equipoise achieved by juxtaposition of the checked material covering the chaise and the bold, flowered coverlet.[49] To this should be added that there is no other Matisse drawing (known, at least, to this author) that contains such an abundance of different tonal forms. It is satiated with them. But not surfeited. It is not in the slightest way ostentatious, for all its riches; they are carelessly displayed. The pearlescent shimmer of the wall; the scribbling of light across the shawl: these sort of details reveal the most remarkable technical virtuosity. But they are not dwelt on as technique. The boldness of the conception carries all before it. Those joined, imprisoning arms we see so often now serve to shade the model's eyes. But far more important than the functioning structure of the body – which we automatically accept – is how Matisse re-imagines it: as a patterned sequence of luminous parts, fabricated from the tonal substance itself, and assembled according to purely visual requirements so stringent and autonomous as to produce, within the very beauty of the substance and the sensuality suggested by the pose, the austerity of a studio doll. Matisse did make some cloying images in the Nice period, but this is is not one of them.

88

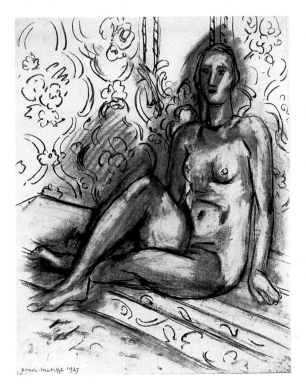
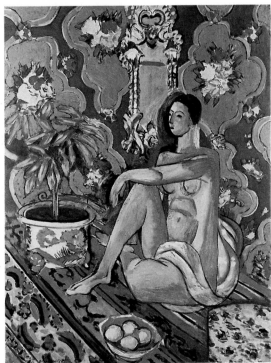

Almost the same superb quality is maintained in 1924, and in a softer, more melancholic mood. Henriette, the model of all of these charcoal drawings, remained with Matisse until 1927, and one sees why he especially liked her. She was so eminently changeable. The introverted images of Henriette playing the violin while seated at the piano (p. 182) – the busy patterns reflecting the sound of her music while she is stilled in concentration – or playing the violin before the (exceptionally) opened window (p. 183), like one of Matisse's imprisoned birds, share a generally similar mood, but they touch on quite different notes along its scale.

In 1925, the atmosphere suddenly changes as Matisse unexpectedly allows one of his figures its full sculptural identity (fig. 33) – and we need this neutral pronoun to describe the drawing because Henriette has become a thing, an object. It undoubtedly reflects his renewed acquaintance with the solidity of early Renaissance art, for he visited Italy that year. The format of the drawing, however, recalls Matisse's great decorative still-lifes of around 1910, like the *Fruit and Bronze*, where common ornamentation on both receding and upright depicted planes tends to align itself to the plane of the picture surface, forcing the objects on top of it into an ambivalent spatial and corporeal position – neither within the patterning nor separate from it, neither flat like the patterning nor completely solid.

Since around 1900, Matisse had struggled with the problem of depicting modelled figures in drawings and paintings where the

33 *Seated Figure on a Decorative Background.* 1925–26
34 *Decorative Figure on an Ornamental Ground.* 1925–26

89

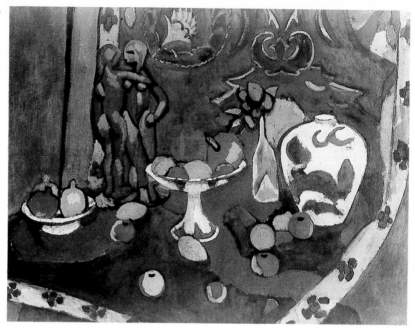

flatness of the background was identified with that of the surface. Figural representation itself, it seemed at times, was a dilemma within an art whose aim was decorative harmony. Hence, Matisse's investigation of sculpture, where the image is the figure; and hence his tendency, in still-lifes like the *Fruit and Bronze*, to introduce the figure into paintings in the form of a sculpture, since the scale relationships between such 'figures' and other objects and the decorative setting could be more freely varied than if he were dealing with human beings.[50] This drawing suggests not a human but a sculpture. One of the lessons of the Nice period was that a figure could assume a wholly decorative function, yet maintain more of its identity than when Matisse had solved the problem of figural representation by simply flattening figures to the surface ground. Now, he seems determined to press this a stage further and give to the figure an independent architectural mass. In doing so, however, Matisse turns against the harmony he has achieved, to create a hard, obdurate lump of a thing that refers more explicitly to Cézanne – indeed to his own Cézanne *Bathers* – than any of his drawings since the First World War. The painting he made after this drawing (fig. 34) enlarges its structural architecture.

In one sense, this was a lapse from the voluptuous Nice mood and from the absorption in light. And yet, even the most luminous of Matisse's other charcoal drawings are tempered in their voluptuousness by a rigour and hardness of design. And, as we have seen, the mood of these drawings is not, in fact, light-hearted and sheerly pleasurable. Without the sensuous beauty of coloured pigment to

entrance us, the protected contentment of the Nice dream does not seem quite complete. Drawing, Matisse wrote to Henry Clifford in 1948, 'belongs to the realm of the spirit and colour to that of the senses.'[51] By 1929, after a decade of the most blatantly sensual painting he had ever produced, he would have concluded: 'One can ask from painting a more profound emotion which touches the spirit as well as the senses.'[52] Drawing would help to show the way.

But not immediately. Indeed, in the second half of the 1920s, Matisse's drawings would seem to throw off their wistful moods to become as relaxed and hedonistic as most of his paintings were. This was accompanied and made possible by a shift from tonal charcoal drawing to line. Unshaded ink drawings began to come into their own (to increase in importance in the 1930s) and fine, light pencil drawing, comparable to that in the *Cinquante dessins*, reappeared, but now in a precise, stripped-down form. *The Three Friends* of 1928 (p. 185) is fairly typical of the ink drawings. The *Odalisque and Tabouret* (p. 186), also of 1928, and *La Persane* of 1929 (p. 187) are masterpieces among the refined work in pencil.

Compared to the ink drawings of the early 1920s, the new ink drawings tend, by and large, to eschew shading, and when it appears, it usually does so to produce areas of decorative pattern rather than to model in the round. Line alone gives weight to figures and participates in the ornamentation provided by the similarly arabesque treatment of the setting. The sheet is often filled right out to the edges to form a single patterned unit within which the identities of the figures are obscured. In drawings of this kind, the decorative function of the figure subsumes its human identity.

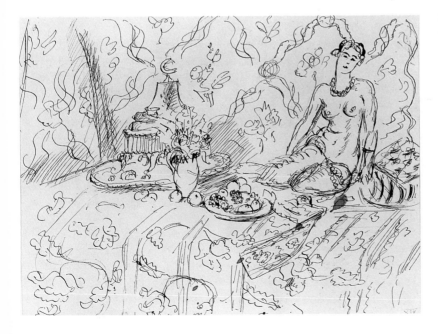

36 *Seated Odalisque with Flowers and Fruit against an Ornamental Ground.* 1927

In *Seated Odalisque with Flowers and Fruit*, Matisse had attempted to maintain the separate expressiveness of the figure by reducing its size, in the thought, perhaps, that this would distinguish it as a marked-out unit within the decorative continuity of the sheet. The result, however, while beautiful and intriguing, suggests even more blatant comparison with the 1910 *Fruit and Bronze* than did the sculptural 1925 drawing of Henriette previously discussed. We cannot be convinced that this is anything other than a sculpture amid a still-life setting. In the drawings that followed, Matisse gave a decorative function to the figure not by swamping it with decoration but by making it into a decoration itself.

The quality of these drawings varies considerably. They did not, by their very nature, allow of revision, and at times Matisse's quickly formed patterns are not relaxed but slack, and at others not fluent but stiff and unbending. This is partly to be attributed to the novelty of the method. And yet, it is surprising. The new method of the plumed hat drawings, for example, had sprung full-grown as if from nowhere. Never before had Matisse produced, as finished drawings, quite so uneven a body of work. There is a popular image of Matisse as the great modern master of virtuoso line drawing, the essence of his art lying in the rhythm of its line. This is no less repeated an opinion than that Matisse is the supreme hedonist of modern art: and, like that opinion, it is simply not true. Matisse was not a naturally talented draughtsman as was Picasso for example, whose line drawings are acts of amazing virtuosity. Pure line drawing was where Matisse failed most (and not only in this period) because it disallowed corrections. When he did succeed, his line is as stubborn and searching as any we know, as well as direct. Like any achieved act of condensation, it simply *seems* so fluently easy. The supposed elegance of Matisse's line, like the supposed hedonism of his work as a whole, is nothing less than the convincing clarity of an art that contains its creative struggle within the vividness, and grace, of its realization.

Matisse himself believed that his works in pure line were the most important of his drawings. This opinion clarified, and strengthened, as line drawings grew in number in the 1930s, and there will be more to say about it when that period is discussed. For the moment, however, let us be satisfied with noting that concentration on line in the later 1920s exposed, more explicitly than ever before, the weaknesses of Matisse's draughtsmanship and that it did so in drawings which illustrate hedonism more completely than any previous ones. Previous drawings had reflected Matisse's hedonism. In these, it is depicted. He draws the very apparatus of pleasure.

Interestingly, the prints he made in these years, and especially the etchings, are far more consistent in quality than the comparable drawings. Matisse had begun etching again in 1925 – at which time pure line reappears in his lithographs – and by the end of 1929 had produced a large body of highly authoritative work. Here too, the models inhabit a harem-like environment but they seem less lethargic than in the drawings, more curious about their surroundings. And the line is

generally firmer. This is no doubt the result of the resistance afforded by the plate, and of the tangibility of line produced in the etching process. As Riva Castleman has pointed out, Matisse's use of non-absorbent China paper for these etchings allows the ink to remain on the surface and enhances the 'threadlike meanderings' of the thin dry lines which result.[53] A comparably threadlike quality comes to characterize his most successful line drawings, which must certainly owe something to his etchings (but not to his drypoints and lithographs, whose more inflected lines are closer to, and derive from, those of the late 1920s drawings).

The fluidity of pen drawing did not impose the same discipline as etching. But pencil drawing did. The fine, silvery pencil drawings of the later 1920s are even more technically assured than those in *Cinquante dessins*, and even more than the pen and ink drawings they illustrate objects of pleasure. After Henriette's interest had been exhausted, Matisse obtained for himself a Persian model. She is the subject of the *Odalisque and Tabouret* (p. 186), *La Persane* (p. 187), and the 1932 drawing *The Lamé Robe* (p. 189). In these scintillating images, Matisse's engrossment in carnal perfection is returned to its source in the East. This real creature from the East is unembarrassedly treated as a slave of earthly delights. The dream, the fantasy, could not be more real, and it is frankly set down with all the skill and all the truthfulness that Matisse could muster. If flesh is the subject and sensuality the emotion, then let that be shown. So in the *Odalisque and Tabouret* the firm line of the pencil draws the fullness of the breasts and the spreading voluptuousness of the torso as it meets the transparent gauze skirt, and the model obligingly arranges her arms and legs so that an arabesque can carry throughout her body.

After the relaxed fluidity of that drawing, *La Persane* seems even prim. But Matisse similarly caresses the forms with fine contouring lines to release their palpable pleasures. Though drawn with only the most minimal shading, the work evokes a still and heavy splendour, lustrous and solid at the same time. The 1932 drawing develops these qualities, the varied pressure of the pencil serving to animate the body of the model with shimmers of light that realize the fleshly substance of the body and cause it to seem to glow, as if with its own well-being. All are extremely carefully constructed works (and we see in *La Persane* how Matisse had to rethink the right-hand section before the parts locked together properly). The insistent architecture of the figures cools their voluptuousness but only to make it the more inviting. They are distant, untouchable – like the East itself – yet provocative in their exoticism for the very same reason. And finally, their coolness is melted by the grace and warmth with which they are drawn.

The *Odalisque and Tabouret* is the closest Matisse comes to the softly pornographic. And yet, for all its promises, it is not even an erotic work of art. Matisse, as noted earlier, never drew coquettes.

As often observed, the new realism of Matisse's Nice period style belongs, in many respects, to a wider realist trend in European art after the First World War, and more generally even, to the so-called *rappel à*

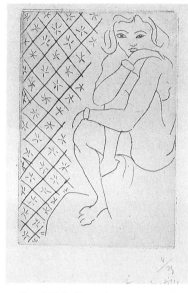

37 *Seated Nude.* Drypoint. 1929

l'ordre of the 1920s, which brought in its wake not only realism but also more obviously ordered abstract art than had previously existed. The Nice period style should indeed be seen in the context, say, of Picasso having begun to make classical-realist drawings in 1917 and having painted some extremely pretty paintings in the early 1920s; or of Derain's consolidation of an affirmatively 'traditional' art; and of the enthusiasm for Courbet (which Matisse shared) that grew apace in this period. And Matisse's discovery of the beauties of Renoir and Bonnard was made by others too.

After the conclusion of the war, France was unique among the major Continental powers in having both achieved victory and escaped revolution. The mood was therefore less one of rebuilding than of consolidation, of attempting to bring into the post-war present the stability of the pre-war past. Curiously enough, even the exotic was a part of this. It was escapist, and Matisse's little harem at Nice was hardly out of place in a period that saw Josephine Baker lauded in Paris and that supposedly 'primitive' invention, jazz, performed everywhere. But the exotic did not have to take one away from the French tradition. It was indeed integral to French nineteenth-century painting: the effect on French culture of the North African protectorates was very considerable. Matisse grew up in the late nineteenth century and shared its nostalgia for what was beyond the Mediterranean. Delacroix as well as Ingres, Romanticism as well as Classicism, were 'French'. Both had their effect on Matisse, as they had on many of his contemporaries.

All this simplifies an obviously more complex situation. But it is true to say that preoccupation with the greatness of the French tradition manifests itself in a whole number of areas after the First World War, ranging from Léger's neo-classical nude compositions to a new interest in French regional art and the French landscape. Indeed, the civic and the bucolic were its principal thematic modes. The more avant-garde forms tended to the civic; the more conservative to the bucolic. Matisse's art, though indeed part of this whole tendency, is neither civic nor bucolic. It is pastoral. In the earlier decorative period it had been explicitly so. In Nice, it is a kind of bourgeois pastoral: of pastoral nudes transported to decorative interiors, whose very decoration mimics and idealizes that of the natural world, just as the pastoral landscape does real landscape.

The sensuality of the nudes in Matisse's Nice period links them to the pastoral tradition, which since its modern, Renaissance beginnings has been an essentially amoral form, concerned not with public deeds and affairs but with private pleasure. (Hence that criticism of Matisse's art as merely sensual which was levelled against it by the more extreme wing of the avant-garde, for the more non-conformist the avant-garde becomes, the more it conforms to the model of a civic, didactic art concerned with the intellect at the expense of the senses.) The pastoral tradition has therefore been particularly open to emotional as well as technical spontaneity. By evoking a feeling of kinship with the natural world, repressed in public society and public

art, its representation of human relationships is necessarily archetypal in kind, and candid in a special sense.

Sensuous art by its very nature seems to require candour, yet a kind of candour that can never slip into the overtly erotic. Overtly erotic art is inescapably illustrative and therefore intrudes something between form and subject − its appeal to lustfulness − so that our interest does not (to use a well-tried expression) terminate in the work of art itself. It also depends for such force as it has on a moral context, if only by defying it. Matisse's treatment of the female figure is candid in the sense that it is amoral. If he 'overcomes' nudity as a subject, it is not, as Aragon claimed, because of the 'intellectual chastity' of his models,[54] not because he had his mind on higher things. (We cannot forget that his ideal world was a world of the senses.) Neither was it because he domesticated the nude. (It goes without saying that those he drew at Nice were not bourgeois wives.) It is true that Matisse did not begin to make truly sensuous images of women until Nice. In that sense the bourgeois trappings are important. (And, of course, the great sensualists of modern French art − Renoir and Bonnard as well as Matisse − were those who lived like the bourgeoisie.) And it is precisely these trappings that make real women from transplanted pastoral nymphs. And nudity, and decorated femininity in general, has the appearance of being an utterly natural state in Matisse's art because these women are representatives of the natural, amoral, pastoral world. They live, in effect, in a pastoral garden, with a wall around it, like paradise.

Of course, so protective a sensibility was not without its risks. The serene might turn out to be inert and the decorative no more than merely pleasing. Hannah Arendt has written of how French nostalgia for its glorious past, linked to a revulsion against the rapidity with which industry kills things of the past to produce today's objects, led the French to become masters of being happy among the 'small things' of domestic comfort.[55] Matisse risks falling at times into this merely *petit bonheur*. It was one form that privacy took. But privacy, as Arendt explains, is more importantly and basically the natural realm of the greatest forces of intimate life − 'the passions of the heart, the thoughts of the mind, the delights of the senses.'[56] They exist only in privacy, where they 'lead an uncertain, shadowy kind of existence'. Until they are made public by being told.

Before Nice, Matisse's art sought to externalize private emotion in essentially this way. In the great decorative period it was a kind of story-telling art, based on home-made narratives, and requiring the narrative continuity of line drawing to give it shape. In Nice, it changed. The private is not told. It is enclosed and documented. Private emotion is embodied in those traditional areas of privacy, the bodily parts of human existence. It was, in part, a flight from the outer world into inner subjectivity − which helps to explain the odd Surrealist associations we will find in some later drawings. More importantly, however, it was a turn to the body rather than the mind as the primal source of man's most private existence. Passions,

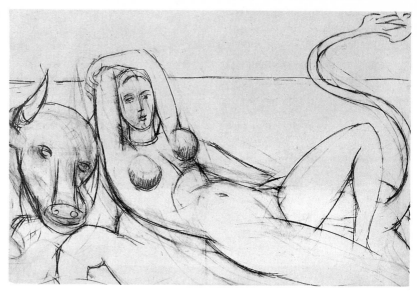

thoughts, delights pertain to the body. Whatever pertained to the body was most private. Women and slaves, Arendt tells us, were traditionally 'hidden away not only because they were someone else's property but because their life was "laborious", devoted to bodily functions.'[57] And these are Matisse's subjects, his possessions, the source of his *grand bonheur*.

The primal nature of these creatures has been remarked on before. Matisse's turn to continuous line drawing suggests that this nature was being reasserted. Line drawing was not 'real' or documentary, it was hierarchical and typical – and it tended to be narrative. It needed not only subjects, it needed a subject-matter. The Persian model came close to providing it. She was not a dressed-up French model, evoking another world. The costume she wore was of her world and it was her own. The subject-matter of the East could become a realist subject. The experiment was tried in 1928–29 and was repeated in 1932. Each time, it was successful within its own terms, providing glimpses of far greater sensuality than previously had been allowed to be seen.

But it was not the solution. In the period that elapsed between the second and the last of these drawings, the solution – or at least the way to it – had been found. In 1929, Matisse made an immense drawing of *The Rape of Europa*, the first broadly mythical subject for over a decade – indeed, really for two decades, since the *Bathers by a River* had been conceived in 1909 – and only the second specifically mythological subject he had ever treated. (The first was the *Nymph and Faun*.[58]) It was an interesting, different twist on the Persian model solution: a generalized subject-matter that was also a particular subject. *The Rape of Europa* is a fascinating drawing. The model is beautifully, crisply drawn in a pared-down version of the *Persane* style and assumes a pose which conflates those of his *Large Seated Nude* and Michelangelo's *Night*.

We know that it was preceded by numerous studies, cost Matisse a great deal of effort, and that the tinted painting which follows it fairly exactly occupied Matisse for three years.[59] That being so, its conception goes back to *c*.1926, which is when the painting, *Decorative Figure on an Ornamental Ground*, was made. This is confirmed by the fact that the model in the drawing, though highly abstracted, is certainly Henriette, who stopped posing for Matisse in 1927.

All of this tends to the following conclusions. First, that this drawing is a work of synthesis, of memory not of observation, and as such returns to the kind of drawing which accompanied Matisse's large decorative compositions two decades before. Second, that it follows the sculptural impetus of the 1925–26 *Decorative Figure* painting, and the drawing which preceded it, and probably therefore also owes its sense of sculptural solidity to Italian sources that Matisse had seen in 1925 – and its mythological subject too. Third, that Matisse's turn to the sculptural in 1925 was motivated by an attempt to understand how the wholeness of the bodily image could be incorporated in a decorative art, in exactly that same way as his study of sculpture had informed his painting in the earlier decorative period after Fauvism.

The second half of the 1920s, it therefore would appear, reacts against the empirical realism of the first half, much as the earlier decorative period reacted against Fauvism. But there is a difference. In the first half of the 1920s Matisse was concerned with sculptural wholeness as well as with its disembodiment by light. Looking back, we understand this in a new way, and want to reconsider the charcoal and estompe drawings in language similar to that used by Albert Elsen to sum up the 1925 sculpture, *Large Seated Nude*: 'He had insured concreteness of form against the accidental effects of light. Luminosity would not weaken solidity or expressiveness.'[60] However, the light in these drawings is not accidental. And in the pencil drawings that follow, the luminous and the sculptural continue to work hand in hand. The pure line drawings, in ink, and the prints, eschew the sculptural. But Matisse, by now, is making sculpture again. Once more, sculpture is used in order to study the figure so that a clarified form of continuous line drawing can be achieved. Realizing the affinity of works like the drawing for the *Decorative Figure* or the 1927 *Seated Odalisque* to the still-life paintings around 1910, it seems as if Matisse is working backwards in order to regain the linear decorative style preceding such paintings. By the end of the 1920s, certainly, he was on the threshold of attaining it.

In retrospect, then, we see that two fairly distinct options were realized in the second half of the 1920s, both based on line drawing. First, re-imagination of the models in the Nice studio in decorative patterns of pure line that join their identities to those of their settings. Then, by the end of the 1920s, excerption of the models from the Nice studio in more clearly defined linear images, made possible by the study of sculpture, which isolates the figures from their settings; this begins in the drawings of the Persian model and is achieved in *The Rape of Europa*.

The first option looks back to the decorative interiors of around 1910, of which the Nice studio itself was a recreation, and develops in line the impetus of the all-over charcoal drawings of the earlier 1920s. It is the quintessential Nice method of drawing, and will be refined in the years to come. Its difficulty, however, is the fact that it seeks to combine a conceptual, hieratic form of draughtsmanship with observed, realistic subjects. This, I believe, is why it caused Matisse such problems. In the 1920s, it depicted pleasure, and only worked properly when the line was sufficiently abstracted (as in the etchings) as to withdraw from it this illustrative role. The problem with these drawings, and we will see it again (for it plagued Matisse in the 1930s and especially the 1940s), is not that they are too decorative: they are not decorative enough. The identities of figures have to be surrendered to the decorative patterning of the sheet.

The second option looks back to the flat, simplified figure compositions of around 1910. Matisse had recreated for himself the two poles, spare and profuse, of his post-Fauvist art. The spare version of drawing, though more difficult for Matisse to disentangle, in the later 1920s, from the clutter of the Nice studio, was, once isolated, overtly conceptual and hieratic in form and in subject, and easier to manage. It blossomed in the early 1930s. But any attempt to draw its firm dividing line across Matisse's career in the year 1930 is challenged by the resurgence, around 1935, of its all-over, decorative alternative. Of course, all such dividing lines, and ends of chapters, falsify the continuity of artistic careers. There are, nevertheless, breaks in mood and shifts in direction. The year 1930 did bring important changes for Matisse, as we shall see. The common practice, in studies of his artistic career, of ending the so-called 'Nice Period' in 1930 has the great advantage of highlighting these changes. But it does disguise the continuity of the 1920s and 1930s, and especially the way in which Matisse's great synthetic compositions of the early 1930s – most notably the Barnes mural – do not depend on a sudden shift in direction in 1930; rather they consolidate, and realize, what had been simmering since 1925, namely a dissatisfaction with the kind of pleasure that the Nice studio, so carefully decorated and dressed up, had brought. Perhaps, after all that effort, it was just a *petit bonheur*.

On at least three occasions, Matisse pronounced against what he considered the purely sensual artists of the past. Once, talking about the importance of emotional sincerity, he said that 'certain works of the Renaissance made in rich, sumptuous, alluring materials ... make us disturbed to see that a feeling which has the characteristics of Christianity has so much that is ostentation and fabrication about it. Yes, that comes from the bottom of my soul: fabricated for the rich.'[61] Matisse's Nice period art was extremely successful in France and brought him a broader bourgeois clientele than ever before. But it is a puritan conscience, not a social one, that speaks these words, and one that turned to drawing as a way of controlling the purely sensual. 'Drawing belongs to the realm of the spirit and colour to that of the senses', he wrote to Henry Clifford in 1948.[62] In 1929 he said to Tériade

that he found emotion to be 'solely physical' in Velásquez. 'Without the sensory pleasure, there is obviously nothing. But you can demand from painting a deeper feeling, which touches the spirit as well as the senses.'[63] And drawing (as well as sculpture) was the way to find it.

Recalling his 1907 visit to Italy, he contrasted the 'primitives of Siena', whom he loved, to Titian and Veronese, 'those wrongly termed Renaissance masters. I saw in them superb fabrics created for the rich, by those great sensuous artists of more physical than spiritual value.'[64] Since this impression was remembered even in the 1950s, it is reasonable to assume that the 1925 trip to Italy produced exactly the same reaction. The more sensual that Matisse's art became, the more, it seems, he came to distrust the senses. The puritan conscience demanded order so that the spirit might be engaged. And drawing was not only an independent means of expression for producing achieved works of art, it was also, like sculpture (as Matisse described it) a means of achieving order: 'That is to say, it was done for the purpose of organization, to put order into my feelings, and find a style to suit me. ... It was always in view of a complete possession of my mind, a sort of hierarchy of all my sensations, that I kept working in the hope of finding an ultimate method.'[65]

The sculpture that followed the Italian trip of 1925 grew increasingly cold and formal, achieving ever greater severity and abstraction. We have already noticed how the pose of the figure in *The Rape of Europa* related to that of the *Large Seated Nude*. Its degree of simplification around the head and arms is comparable to that of the 1927 *Upright Nude, Arms over her Head*, while the mask of the head itself relates to the three sculptured heads of Henriette that Matisse made in the years 1925 to 1929. And the treatment of the body itself has to be seen in the context of the two great *Reclining Nudes* of 1927 and 1929, the extremely contracted two torsos of *Venus* of 1929 and the fourth *Back*, which was completed around the same year.[66]

In 1927, or thereabouts, Matisse had made a quick sketch – hardly an important work of art – that is highly reminiscent of the first *Back* of 1909. Unlike those doodled figures which introduced *Cinquante dessins* in 1920, this one maintains the pose of the sculpture, and rather than turning inwards upon itself, as they do, it spreads and flattens across the sheet. As a result, the serpentine movement of those other figures here becomes stilled. Drawn after the solid *Decorative Figure* and in the germinal period of *The Rape of Europa*, it is yet another indication, not only of Matisse's renewed interest in the sculptural, but also of his desire to release the Nice models from their decorative imprisonment and return them to their original, primal state. The last, monumental *Back* (fig. 63) does just that. It has the same sense of stillness as the drawings of the Nice period, the same sense of solidity having been absorbed into the continuity of the ground, the same feeling that the mass expressed by the figure is relieved and lightened in its formalization. But unlike any of the drawn, or painted, images that Matisse produced in the later 1920s, its formalization (partly derived from that of his Cézanne *Bathers*) is so extreme as totally to escape

39 *Nude from the Back.* 1927

contemporary suggestion. What had been announced at the beginning of *Cinquante dessins* – the dream of an ordered, harmonious existence, an arcadia, where the primal nude could find its home – is now resolved not by attempting to build such an arcadia, an earthly paradise, but by rebuilding, in harmonious order, the form of the nude.

The Rape of Europa attempts something similar. It only gets, as it were, halfway there, for the mythological is halfway between the earthly and the eternal, showing us gods as they appear to mortal eyes. Still, given the time that Matisse spent on this subject, it is difficult not to think of it as a consciously synthetic work – especially in view of the nature of the subject itself. It would not be the first time that the rape of Europa by Zeus in the form of a bull became the vehicle for allegorical representation of the artist and his model. And does it not, in fact, present the same lustful relationship in this allegorical, and therefore removed, form as the realist drawings we have seen? At which point, a similarity seems gradually to develop, before our very eyes, between the image of the bull and Matisse's own face.

We necessarily start to wonder about the choice of this particular form of the subject of godly seduction. The *Nymph and Satyr*, back in 1909 (to which date Matisse seems inescapably to be returning), showed Zeus, or Jupiter, in the form of a satyr approaching the sleeping nymph, Antiope. In 1930, he would redraw that very subject. But this 1929 personification of the artist as the seducer of Europa – of Europe – cannot help provoking speculation that affects one's understanding of the Nice period as a whole. Also, of what follows. For Matisse to base this consciously synthetic, summarizing work on an image of completed European seduction was certainly a very interesting choice.

This is an extraordinary and evocative drawing – but not an entirely resolved one: a 'premature synthesis', in fact, to use an expression that Matisse once used.[67] The reclining figure is wonderfully realized, but seems uncomfortable in so explicitly mythological a setting. The parts do not quite combine. Compositional order is more crucial to the success of ambitious works like this than the actual character of line. Indeed, as in Matisse's paintings, the very decisiveness of line can hinder harmonious combination of the parts, and it tends to here.[68] The two parts of the subject seem merely juxtaposed; and it is difficult to repress the wish that the bull, now that Europa has been ravished, will get up and go away.

At the end of 1929, Matisse made a trip to Tahiti and America. Having hardly stirred for a decade, except travel between Nice and Paris, he left the European hemisphere for the very first time. 'When you have worked for a long time in the same milieu,' he told his friend Tériade, 'it is useful at a given moment to stop the usual mental routine and take a voyage which will let parts of the mind rest while other parts have free rein – especially those parts repressed by the will. This stopping permits a withdrawal and consequently an examination of the past. You begin again with more certainty …'[69]

4 · Illuminations

The character of a face in a drawing depends not upon its various
proportions but upon a spiritual light which it reflects. . . .

MATISSE, *Jazz*

The statements that Matisse made to Tériade before and after his 1930
journey from Europe to 'Oceania' (as he persisted in calling Tahiti)
and America allow us to understand something of his state of mind at
that time.[1] The following points emerge.

The 'silence and isolation' of Nice were important to him. However,
too much confining order could be harmful. Recalling his short
affiliation with the Neo-Impressionists, but also perhaps thinking of
what his life had been like for the past decade, he remarked: 'One can't
live in a house kept by country aunts. One has to go off into the jungle
to find simpler ways which won't stifle the spirit.' The models of Nice
were hardly country aunts. And yet, that kind of sensual, comfortable
existence could also inhibit the spiritual life.

Oceania, however, was a disappointment. It was superb but it was
boring. 'The solitary paradise', he said later, 'doesn't exist. One would
quickly be bored there because one would have no problems.'[2] That,
however, was a judgment on Nice, perhaps, as well as on the South
Seas. The private had to be brought in contact with the public world –
which is exactly what happened in the early 1930s. America, especially
New York, Matisse did like. 'The great quality of modern America is in
not clinging to its acquisitions. Over there, love of risk makes one
destroy the results of the day with the hope that the next day will
provide better.' For the artist, he said, this 'must be extremely
agreeable.' Nice, and its beautiful possessions, could easily become
inhibiting. 'An artist must never be a prisoner of himself, prisoner of a
style, prisoner of a reputation, prisoner of success, etc.', he stated in
Jazz. 'Did not the Goncourt brothers write that Japanese artists of the
great period changed their names several times during their lives? This
pleases me: they wanted to protect their freedom.'[3] Artistic expression
of freedom became an especially important theme for Matisse. The
New York sky-scrapers were impressive because their mass was 'eaten
up by the light'. This 'lightening' effect, 'which corresponds to a
feeling of release, is quite beneficial. . . .' And it 'enlarges our space'.
The dissolution of mass by light had already been a crucial motif. But
now, Matisse's understanding of light began to change.

Analysis has to precede synthesis. 'When the synthesis is immediate,
it is schematic, without density, and the expression suffers.' The
renewal of analysis in the Nice work of the 1920s was very necessary.
However, particularized renderings of space and light need eventually

to give way to freer, less real spaces and to less material an understanding of light:

> Having worked forty years in European light and space, I always dreamed of other proportions which might be found in the other hemisphere. I was always conscious of another space in which the objects of my reveries evolved. I was seeking something other than real space.

A journey into the unfamiliar is therefore a journey into what previously had only been imagined. Whereas purely realist artists 'can express themselves anywhere as long as their interior life does not change', artists 'for whom imagination plays an important role' should travel from time to time – not only because such travel 'permits a withdrawal and consequently an examination of the past'; also, because it allows imaginative artists to test the veracity of the internal visions they derive from objects by seeing objects under changed spatial and luminous conditions. This will confirm that what is important is not the physical appearance of things but their essential, internal character. In 1930, Matisse begins to describe this character as the manifestation of internal light:

> Most painters require direct contact with objects in order to feel that they exist, and they can only reproduce them under strictly physical conditions. They look for an exterior light to illuminate them internally. Whereas the artist or the poet possesses an interior light which transforms objects to make a new world of them – sensitive, organized, a living world which is in itself an infallible sign of the Divinity, a reflection of Divinity.

We have noticed before how Matisse contrasts the words 'painter' and 'artist', suggesting superiority to the latter. The painter, it seems, deals with the physical, reproduces objects, and is concerned with exterior light. The artist deals with the spiritual, makes signs for objects, and transforms objects with his own internal light – not, as he wrote later, 'the physical phenomenon, but the only light that really exists, that in the artist's brain.'[4] The painter Matisse obviously thought of himself as an artist, so defined. Just as obviously, his central achievement is as an artist who is a painter, and his drawings are the drawings of a painter. At the same time, the painter – absorbed in the sheerly physical appearance of the world and in its sensual attractions – had to be disciplined by 'the artist or the poet' in Matisse, who eschewed the physical and sensual for the mental and spiritual. And the methods of the painter and of the artist or the poet were significantly different.

Painting was a physical, material art. It involved transformation of the mental and the spiritual into the constructed tangibility of durable things – more than transformation, in fact. As Hannah Arendt has explained, even the creation of objects of ordinary use involves transformation of thought – of some mental blueprint – into durable

form in the process of building that she calls 'reification.'⁵ In the case of art works, she says, 'reification is more than mere transformation; it is transfiguration.' It is the transposition of something living into dead matter. And the 'thought', the shock of emotion, that inspires it is only clarified, realized and remembered in the process of working. 'The thought of a painter,' says Matisse, 'must not be considered separate from his pictorial means.'⁶

The thought of a poet has necessarily a somewhat different relationship to its material form, for it can manage to exist without any material form at all. It does, however, eventually get 'made' into a tangible thing 'because remembrance and the gift of recollection, from which all desire for imperishability springs, need tangible things to remind them, lest they perish themselves.'⁷ But poetry, says Arendt, retains its permanence, its durability, without a material form because it 'is perhaps the most human and least worldly of the arts, the one in which the end product remains closest to the thought that inspired it. The durability of a poem is produced through condensation, so that it is as though language spoken in utmost density and concentration were poetic in itself.'

With slight alteration, this statement could apply to drawing. The draughtsman is the artist whose methods come closest to that of the poet. Of all the visual arts, drawing can exist with the least accommodation to material form, and can, in theory at least, exist without a limited material form and on any such form. A poem, says Arendt, 'is less a thing than any other work of art.' A drawing can be less of a thing than any other visual work of art. The thought of the artist-draughtsman or the poet is less constrained by his material. Objects do not have to be produced to reify that thought, and when they are, they do not reproduce other objects in the world, they make signs for them. If the painter is to be an artist, he too must create signs for objects, must speak his language in its densest and most concentrated form.

'I now want a certain formal perfection', Matisse said to Tériade before he left Europe at the end of 1929.⁸ When he returned, it was to talk of how preparatory studies were important to purify his subjects. Once a succession of such studies had been made, it was possible to work very directly and achieve 'the spontaneous translation of feeling'. 'It is these studies which permit the painter to free his unconscious mind.' By making drawing a study medium; by making drawing as deliberated a thing as painting; by making it even more of an object than painting (an object of use); to do this would be to make possible, in painting and in certain refined forms of drawing, the spontaneous creation of newly dense and concentrated images that would have the vividness of suddenly realized thought.

In the later 1920s, two forms of image-making had separately emerged in Matisse's drawings: the abstraction of figures until they blended with the all-over decoration of the sheet, which analogized the decorated studio interior; and the isolation of abstracted figures as bodily wholes in a way that removed them from the contemporaneity

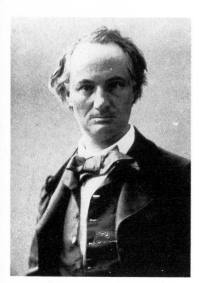

40 Charles Baudelaire. 1855

of their setting. What Matisse was now proposing was first of all a development, and refinement, of the latter approach. It soon affected the former. Initially, however, Matisse's return to Europe saw him building on the less temporal method of the later 1920s. The vision of 'other than real space' had been opened. The commission in 1930 to illustrate the *Poésies de Stéphane Mallarmé* offered a way of creating it.[9] The artist would join the poet, transform objects into signs, and make a new world of them in his own luminous image.

To prepare for the etchings that would illustrate the Mallarmé poems (this was Matisse's first illustrated book), he made numerous drawings, some on a proof copy of the book with blanks where his images were to be, some on separate sheets, each the size of one of the book's pages. The drawings, in pencil, include tracings onto the verso of the page-proof of studies developed on the recto (which produced reversed images ready for transfer to the plate for etching), and more complicated sequences of preliminary studies requiring the movement of images backward and forward between page-proofs and separate sheets. Some images were very carefully prepared on separate sheets before the proof was touched. Others, having been established on the proof and traced onto its verso, then etched, were rejected and redrawn on a new plate.

As with Matisse's earlier use of studies and then cartoons to prepare for his paintings, this patient, traditional approach to design becomes the method of achieving the most highly condensed abstraction. As the images shuttle about, it seems as if, like the words of a poem, they have no unique material form. But as they are clarified, they come to discover their form because the process of their clarification is that of making them specifically belong to the form of the sheet. The design 'bleeds over the whole page' and 'the page stays light', Matisse said.[10] He used 'an even, very thin line, without hatching, so that the printed page is left almost as white as it was before printing.' Space, light, and signs for objects: those were the aims of the Mallarmé illustrations.

The images of Edgar Allan Poe and Charles Baudelaire that appear in the book were of course drawn from photographs or other portraits. To compare a photograph of Baudelaire to the softly modelled pencil drawing and the completed etching is to understand the kind of synthesis that Matisse was seeking. This process of condensation became central to his draughtsmanship, and especially important was the change that occurred from the penultimate to the final image: soft to hard, intuitive to precise, modelling to pure line.

We have already seen how, as early as 1910, Matisse was conceiving of the softer forms of drawing – pencil and charcoal – as especially suited to preparatory analysis. This was not his attitude in the 1920s, when the charcoal and estompe drawings were among his most finished and complete. That the earlier conception returned in the early 1930s is more evidence that Matisse no longer believed in the truth of empirical realism, which the softer, more pliable forms of drawing, based on shading, were especially fitted to reveal. Shaded, tonal drawing, which traditionally individualizes things, making them

tangibly real, is now definitively given a preparatory role. Conceptual line drawing is the ultimate method.

Only one last portrait drawing reserves for charcoal and estompe (for the moment at least) its earlier authority: the posthumous portrait of Dr Claribel Cone, commissioned in December 1930 (when Matisse had returned to America to study the location of the mural he had agreed to paint for Albert C. Barnes at Merion) but not realized until 1933–34." Working from a photograph, he made three preparatory pencil studies of Dr Cone seated beside a table with a book in her hand. The last of these studies (p. 190)[12] is a wonderfully condensed work, 'quite as stylized in drawing as an archaic Greek head',[13] but with a certain equine cast to the features – hardly a portrait, more a metaphor. It looks forward to the almost Surrealist *Dormeuse* drawings of 1940 (fig. 55).

The project cost Matisse a great deal of trouble as he struggled to meld in a single image what the photograph, what his memory of Dr Cone, and what his imagination told him. He therefore set aside the photograph to create a bold, affectionate remembrance of his friend as the youthful looking figure he had known – and returned to the charcoal and estompe medium, and to the earlier simplifying method of such works as the 1914 *Elsa Glaser*, to realize it (p. 191). Even here, however, line does not seem integral to tonality as it did in the charcoal and estompe drawings of the 1920s or in pencil drawings like *Elsa Glaser*. Rather, line is condensed from the softer medium and overlays it. This method recalls the Cubist drawings of 1915–16, except that we are now shown, superimposed, the tonal substance that gives mass to the image and the linear outlines that condense it. This particular approach to charcoal and estompe was developed in future drawings using the same medium, among them some of Matisse's finest and most audacious works.

New methods of abstraction resulting in new emphasis on linear purity were not the only lessons of the Mallarmé illustrations. With them came a new iconography – in particular, extremely generalized nudes, sprawling and playing in some rarely specified arcadia. They are obviously not contemporary Nice models. At times, they are obviously nymphs and satyrs. More often than not, they are simply primal beings, drawn and then etched in even, fine lines and clearly enjoying their primitive existence. There are other subjects as well – including two boats, one moored outside Matisse's window at Tahiti – but the nudes predominate.

Matisse's turn from the self-constructed arcadia of Nice to the primal world of the imagination, already predicated in the later 1920s, is completed, and the third recreation of *Bonheur de vivre* begins. The first, in the great decorative compositions of 1907–10, took fragments from the world of that picture and, enlarging them to often magnificent scale, used the fraction to condense the feeling of the whole. The second, in the Nice period of the 1920s, remembered the observed Moroccan reality of that ideal world, and created from it an earthly paradise. Now, in the years 1930–32, as Matisse worked on the Mallarmé

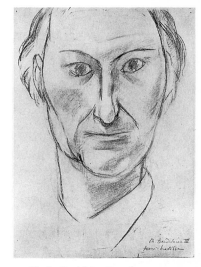

41 *Charles Baudelaire.* Pencil. 1931–32

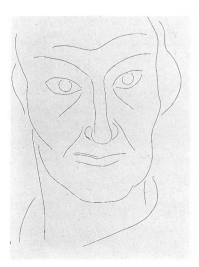

42 *Charles Baudelaire.* Etching. From Stéphane Mallarmé, *Poésies*, 1932

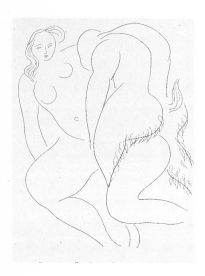

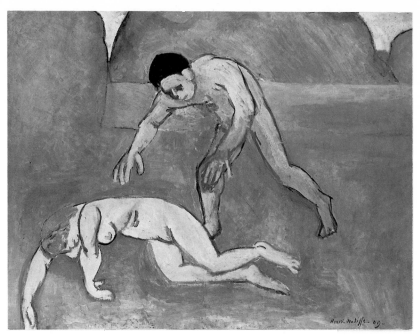

43 *Faun and Nymph.* 1930–32. From
Stéphane Mallarmé, *Poésies*, 1932
44 *Nymph and Satyr.* 1909

illustrations – or rather, in the years 1930–33, for his work on the Barnes mural was part of the same endeavour – the third recreation is formed. It looks back to the first recreation, and beyond that to *Bonheur de vivre* itself, with its piping nymphs and generalized allegorical setting.

Like *Luxe, calme et volupté* before it, *Bonheur de vivre* represented a distant land: the land of the imagination, the land of memory, reached by a journey into the past. As we have seen, it encapsulated iconographically the theme of remembrance crucial to Matisse's working methods as a whole, and posited a quasi-narrative style, based in line drawing, in order to relate it. Matisse's basic subject is the passing and recovery in time of the first emotional sensation. Since physical motion is a basic metaphor of the 'passing' of time, the journey is an especially appropriate way in which to represent it. Since a journey spans space and time together, this makes it even more appropriate. Since a journey has a beginning that leads to an end, it is the most basic metaphor for the act of narration, which adds potency to its meaning and meaning to its style. And since this particular journey advances in space but retreats in time (for when the boat arrives in the promised land, time has been turned back), it perfectly expresses that working forward, only in order to return to primary sensations, at the heart of Matisse's conceptual method.

The imaginary world of *Bonheur de vivre* is constantly recreated in Matisse's art because 'remembrance and the gift of recollection ... need tangible things to remind them.' And the tangible things refer not only to *Bonheur de vivre* itself but to the more particularized remembrances that kept recalling it to Matisse's mind. He made three works in his career which he specifically described as remembrances –

souvenirs. They tell of the three different recreations of the world of *Bonheur de vivre*. They also specify, geographically, its three different locations. The first is the *Blue Nude* of 1907,[14] the 'souvenir of Biskra' in African Algeria, visited by Matisse the previous year, which initiates the 'primitive', decorative first period of *Bonheur de vivre*'s recreation. The second is *The Moroccans* of 1915–16, which he referred to as 'un souvenir du Maroc.'[15] It preserved the memory of the Moroccan experience during the difficult years of the First World War until peace returned and the memory could physically be reconstructed in Nice. The third work is the great cut-out of 1952–53, *Memory of Oceania*, which remembers the trip to Tahiti in 1930 and is based on the Mallarmé illustration of the ship outside Matisse's window referred to earlier.[16] From Africa to the Middle East (as reconstituted in Europe) to Oceania is the form the journey takes, and each time it returns to the primal world of *Bonheur de vivre*.

If each of these recreations had a specific location and a specific form, they also had their own particular kind of light. The first was dazzling, produced by the vibration of juxtaposed high-intensity hues. The second was softer, produced by blending colours and volumes alike in underlaid whiteness. The third was bright and white, and drawings sparely formed on sheets of paper, where 'the page stays light', as vivid and luminous as it was before it was touched, were essential to its creation. In the 1930s, drawing became more central to Matisse's art than ever before. Not only because he was now again a creator of 'signs', which required drawing for their realization. Also because the harmony of light required it. What emerged in the Mallarmé illustrations was nothing less than Matisse's restatement of Mallarmé's own belief that 'the intellectual core of the poem conceals itself, is present – is active – in the blank space that separates the stanzas and in the white of the paper: a pregnant silence, no less wonderful to compose than the lines themselves.'[17]

The Mallarmé illustrations also maintained the interest in mythology that had re-emerged in 1929. And the experience of working on the two versions of the Barnes mural strengthened their interest. It was while working on this huge project that Matisse began to draw with charcoal attached to the end of a long stick in order to lay out the mural with drawing appropriate to its scale, and first extensively used paper cut-outs to plan the choice and disposition of colours. Both methods would be important to his drawing – broadly defined – in later years. But at this time, the iconographic scheme of the mural, and the simplification of drawing it required, were more important.

The first version began as a return to the *Dance* motif of 1909, but by the time that the second version was completed and in place by May 1933 it had become what Alfred Barr describes as 'some frenzied, Dionysian game or tumbling act or perhaps a savage pyrrhic dance or gladiatorial miming, since the figures seem paired in single combat.'[18] Except that the frenzy is stilled and frozen in the architectural lunettes. Barr draws especial attention to Matisse's modulation, through several months of trial and error, of the lower figure of the

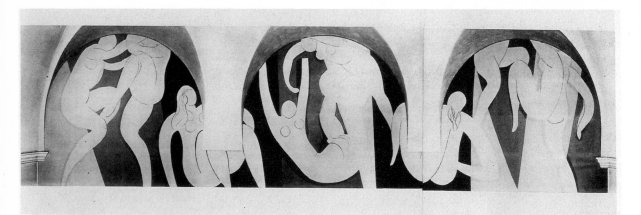

45 *Dance II.* 1932–33

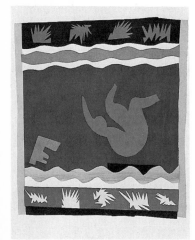

46 *The Toboggan.* From *Jazz,* 1947

pair in the central lunette. The particular form of combat presented there is that between a nymph and satyr, a subject which had appeared among the Mallarmé illustrations, but which returns, of course, to Matisse's great painting, *Nymph and Satyr,* of 1909 – indeed further, for the very first appearance of this motif was at the centre of another architectural decoration, the ceramic Hohenhof triptych of 1907.[19]

There, the nymph was generally based on the 1907 *Blue Nude* (itself derived from *Bonheur de vivre*), but transposed into this specifically mythological form. The years around 1907 had seen a number of other works with specific mythological creatures.[20] What appears in the Mallarmé illustrations, the Barnes mural and, as we shall see, some extremely ambitious drawings, is a *dramatis personae* very similar indeed to that of the first period of *Bonheur de vivre*'s recreation, initiated by the *Blue Nude* in 1907. We would hardly be surprised, I think, if that very image were to reappear. And of course it does. In 1935, after numerous studies (p. 193) and a long period of painting, the *Pink Nude* was created.[21] It brings indoors the original image of the Golden Age, and therefore requires coloration close to that of observed flesh. This painting and the studies that surround it fuse together the primal ethos of the first recreation period of *Bonheur de vivre* with the interior comfort of the second. Matisse's mid-1930s synthesis of these two forms realizes what had first been posited exactly a decade earlier, when figures drawn in the Nice studio began to take on a greater solidity and generalization. Development of this synthesis became a major theme in Matisse's drawings of the later 1930s and 1940s.

At the same time, however, the two parts of the synthesis were often explored separately. As might be expected, the more ambitious single drawings were devoted to the primal, mythological component and the grouped series of drawings to the more realistic one. Like Cézanne, Matisse was now tending to follow two parallel tracks: in works developed from observation, and in compositions of bathers – for that, in effect, is what the mythologically based drawings show. And, as with Cézanne, it was the bathers that caused him the most trouble.

In 1935, Matisse made a series of drawings of Homeric subjects in preparation for his second illustrated book, James Joyce's *Ulysses*.[22] Of the six soft-ground etchings that appeared in the book, the first and third show paired combative figures. The first, the *Bataille de femmes*, illustrates the episode of Calypso, the sea-nymph who traditionally personifies depths of water (a suitably Oceanic theme), who kept Odysseus on her island for seven years until Zeus ordered her to release him. The third, *Polyphème*, shows Odysseus blinding that one-eyed giant who had imprisoned him and his companions. In each case, the subject is of constraint versus freedom. *Polyphème* was based on a drawing after Pollaiuolo's *Hercules and Antaeus*, which transformed into an extraordinary image of violence before being tempered and cooled in the etching. (This is not the last time that the ultimate linear reduction loses the force of its predecessor.)

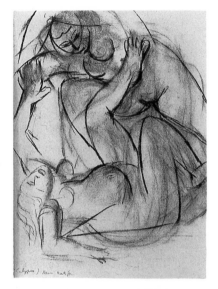
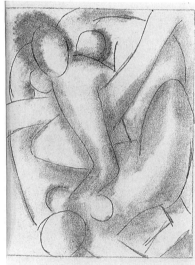

47 *Study for Bataille de femmes*. From James Joyce, *Ulysses*, 1935
48 *Bataille de femmes*. From James Joyce, *Ulysses*, 1935

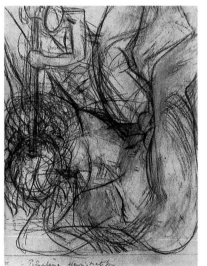
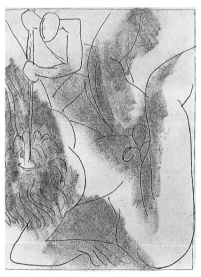

49 *Study for The Blinding of Polyphemus*. From James Joyce, *Ulysses*, 1935
50 *The Blinding of Polyphemus*. From James Joyce, *Ulysses*, 1935

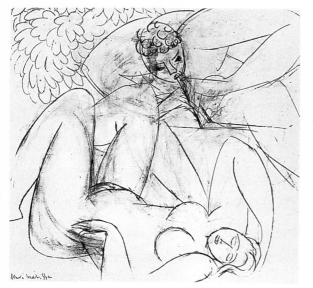

Matisse had a fear of losing his sight. It is not surprising, therefore, that his first ever explicitly violent image should be devoted to this subject. Nor it is surprising that the subject of a piping faun with a nymph should be its restful companion, for Matisse is said to have told his wife that he took up music (he was a dedicated amateur violinist) in order to be able to earn the family living if he did in fact become blind.[23] The first of the three studies he made for the Ulysses *Bataille de femmes* was reworked to become the impressive *Faun and Nymph* drawing of 1935 (p. 192). And as reworked, it came also to resemble the image of *Polyphème*, but the vertically held rod that blinds the giant is replaced by the vertical of the lulling pipes, as the male faun serenades his female companion.

Also in 1935, Matisse revised the composition yet again, possibly with the intention of making a painting on the faun and nymph subject, for the new drawing, *Nymph and Faun with Pipes*, was made on a 60 × 65 inch canvas. It remained a drawing, however, and was offered for sale as such in September 1935.[24] Compositionally, it is quite close to the preceding work on paper, especially in the pose of the reclining figure. The faun, we notice, has been redrawn in such a way that its right leg does not press forward into the bodily space of the nymph. As a result, the image is far less aggressive. The wonderfully crisp simplification of the line and the carefully balanced spatial relationships similarly induce an effect of calm.

Since Victor Carlson first published the photograph of this drawing that Matisse sent to Etta Cone in 1935,[25] it has been assumed that Matisse reworked the drawing around 1942–43 to produce the even more simplified *Nymph and Faun with Pipes* (p. 212), since the c. 1942–43 work is also on canvas, and of the same dimensions. In fact, the 1935 drawing was not changed, but remained in its original state in Matisse's studio,

where it can be seen in photographs taken as late as 1953. The second drawing on canvas can be seen in a studio photograph, taken either in December 1940 or August 1941.[26] It is not yet quite finished, but most of the composition is established − which suggests that it too may possibly have been begun in the mid 1930s, especially since it is seen in the photograph hanging behind the painting, *Nymph in the Forest*, begun around 1935–36 and worked on for approximately eight years before Matisse abandoned it.[27] In any event, the drawing was begun no later than 1940–41. A photograph taken in October 1942 shows it in essentially the same state as in 1940–41.[28] After that date, Matisse erased the head of the nymph, redrew her right breast and repositioned her arms. The result was a substantial alteration in the mood of the drawing as compared to the 1935 version. It is even more generalized and abstracted − and self-contained: a bold, monumental image at once energetic and reposed.

Again around 1935, Matisse drew yet another version of this two-figure mythological subject: the so-called *Bataille de femmes* (p. 192).[29] This obviously relates to the *Ulysses* etching of this subject, also to the central lunette of the Barnes mural, as well as to the 1907 and 1909 conceptions of the *Nymph and Satyr*. Now that the male-female confrontation is removed, the mood necessarily changes. There seems to be greater equality in Lesbos than in the other islands we have recently visited with Matisse. This drawing again conflates the imagery of the two Ulysses etchings, but whereas the *Faun and Nymph* shows us a helpless sleeper and obviously opportunistic musician, the *Bataille de femmes* suggests matching powers. Leo Steinberg has asserted that when a change of this kind occurs 'the chances are that the scene has shifted from the narrative and the literal level to a symbolic plane.'[30] It is indeed true that it introduces a new kind of tension in the relationship between the two figures. In this sense, certainly, it is more symbolic. At the same time, however, the equality of the figures, far from shifting the scene from the narrative, allows the narrative to continue. The 'savage pyrrhic dance' about to begin can never end: such is the balance of power that the only conclusion possible would be a merely pyrrhic victory.

And the struggle goes on for years. Whether between two women or between a woman and man, the theme of confrontation dominates Matisse's subject compositions, as we might call them, for the next decade. Thematic repetition itself is not an invention of the 1930s. It runs right through Matisse's earlier career. What begins in the 1930s, however, is Matisse's development of serial methods to enhance it. In 1935, he began obsessively documenting photographically the stages of his work in progress in case a subsequently reworked state needed to be recalled for further development. This extension of the approach of his earlier serial sculptures led eventually to the production of specifically serial drawings, the *Themes and Variations* of 1941–42. But the unprecedented, concentrated attention paid to this single confront-ation theme over a ten-year period was part of the same general development.

The *Nymph in the Forest* painting of 1935/36–1942, mentioned earlier, places the nymph and faun motif in a landscape based on the Mallarmé illustration *L'Après-midi d'un faune: Prose (Pour des esseintes)*. In 1936, Matisse made a separate drawing of the nymph; in 1938, he isolated the faun in a design for a piece of Steuben glass; around 1940, he made another nymph and faun drawing.[31] Between 1937 and 1939, he enlarged the confrontation theme in his designs for the Massine ballet, *Rouge et noir*, whose subject is quite specifically the 'eternal struggle between the spiritual and material forces in Man' and tells of 'the men of the city' attacking and capturing 'the men of the field', who eventually elude their captors to rejoin their women.[32] Hardly a more concise summary of Matisse's pastoral opposition to the urban could be imagined. (It was probably in the context of his work on *Rouge et noir* that Matisse drew the forceful *Portrait: Dancer* ['The Buddha'] of 1939; p. 211.) And then, in the years 1944 to 1947, Matisse reworked the nymph and faun motif yet again, this time transforming it into a *Leda and the Swan*.[33] (Zeus, the seducer, is constantly returning. We will look at some of his victims in a moment.) And around 1945, Matisse even considered the idea of designing a postage-stamp on the confrontation theme of Hercules and Antaeus (on which the Ulysses *Polyphème* illustration had been based, ten years earlier).[34]

'Starting as I do from direct contact with nature,' Matisse remarked to Raymond Escholier in 1947 about abstract painting, 'I have never wanted to be confined inside a doctrine whose laws would prevent me from getting health and strength through contact with the earth; like Antaeus.'[35] The struggle of Hercules and Antaeus is the struggle of Antaeus to keep in contact with the earth, with nature. Even at his most abstract and imaginary, Matisse is reminding us that his art is rooted in his reactions to the external world. The ten-year period of these mythological subjects, beginning in 1935, was a period of equally important advances in terms of observed subjects too.

Matisse himself believed the mid 1930s to be important in his artistic development. Not having made a formal written statement on his art since 'Notes of a Painter' in 1908, he wrote a short text, 'On Modernism and Tradition' in 1935, which stressed the importance of a pure and durable art and placed himself within a long, noble tradition where 'only plastic form has a true value.'[36] In 1936, reminiscing about Fauvism, he applauded 'the courage to return to the purity of the means.' Of his most recent work, he said: 'I have united the acquisitions of the last twenty years to my essential core, to my very essence.'[37]

The word 'acquisitions' may seem a curious one for Matisse to have chosen, but it is clear that he did think of his development as the acquisition of knowledge. Talking in 1951 about how all of the 'rebellions' of his career were against the idea of the literal copy, current when he began his career, he explained:

These rebellions led me to study separately each element of construction: drawing, colour, values, composition; to explore

how these elements could be combined into a synthesis without diminishing the eloquence of any of them by the presence of the others, and to make constructions from these elements with their intrinsic qualities undiminished in combination; in other words, to respect the purity of the means.[38]

Drawing dominated Matisse's art in the years before Fauvism. From Fauvism until the Nice period, colour tended to be given priority. In the Nice period, values or tonality were important. Then in the early 1930s composition began to assume a major role. In 1936, he believed that he had synthesized the past twenty years' study – that is to say, since the beginning of the Nice period. He had certainly synthesized, in his recent subject compositions, the various themes of bodily wholeness and mythological evocation, that began to develop around 1925. And recent paintings like the *Pink Nude* united the resimplified drawing and primal grandeur, achieved in that synthesis, with an observed, interior-situated subject such as might have been painted in the Nice period. Combining these two forms had been difficult, but it had been achieved by giving layout or composition new prominence, playing off image and ground until they exactly balanced, joining drawing and colour as one.

Matisse was on top of his form, having apparently managed what even his idol Cézanne was unable to do: to combine the real and the imaginary, the observed and the mythological, the intimate and the grand. Having previously refused to sell his Cézanne *Bathers* to Albert C. Barnes for a very high price, he now made a last, beautiful drawing (p. 196) to remember that solid rock of a back that had inspired him for so long, then gave the Cézanne away to the Musée de la Ville de Paris. 'I have come to know it quite well, I hope,' he wrote to the Director, 'though not entirely; it has sustained me morally in the critical moments of my venture as an artist; I have drawn from it my faith and my perseverance. . . .'[39]

In 1935, Matisse began a series of most beautiful pen drawings of models in his studio. A large selection of them were reproduced in *Cahiers d'art* in 1936, but the series continued into 1937. They are among the greatest achievements of his draughtsmanship. Some of the individual sheets are breathtaking in their assurance and audacity, and almost without exception, they realize what the comparable, late 1920s ink drawings did not: decorative assimilation of the figure into the decorated unity of the sheet. The difficult lessons in composition Matisse had taught himself in the earlier 1930s made possible the utter fluency and sense of almost instantaneously achieved order that emerges from these remarkable works.

Drawing, Matisse said, 'is the expression of one who possesses objects. When you understand an object, you are able to encompass it with a contour that defines it entirely.'[40] He is referring to drawing in its most primary, indeed primitive function: making images to gain control of them. The purified line, he proclaims, is 'the most synthetic way to express oneself in all one's aspects. You find it in the general

outline of certain cave drawings.'[41] The first definition of the word 'draw' in the six-page *Oxford English Dictionary* entry on that word is: 'to cause (anything) to move towards oneself by the application of force.' The reference, of course, is to broader than purely artistic meanings of the word, but that notion of drawing as bringing things closer to oneself, of drawing as possession, is primary to draughtsmanship as well. Both procedurally and chronologically, it is the most basic of drawing's forms.

In the early 1920s, Matisse had turned to a later form of drawing, based in the Greco-Roman tradition of sculptural illusionism, where a more sophisticated idea of possession obtained: by throwing up volume from void, knowledge of the tangible wholeness of bodies could apparently be possessed. In the later 1920s, however, he had returned to line drawing – only to find that it seemed often not quite to work with observed subjects. In the great mid-1930s drawings, it magically finds affinity with the 'primitive' sources appropriate to it: not with those quite as distant as cave paintings, but with linear Eastern decorations and patterned fabrics, with arabesque ornamentation and latticework screens. In the Nice period, things of this kind had frequently been represented, and Matisse continued this practice in the 1930s. But now, the drawing itself is a latticework, an all-over patterned fabric. The exotic mood of the earlier drawings disappears, and with it their Turkish (and occasionally Biblical) connotations. And so does the heavily sensual atmosphere. No longer does Matisse depict the exotic or the sensual. His drawings embody exoticism and sensuality within the purity of their means.

The beautiful 1935 Halpern drawing (p. 194) is one of the greatest of the series. The depiction of the model that we see Matisse's own hand drawing, the depicted model herself, and her reflection in the mirror behind her spread in waves of analogous lines across the whiteness of the sheet. The fluidity of these lines is enhanced by the counterposed geometry, which mimics the shape of the sheet just as the depicted drawing and mirror mimic its contents.

Drawings, mirrors and Matisse himself appear in a number of these works, emphasizing their self-containment. Once more, we are shown a private world, where everything is related to everything else, but now it has been decisively close-circuited in its references. No more dreaming of the East. The drawing *is* Eastern. No more nostalgia for the primal. The drawing *is* primal. Art and representation are sources of art and of representation; and Matisse, through the model, makes of the innately beautiful a securely internal world. Previously, he had often seemed a somewhat estranged figure when shown in his own work.[42] Now, in the Halpern drawing, he is the controlling hand. In the thematically similar, but more boldly refined, 1937 Baltimore drawing *Artist and Model Reflected in a Mirror* (p. 200), he is the presiding deity of the work. When he appears in these drawings, it is simply to remind us that he is their medium – and has, in any case, always put himself, and his own emotional reactions, at the very centre of his world.

Proust's name has appeared from time to time in these pages. Let us hear from him one last time, on a sensitive question that Matisse referred to with increasing frequency towards the end of his life: the question of love. In Lawrence Gowing's superb study of the artist, he quotes this shocking statement which Matisse made: 'As in love all depends on what the artist unconsciously projects on everything he sees. It is the quality of that projection rather than the presence of a living person, that gives an artist's vision its life.'[43] Gowing's analysis of the problem is highly acute: 'Involuntarily he was admitting to a far from amiable conception of love. The fact that the object of love was never wholly real to Matisse, or meaningful to him in her human role for her own sake, placed a limit on the emotional depth of which he was capable.' It is the perfection of unreality that makes the drawings of 1935–37 so completely realized. And their triumphs, as Gowing says of Matisse's art generally, 'are at root triumphs of the self' – to which he correctly adds that the cause of this is not to be attributed solely to Matisse himself but to the emotional language available to him, and to us, which 'does not equip us to respond to sexuality as the greatest humane painting of tradition.' This is well said, but it is not the last word on the subject, if only because alienation is too wide a subject to admit a last word.

Before Marx and Freud (and students of Manet or Matisse) started using the term 'alienation' for their own purposes, it meant separation from God, from grace. When Matisse talks of the 'interior light' of the artist as a path to the Divine, he recalls the original meaning of 'alienation'.[44] But his way of relieving it – by 'love' of his subjects – looks extremely secular, because it is self-centred. When Matisse, at the very end, said with Rembrandt that his work was 'nothing but portraits', he must really have meant self-portraits.[45] The models were not real and it was through them not in them, and by transforming them in his own image, that the Divine 'interior light' would be found.

Each of Matisse's characters, like those in Proust, is not one but many. 'All of them', Martin Turnell observes in a provocative study of this subject in Proust, 'give us a glimpse of the truth, but none of them the whole truth.'[46] (Hence, the importance of serial representations.) The artist therefore proceeds in a state of scepticism. When the characters are objectively described, they turn out to be 'prisoners' (in Proust, of their class, or *côterie*, or of their vices; in Matisse, of comparably enclosed, and often sensual worlds), and the artist is likewise a prisoner, of his own sensibility, and is constantly seeking to escape, in the creative freedom of his vocation, from the imprisonment his vocation creates, as necessarily it must for it is founded in his sensibility ('which appeared the same no matter what different states of mind I happened to have passed through').[47] Risk therefore is important, as is change, and new experiences. It is also important to express freedom iconographically, in pictures of struggle to achieve it, and pictorially, in the openness of space and the spreading harmony of light. But sensibility itself must also be isolated and examined (again, with the help of serial imagery as well as of photographic document-

ation). And, most crucial of all, the artist's scepticism must be relieved. He must discover the 'truth', the essential identity, of his characters, for only by so doing will he free himself from his imprisonment in his own feelings. If he can realize that truth in a successfully completed work of art, 'at the final stage, the painter finds himself freed and his emotion exists complete in his work. He himself, in any case, is relieved of it.'[48]

The path to such truth, for Proust, was love. Odette is 'more desirous perhaps to know what sort of man he [Swann] was than desirous to be his mistress.' As Turnell observes, 'Proust's psychology is a reversal of the traditional view. You do not get to know a person to see whether you love her; you love her in order to get to know her or, to use a term which conveys Proust's double purpose, to "possess" her.'[49] That same term conveys a double purpose for Matisse. 'Drawing is the expression of one who possesses objects.' And love has to be 'capable of inspiring and sustaining the patient striving toward truth.'[50] It was with this rider, and not merely referring to art as a procreative form, that Matisse stated, with apparent innocence: 'But is not love the origin of all creation?' Love produces knowledge, not knowledge love. Portraits are self-portraits. And Matisse, as he is now drawn, seems towards his subjects selfish and ungenerous in a way that the work itself disputes.

'Every object can affirm its existence', writes Merleau-Ponty, 'only by depriving me of mine.'[51] It cannot be allowed to exist at the artist's expense: that seems to be the point of Matisse's shocking statement. But: 'It is I who bring into being this world.... I am therefore a consciousness, immediately present to the world, and nothing can claim to exist without somehow being caught in the web of my existence.' Discussing his *Themes and Variations* drawings of the early 1940s (which we will consider shortly), Matisse compared himself to a spider who 'throws out ... its thread to some convenient protuberance and thence to another that it perceives, and from one point to another weaves its web.'[52] His description could apply to the 1935–37 drawings too. As with a spider's thread, line is drawn out of him thus to capture the objects of the world. The artist does not diminish objects, he possesses them and manifests in that possession 'the diagram of an encounter with the world.'[53]

But people are not objects, they are consciousnesses. 'If he is consciousness,' says Merleau-Ponty, 'I must cease to be consciousness. But how am I then to forget that intimate attestation of my existence ...? And so we try to subdue the disquieting existence of others.' Matisse harmonizes the world. Thus he remains 'the center of the world ... and animates it through and through'. Everything exists only for him – which does not mean, however, that he uses people selfishly; rather the opposite, because he has, in his art, no private life. 'All other people and the world coexist' in him. He is an 'indestructible, impartial, and generous spectator', not selfish but selfless, and everything is a spectacle for his eye. And this is why the spectacle can become, at times, so utterly sensual. As Northrop Frye once wittily

observed, the only true obscenity known to art is the naked display of the artist's own ego; and Matisse, in his art, has less of an ego than any modern artist even approaching his stature, except possibly his admired Manet. The coolness of his 1935–37 drawings is just what Matisse himself said that perhaps it was: 'sublimated sensual pleasure, which may not yet be perceived by everyone.'[54]

Such pleasure, he frankly recognized, was sublimated in his creation of 'plastic signs'. The models, he said, thinking no doubt of those in works like the 1937 drawing, *The Rumanian Blouse* (p. 199), or like those we have already looked at, 'are never just "extras" in an interior. They are the principal theme of my work. . . . The emotional interest aroused in me by them does not appear particularly in the representation of their bodies, but often rather in the lines or the special values distributed over the whole canvas or paper, which form its complete orchestration, its architecture.' Something has indeed changed since comparable drawings of the late 1920s. These had not, in quite the same way, sublimated sensual pleasure; nor were they so completely orchestrated. Expression, as Matisse points out, is now distributed over the wholeness of the paper:

> In spite of the absence of shadows or half-tones expressed by hatching, I do not renounce the play of values or modulations. I modulate with variations in the weight of line, and above all with the areas it delimits on the white paper. I modify the different parts of the white paper without touching them, but by their relationships.

This, he said, is the drawing method of colourists. Even the most ornamental passages are there as 'form or . . . value accents' to assist the play of light and shade across the sheet, not as evidence of technical dexterity. And the aim of drawing is to 'generate light' with the aid of signs that condense feeling. 'Once my emotive line', Matisse says, 'has modelled the light of my white paper without destroying its precious whiteness, I can neither add not take anything away. The page is written; no correction possible.' The image is of a linear web that gradually closes in order to hold and possess. 'Ingres said that drawing is like a basket: you cannot remove a cane without making a hole.'[55] And while the web of signs itself does give us images of figures and objects, it is the container and not the content of what we see. Like the represented lattices in earlier works, it is a passageway between the interior and exterior, and the means of opening space. The web or lattice is modified to indicate different spatial planes: 'thus, in perspective, *but in a perspective of feeling*' aimed at creating 'luminous space'.

The preceding quotations principally derive from 'Notes of a Painter on his Drawing' of 1939, a highly important essay written in the middle of a period (c. 1937–43) that saw a number of theoretical writings and statements by Matisse on drawing. The reasons for this preoccupation with drawing would seem to be two-fold. First: according to Lydia Delectorskaya (who became his principal model,

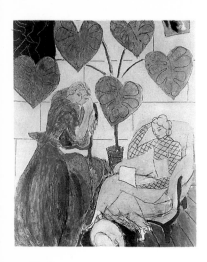

53 *The Conservatory.* 1938

later housekeeper and secretary, in 1935), Matisse, by the mid 1930s, considered line drawing a totally independent form of expression. He would paint in the mornings and draw in the afternoons. The drawing 'prolonged' each morning's painting just as much as it prepared for the next day's session at the easel.[56] Second: whereas in 1935 it had seemed to Matisse that line and colour were perfectly in accord, the paintings of the later 1930s increasingly displayed not synthesis but counterpoint of the two forms, typically comprising – as, for example, in *The Conservatory* of 1937–38 – large flat areas of colour with drawing on top of the colour. Both of these factors gave to drawing a renewed importance as an image-condensing act.

At the same time, however, both of these factors gave cause for concern. Painting and drawing were separated activities, and line and colour functioned separately. This led Matisse to shift his attention, around 1937, to charcoal drawing, where line condensed from areas of tonal shading (in a manner predicated by the final version of *Dr Claribel Cone*; p. 191) necessarily formed an extremely 'synthetic' relationship to that shading. This, it seems, could help bring back line and areas of colour more closely together. Such would appear to have been the always clear-headed Matisse's reasoning at this time. The same year that 'Notes of a Painter on his Drawing' was published, *Cahiers d'art* followed its earlier (1936) presentation of Matisse's ink drawings with a generous selection of his new work in charcoal.

In the later 1930s, Matisse went back, in fact, to the two different approaches he had used when tackling the difficult subject of *Dr Claribel Cone*. A year after completing the Cone portrait, he made a pencil drawing in the reductive style of the earlier Cone studies in order to prepare a pose for the 1935 paintings *Blue Eyes* and *The Dream*. Then, the next year (1936), he further refined this image to become the *Model Resting on her Arms* (p. 197),[57] a wonderfully abbreviated drawing which investigates how line can bound and belong to the patterned areas from which the work is composed. This would be one method of realigning drawing with colour area composition. The other method was through charcoal drawings. In the severe, indeed rather daunting images of himself that Matisse drew in 1937 (p. 201), we see how the linear armature seems bonded to the tonal shading that engendered it, in a way that recalls the Cone portrait's finally established form.

The latter method was the preferred one, and proved to be remarkably flexible. The very clothes that Lydia or the other models wore seemed to evoke styles of drawing appropriate to them: a taffeta dress (p. 202), simple, direct and somewhat demure; a Rumanian blouse (p. 209, above), rich, dense and sumptuous; a boldly patterned blouse and the tiniest of shorts (p. 208), crisp and blossoming with luminosity; and a fishnet dress, of all things (p. 209, below), swerving with not so sublimated voluptuousness. These charcoal drawings of 1937–39 were often specific preparations for paintings. But they are realized entirely in their own terms, and without exception show Matisse's stunning mastery of this especially sensual medium. The tonal gradations are extraordinarily subtle, yet appear to have been

realized very spontaneously, and the keen sense of interchange and interaction between linear figure and ground (Matisse was making linocuts in 1938)[58] adds tautness and intensity to their compositions. Not all, by any means, of the charcoal drawings of these years approach this quality. (Almost everything, it seems, was kept; and much that was published, even, was disappointing.) But at their best they are emotionally as well as technically rich and show us a more mortal Matisse than his line drawings do.

Among the greatest of them are two of the audacious nude studies that Matisse made in the summer of 1938. At some time in 1937, Matisse returned to the pose of the 1925 sculpture *Large Seated Nude* (and its derivatives) and made a pair of splendid charcoal drawings that remember its manifest solidity but flatten it two-dimensionally to the surface, one of them (p. 203) with the help of an unusual variation on the pose: a leg so firmly (and unembarrassedly) pulled up toward the head as to create sequences of fluid, looping rhythms in the centre of the sheet.[59] One of the highly experimental studies of summer 1938 (p. 204) expands on this theme with extraordinary vigour, and another (p. 205) as surely opposes it.

Using the familiar motif of the fully reclining nude, these two drawings take astonishing liberties with representation in order to channel and condense feeling into their linear armatures – one heavily, sensually rhythmical; the other, as geometric as any of the Cubist drawings of more than twenty years before. We know that Matisse most prized those works in pure, uncorrected line. It is certainly arguable, however, that witnessing the struggle to achieve purification is more rewarding an experience than sight of the chaste result. The sublimity of Matisse's charcoal drawings, in which he searches and erases, and rubs down the forms, only to draw them again and again, tends certainly to support that proposition. In each of these works, a true picture of creation and, superimposed, of its realization, is revealed. And these are such different creations – or, rather, such different versions of creation. For, viewed together, they suggest the same body turned over to reveal opposing versions of itself. Sculptures seen from opposite sides often are surprisingly different; Matisse's sculptures, certainly. The contradiction of these images prevents us from identifying the subject with either of them.[60] The subject is not one image, it emits images; each image is whole, but neither is wholly the subject. We seem mired in tautology. In fact, it is Matisse's familiar theme – not things but the difference between things – radically reworked. In yet another guise, it will soon surprise us again.

It is obviously tempting to interpret these highly abstracted drawings in the context of the earlier Cubist ones and see in both groups of works Matisse's reactions to two World Wars – for by the summer of 1938 it was clear to many that war was indeed imminent. Indeed, the 1938 drawing, *Nude Study*, is as brutally deformed as any of the Cubist works. To Matisse, who had been brought up in an area of France just devastated by the Franco-Prussian War and who had been

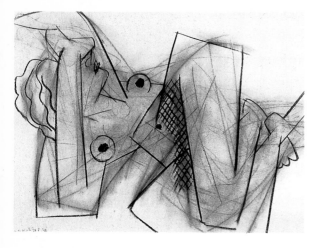
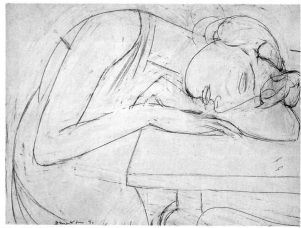

54 *Nude Study.* 1938
55 *Dormeuse.* 1940

deeply troubled by the war of 1914–18, the events of the later 1930s must certainly have been disturbing. And there were personal difficulties. He had been seriously ill with influenza in the winter of 1937–38 and thought he would die.[61] And he was undergoing the painful and prolonged process of gaining a separation from his wife. His most important undertaking at the very end of the 1930s, the painting known as *Sleeping Woman* or *The Dream*, certainly cost him enormous effort and is exceptional in the absoluteness of the introversion it conveys.

In making the numerous drawings that prepare for this painting,[62] Matisse used both of his characteristic late 1930s methods. Some follow the preceding charcoal drawings in setting down the image of isolated sleep with swerving dense lines within a tonal atmosphere. In one (p. 206), dated 20 December 1939, the figure flattens herself to the surface of the table on which she is resting. Then in another (p. 207), dated to that same month but probably slightly later on, her position is reversed and one of her hands falls off the edge of the table: a sort of claw. There are two kinds of artist, Matisse says: those who make a 'portrait' of a hand, 'a new hand each time, Corot for instance', and those who have a 'sign-for-a-hand, like Delacroix.'[63] Delacroix's hand was 'the claw' and Matisse recalls here a certain cruel Romanticism within the arabesque splendour of this drawing.

We wonder, of course, what Matisse was doing drawing images like this, so restless and reaching for new emotions, in the month of his seventieth birthday, when surely something settled had been established and when retrospection would have been only natural. But that, apparently, was not the way. Other drawings, in 1940, return to the first pose, but in the style of the earlier Cone studies, and at times they worry their contours so much that they become brittle and start to fracture. Matisse worked on the painting from December 1939 to November 1940. When completed, it reminded Alfred Barr of Arp's biomorphic forms.[64] Certain works by Picasso close to Surrealism also come to mind. The mutely isolated figure, wrapped in the womb of

sleep, is among Matisse's most haunting and unsettling images, for all its beauty. And for all their beauty, the drawings that prepare for it are unsettling too.

Knowing Matisse's personal difficulties and public concerns, however, what we finally are forced to admire as much as anything is how he remains an artist. His stance is unchanged. He does not turn to quasi-propagandist art. And during the distressing years of the war, and after serious illness, he wrung from his art two most important methodological changes: one in drawing, the other derived from drawing. If his art was going to affect public affairs, it was going to be in the same way as it had always done: by providing harmony. But harmony was precisely what was eluding him. On 13 January 1940, he wrote to Bonnard: 'Your letter has found me knocked out this morning, completely discouraged.... For I am paralysed by something conventional which keeps me from expressing myself in painting as I would like. My drawing and my painting are separated.'[65]

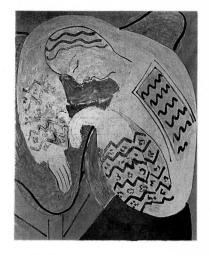

56 *The Dream.* 1940

The problem, he explained, was that the intuitive adjustment of flat colour areas was causing him to reconceive the whole design of his picture several times in the course of its execution. And this was hardly compatible with the spontaneity of the line drawing which counterposed these areas. 'I have found a [form of] drawing which, after the preliminary work, has the spontaneity which empties me entirely of what I feel.' But an equivalent in colour eluded him. The subject here is Matisse's drawings. They are, however, the drawings of a painter, and this crisis of 1940 has crucial ramifications for the future of his drawings as well as of his paintings. It was 'the eternal conflict of drawing and colour in the same individual', as he described it in a letter to André Rouveyre of 6 October 1941.[66]

By then, Matisse was recuperating from an extremely serious operation that left him a semi-invalid for the rest of his life. During the period of this recuperation, when his ability to paint large, ambitious paintings was necessarily curtailed, he developed, in small-sized works, the two important methodological changes previously mentioned. The second of these, using paper cut-outs with an entirely new level of ambition, would resolve the conflict of drawing and colour, changing his draughtsmanship as well as his painting, indeed fusing the two activities. The first, however, was purely a matter of draughtsmanship. On 3 April 1942 Matisse wrote to his son Pierre: 'For a year now I've been making an enormous effort in drawing. I say *effort*, but that's a mistake, because what has occurred is a *floraison* after fifty years of effort ...'[67]

The famous *Themes and Variations* drawings of 1941–42 comprise 158 sheets, divided into 17 groups (marked A–P), each of 3 to 19 works. Each group has a 'dessin du thème', usually in charcoal, then 'variations' in pen or crayon.[68]

In 'Notes of a Painter on his Drawing' of 1939,[69] Matisse had written of how line drawing was 'the purest and most direct translation' of his emotion because it was such a simplified medium. Pure line drawings, he added, were 'always preceded by studies made in a less rigorous

medium ... such as charcoal.' These allowed him to study 'the character of the model, the human expression, the quality of surrounding light, atmosphere' and so on. Only then, he wrote, 'can I with a clear mind and without hesitation give free rein to my pen. Then I feel clearly that my emotion is expressed in plastic writing.' That was indeed Matisse's favoured approach. In the late 1930s, however, as we have seen, it was less strictly followed than his text suggests. While Matisse was in no sense a 'theoretical' artist, he again proves himself to be an extremely clear-minded one, predicting the direction his art will take.

The 1939 text had explained that the more consciously observed charcoal studies were what permitted the line drawings that followed them to be so spontaneously made. In the case of the *Themes and Variations*, we know that each *dessin du thème* was indeed thought of as a 'study drawing', and was done in a relaxed, observant mood, often chatting to the model.[70] Then the variations were drawn, in two- to four-hour periods of total concentrated silence. During this time Matisse did not constantly keep looking at the model (for the *dessin du thème* had remembered her appearance) – but it was hardly to be recommended that she fidget or actually move. 'I come out of a different world', Matisse said about the occasions on which his concentration was disturbed. The variations were what he called 'inspired drawings', and we should take that description literally. Lydia Delectorskaya has said that he worked like a medium in a trance, and we should take that literally too. Even more than with the mid-1930s line drawings, Matisse is a vehicle of inspiration and expiration as he reshapes the world through the medium of himself.

To Aragon he remarked:

Isn't a drawing a synthesis, the culmination of a series of sensations retained and reassembled by the brain and let loose by one last feeling, so that I execute the drawing almost with the irresponsibility of a medium.[71]

'The irresponsibility of a medium'. In 'Modernism and Tradition' of 1935, Matisse had written of his long-standing belief that 'a large part of the beauty of a picture arises from the struggle which an artist wages with his limited medium.'[72] Now, artist and medium are one.

The subjects of the *Themes and Variations* are mostly figures. But a number of sequences are of still-life motifs, either grouped objects or individual ones, usually flowers. Around 1940, Matisse had returned to still-life subjects in his drawings, not having concentrated on them for many years. A richly rhythmical charcoal drawing of November 1939 (p. 210, below) prepares for the kind of motif and treatment developed by the *dessins du thème*. And the *Still-life, Fruit and Pot* of 1941 (p. 210, above) uses a similar grouping of objects to the G series of *Themes and Variations*. But the treatment of this ink drawing is more deliberated than in the 'inspired drawings' within that series. The M series of *Themes and Variations. Study of Flowers and Fruit* (1942) (pp. 218–21), perfectly demonstrates how the first searching study was followed by a sequence of

shifting frames that show the subject in varying positions and degrees of linear definition. Each spontaneously realized image is complete unto itself, and each gives us the subject in all its wholeness. The subject has emitted all of these images: each is a version of it, and the subject itself exists in their totality.

Matisse continued to work with still-life subjects through the 1940s, especially with isolated flower or leaf motifs. The beautiful 1942 charcoal drawing, *Branch of a Judas-tree* (p. 222), generally relates to a vignette he designed for the *Florilège des amours de Ronsard*.[73] The 1945 *Amaryllis* charcoal (p. 226) seems specifically to develop the central motif of the M series itself. Matisse's concentration on such isolated images of nature is additionally interesting in the context of his paper cut-outs, which frequently used just this kind of vocabulary of organic forms.

In the *Themes and Variations* series that show figures, we often notice that Matisse based them on poses derived from his earlier work. Hence, the 1941 F series (pp. 214–17), showing a woman reclining in an armchair, may be related to a number of immediately preceding drawings and paintings of what was then a favourite Matisse subject. This series is among the most beautiful, for as we follow from the *dessin du thème* through the numbered variations, the model seems to awaken from sleep, gradually uncoil her entwined arms, then find a new, more comfortable position before settling, more relaxed, ready for sleep again. Aragon said that the repeated images of girls on Matisse's walls reminded him of Snow White.[74] In this case, another Disney cartoon comes to mind. Either way, 'the essential thing is the *serial* character of the drawings.' Aragon wrote this statement in his preface to the published *Thèmes et variations*. In the margin of the proof, Matisse pencilled his approval: 'T.B.' (Très bien.)

The method recalls the plumed hat drawings, of almost exactly twenty years before, except that now the one pose moves and multiplies across the sequence of sheets. And costume changes are no longer needed. The theme of growth, or what Jack Flam more precisely describes as 'becoming', which appears in so many of Matisse's individual works (the 1910 *Girl with Tulips* is an explicit example) is now the very basis of his working procedure. 'I do not paint things, I paint only the difference between things', he told Aragon in 1943.[75] In 1908 he had written: 'Movement seized while it is going on is meaningful to us only if we do not isolate the present sensation either from that which precedes it or that which follows it.'[76] The serial approach provided a sense of temporal flow. The essential character of beings and things was discovered within the very succession of moments which continually modified and transformed them. The differences between things were reconciled in flashing frames of light, one after the other, pinned onto his studio wall. To a visitor to his studio, he said: 'That's what I call the cinema of my sensibility.'[77]

There was a price to be paid for this. No longer are we offered individual masterpieces. The perfection of the 1935–37 pen drawings is

57 Matisse's studio at Cimiez with *Themes and Variations* pinned on the wall. *c.*1943

lost; taken separately, some of the *Themes and Variations* sheets are undeniably weak. And as Matisse continued this method of drawing through the later 1940s, he increasingly tended to produce somewhat slight and offhand work. But only extremely rarely is it prettified work. Matisse has become far more fluent in his drawing in the course of his career. But even now there is an obdurate quality to his line, especially in his finest work.

Now, however, the whole is greater than its parts in a different way. The 1942 drawings of Aragon follow the new methods, comprising four charcoal 'themes' and thirty-four pen 'variations' in wiry twisted lines (p. 223). From 1942 onwards, Matisse made many sets of charcoal drawings, usually of heads, in small groups which led to a 'definitive state', and also took up etching and lithography again (for the new methods relate to the repeatability of print-making) to deal with similar subjects. His work on illustrations for Baudelaire's *Les Fleurs du mal* (begun in 1944, published in 1947) produced the impressive *Baudelaire, Man and the Sea* (p. 224), and that was followed by a large group of portrait heads, some of which were published in a special 1945–46 issue of *Cahiers d'art*.

The Baudelaire drawing shows us a more severe Matisse. There seems even something of Léger in the drastically simplified forms. The 1944 *Still-life with Fruit* (p. 225) is equally robust and monumental. And

the extraordinarily beautiful *Ballerina Seated in an Armchair* (p. 227), again of the same year, is solidly, boldly drawn in a way that opposes the nominal charm of the subject itself.[78]

The boldness of the 1944 drawings was maintained through to works like the *dessin du thème* of the 1947 *Jackie* series (p. 228–31), which even recalls *Josette Gris* of 1915. And in 1947 another, equally vigorous style was developed, in ink drawing, which supplanted the traceries that had been woven from the *Themes and Variations* for the past five years. Before turning to these, however, we must consider an aspect of Matisse's 1940s drawings which is of equal importance to their serial format and which, like the serial format, was consolidated by work on the *Themes and Variations* themselves. Those drawings were like cinematographical frames. But they do not show pictures; they show 'signs'.

If the serial continuity of drawings was a manifestation of growth, or 'becoming', then so was the creation of signs. In his preface to *Thèmes et variations*, Aragon quotes Matisse's comments on some drawings of trees that he had been making. 'I shan't get free of my emotion', Matisse says, 'by copying the tree faithfully, or by drawing its leaves one by one *in the common language*, but only after identifying myself with it. I have to create an object which resembles the tree. The sign for the tree ...'[79] And later, he quoted to an interviewer 'an old Chinese proverb': 'When you draw a tree, you must feel yourself gradually growing with it.'[80] Line drawing had always been the way of condensing the essential character of things. In the 1920s, and especially in the 1930s, it was the means of 'possessing' them. In the 1940s, the aim remains the same: 'An artist must possess Nature', Matisse writes in 1948. 'He must identify himself with her rhythm.'[81] But now he does so through newly spontaneous rhythms of drawing which analogize the growth, the becoming, of nature in the signs these rhythms produce. But as always, it is a search for 'inherent truth', as he wrote in 1947 about some fig leaves he was drawing (p. 237). It was a matter of discovering the 'common quality' that united things despite their visible differences: what it was that made them, 'always unmistakably fig leaves.'[82] And the sign for that particular form of growth had to be discovered.

In 1935, he had compared two of his works to two stages of a chess game.[83] He now realized that the simile was inexact. He had never (he claimed) played chess: 'I can't play with signs that never change.'

> The sign is determined at the moment I use it and for the object of which it must form a part. For this reason I cannot determine in advance signs which never change, and which would be like writing: that would paralyse the freedom of my invention.[84]

He was interested in writing as a form of sign language. His handwritten text in *Jazz* (1943–47) proves that. So does the large piece of cloth with four Chinese characters on it he pinned onto his studio wall.[85] But writing, like faithful representation, was 'in the common language.' Both paralysed freedom. Stable, conventional signs were useless. 'Thus the sign for which I forge an image has no value if it

doesn't harmonize with other signs which I must determine in the course of my invention and which are completely peculiar to it.'[86] As with the serial method, the aim was to harmonize differences and manifest continuity: in individual signs and in their arrangement, for these two factors were inseparable.

It was not only a matter of the relationship of individual signs; also, of their relationship to the sheet itself. Matisse stressed to Aragon the symmetry of trees and no doubt was attracted to that subject by the symbiosis of image and support it offered him.[87] And when, in 1944, a young girl forced some drawings on Matisse for his criticism, he put her on what he called 'the double buckle diet'.[88] She had to divide the sheet both horizontally and vertically then 'draw the lines of the tree in relation to these two fundamental directions'. Matisse himself, we can assume, did the same.

He gave two other pieces of advice to the same girl: '*exaggerate the truth* and . . . study at length *the importance of voids*.' Signs exaggerate the truth. And signs occupy voids – without interrupting the purity of their whiteness. Writing to André Rouveyre in 1942, Matisse observed: 'I had noticed that in the work of the Orientals the drawing of the empty spaces left around leaves counted as much as the drawing of the leaves themselves.'[89] Showing Aragon one group of the *Themes and Variations*, he proudly announced: 'You see, it's the same whiteness everywhere . . . I haven't removed it anywhere . . .'[90] Aragon quickly makes the connection with Mallarmé: the poet's cult of the empty page. It no longer quite seems, as it did in 1930, that 'the artist or the poet' are entirely the same. The former need not use 'the common language'. But did the Symbolist poets? Not quite. Like them, Matisse is a maker of illuminated signs. And 'the importance of an artist is to be measured by the number of new signs he has introduced into the language of art'.

In 1943, a new form of sign-making was developed: paper cut-outs, the second important methodological change of the early 1940s. Matisse had used the method before, notably in preparing the Barnes commission, but largely for utilitarian, planning purposes rather than for the creation of fully ambitious works of art. The paper cut-outs that he made for his book *Jazz* were translated into *pochoir* prints and therefore were also utilitarian. But the work on *Jazz* transformed what had been a technique into a medium, and one that produced signs which not only were extremely harmonic in themselves but which harmonized the conflict that had reached a crisis point at the beginning of the decade: the eternal struggle of drawing and colour.

The more purified and precise Matisse's signs became, the more difficult it was to relate them to colour. The method of the late 1930s – placing drawn lines on top of areas of colour – had not seemed satisfactory, and the charcoal drawings of that period studied that problem. The way that drawn charcoal lines seemed actually to belong both to the areas of tonality they defined and to the surface outside these areas was the solution. Something similar had worked with colour in the 'incised', at times 'negative' drawing of the

paintings of the early decorative period. But now drawing itself was a more spontaneous activity and more assertive a presence. Colour could not 'simply "clothe" the form: it must constitute it' if the signs were to appear whole.[91] With paper cut-outs, however, 'instead of drawing an outline and filling in the colour — in which case one modified the other — I am drawing', Matisse said, 'directly in colour. This simplification ensures an accuracy in the union of the two means.'[92] Colour and contour, that is to say, are made coextensive: by 'drawing with scissors on sheets of paper coloured in advance, one movement linking line with colour, contour with surface.'[93] It was a breakthrough in colour comparable to that achieved in drawing the year before.[94]

In this process, figure is liberated from ground because the signs thus formed are formed independently of the drawing support. Drawing takes place in the air. Though based on objects in the world, the signs were not usually drawn in front of objects. They are sheerly mental images released between thinker and thumb (to borrow a Nabokov phrase) from pure colour into free space, then adjusted one to the next in chromatic harmonies. Drawing and composition are now separated. But that separation was easier to manage than that of drawing and colour — or so it appeared in the early 1940s. And *Jazz* is a celebration of harmonic, purified signs:

> There is no separation between my old pictures and my cut-outs. except that with greater completeness and abstraction, I have attained a form filtered to its essentials and of the object which I used to present in the complexity of its space, I have preserved the sign which suffices and which is necessary to make the object exist in its own form and in the totality for which I conceived it.[95]

With this newly purified language, Matisse returned to the primal themes of the early 1930s and recast them in a joyously happy mood. In 1943 he had completed the revised version of the *Nymph and Faun* (p. 212). In *Jazz*, the nymph is liberated to become a tobogganist simply having a good time (fig 46). Concurrently, Matisse was transposing another nymph and faun into *Leda and the Swan*. In *Jazz*, confrontational figures are replaced by pairs of circus performers. Travel is evoked, especially oceanic travel. Only in a few, more sombre images are we reminded of a darker outside world.

Beautiful though the *Jazz* cut-outs are, we miss the imagist toughness of inscribed signs. And Matisse must have felt this, for he added to the book a handwritten text of signs (albeit in the common language) whose role was '*purely visual*', as he insisted in the text itself. A similar aim guided his layout of the Chapel of the Rosary of the Dominican Nuns at Vence on which he worked from 1948 to 1951. 'Matisse's artistic activity', explained Lydia Delectorskaya, 'was divided at that time between two modes: large drawings made with a thick brush and india ink . . . and compositions of cut-out gouache-painted paper. . . . He envisaged the Chapel scheme as a chance to combine these two modes'.[96]

The large brush and ink drawings were those referred to earlier as maintaining the boldness which Matisse had attained in his charcoal drawings of the mid 1940s. Matisse had made very few broadly executed ink drawings since the Fauve period. Having achieved in his cut-outs dazzling colour contrasts comparable to those of the early decorative period, he took a further step backward to Fauvism itself – indeed earlier in some respects, for the great series of interiors of 1947–48 have no precedent except in some interiors with still-life subjects around 1900 (p. 139). Those early drawings used areas of boldly juxtaposed black and white to generate an equivalent sensation to that of contrasting colours. The Fauve drawings had enriched this method with broadly drawn lines and spots and scribbles of ink disposed across open, 'breathing' white grounds. The 1947–48 interiors capitalize upon both of these approaches, and bring to them two important additions.

First is a new vividness in all-over design. The entirety of the sheets is addressed, whether by packing them with patterned incident, as in the *Dahlias, Pomegranates and Palm Trees* (p. 233), or by enlarging them with boldly geometric grids, as in *Still-life with Pineapple* (p. 234). In either case, figure and ground interact in a give-and-take of space that keeps them both resolute in their flatness and luminous in their exhilarating openness. This is truly a kind of painting with reduced means. Matisse himself emphasized that:

> the special quality of brush drawing, which, though a restricted medium, has all the qualities of a painting or a painted mural. It is always colour that is put into play, even when the drawing consists of merely one continuous stroke. Black brush drawings contain, in small, the same elements as coloured paintings ... that is to say, differentiations in the quality of the surfaces unified by light.[97]

At times, the varied densities of the ink accentuate their painterly qualities, but whether or not this happens, both black and white seem to project light: it is not only a function of the optical dazzle of their combination. Since 1915–16, and work on paintings like the *Gourds* and the *Moroccans*, Matisse had become conscious of the possibilities of creating luminous blacks. The charcoal drawings of the early 1920s contained their share of them. Since the late 1930s, he had regularly explored very dramatic tonal contrasts, turning occasionally to linocuts to isolate them absolutely. Contemporaneously with these drawings, he was making some major paintings dominated by black, among them *The Silence Living in Houses* (1947) and *The Egyptian Curtain* (1948), as well as using the aquatint medium to draw the simplest of mask-like faces in broad black lines.[98] In these beautiful, grave drawings he similarly deals with the contrasted poles of conventional tonal modelling to give to his work the solidity and authority of traditional chiaroscuro without excavating the illusion of deep space that had once been necessary to achieve a grandeur of this kind.

And the second new attribute of these drawings pertains to their grandeur. They achieve a similar, almost melancholy beauty to that of *The Silence Living in Houses* even without a specifically emotive subject to

focus it. Black, Matisse said in 1946, serves as 'a force ... to simplify the construction.'[99] It is a force of sentiment as well as of structure. In a way quite unlike any previous drawings except the still-life drawings of the Cubist period, the emotive identity of objects is preserved in their signs even as the signs cluster to form larger wholes. In one of the most remarkable of these works (p. 235), a figure appears, a kind of mirage in its sheer emptiness, a blind spot almost within the sheet. Yet the presence of this figure is manifested. Indeed, it seeps through the latticework beside it to lend weight to the whole composition.

The monumentality and luminosity thus derived from observed subjects was then fed back, through work on the Vence Chapel, to synthesize with the coloured art of memory achieved in the cut-outs. In this way, the two new procedural strands of the 1940s were united. Matisse seems regularly to have sought to take stock of himself and his art at the end of each decade of his working life. He was born in 1869. In 1899, 1909, 1919, 1929 and 1939 important re-evaluations and, often, syntheses had occurred. The year 1949, when Matisse was eighty, was no exception. Working on the Vence Chapel, he sought, he said, to unite his 'researches' and in so doing create a monument to the 'living part' of his 'expression of human feeling ... which will unite the past with the future of the plastic tradition.'[100]

'I hope', he continued, 'that this part, which I call my revelation, is expressed with sufficient power to be fertilizing and to return it to its source.'

The juxtaposed harmony of stained-glass windows, derived from paper cut-out designs, and black brush drawings on tiles that were subsequently glazed, combined the two forms to which Matisse's art had been reduced. In 1950, he made his last finished sculpture, in 1951 his last painting. And after working on the Chapel, independent drawings other than in brush and ink are rare. To prepare the drawings for the Chapel, however, he turned to that trusty study medium, charcoal, and produced some of his most moving works, which even exceed the stripped-down beauty of the signs they engendered. The 1949 study of hands after Grünewald (p. 238) is just such a drawing. It recalls what Matisse called 'the Burmese sign-for-a-hand' he drew for Aragon in 1944 when explaining signs to him.[101] 'The sign may have a religious, priestly, liturgical character', he said then. Equally moving are the four great 1949 Entombment drawings (pp. 240–41), which return in spirit over a half a century to the copy of Philippe de Champaigne's *Dead Christ* he made around 1895.[102]

It is ironic, of course, that Matisse's last treatment of this familiar and favourite subject, the reclining nude, should not be an image of mortal female sensuality but a male image of divinity. But it would be flippant to read some kind of personal assertion in this fact. These great, brutal works of art refuse any such interpretation. All that can reasonably be said on this subject is that Matisse, having turned so often to the female figure to evoke pleasure, solace and art of the most exalted standard, turns now to what his own body is like to evoke tragedy.

Not all of the charcoal drawings for the Chapel achieve such intensity, and when we see the reduction from the Grünewald hand study to the hand in the *St Dominic*, our reaction is of puzzlement and disappointment. And in the Chapel itself, the abbreviated signs do not have the emotional force of the studies that prepare for them. We must remember, however, that Matisse strongly believed that in architectural work artists had not to 'weigh down their walls' with expression. In consequence, 'the human element has to be tempered, if not excluded . . . the spectator should not be arrested by this human character with which he would identify' and which would 'separate . . . [him] from the ensemble.' The effect should be 'of a wide and beautiful glade filled with sunlight, which encloses the spectator in a feeling of release in its rich profusion. In this case, it is the spectator who becomes the human element of the work.'[103] And the aim of the Chapel, he said, was to create a spiritual space that would arouse 'feelings of release, of obstacles cleared . . . where thought is clarified, where feeling itself is lightened.'[104] Hence the choice of brilliant ceramic tiles for translation of his drawings, and stained-glass for his cut-outs. Together they would create an environment of shining signs that radiate a beneficent light.

58 Matisse drawing on the wall of his apartment at the hotel Le Régina, Nice, 15 April 1950. On the left are studies of St Dominic (1948–49)

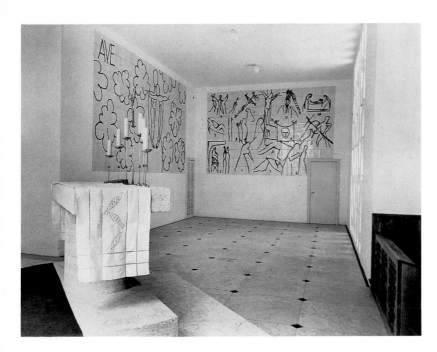

The set of huge tree drawings in brush and ink (pp. 242–43) that Matisse made in 1951–52 were likewise intended as preparations for a ceramic mural – for the house of his friend Tériade, who had published *Jazz*. (A number of the late, large-scale cut-outs were also designs for ceramics.) These drawings develop the impetus of the 1941 series of trees and themselves culminate in an immense, simplified image that Matisse intended to be seen wrapped around the corner of a room, branching onto adjacent walls as the completed mural does (figs 60, 61). In these late works, Matisse's draughtsmanship is stripped to its minimum and expanded in its scale.

While working on the Vence Chapel, he had resumed the Barnes mural method of drawing with charcoal attached to the end of a long stick. Forced, in the early 1950s, to spend most of his time in bed – for by now he was a dying man – he drew on the walls and ceiling of his apartment in this way. The photographs that remain to us from this period of Matisse's life, showing drawings and paper cut-outs surrounding him, speak volumes for the resolution with which he persisted in wanting actually to portray that ideal land of *Bonheur de vivre*, first glimpsed a half a century before. He spoke of one of the late cut-outs, *The Parakeet and the Mermaid*, as 'a little garden' he had created for himself, and of another, *The Swimming Pool*, as an imagined sea ('now that I can no longer go for a swim, I have surrounded myself with it').[105] It would be entirely wrong, however, to think of this as some private Club Méditerranée of the imagination. Art was indeed a reaction from life but never an escape from it. That was a Symbolist motto and it was Matisse's too. At times, this ideal environment looks purely peaceful – indeed, like 'a wide and beautiful glade filled with

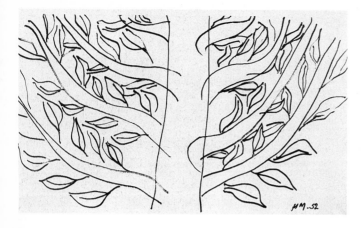
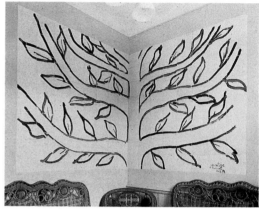

60 *Tree*. 1952
61 Ceramic *Tree* (1952) in Tériade's
home at Saint-Jean, Cap Ferrat

sunlight' – but at others, for example when we see together the huge tree drawings, we think of a primal forest instead.

The inhabitants of this world take two principal forms: figures and faces, or rather, dancers and masks. The figures begin as bathers. That, in effect, is what the 1952 *Blue Nudes* are (pp. 244–45): descendants of a race of reclining or seated figures that we have seen time and time again. When Matisse 'drew' them with his scissors, he had tired of the extremely architectural form his cut-outs had assumed, built up as they were from blocks of colour, each containing an abbreviated sign. The separation of drawing and composition was finally as bothersome as that of drawing and colour. Even when it could not be resolved – for it was built into his very procedures – it had to be harmonized: by composing as freely and intuitively as the act of drawing itself. And once he released his bathers from their earthbound status he discovered for them a far more exhilarating environment.

Whether sent into the water as swimmers or thrown into the air as acrobats (p. 248), they could finally dance in the undivided whiteness – that simplest of solutions – that Matisse provided for them. Arranged across brilliant white grounds, like the shadows of objects cast upon a flat surface, these silhouetted forms analogize the static, characteristic images of memory cut out from the flux of the passing world. Projected, however, into this new dimension, they render pictorial the whiteness that surrounds them, giving to what Matisse called this 'white atmosphere'[106] a sense of dazzling light from the reflected radiance of their colour. This is neither drawing nor painting, though it partakes of both. And while, at times, we miss drawing as we miss painting, we can hardly argue with the magnificence of the synthesis Matisse is able to create in the grandest of these last works.

This was a truly radical conception – one which returned to those roots of modern drawing that lay in Cézanne's watercolours, with their synthesis of colour and drawing in colour extended over an incorporeal whiteness indicative of nature's light. Matisse's cut-outs are more purely abstract, of course. Their colour-contrasted whiteness is not that of the natural world. It is that 'very pure, non-material

light' for which he had been searching, 'not the physical pheno-menon, but the only light that really exists, that in the artist's brain.'[107]

It is across, or rather within, that same whiteness that the brush-drawn acrobats dance (p. 247). The Circe illustration in *Ulysses*, back in 1935, had been based on photographs of acrobats.[108] And these new, great energetic signs – for by now it is hard to talk of drawings, so instantaneously stamped on their sheets do they appear – carry forward into the 1950s the primal ethos of that earlier period; as indeed do the cut-outs as well. The dancing figure is the essential Symbolist sign of art's own organic unity ('How can we know the dancer from the dance?'), of an art where subject and expression 'inhere in and completely saturate each other.'[109] It expresses the ideal of autono-mous creativity that has been the aspiration, and burden, of the most ambitious of modern art. And beside it, we find in Matisse's last drawings that other famous Symbolist image, with very similar connotations: the mask.

Gustave Moreau had told Matisse that he would simplify painting.[110] Matisse himself, when pressed to define his aims, would talk of wanting to create an equivalent for his emotions, and would happily repeat a phrase of Cézanne: 'I want to secure a likeness' – not a copy, of course, a likeness.[111] To secure that likeness meant seeing things without the distortion of preconceptions, which in turn meant distrusting established styles, even his own; avoiding any 'ready-made images which are to the eye what prejudices are to the mind.'[112] This, in its turn, meant 'looking at life with the eyes of a child' – and accepting the consequences of that, namely that children really 'have no inner life' and 'always believe themselves to be in the midst of the world because they project everything, including their dreams, into that

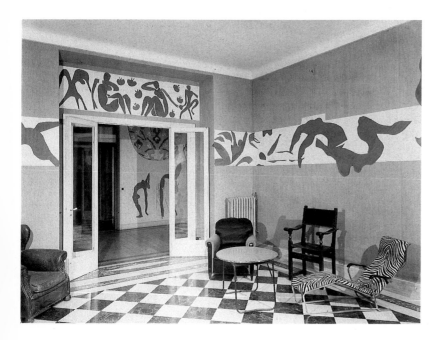

62 The dining-room in Matisse's apartment at the hotel Le Régina, Nice, 1952. Around the walls is *The Swimming Pool* (1952) and, in the corridor, *Acrobats* (1952)

world.'[113] Matisse's whole career was a constant emptying himself of emotion into images constructed from the world. He had no separate inner life, in art, because all the world coexisted in him. And art was its exhalation. Drawing was what organized likenesses of the world, and without drawing one could never be an 'artist'. Yet finally, the ideal was 'a natural, unformulated and completely concealed' kind of organizational drawing that would allow Matisse to exclaim: 'At last, I no longer know how to draw.' This would mean that 'he had found his true line, his true drawing, his own draughtsman's language.'[114]

The last masks are not Matisse's greatest drawings. They summarize, in fact, a problem in his conception of draughtsmanship: that the ultimate, purified solution is not necessarily the best one. But they are, for all that, haunting and highly memorable works of art – such bare, exposed things. They illuminate, as does the late work in particular, with a very steady light, spreading to fill the sheet with an even radiance. And for all their power as images, their drawing is indeed curiously unobtrusive: the fewest and swiftest of lines and the glowing sign was there. Matisse, forever knowing about himself, was probably right when he wrote that 'The conclusion of this is: the art of portraiture is the most remarkable.'[115] He was writing in 1954, the year of his death, and recalling 'the revelation at the post-office' over half a century earlier. Portraits, he said, offered the possibility 'of an almost total identification' of artist and subject. But then, he wrote of all of his work that it was 'nothing but portraits'. Portraits – and epiphanies, signs, possessions and illuminations.

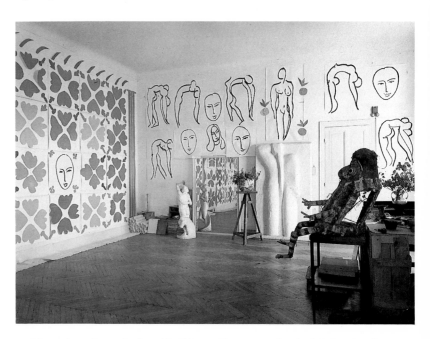

63 Matisse's studio at the hotel Le Régina, Nice, c.1953. On the left-hand wall is *Large Decoration with Masks* (1953), on the right-hand wall *Acrobats* and portrait heads, and on the chair an Oceanic figure

THE PLATES

Numbers in parentheses at the end of each caption refer to the Catalogue (pp. 250–82).

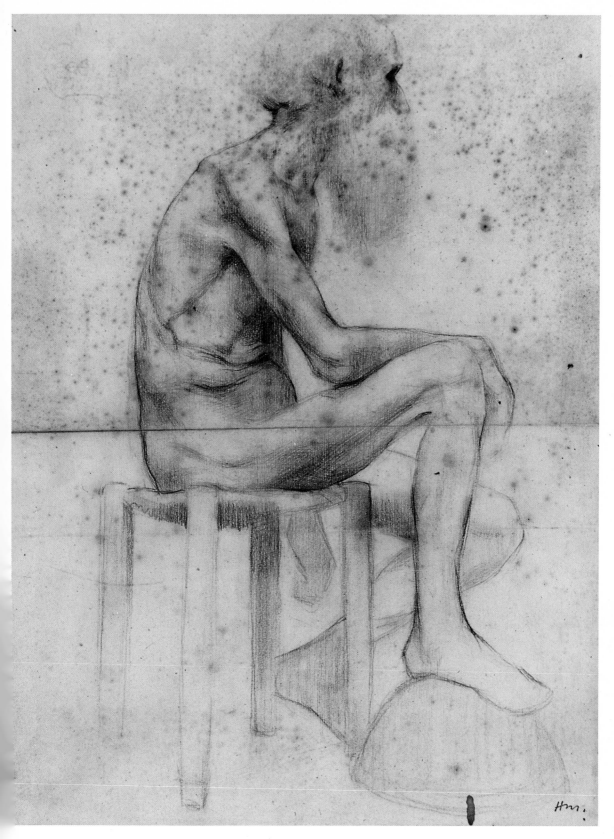

L'homme – académie. 1891–92 (1)

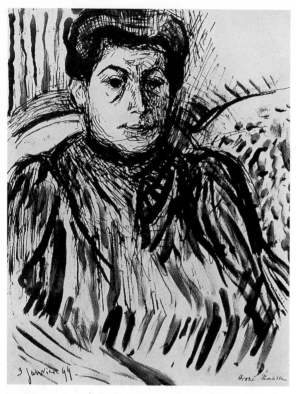

Portrait of Madame Matisse. 1899 (2)

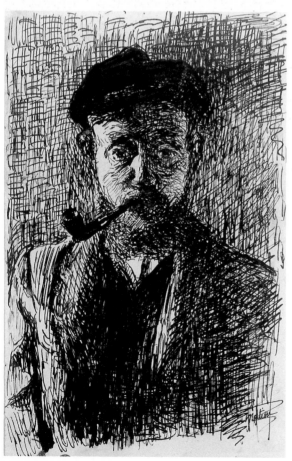

Self-portrait, Smoking Pipe. 1900 (3)

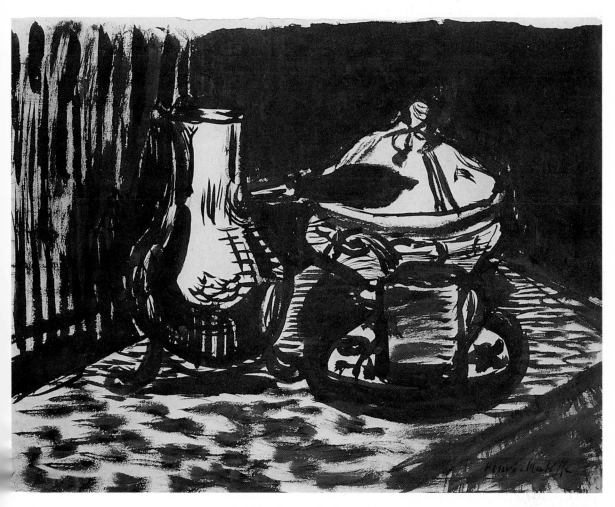

Still-life with a Chocolatière. 1900 (4)

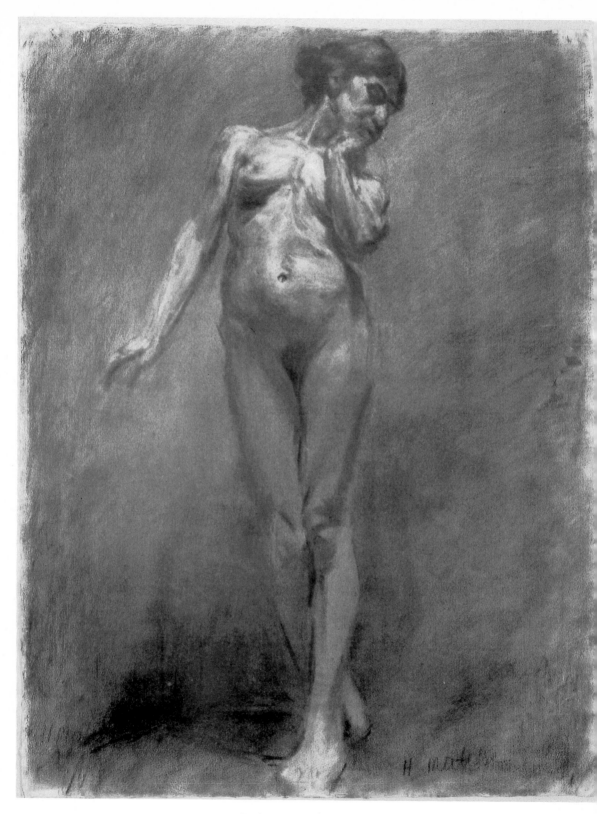

Standing Nude Model. c. 1900 (5)

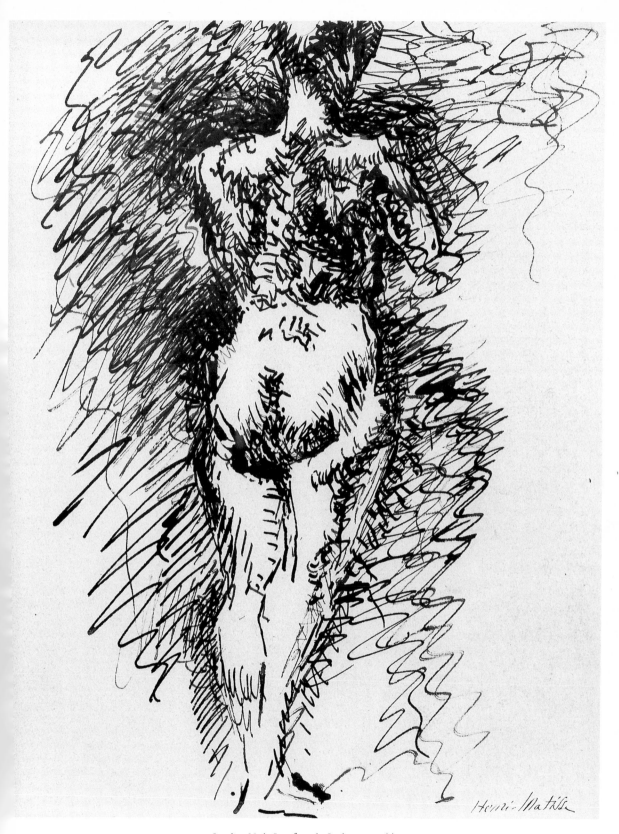

Standing Nude Seen from the Back. 1901–03 (7)

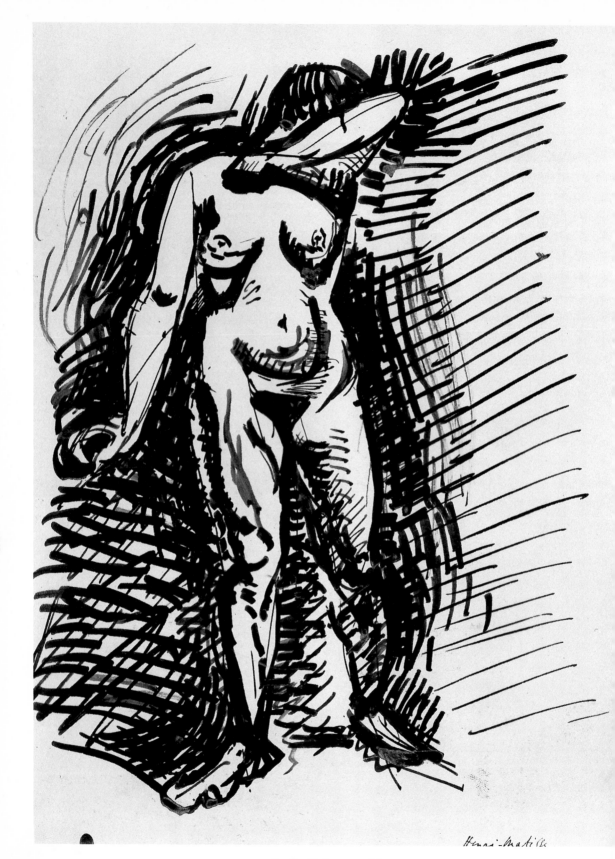

Standing Nude. 1901–03 (6)

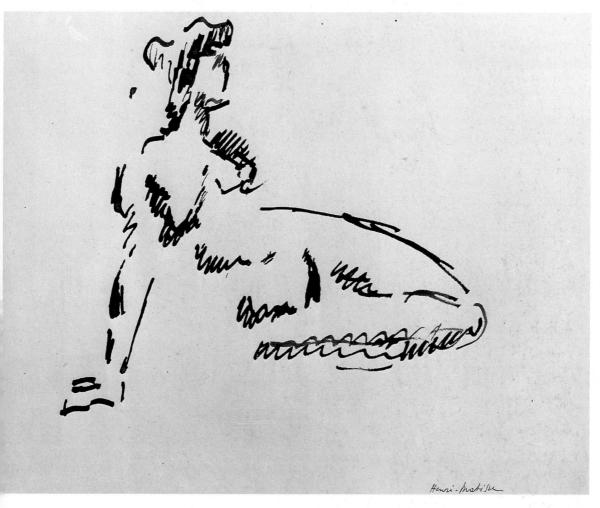

Nude, Semi-abstract. 1901–03 (8)

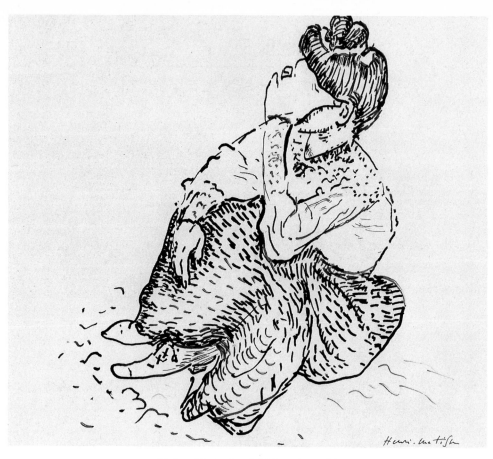

Madame Matisse Seated (Collioure). 1905 (9)

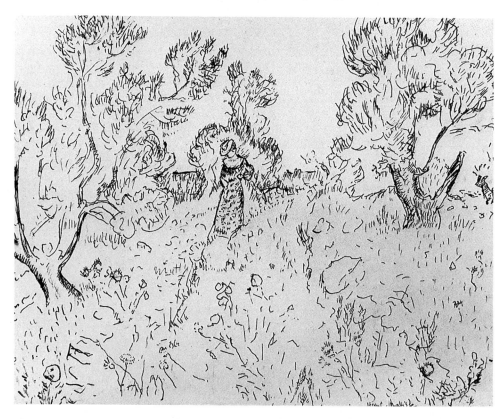

Madame Matisse Among Olive Trees. 1905 (10)

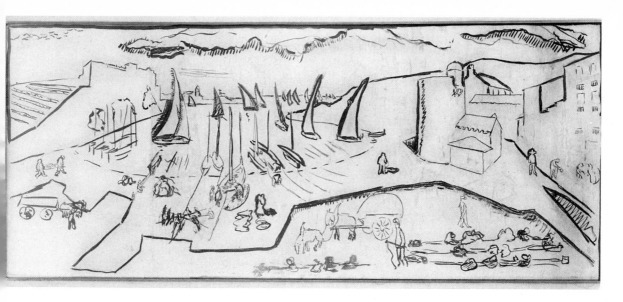

Le Port d'Abaill. 1905–06 (12)

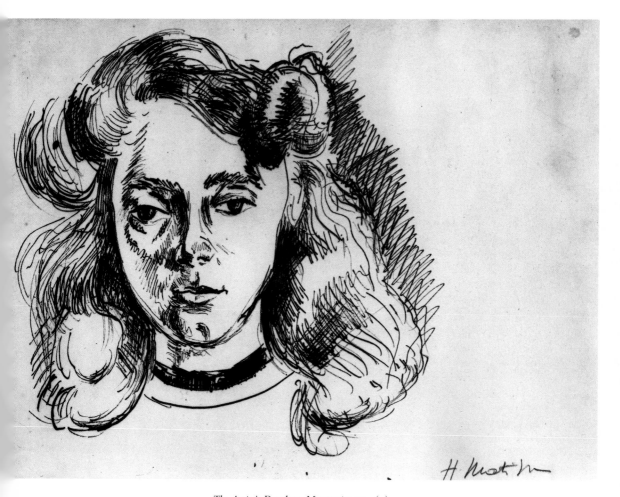

H. Matisse

The Artist's Daughter, Marguerite. 1905 (11)

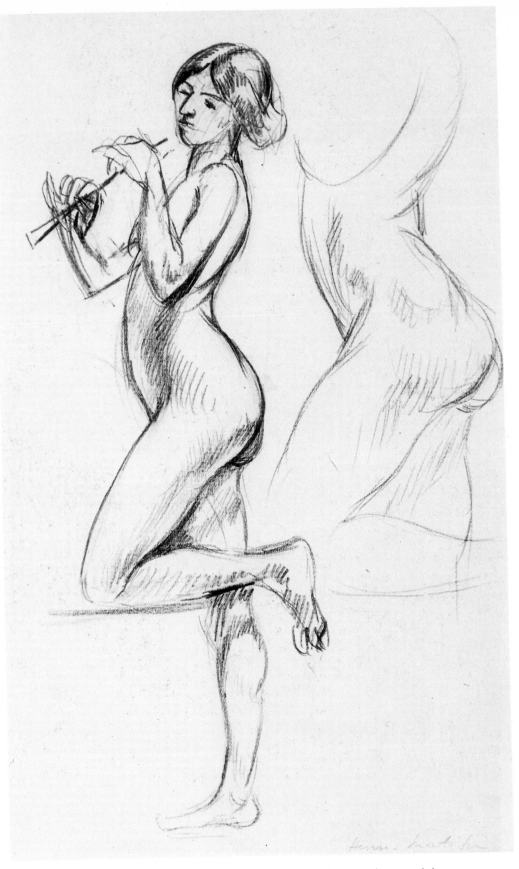

Two Sketches of a Nude Girl Playing a Flute (study for *Bonheur de vivre*). 1905–06 (14)

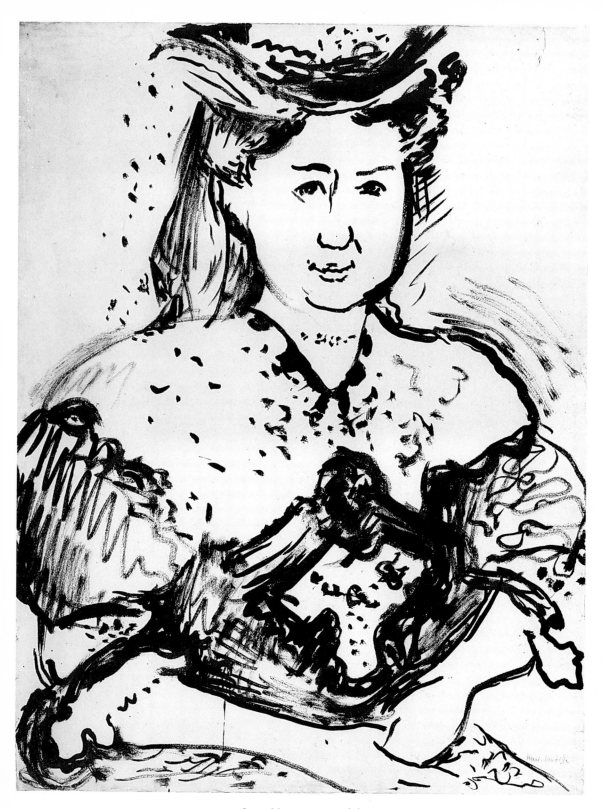

Jeanne Manguin. 1905–06 (13)

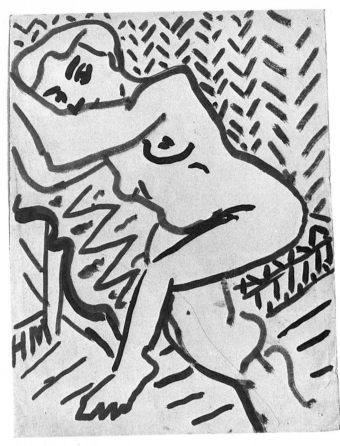

Seated Woman. 1906 (16)

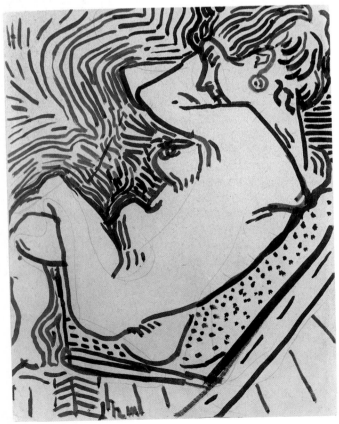

Seated Nude. 1906 (15)

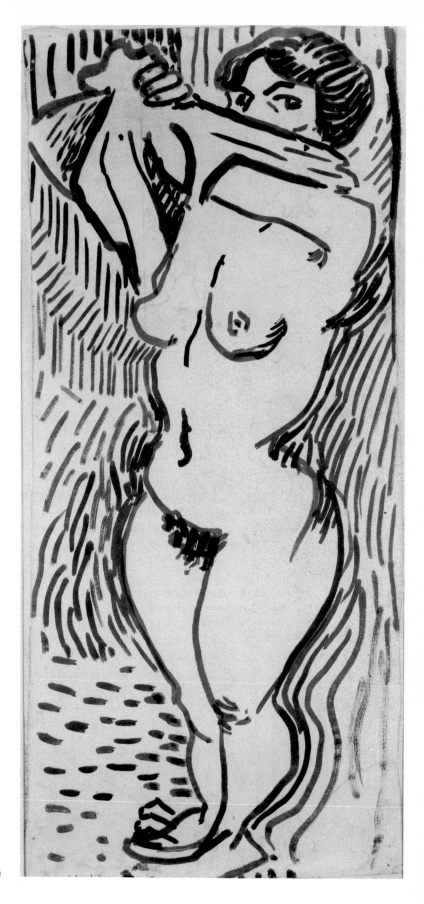

Standing Nude, Undressing. c. 1906 (17)

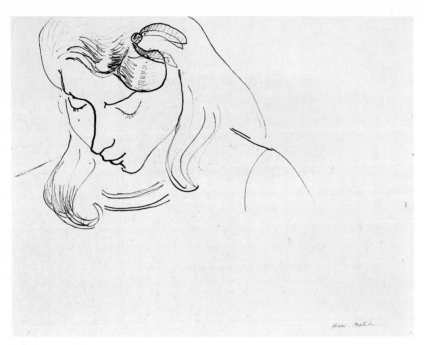

Marguerite Reading. 1906 (18)

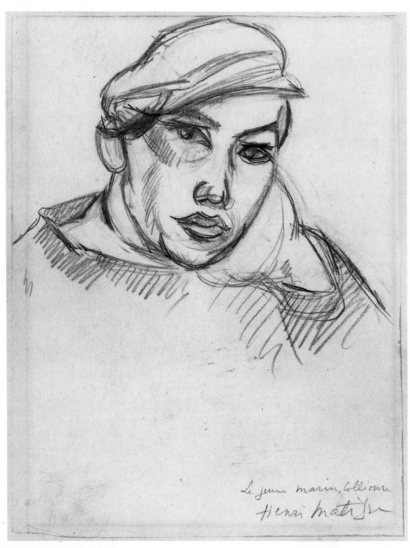

Head of a Young Sailor. 1906 (19)

Standing Nude Seen from the Back. 1909 (21)

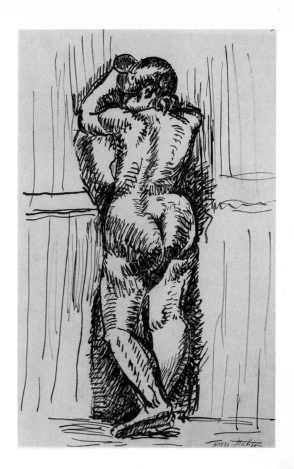

Man Reclining. c. 1909 (20)

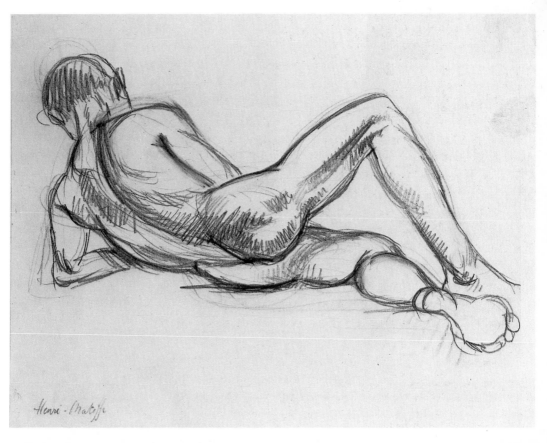

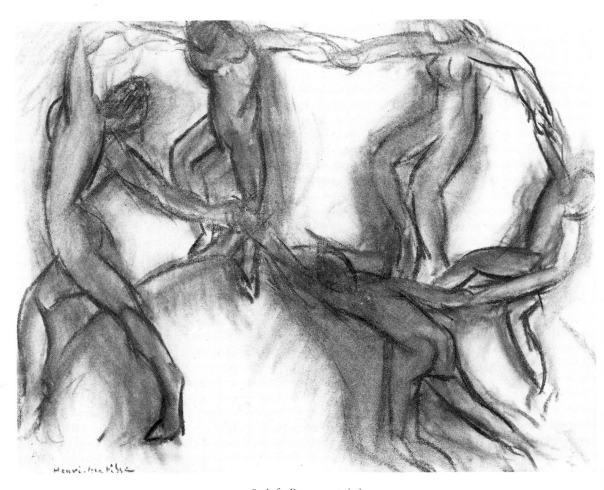

Study for Dance. c. 1910 (23)

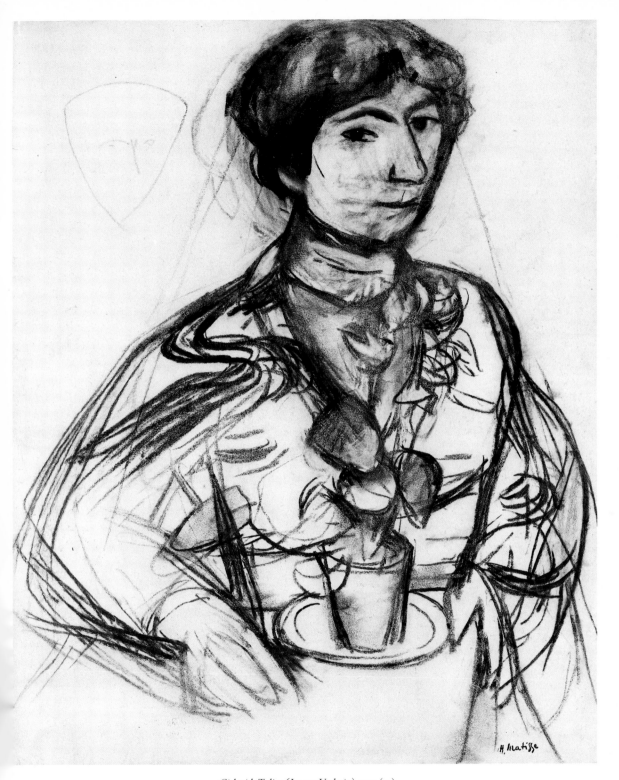

Girl with Tulips (Jeanne Vaderin). 1910 (24)

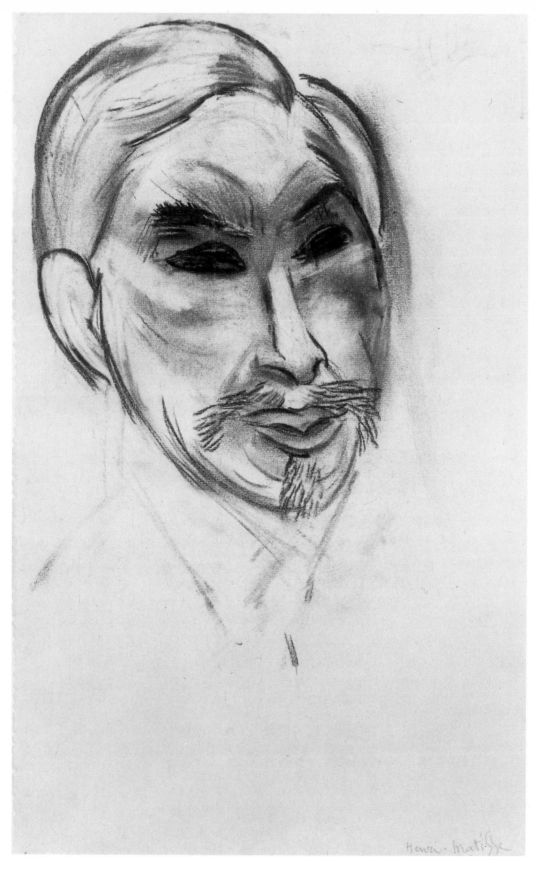

Sergei I. Shchukin. 1912 (26)

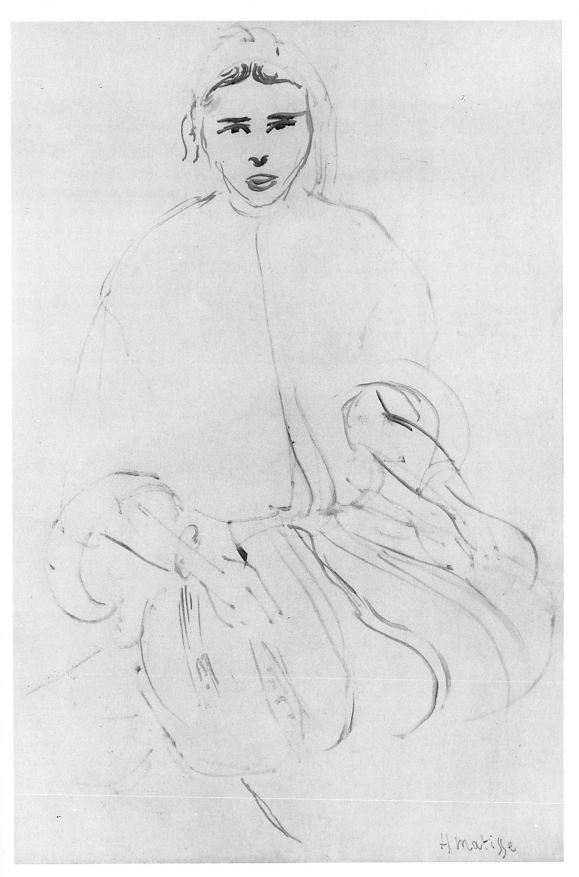

Zorah Seated. Autumn 1912 (25)

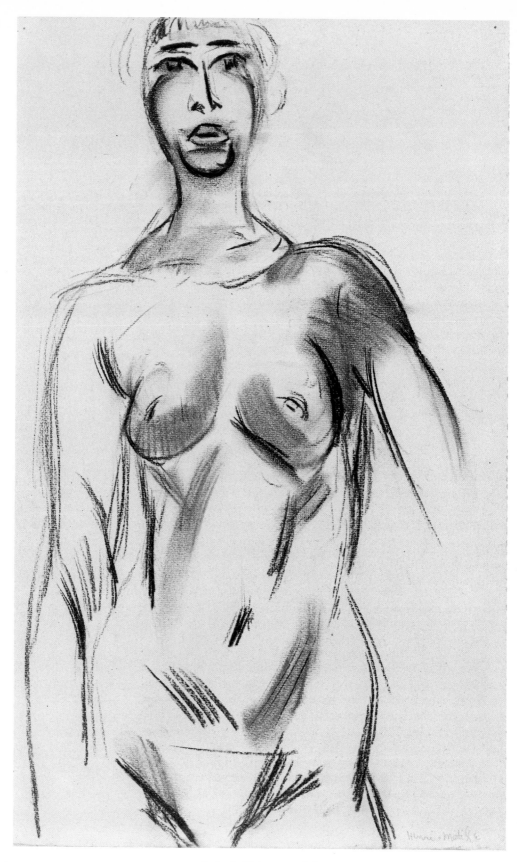

Study of a Nude. 1912–13 (27)

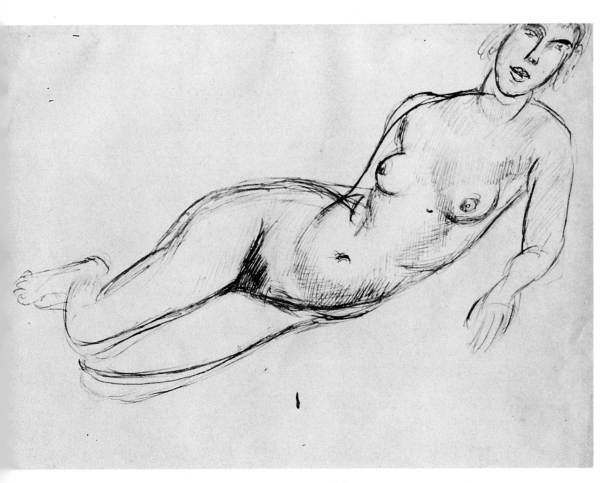

Reclining Nude. 1914 (28)

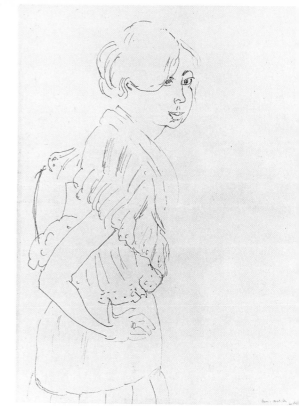

Yvonne Landsberg. July 1914 (29)

Yvonne Landsberg Smoking. July 1914 (30)

Mademoiselle Yvonne Landsberg. July 1914 (31)

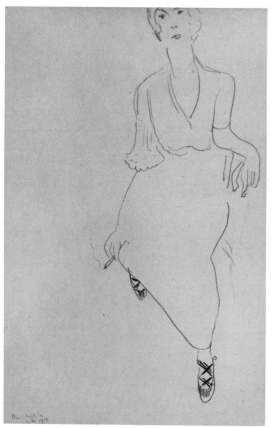

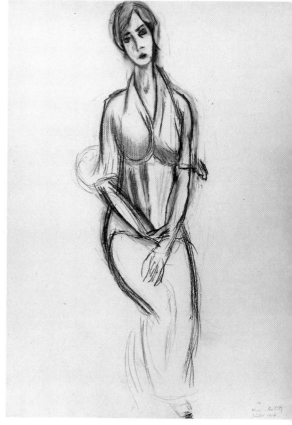

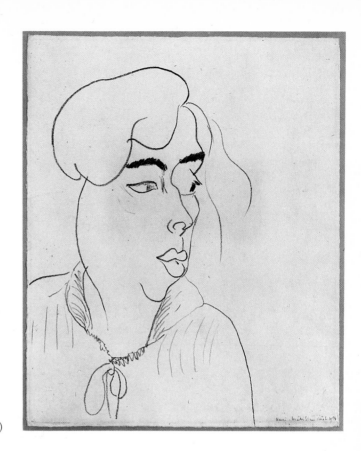

Yvonne Landsberg. August 1914 (32)

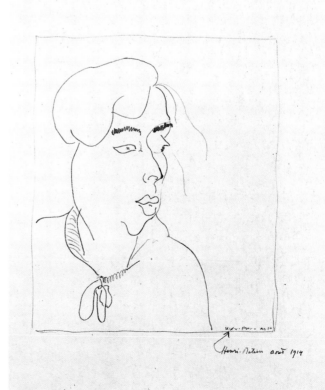

Yvonne Landsberg. August 1914 (33)

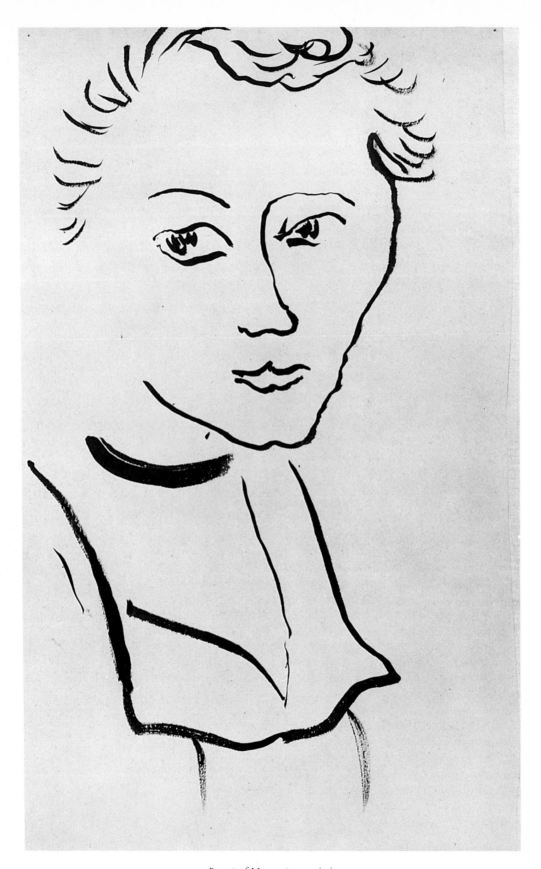

Portrait of Marguerite. 1915 (34)

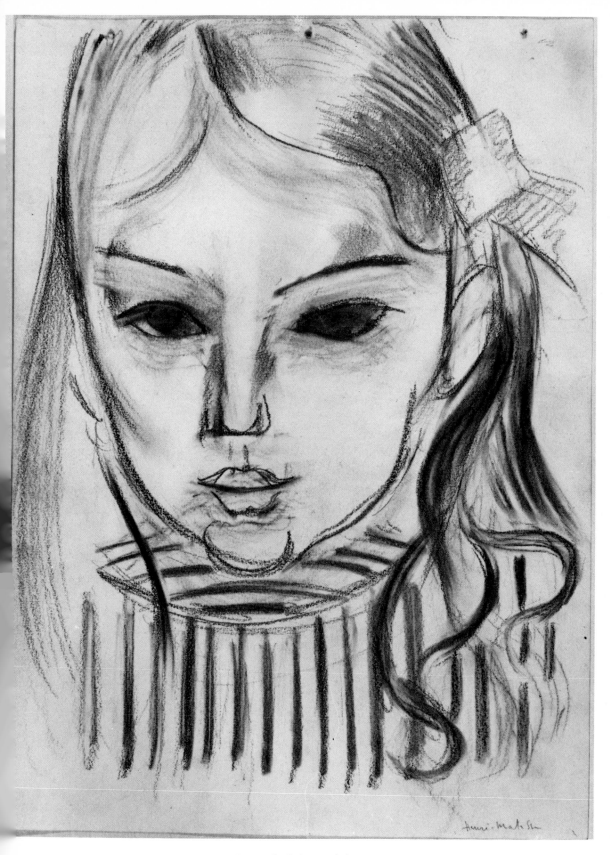

Portrait of a Girl. c. 1915 (35)

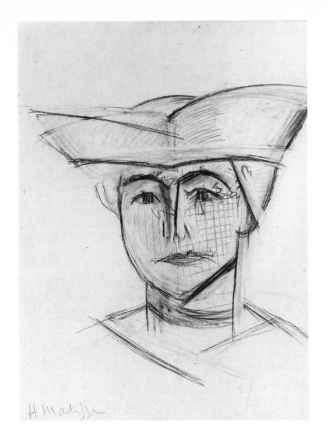

Madame Matisse. Summer 1915 (36)

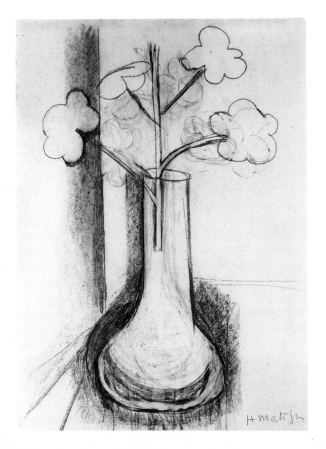

Vase with Geraniums. 1915 (40)

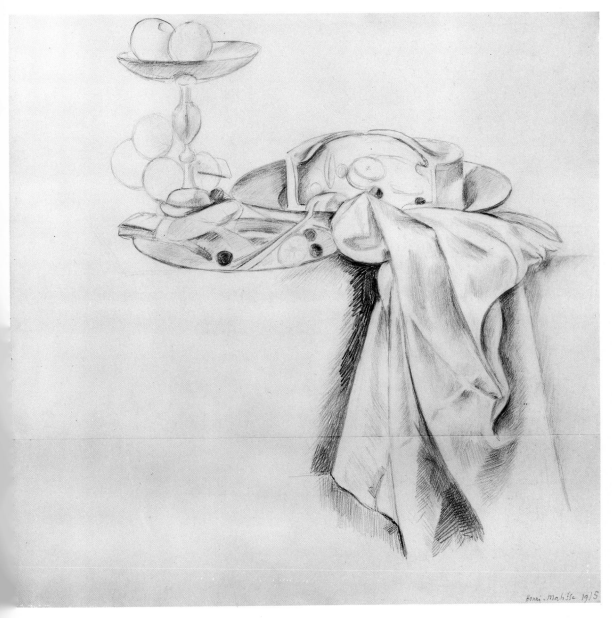

Study for Still-life after de Heem. 1915 (37)

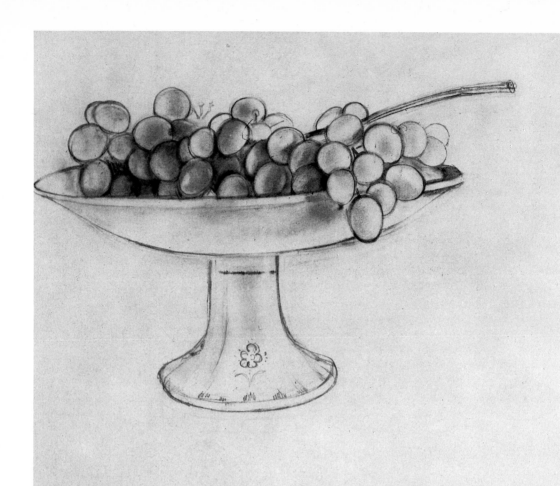

La Coupe de raisin. 1915 (38)

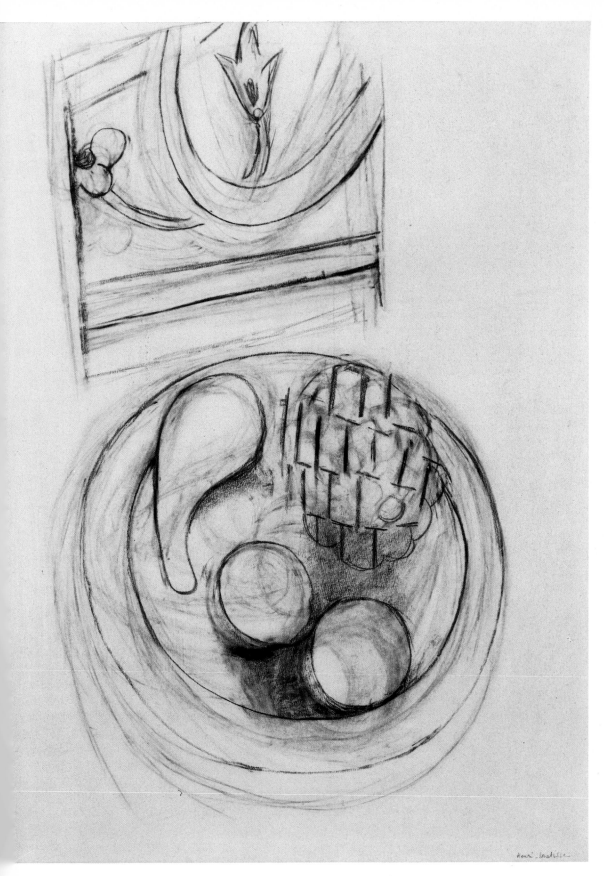

Still-life with Oriental Bowl. Autumn 1915 (39)

Group of Trees at L'Estaque. 1916 (45)

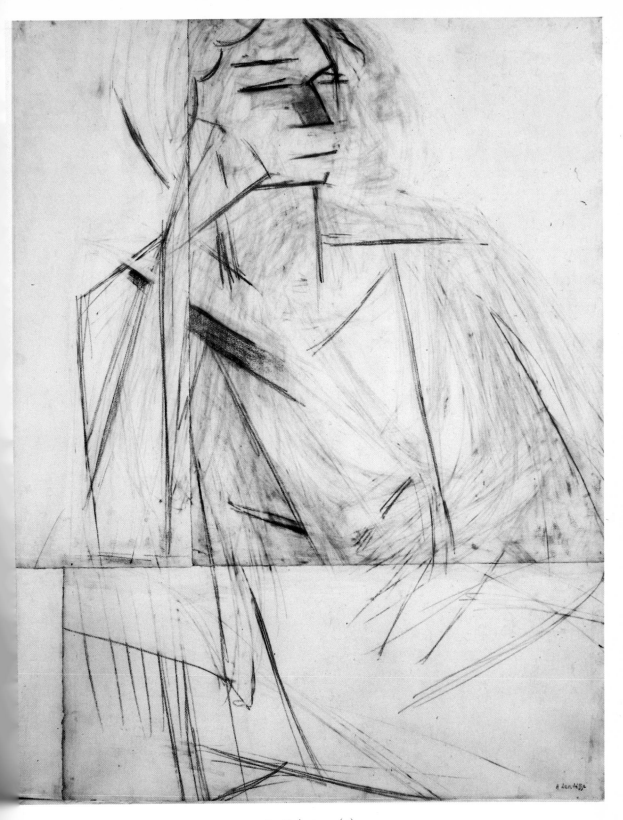

Eva Mudocci. 1915 (41)

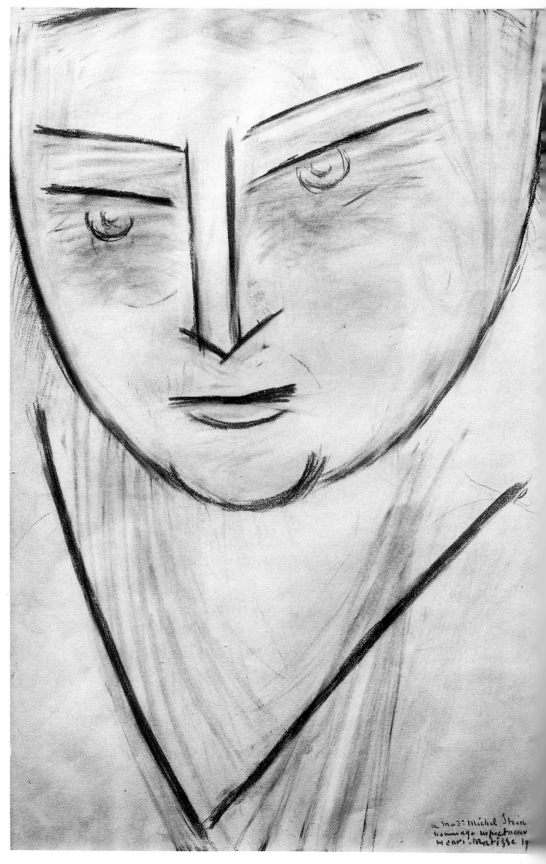

Study for Portrait of Sarah Stein. Winter 1915–16 (42)

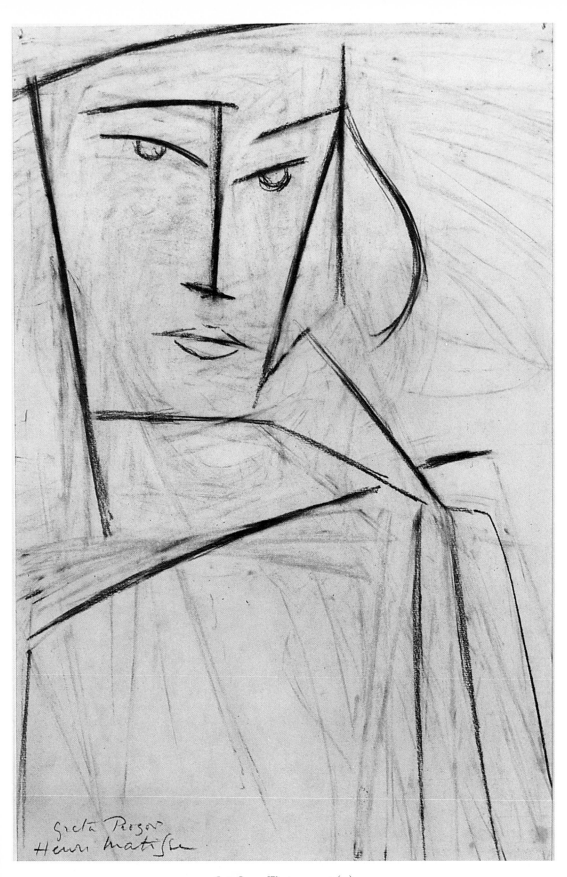

Greta Prozor. Winter 1915–16 (43)

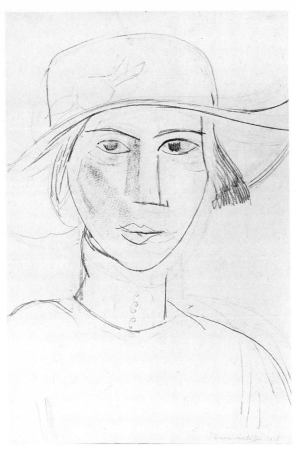

Greta Prozor. Winter 1915–16 (44)

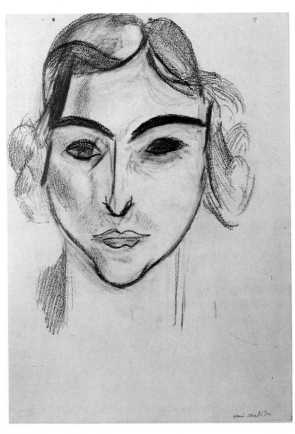

Portrait of a Woman. c. 1916 (46)

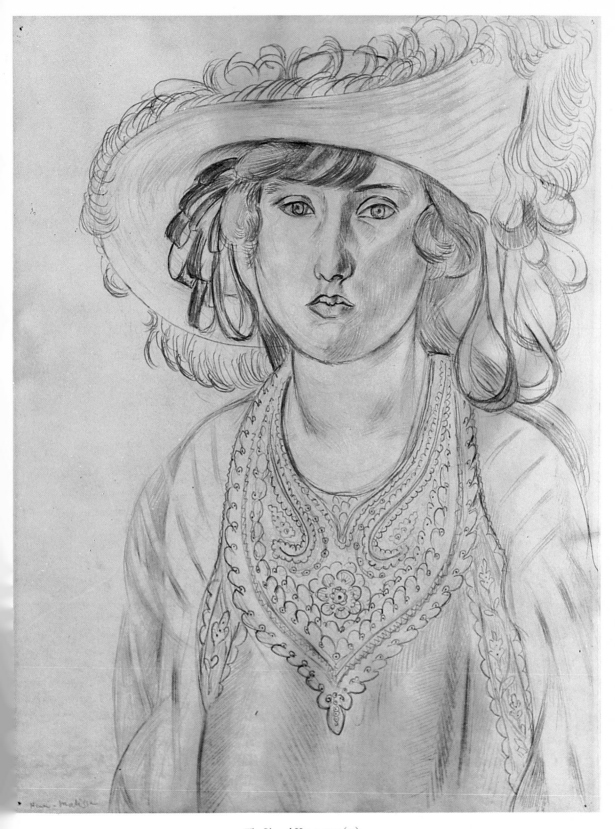

The Plumed Hat. c. 1919 (47)

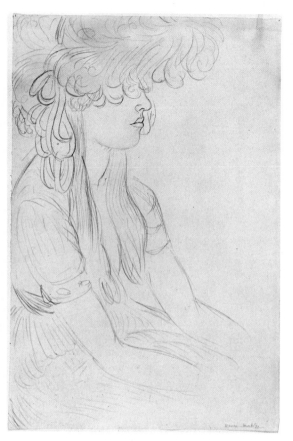

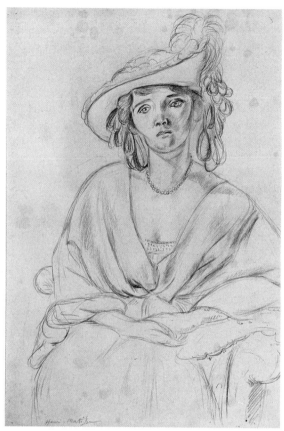

A Young Girl, with Plumed Hat, in Profile. c. 1919 (48) *Antoinette au chapeau à plumes.* 1919 (51)

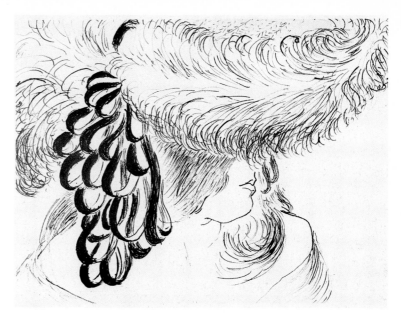

Antoinette Wearing Plumed Hat. c. 1919 (49)

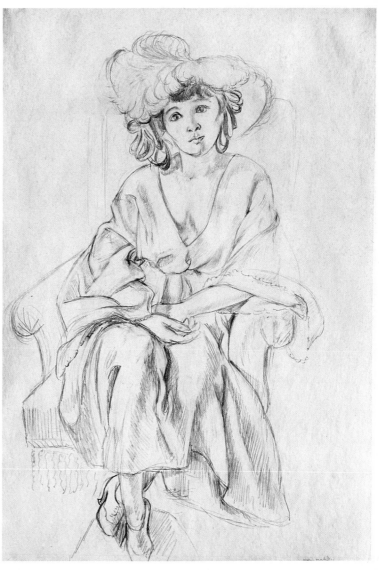

The Plumed Hat. 1919 (50)

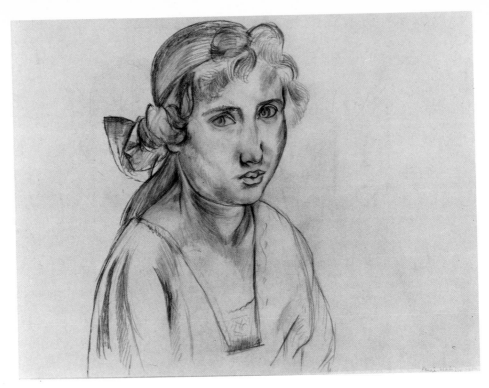

Tête d'Antoinette. 1919 (55)

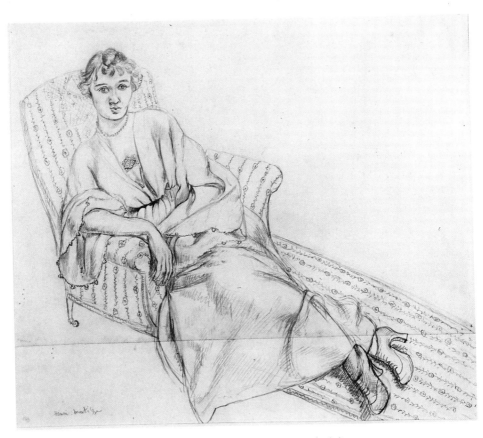

Antoinette étendue sur une chaise-longue. 1919 (57)

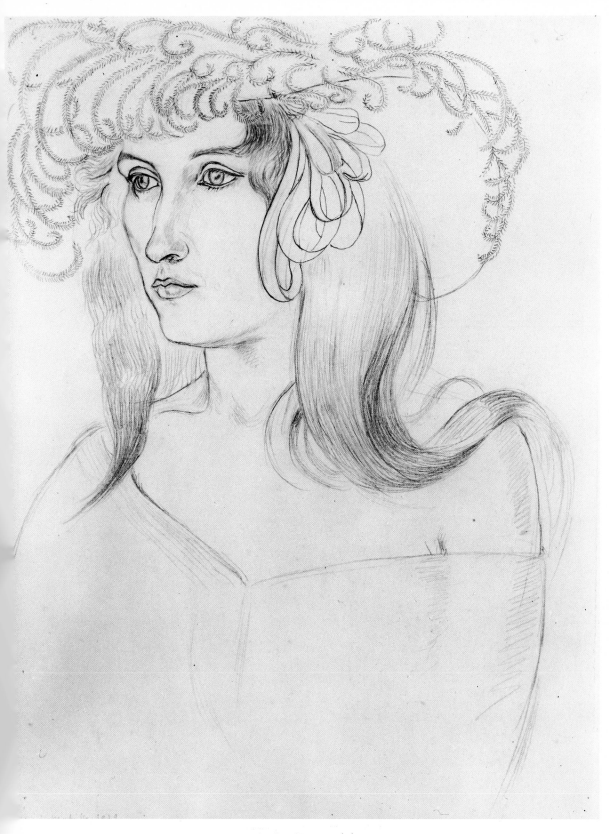

The Plumed Hat. 1919 (52)

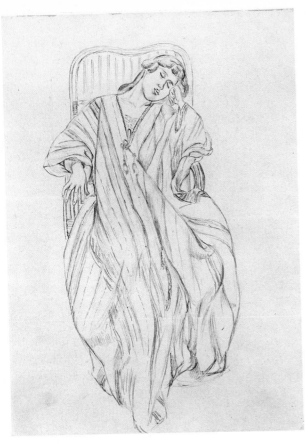

Sleeping Figure (La Gandoura). 1919 (54)

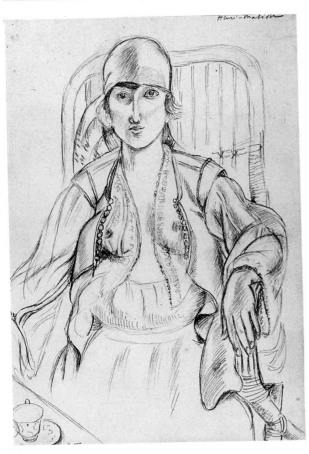

Seated Woman. Summer 1919 (53)

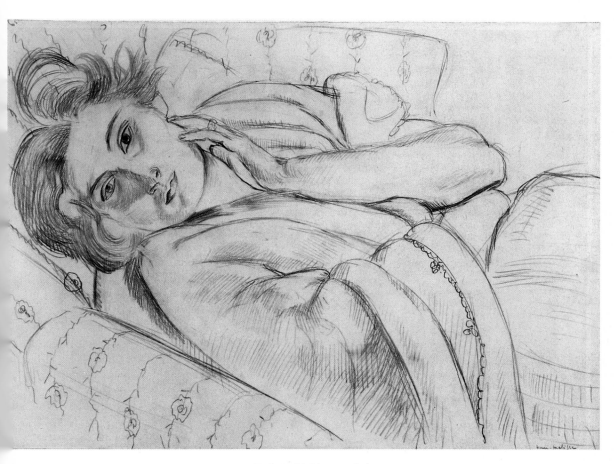

Reclining Model. c. 1919 (56)

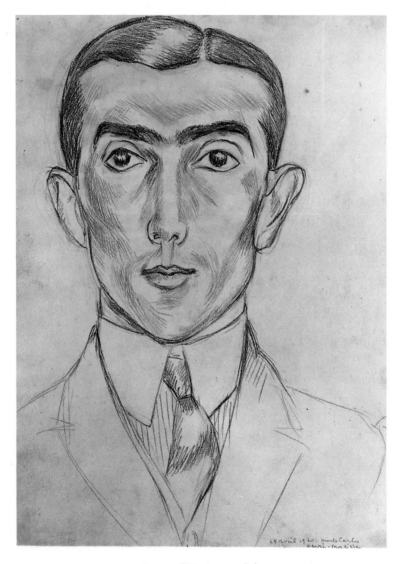

Portrait of Massine. 1920 (58)

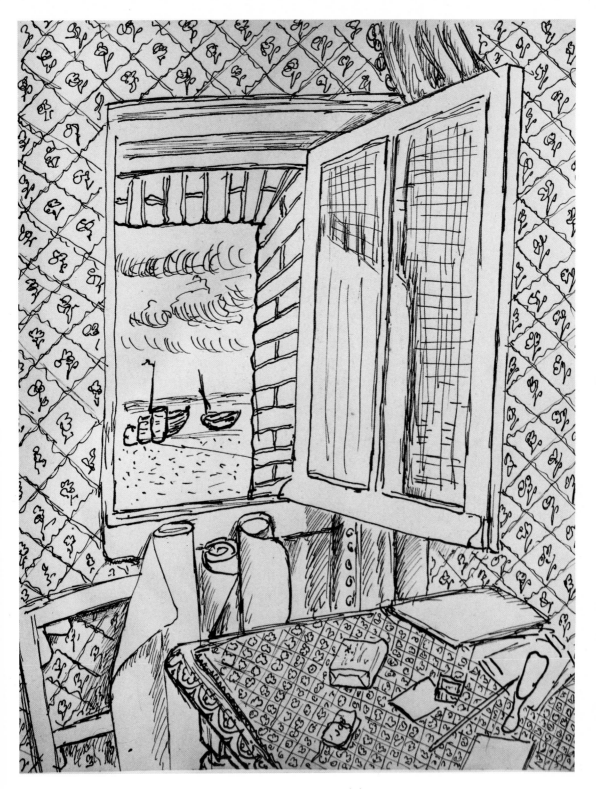

Open Window at Etretat. 1920 (59)

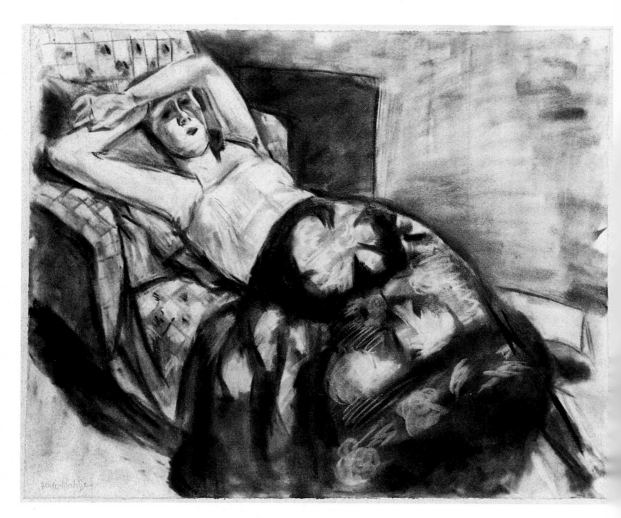

Reclining Model with Flowered Robe. c. 1923–24 (62)

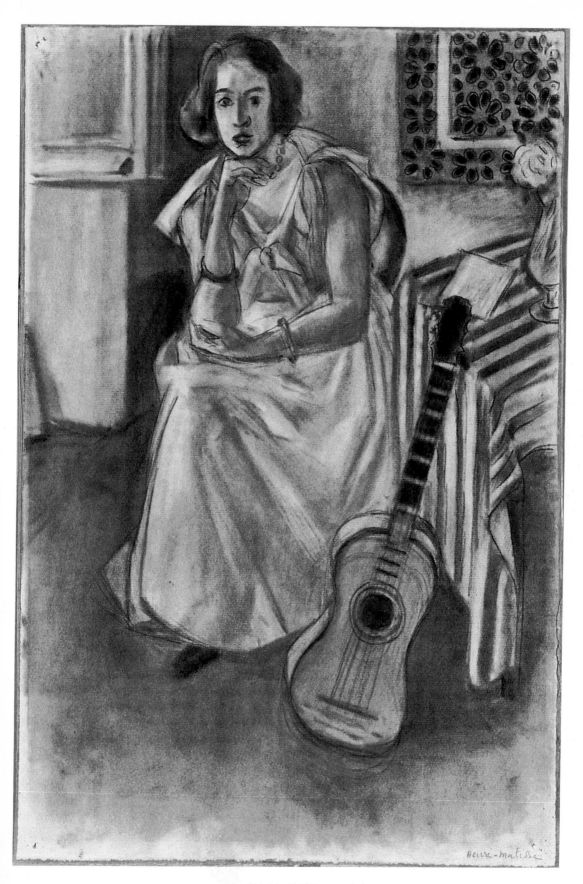

Seated Model with Guitar. 1922 (60)

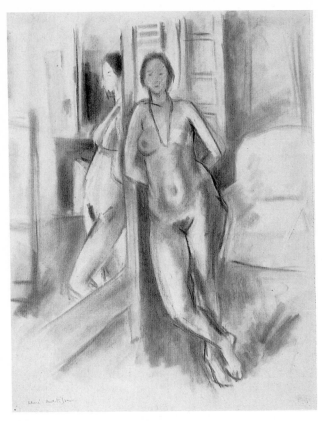

Reflection in the Mirror. 1923 (61)

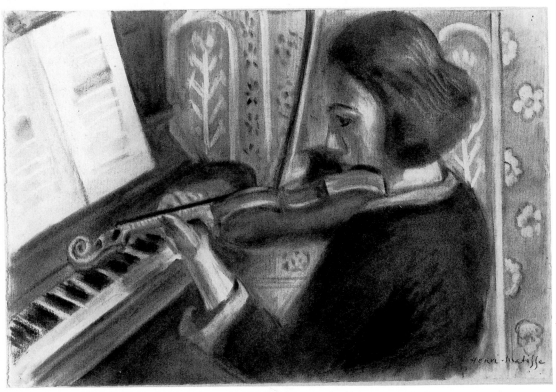

Young Woman Playing a Violin in Front of a Piano. 1924 (63)

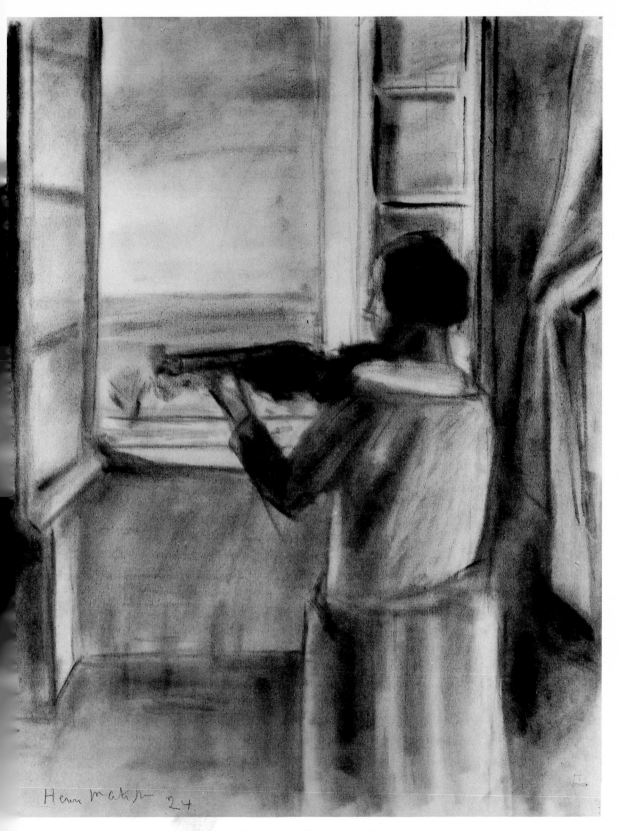

Violinist at the Window. 1924 (64)

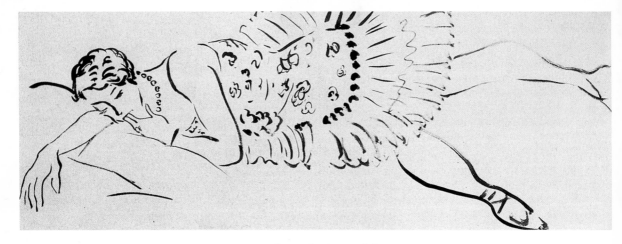

Dancer Resting. 1927 (67)

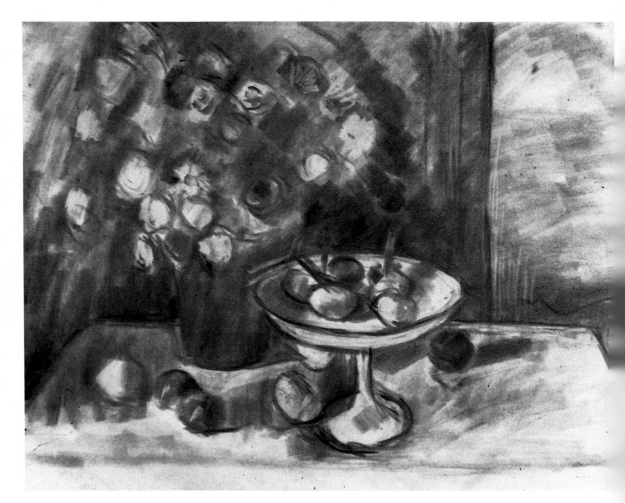

Still-life. 1924 (65)

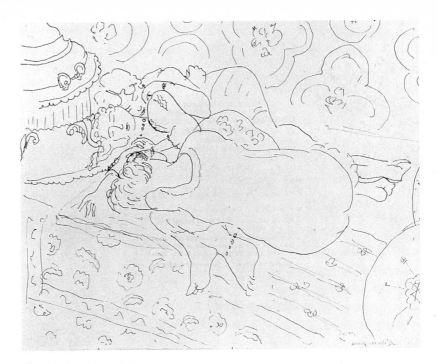

The Three Friends. 1928 (70)

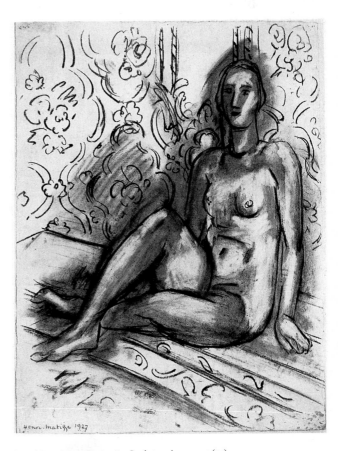

Seated Figure on a Decorative Background. 1925–26 (66)

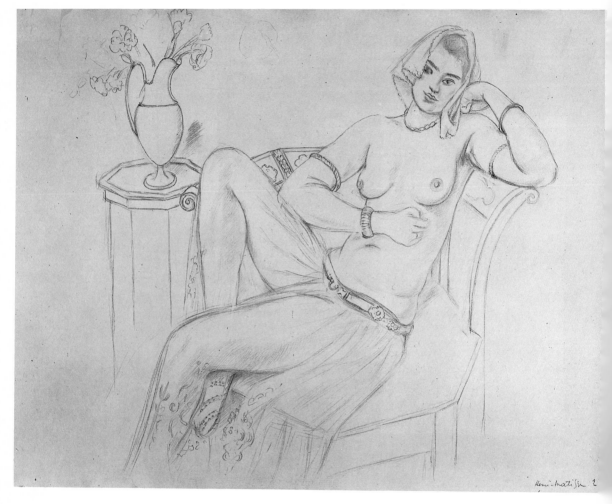

Odalisque and Tabouret. 1928 (69)

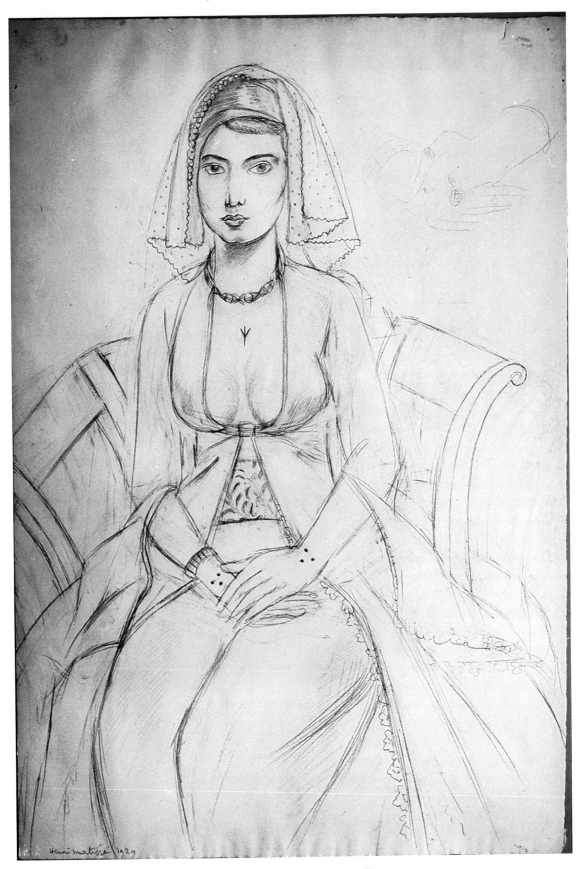

La Persane. 1929 (71)

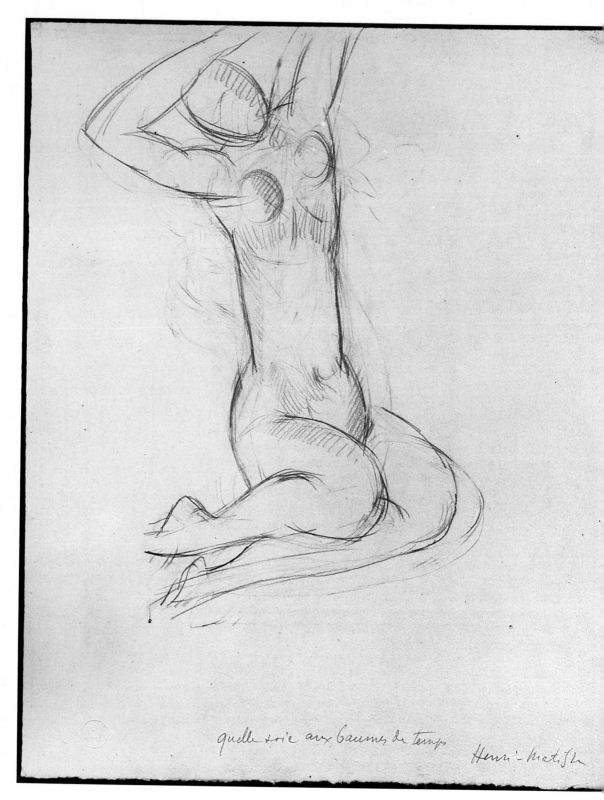

'Quelle soie aux baumes de temps'. 1931–32 (72)

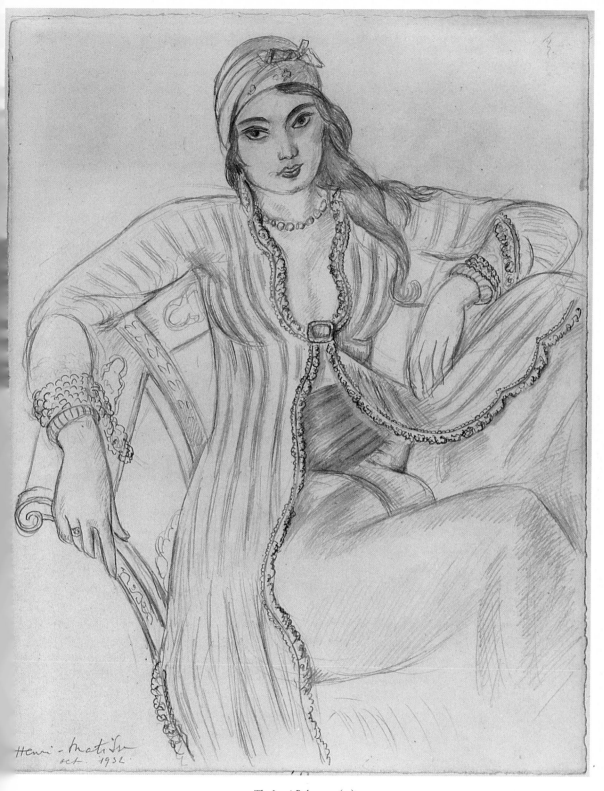

Henri-Matisse
oct. 1932.

The Lamé Robe. 1932 (73)

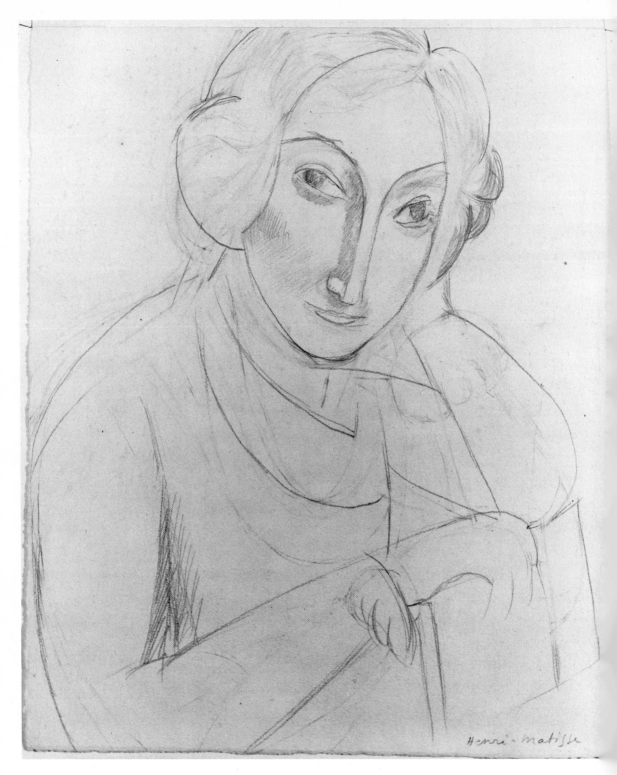

Portrait of Dr Claribel Cone. 1933–34 (74)

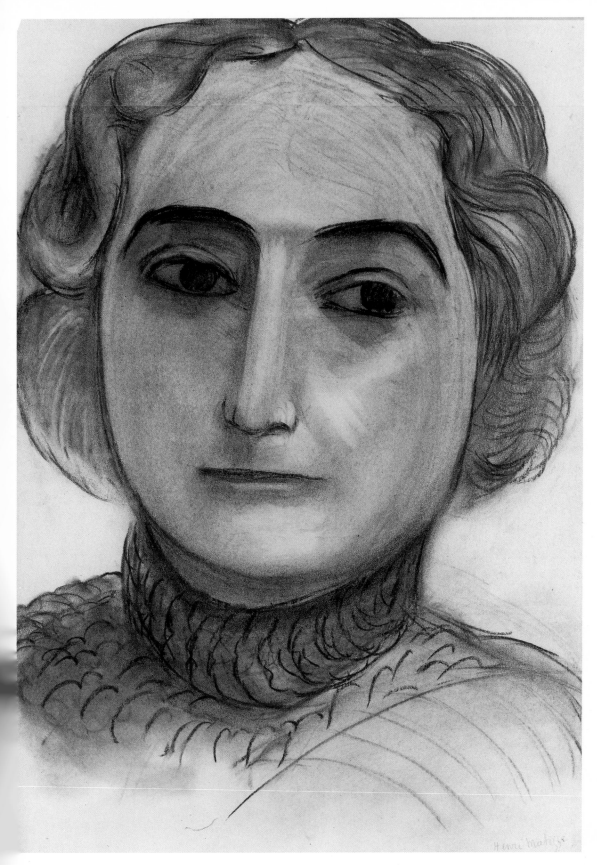

Dr Claribel Cone. 1933–34 (75)

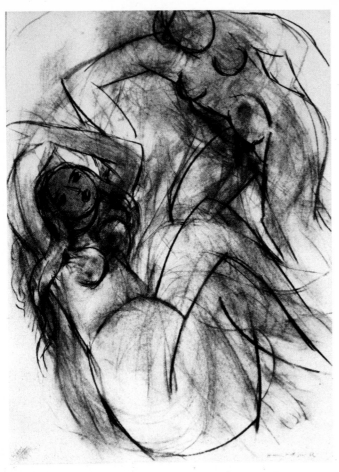

Bataille de femmes. 1935 (77)

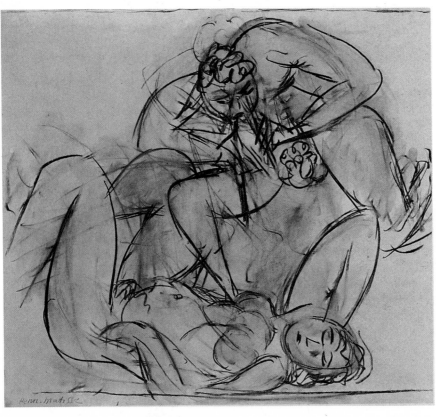

Faun and Nymph. 1935 (76)

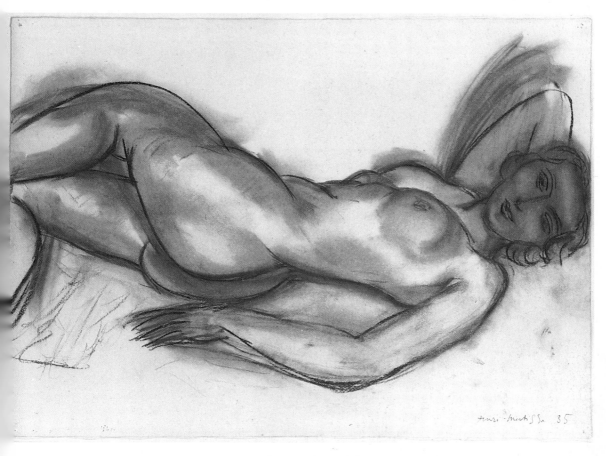

Study for Pink Nude. 1935 (78)

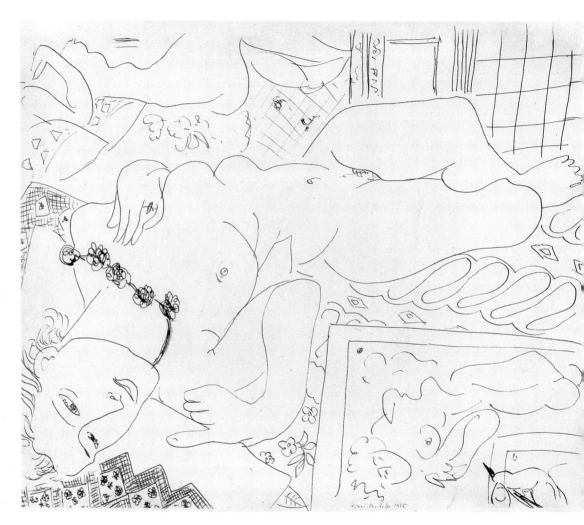

Reclining Nude in the Studio. 1935 (79)

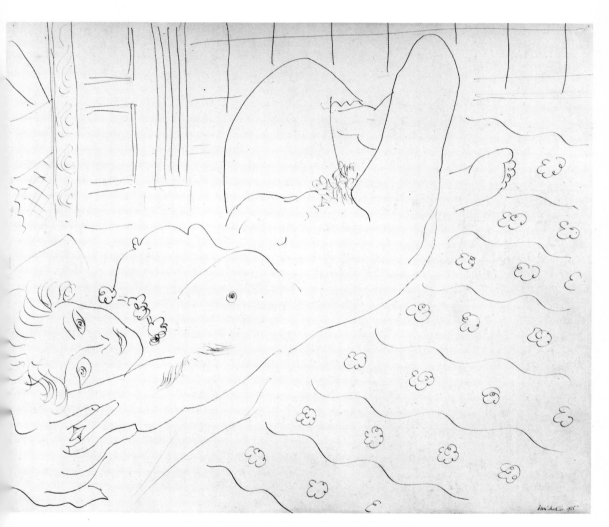

Nude with Necklace Reclining on Flowered Quilt. 1935 (80)

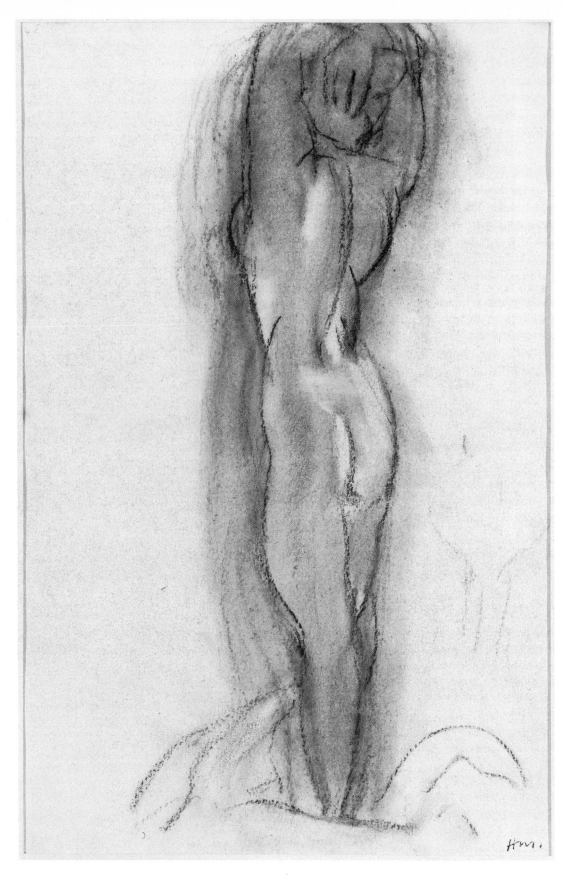

Standing Nude, Seen from the Back. 1936 (82)

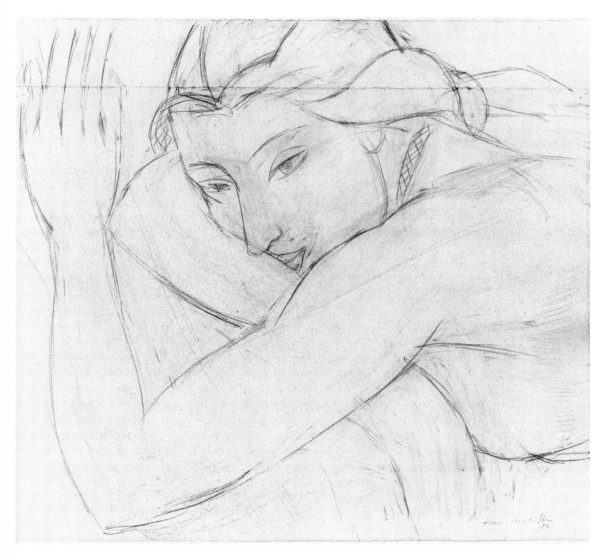

Model Resting on her Arms. 1936 (81)

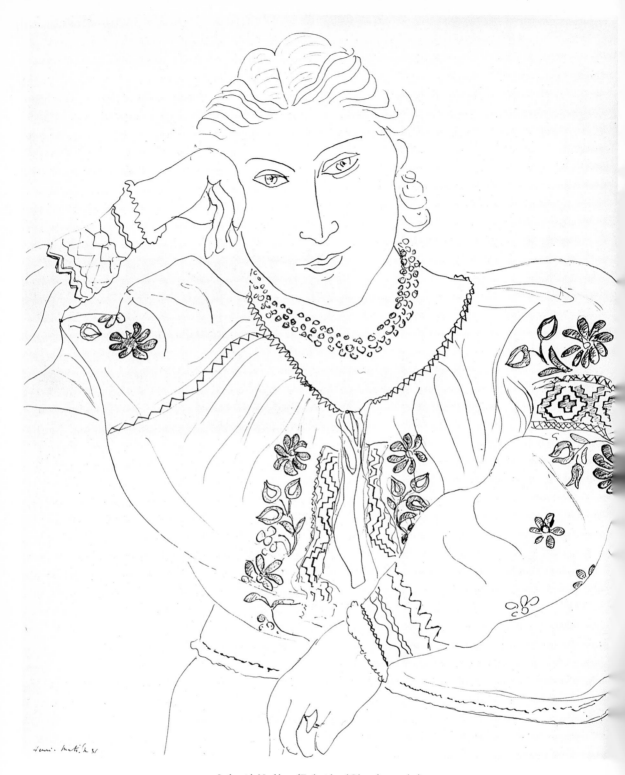

Lady with Necklace (Embroidered Blouse). 1936 (83)

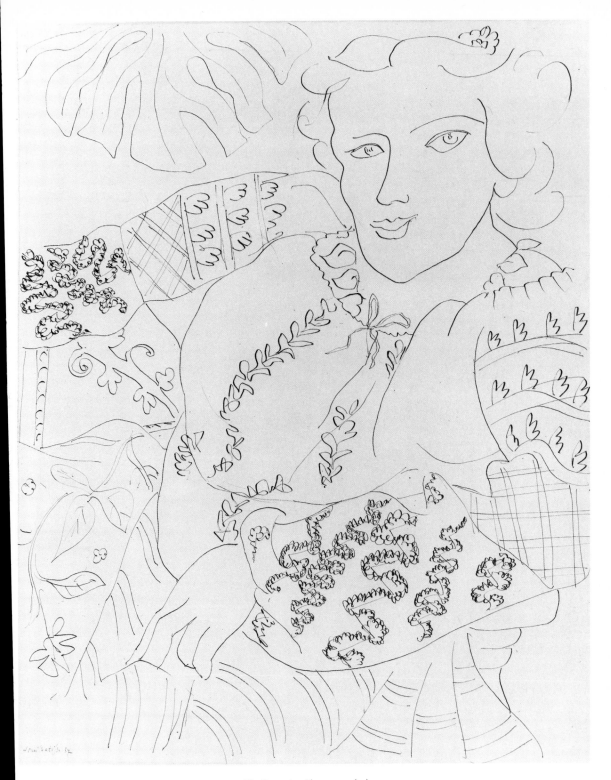

The Rumanian Blouse. 1937 (84)

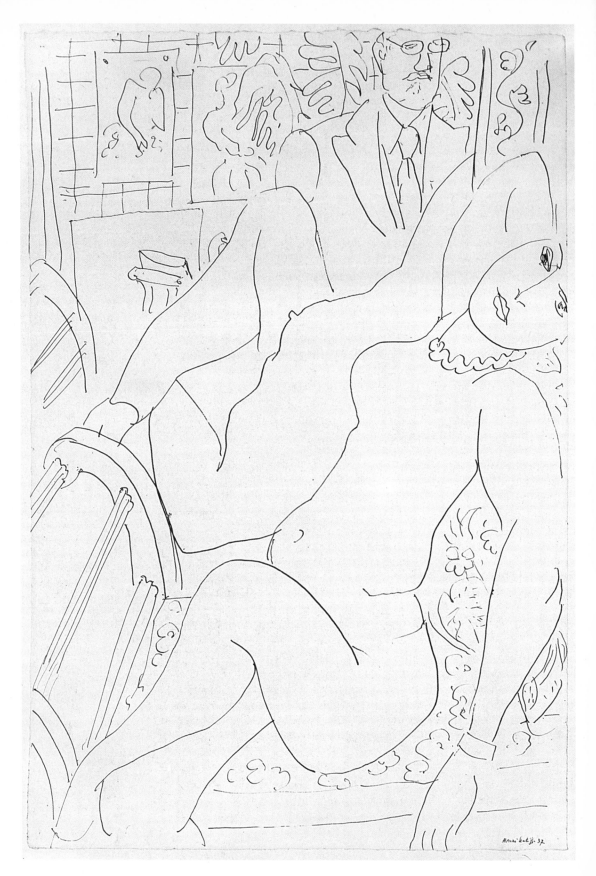

Artist and Model Reflected in a Mirror. 1937 (85)

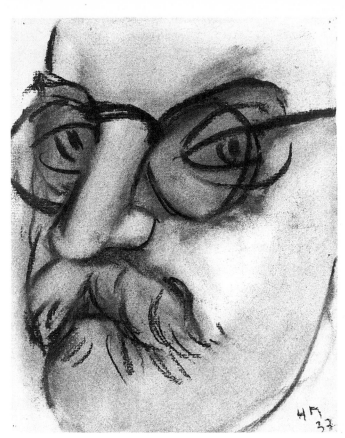

Self-portrait. 1937 (87)

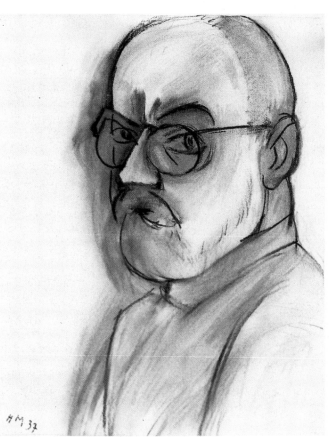

Self-portrait. 1937 (88)

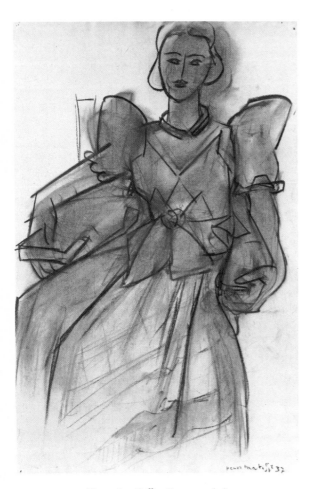

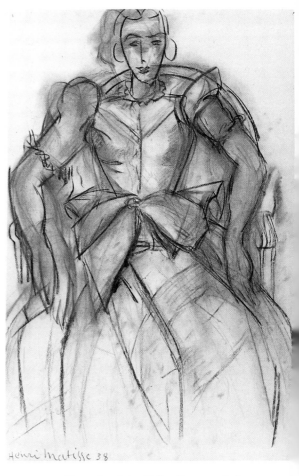

Woman in a Taffeta Dress. 1937 (89)

Woman Seated, in a Taffeta Dress. 1938 (90)

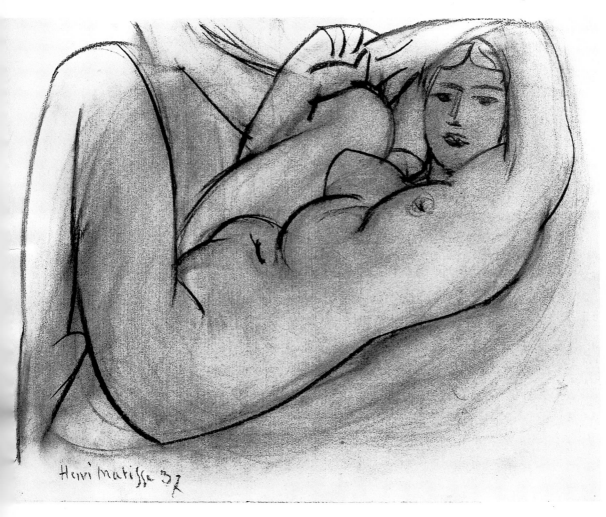

Reclining Nude with Arm behind Head. 1937 (86)

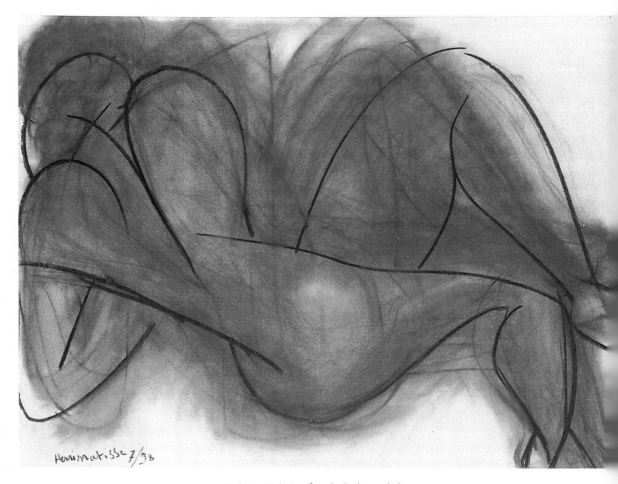

Reclining Nude Seen from the Back. 1938 (92)

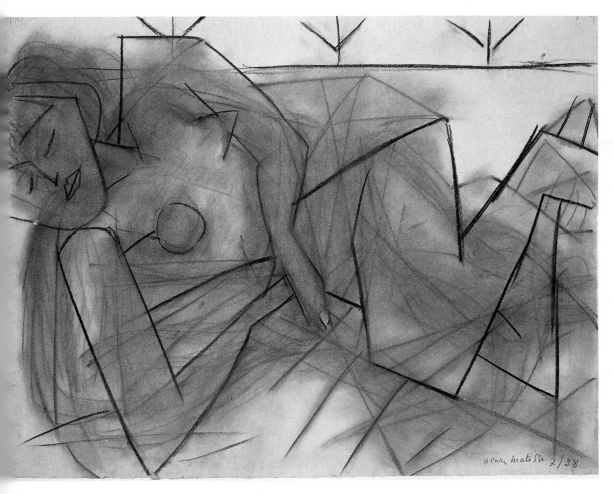

Reclining Nude. 1938 (93)

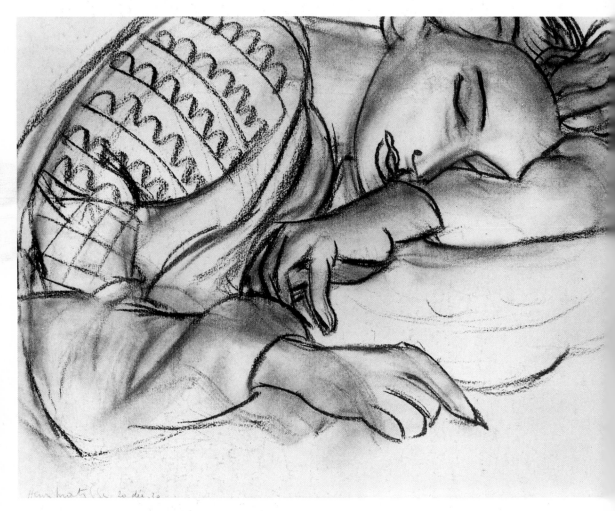

Young Woman Sleeping in Rumanian Blouse. 1939 (95)

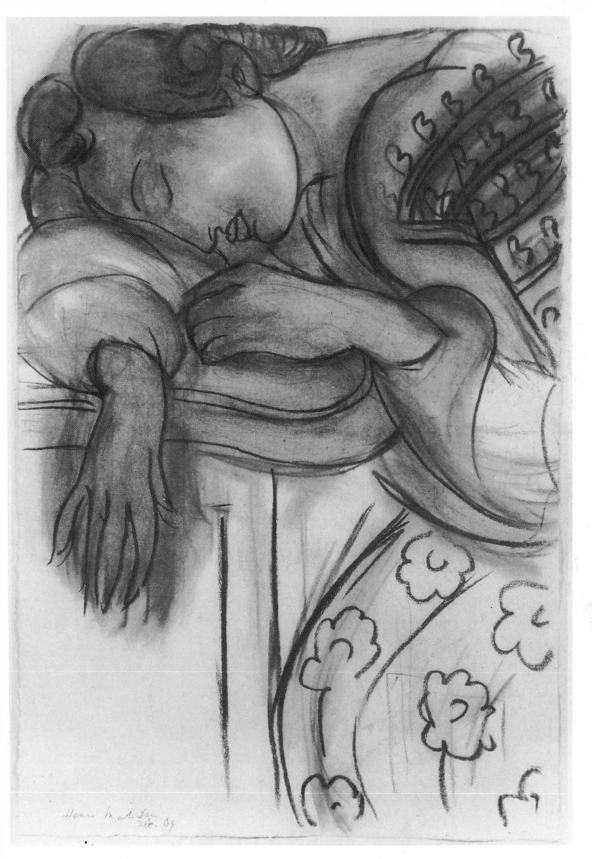

Woman Sleeping at the Corner of the Table. 1939 (96)

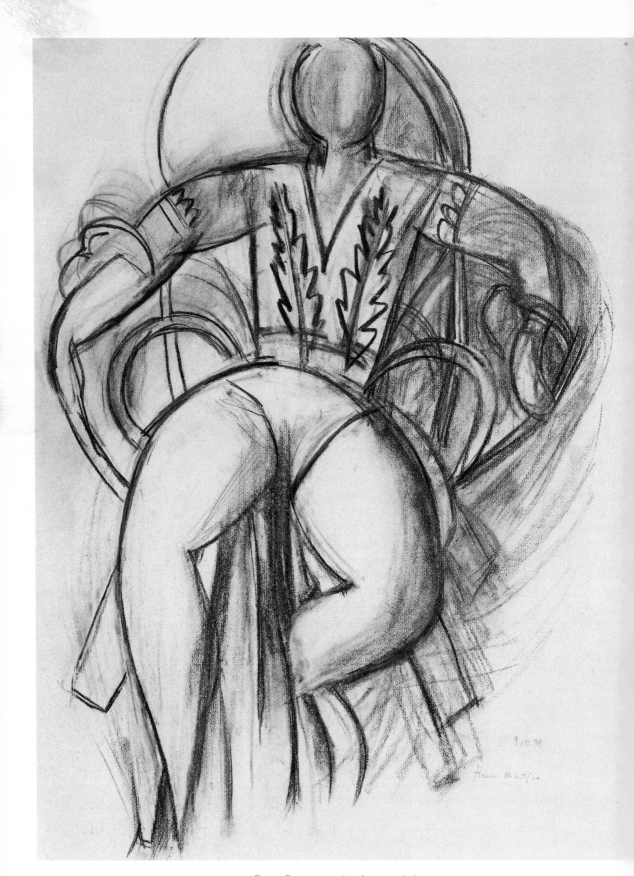

Dancer Resting in an Armchair. 1939 (94)

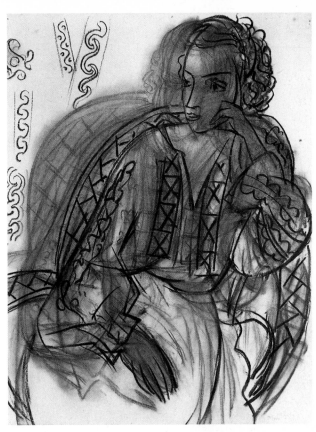

Seated Woman in a Rumanian Blouse. 1938 (91)

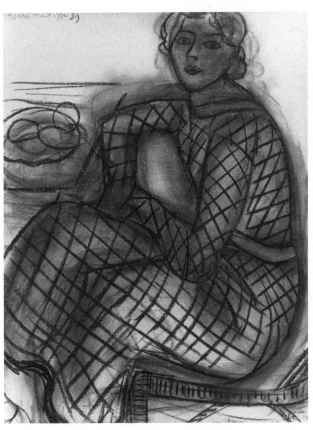

Young Woman in a 'Fishnet' Dress. 1939 (97)

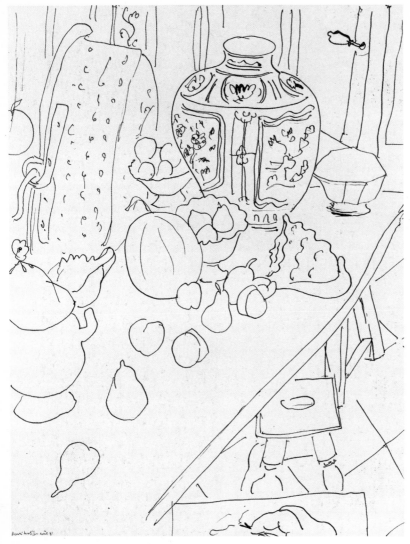

Still-life, Fruit and Pot. 1941 (101)

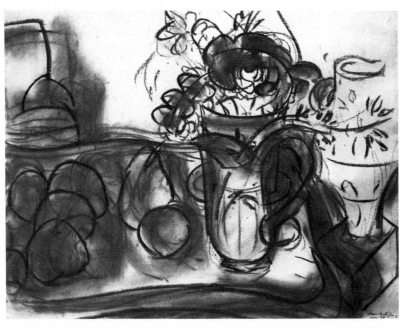

Still-life. 1939 (99)

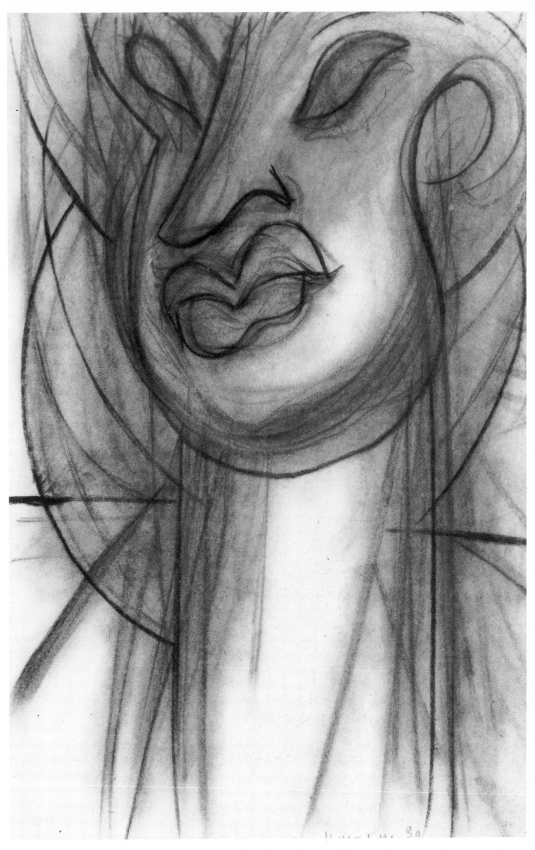

Portrait: Dancer ('The Buddha'). 1939 (98)

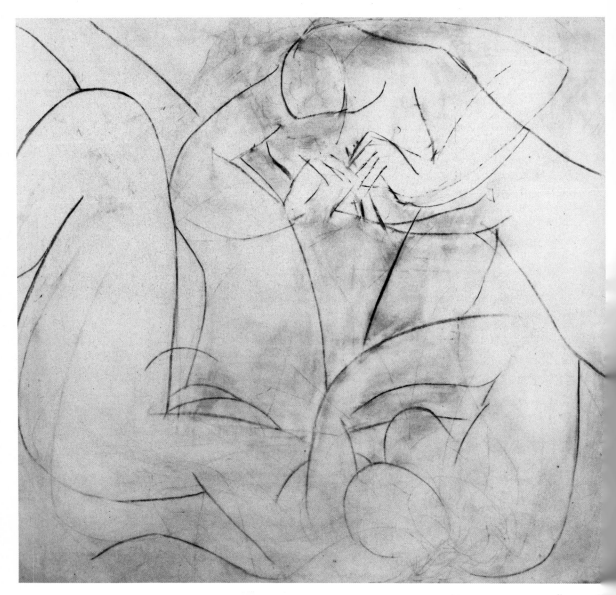

Nymph and Faun with Pipes. 1940/41–43 (100)

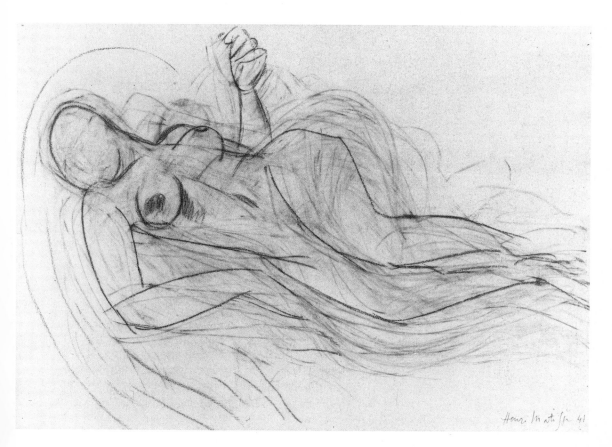

Reclining Nude. 1941 (102)

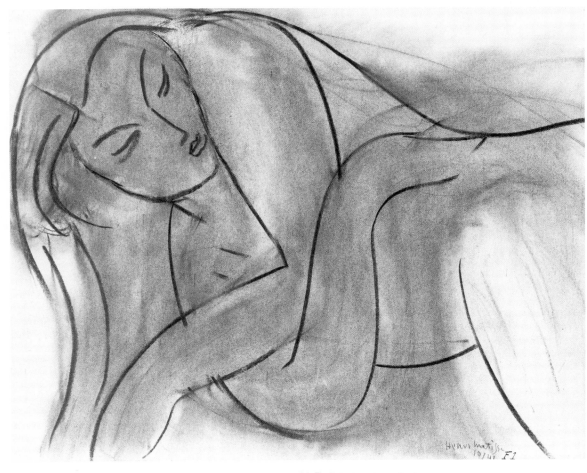

Themes and Variations. Series F, 'dessin du thème'. 1941 (103)

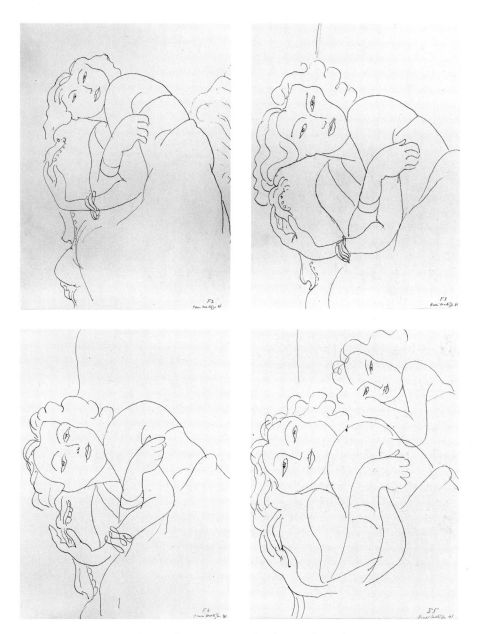

Themes and Variations, F2–5. October 1941 (104–07)

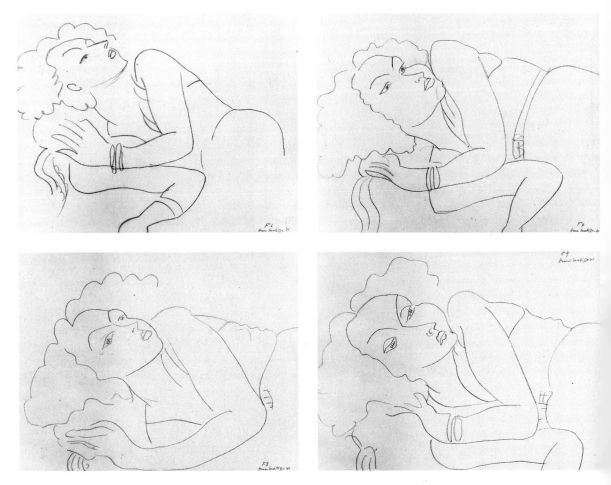

Themes and Variations, F6–9. October 1941 (108–11)

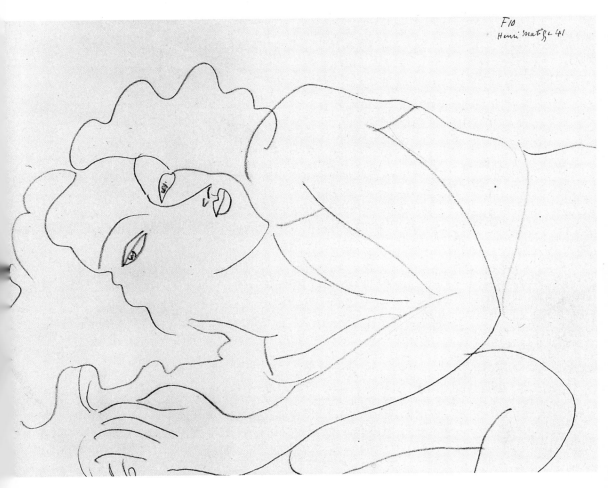

Themes and Variations, F10. October 1941 (112)

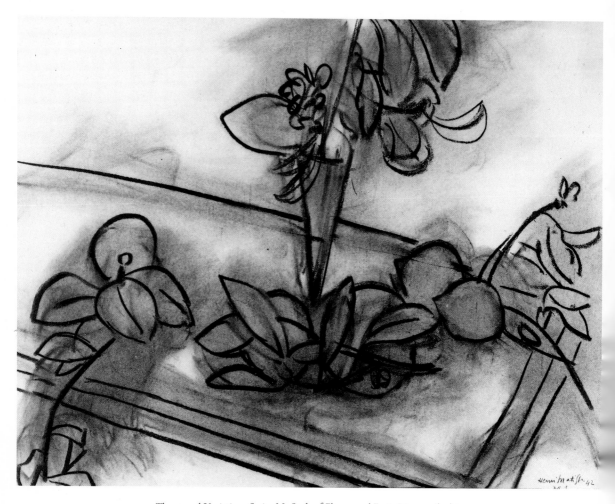

Themes and Variations. Series M, Study of Flowers and Fruit, M1. 1942 (113)

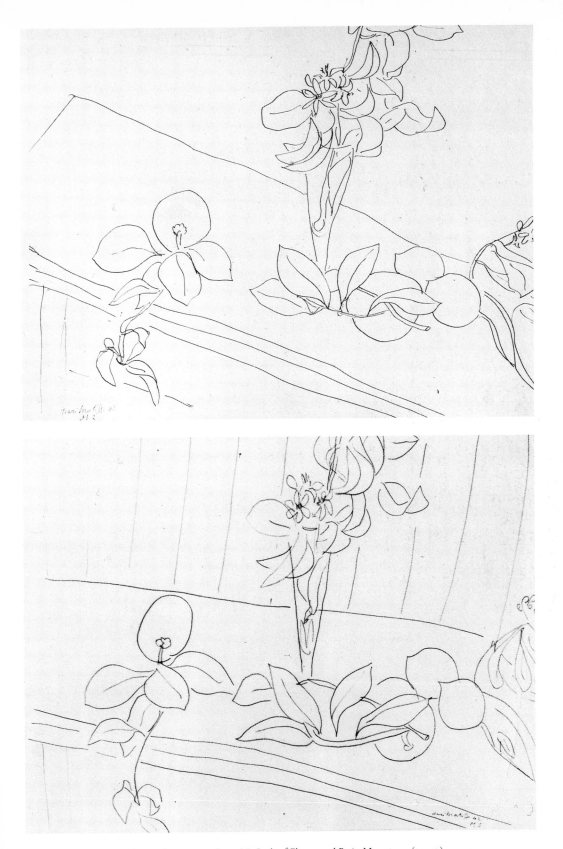

Themes and Variations. Series M, Study of Flowers and Fruit, M2–3. 1942 (114–15)

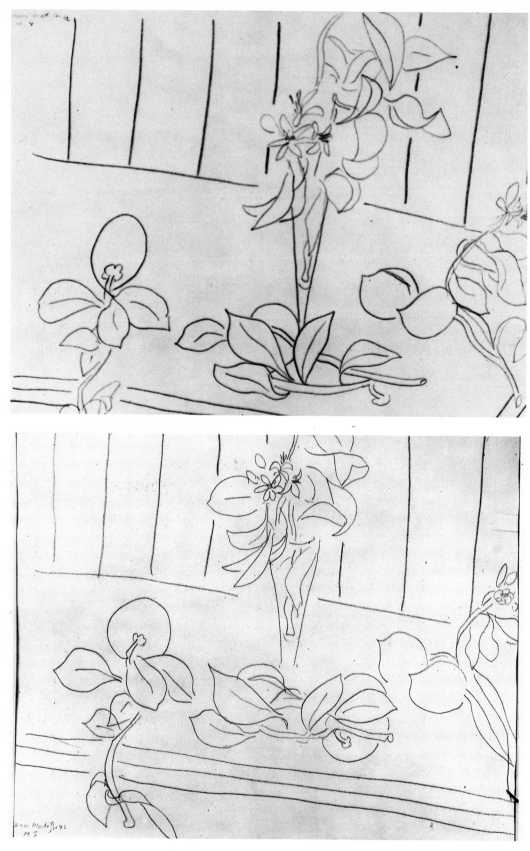

Themes and Variations. Series M, Study of Flowers and Fruit, M4–5. 1942 (116–17)

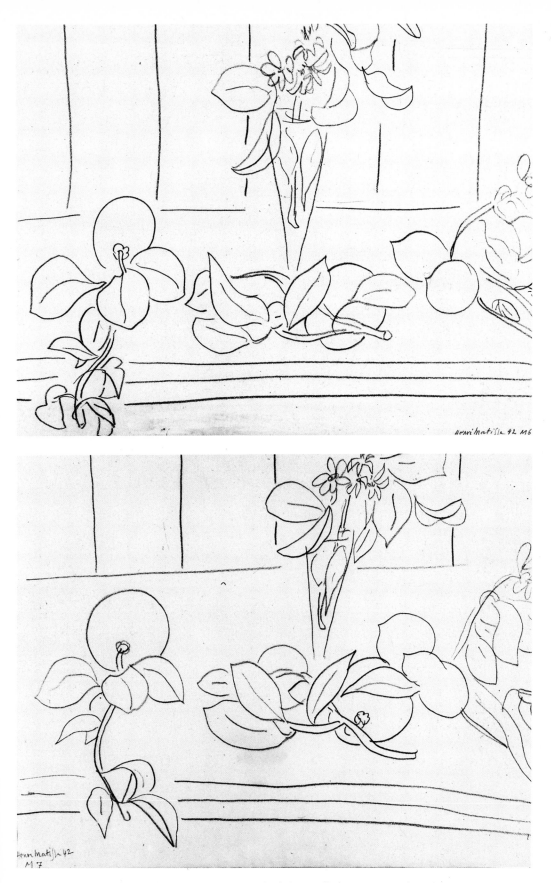

Themes and Variations. Series M, Study of Flowers and Fruit, M6–7. 1942 (118–19)

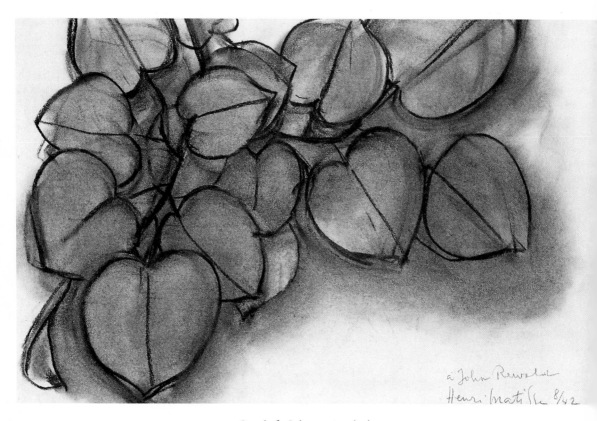

Branch of a Judas-tree. 1942 (120)

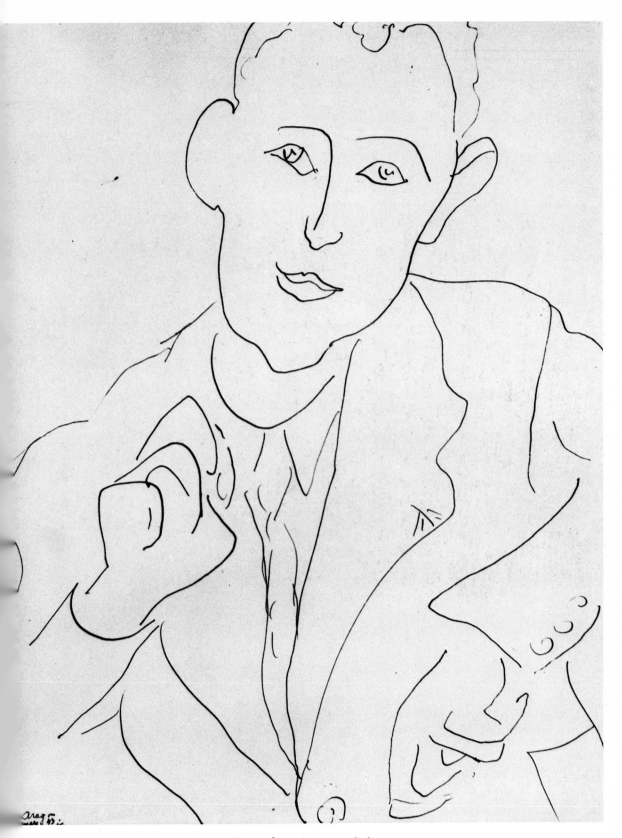

Portrait of Louis Aragon. 1942 (121)

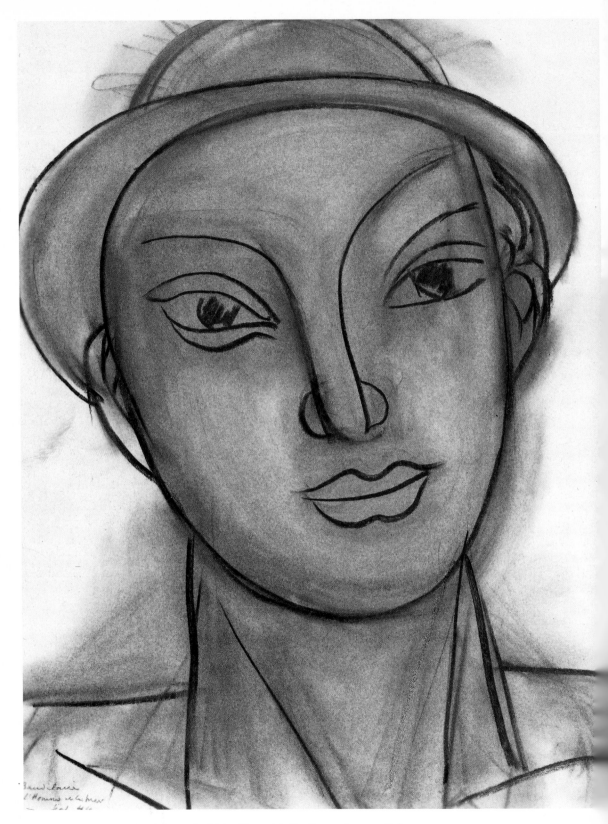

Baudelaire, Man and the Sea. September 1944 (123)

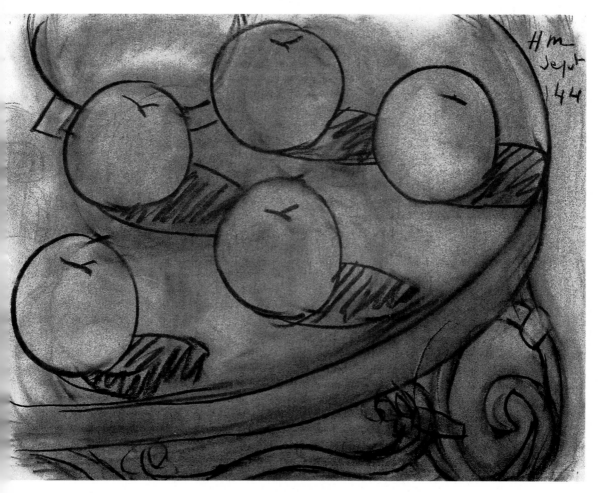

Still-life with Fruit. September 1944 (124)

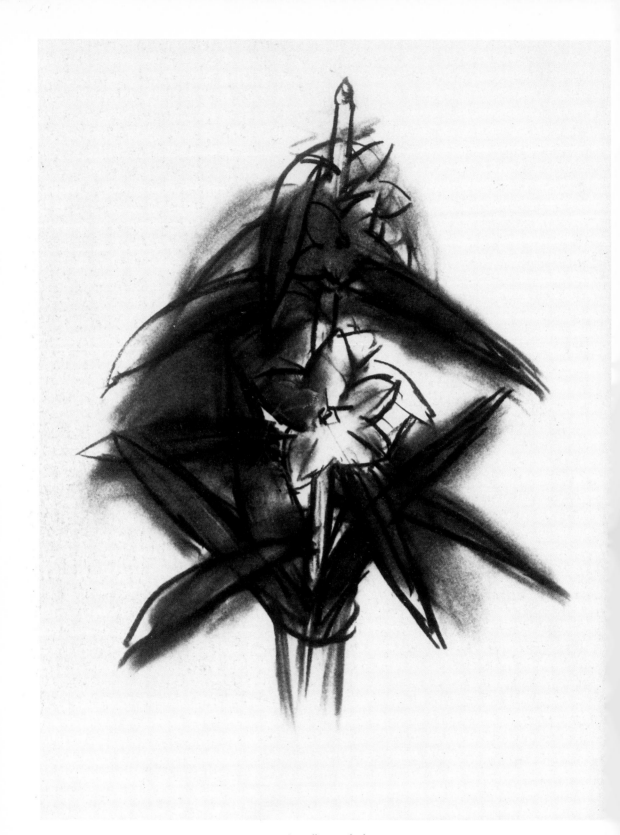

Amaryllis. 1945 (125)

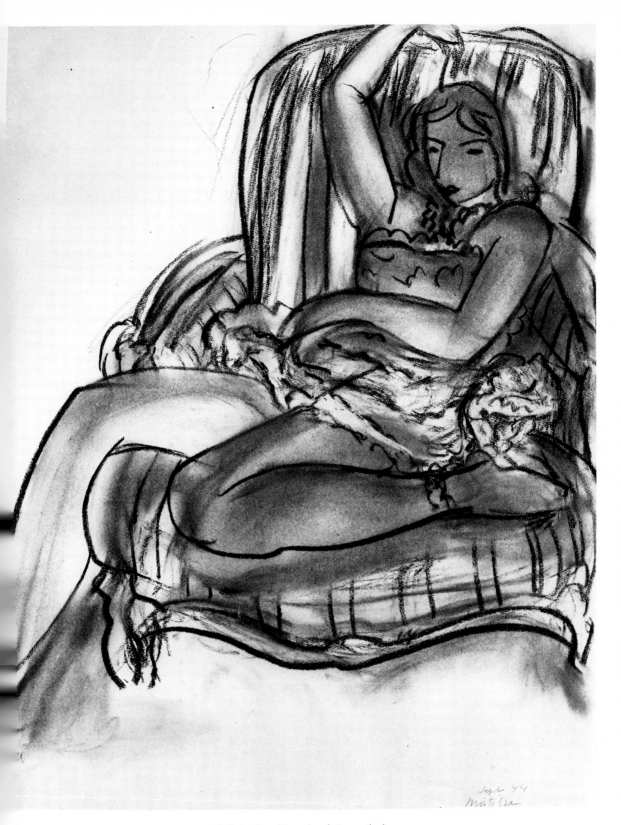

Ballerina Seated in an Armchair. 1944 (122)

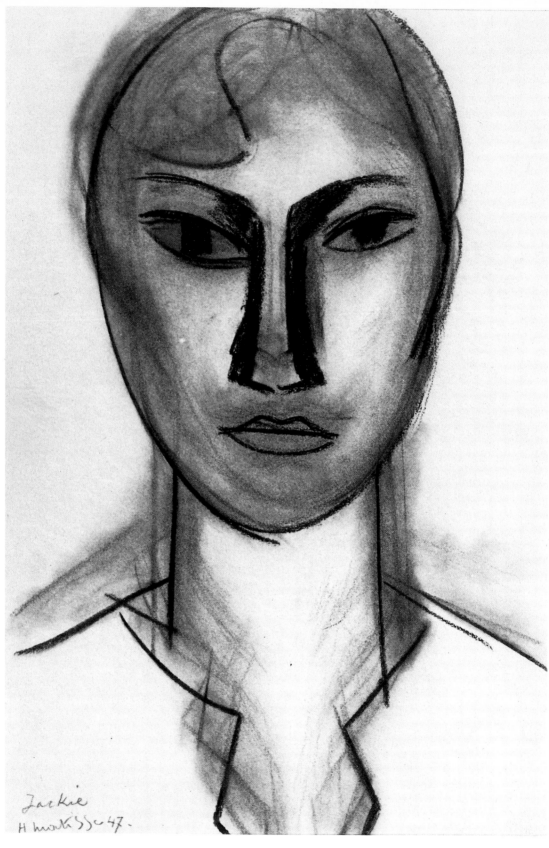

Jackie. 1947 (126)

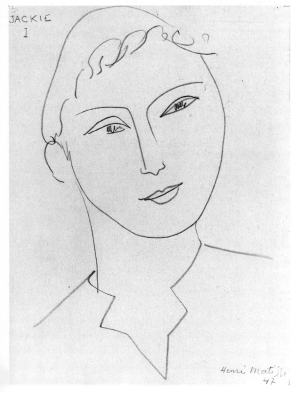

Jackie I. 1947 (127)

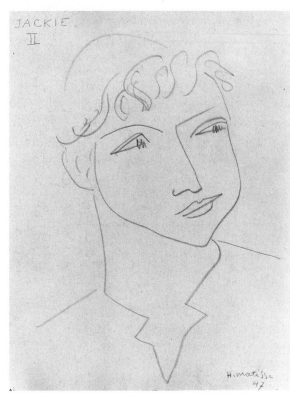

Jackie II. 1947 (128)

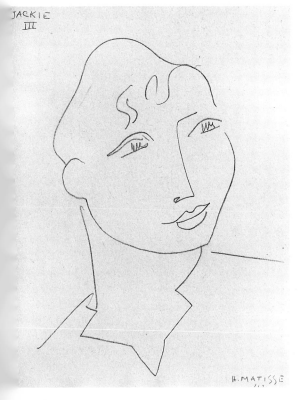

Jackie III. 1947 (129)

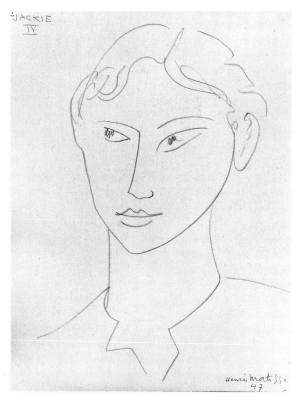

Jackie IV. 1947 (130)

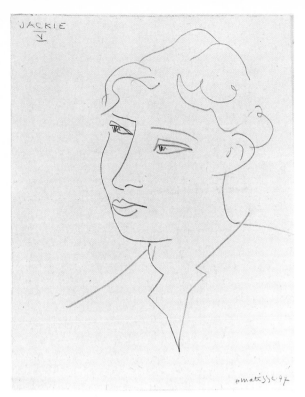

Jackie V. 1947 (131)

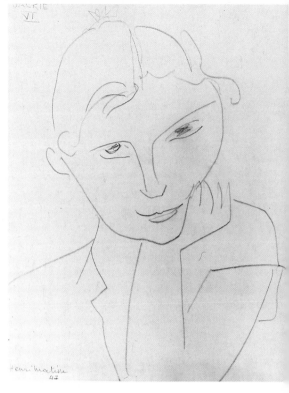

Jackie VI. 1947 (132)

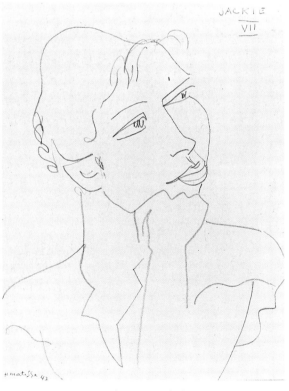

Jackie VII. 1947 (133)

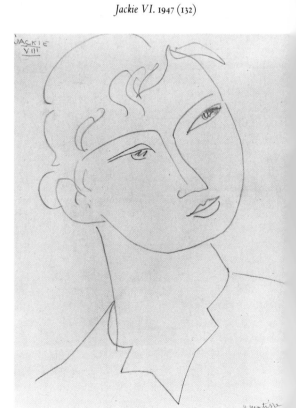

Jackie VIII. 1947 (134)

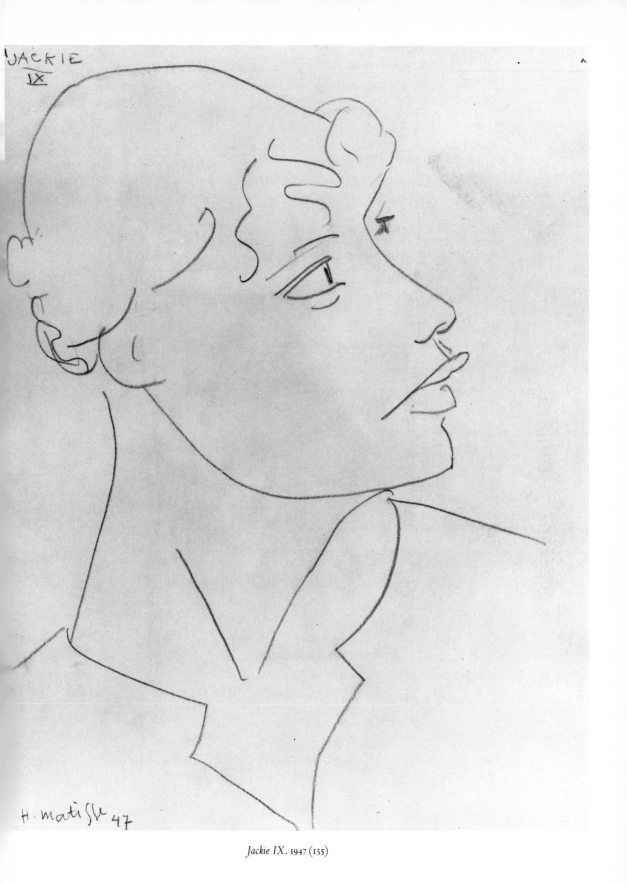

Jackie IX. 1947 (135)

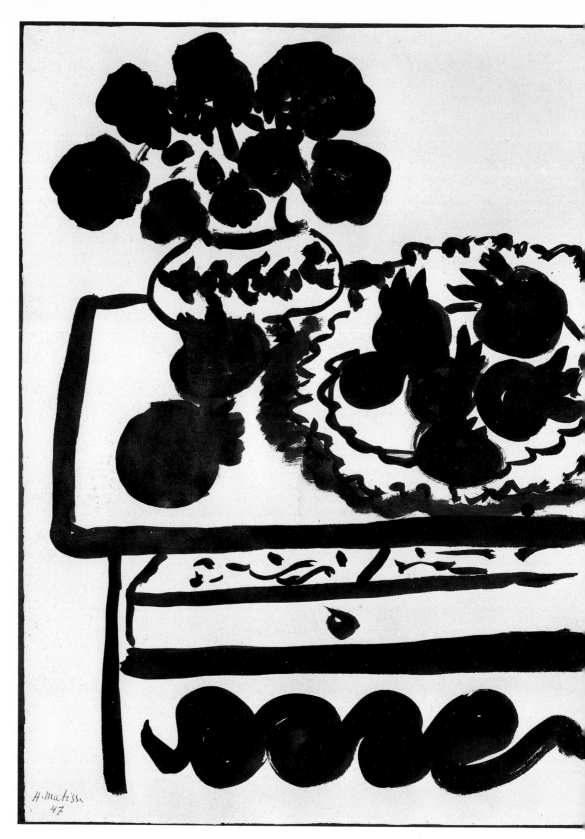

Dahlias and Pomegranates. 1947 (136)

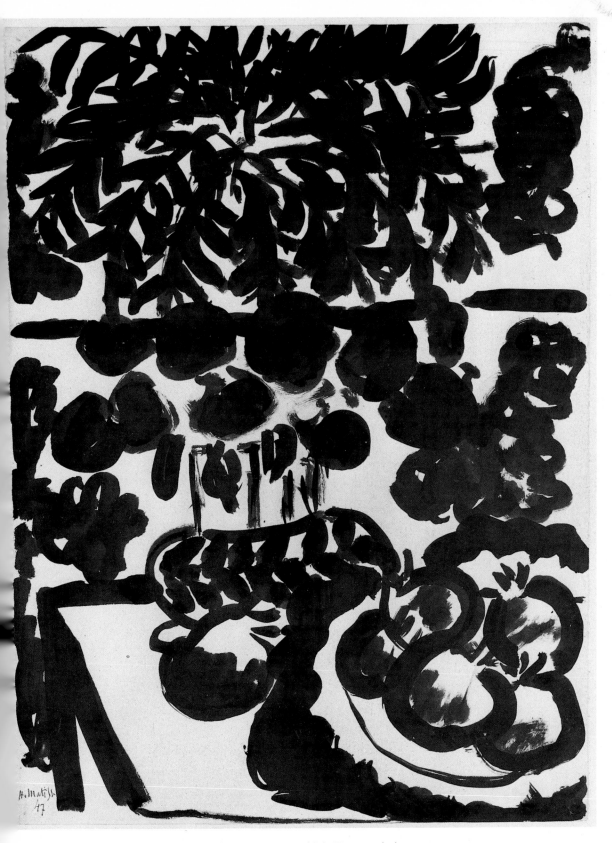

Dahlias, Pomegranates and Palm Trees. 1947 (137)

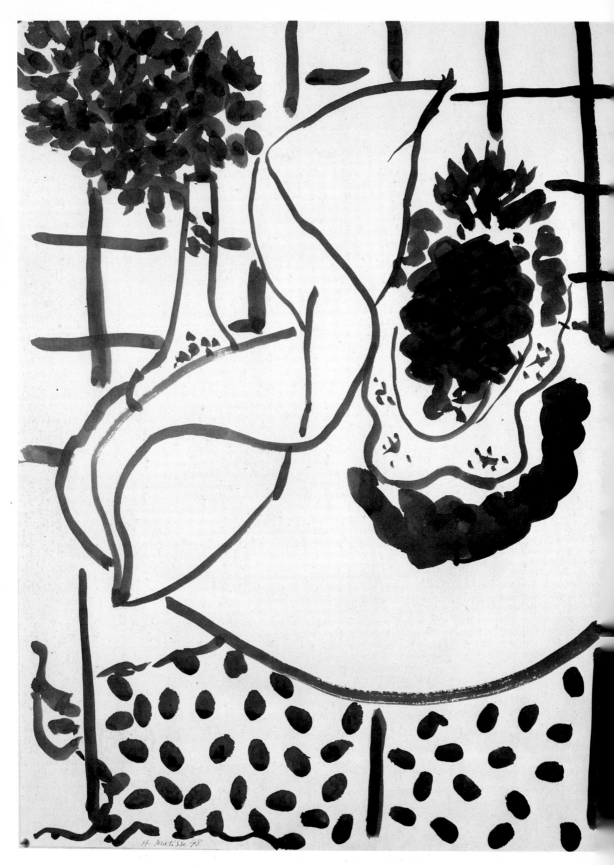

Still-life with Pineapple. 1948 (138)

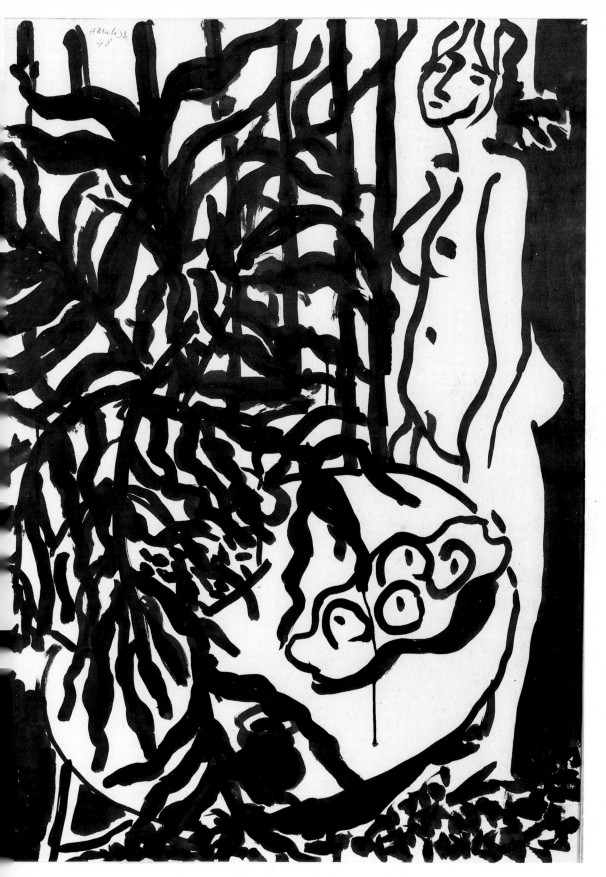

Composition with Standing Nude and Black Fern. 1948 (139)

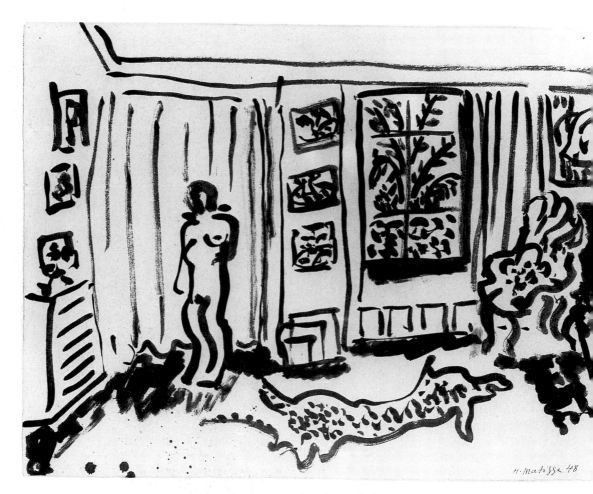

Model in the Studio. 1948 (140)

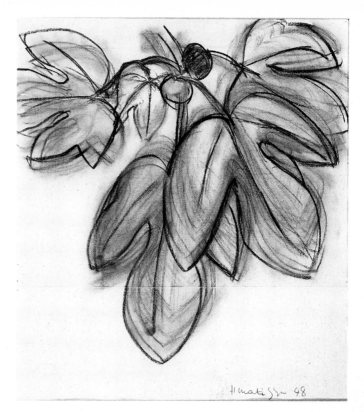

Fig Leaves. 1948 (141)

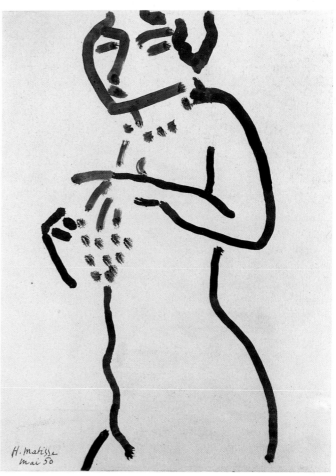

The Necklace. 1950 (149)

Head of St Dominic. 1948—49 (142)

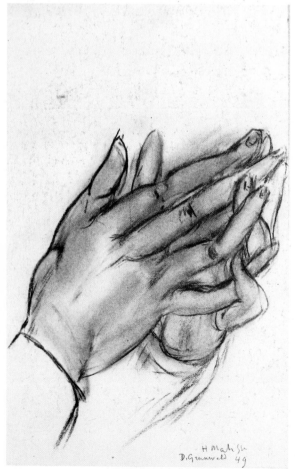

Study of Hands. 1949 (143)

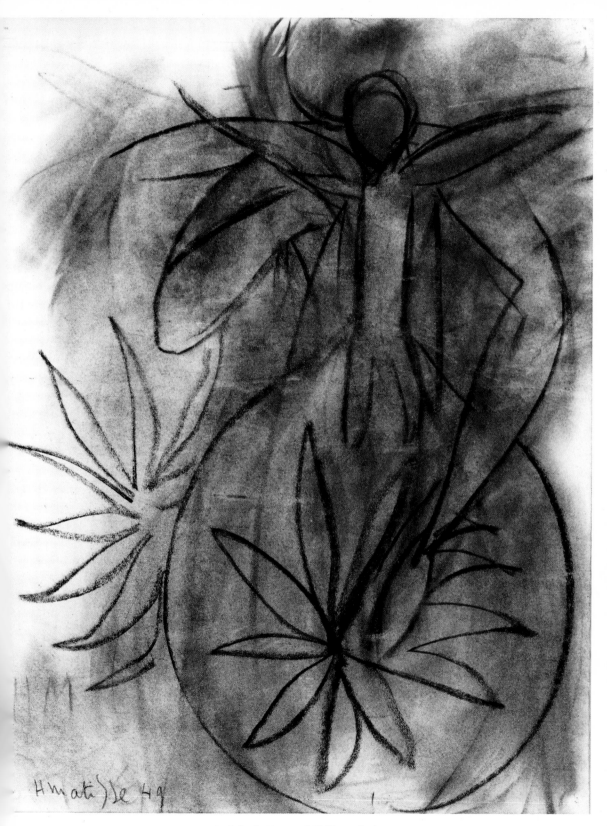

Study for the Virgin and Child. 1949 (148)

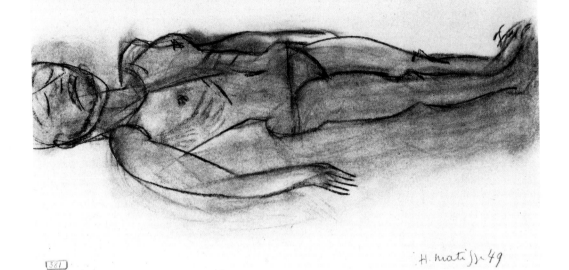

Study for The Entombment. 1949 (144)

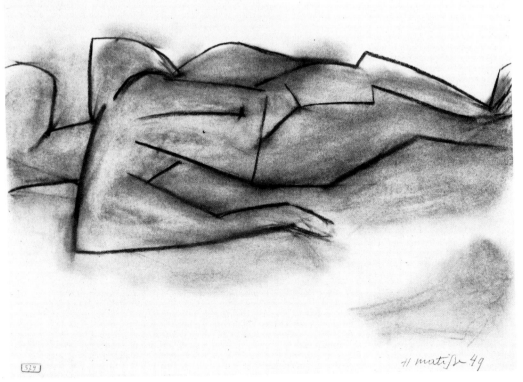

Study for The Entombment. 1949 (145)

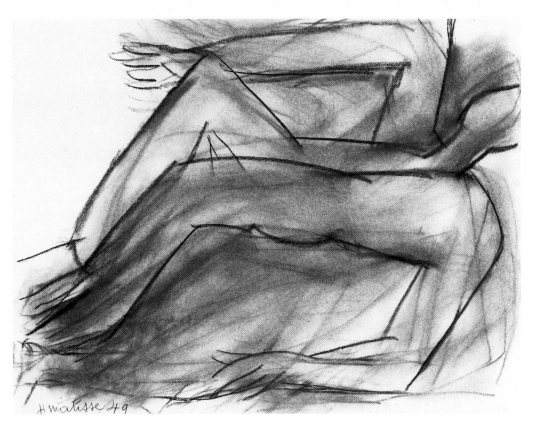

Study for The Entombment. 1949 (146)

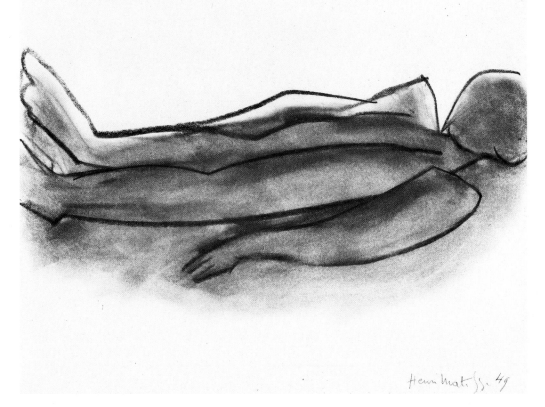

Study for The Entombment. 1949 (147)

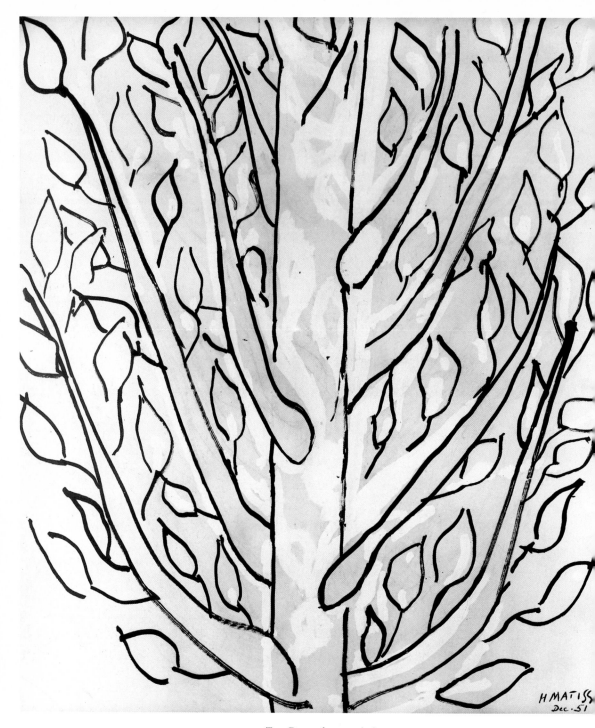

Tree. December 1951 (151)

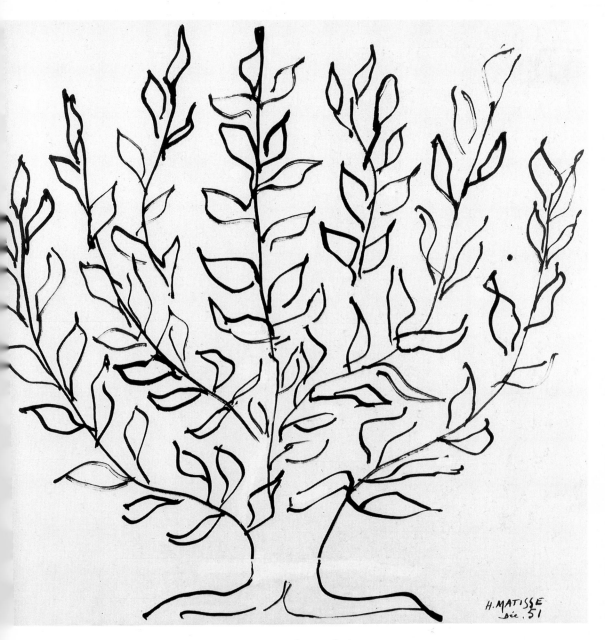

Tree. December 1951 (150)

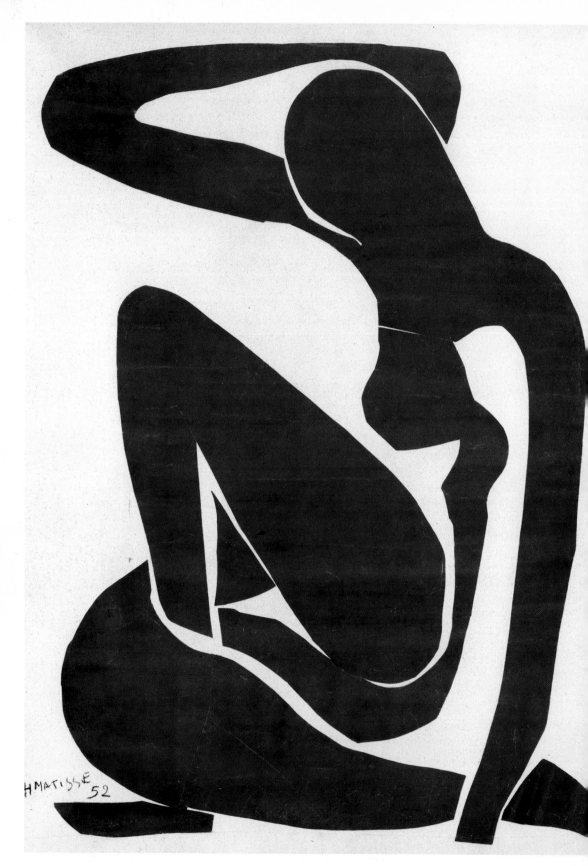

Blue Nude I. 1952 (152)

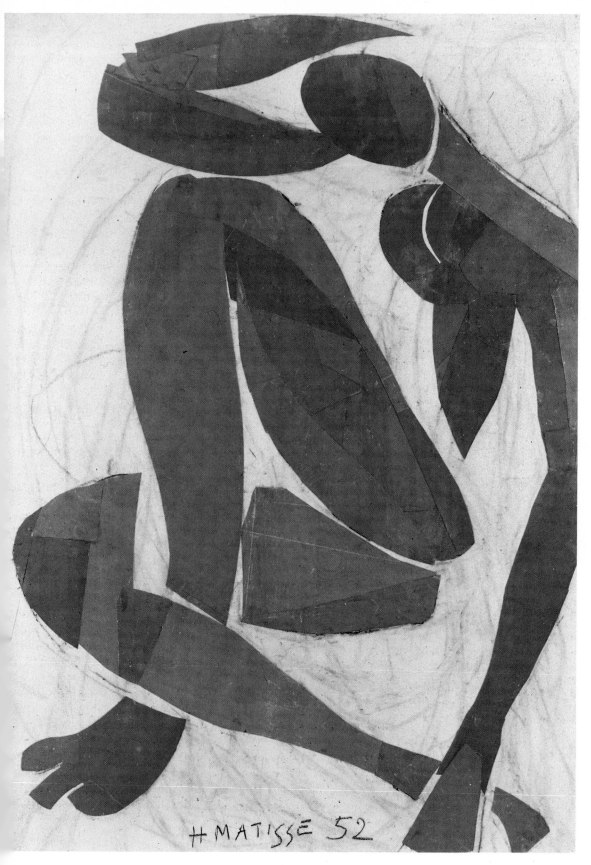

Blue Nude IV. 1952 (153)

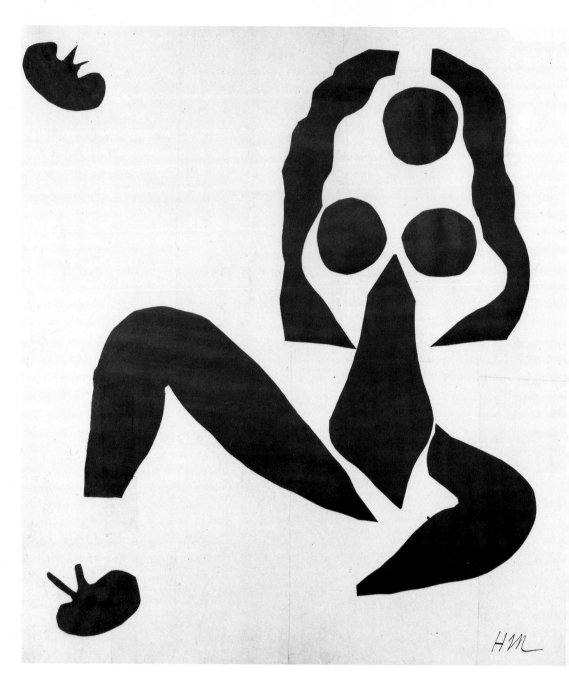

Blue Nude, The Frog. 1952 (154)

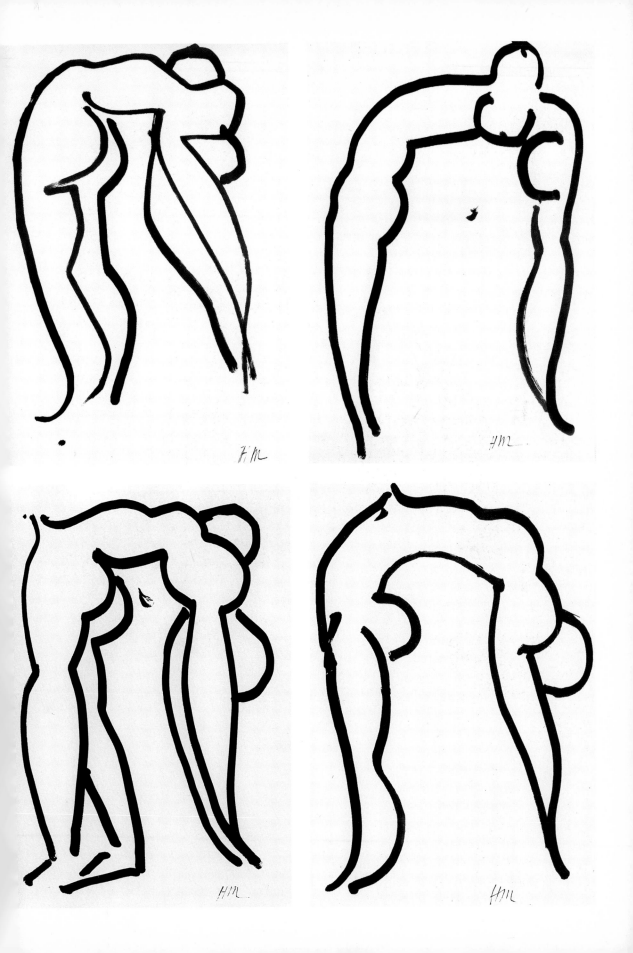

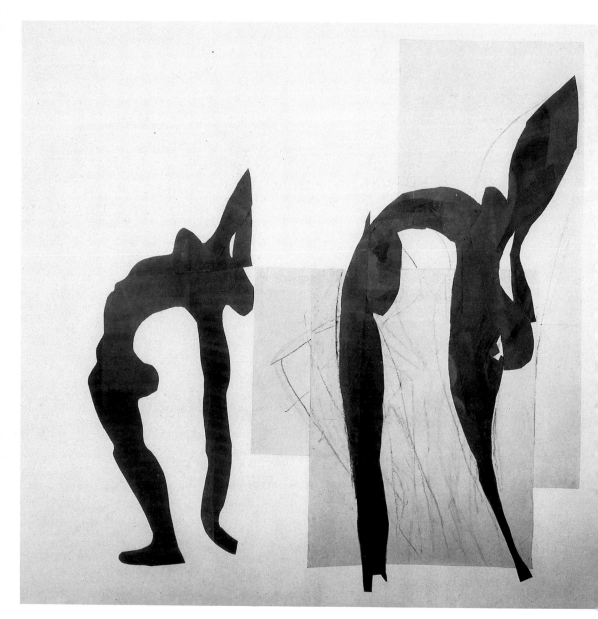

Acrobats. 1952 (159)

THE CATALOGUE

THE CATALOGUE

Drawings are listed chronologically, and the date is enclosed in parentheses when it has not been verified. Where the location is not certain, this is also enclosed in parentheses. Dimensions are given in centimetres and inches, height before width. Dimensions, media and paper colour are generally those given by the lenders.

Bibliographical and exhibition references are given only when they discuss the drawings in depth. Such references are abbreviated according to the system used in the List of Exhibitions and Select Bibliography (pp. 291, 296), to which they refer: exhibitions and exhibition catalogues are indexed by the name of the city, arranged alphabetically and followed by the year, and other bibliographical references are found under the author's name, followed by the year of publication.

1 *L'Homme − académie*. Paris (1891−92) (p. 137)
 Graphite on paper
 62 × 48.2 ($24\frac{3}{8}$ × 19)
 Musée Matisse, Nice-Cimiez

Matisse's beginnings as a draughtsman conform to the traditional nineteenth-century academic practice of drawing from plaster casts of antique statuary and from live models. During the winter of 1891−92 Matisse registered at the Académie Julian in Paris for a course of twenty drawing lessons under the tutelage of Adolphe William Bouguereau. At that time he made a group of drawings in a dry academic manner (most of which are preserved at the Musée Matisse at Le Cateau), and the present drawing is one of that group. Known also as *Etude de vieillard* or *Old Man*, it relates to the painting *Le Vieillard* of 1892 (private collection, Paris). Done from a live model, the rendering of the body seems to be a compromise between realistic definition and academic idealization. The articulation of the limbs recalls that of Michelangelo's *Ecorché*, which was frequently found in the repertoire of antique statuary in artists' studios at the time (Elsen, 1972, fig. 23).

Elsen, 1972, pp. 12−14

2 *Portrait of Madame Matisse*. (Toulouse)
 3 January 1899 (p. 138)
 Pen, brush and ink on paper
 32.2 × 24.6 ($12\frac{5}{8}$ × $9\frac{5}{8}$)
 Private collection

In January 1898, Matisse married Amélie Noémie Alexandrine Parayre from Toulouse. Their honeymoon trip to London was followed by a six-month stay in Corsica and another six-month visit, from August until February 1899, to Toulouse and Fenouillet (a small town in the eastern Pyrenees near Perpignan). From the beginning, Madame Matisse was her husband's most patient and devoted model. This is one of the earliest portraits of her, and also one of the earliest drawings to show Matisse's personal style. It is striking in its exploration of positive-negative qualities, using the whiteness of the paper to model light.

Barr, 1951, p. 37
Paris, 1975, no. 1

3 *Self-portrait, Smoking Pipe*. Paris (1900) (p. 138)
 Pen, brush and ink on light tan paper
 30.8 × 19.9 ($12\frac{1}{8}$ × $7\frac{7}{8}$)
 Private collection

Among important examples of Matisse's early draughtsmanship in his pre-Fauve period is a group of three self-portraits (Barr, 1951, p. 39; Paris, 1975, no. 2). This is the most complete in

terms of the use of hatching and cross-hatching to model the form. In its drawing technique it relates to the print *Self-portrait as an Etcher* (etching and drypoint, 1900–03; Fribourg, 1982, no. 1). There is another version of this self-portrait – without the pipe, in the classical pose of the artist drawing from his mirror reflection – at the Musée Matisse, Nice-Cimiez (inv. no. 374).

Baltimore, 1971, no. 1
Paris, 1975, no. 3

4 *Still-life with a Chocolatière.* Paris (1900) (p. 139)
Brush and ink on paper
22.8 × 29.9 $(9 × 11\frac{3}{4})$
The Bragaline Collection

This drawing is a study for the painting *Still-life with a Chocolatière* of 1900, in the Hermitage, Leningrad (Izerghina, cat. 7). Stylistically, it is a further development of the method used earlier in the *Portrait of Madame Matisse* (cat. 2) and in certain self-portraits of the period (Barr, 1951, p. 39; Paris, 1975, no. 2) where the artist utilizes bold black-and-white contrasts to structure the composition. The central part of the composition – the *chocolatière*, cup and saucer and sugar bowl (?) – is the subject of another drawing at the Musée Matisse, Le Cateau (Guide de Visite, 1982, p. 28). The motif of a *chocolatière* is repeated in several of Matisse's paintings of 1900, such as *Still-life with a Chocolatière* (Alex Maguy Collection, Paris; Paris, 1970–3, p. 125, no. 32) and *Flowers in a Chocolatière* (ex-Pablo Picasso Collection; Aragon, 1971, vol. I, p. 304), and later in 1909 in *Blue Table-cloth* (*Nature morte, camaïeu bleu*, Hermitage, Leningrad; Izerghina, 1978, cat. no. 26).

Izerghina, 1978, cat. 7
Paris, 1975, no. 4

5 *Standing Nude Model.* Paris (c. 1900) (p. 140)
Charcoal and estompe on cream paper
62.5 × 47.3 $(24\frac{5}{8} × 18\frac{5}{8})$
Private collection

In 1908 in 'Notes of a Painter' Matisse stated that 'what interests me most is neither still-life nor landscape, but the human figure' (Flam, 1973, p. 38). The present drawing belongs among the early figure studies executed between 1899 and 1901. After the death of Gustave Moreau and following Matisse's return from the South, he was again feeling the need to work from a live model and, seeking the guidance of Eugène

Carrière, frequented the Studio Camillo. This sheet bears affinities to the drawing *Etude de femme nue, debout de trois quarts* (1899–1901) at the Musée de Peinture, Grenoble (Paris, 1975, no. 5), and to various academic studies in oil, such as *Study in Blue* (*Académie bleue, c.* 1900, Tate Gallery, London; Gowing, 1979, pp. 38–39). The beautiful tonal modelling of the drawing and the *sfumato* background, reminiscent of Carrière, are achieved here through the use of a new technique of estompe and charcoal, which Matisse favoured particularly in the 1920s and again in the late 1940s.

Baltimore, 1971, no. 2
Paris, 1975, no. 6

6 *Standing Nude.* Paris (1901–03) (p. 142)
Brush, pen and ink on paper
26.4 × 20.3 $(10\frac{3}{8} × 8)$
The Museum of Modern Art, New York.
Gift of Edward Steichen

This drawing, also known as *Figure Study* and *Nude Study*, is among the more important works of Matisse's proto-Fauve period. Like most of the drawings in the first decade of the artist's activity, it is undated. Originally placed at *c.* 1907, it was subsequently redated 1901–03. In the use of quick brushstrokes around the outline of the body, reminiscent of his early etchings and drawings of around 1900, and in the use of expanses of white paper in large planes to model the volumes of the body, it seems to approach such drawings as *Self-portrait* (1900; Paris 1975, no. 2) and *Standing Nude Seen from the Back* (cat. 7). It is particularly close stylistically to the pen and brush and ink drawing *Nude in Profile, Left Leg Raised*, 1901–03, in a Swiss private collection (Zürich, 1982–2, no. 63).

Baltimore, 1971, no. 3
Grenoble, 1963, no. 131
Paris, 1975, no. 11

7 *Standing Nude Seen from the Back.* Paris (1901–03) (p. 141)
Pen and ink on paper mounted on card
27 × 20 $(10\frac{5}{8} × 7\frac{7}{8})$
Musée de Peinture, Grenoble. Agutte-Sembat Bequest 1923

Within the context of Matisse's pen and ink drawings of nude figures executed between 1898 and 1903 the present work is one of the most

vigorous. It relates directly to several other pen and ink drawings, such as *Standing Nude* (1901–03; cat. 6), *Nude, Semi-abstract* (1901–03; cat. 8), *Nude Study* (1898; George, 1925, pl. 13), *Nude Study* (1900; George, 1925, pl. 12), *Male Model* (*c.* 1900; Guggenheim Museum, New York; Barr, 1951, p. 44), the *Nude in Profile, Left Leg Raised* (1901–03; Zürich 1982–2, no. 63), *Nude* (1901–02; *XX siècle*, 1970, p. 97).

Grenoble, 1963, no. 131
Paris, 1975, no. 10

8　*Nude, Semi-abstract.* (1901–03) (p. 143)
　　Pen and ink on paper
　　20.3 × 26.3 $(8 \times 10\frac{3}{8})$
　　The Metropolitan Museum of Art, New
　　　York. The Alfred Stieglitz Collection, 1949

Also known by the title *Nude Seated on Floor, Leaning on her Hand* this drawing was originally dated by Barr 'before 1910' (Barr, 1951, p. 50) because it was included in Matisse's second show at Stieglitz's Gallery '291' in February–March 1910 (see cat. 20). Recent research indicates that the drawing was also included in the first exhibition of Matisse's work at Stieglitz's gallery in April 1908 and was then dated 1907. It can be argued, on stylistic grounds, by comparison with pen and ink drawings executed between 1898 (George, 1925, pl. 14) and 1906 (Duthuit, 1949, p. 161), where Matisse uses similar squiggly brushstrokes, that the present dating is the most convincing.

Barr, 1951, pp. 50, 97–98
Duthuit, 1949, pp. 78, 161
George, 1925, pls 12, 13, 14
Zürich, 1982–2, cat. 64

9　*Madame Matisse Seated (Collioure).* (1905) (p. 144)
　　Reed and ink on paper mounted on card
　　19.3 × 23.7 $(7\frac{5}{8} \times 9\frac{1}{4})$
　　Musée National d'Art Moderne, Paris.
　　　Centre Georges Pompidou

In 1905 Matisse and his family spent the summer at Collioure, a village on the southern coast near the Spanish border. It remained their retreat for several months almost every year during the next decade. There Matisse executed several landscape drawings and a number of indoor and outdoor portraits of Madame Matisse. This drawing represents Madame Matisse seated probably on the shore at the harbour of Collioure. It seems to use the same formal language influenced by Neo-Impressionism that

is seen in the painting *La Japonaise: Woman Beside the Water* (1905; The Museum of Modern Art, New York; Paris, 1970–3, no. 62). The pose of the sitter recalls – in reverse – that of the figure seated at the left in the painting *Luxe, calme et volupté* of the previous summer.

Paris, 1975, no. 18

10　*Madame Matisse among Olive Trees.* Collioure,
　　　1905 (p. 144)
　　Pen and ink on paper
　　20.3 × 26.7 $(8 \times 10\frac{1}{2})$
　　Collection Louise E. Steinberg, Palm
　　　Springs, California

This is one of the numerous outdoor sketches of the Collioure landscape done in the summer of 1905 (see also cat. 9). Its composition is repeated, in almost exact detail, in the painting *Olive Trees (Collioure)* (1905, private collection, Paris; see Barr, 1951, p. 318), executed in the Neo-Impressionist idiom. The same motif, viewed from a different angle, reappears in another canvas of 1905: *Trees at Collioure* (Lehman Collection, The Metropolitan Museum of Art, New York).

Paris, 1975, no. 15

11　*The Artist's Daughter, Marguerite.* Collioure
　　　(1905) (p. 145)
　　Pen and ink on white paper
　　39.7 × 52 $(15\frac{5}{8} \times 20\frac{1}{2})$
　　Mr and Mrs Alfred C. Cowan, Toronto

Among Matisse's most devoted and frequently used models was his daughter Marguerite (later Madame Georges Duthuit). She posed for innumerable paintings and drawings, particularly before her marriage in 1923. The present dating of this portrait, often attributed to 1906, has been confirmed by Marguerite Duthuit who remembered posing for it in the summer of 1905 in Collioure (letter of 2 August 1971, Archive of The Museum of Modern Art, New York). However, stylistically, the use of the contour line around the face, and the way in which it articulates the volume, show close analogy to the 1906 drawings for woodcuts (cat. 15, 16), and the pen and ink drawing *Nude in a Folding Chair* (*c.* 1906, Chicago Art Institute; Barr, 1951, p. 322). The drawing relates to the sculpture *Head of a Young Girl (Marguerite)* (1906, bronze, Baltimore Museum of Art, Cone Collection), and the

painting *Margot* (1906, Smooke Collection, Los Angeles, California; Paris, 1970–3, no. 76).

Baltimore, 1971, no. 8
New York, 1972, no. 73
Paris, 1975, no. 21

12 Le Port d'Abaill. (1905–06) (p. 145)
Ink on paper
60 × 148 ($23\frac{5}{8}$ × $58\frac{1}{4}$)
Private collection

In a letter of 19 September 1905 (Elderfield, 1978–1, p. 180, note 6) Matisse wrote from Paris to Simon Bussy that he was at work on a large canvas, in the Neo-Impressionist idiom, depicting the harbour at Collioure. He intended this painting, *Le Port d'Abaill*, as his major submission to the Salon d'Automne in October 1905, but it was not included there, and was first exhibited in Matisse's second one-man show at the Galerie Druet in March–April 1906. This drawing relates closely in composition to the painting, and is exactly the same size. Stylistically, however, it is very different. It has been suggested that it is the cartoon for the painting; yet the 'un-searching' quality of line (in which it differs from other drawings of Collioure harbour done that summer), and the feeling almost of a tracing, raise the question whether it was not in fact done after the painting. The motif of a 1906 small oil on card, *The Sailboats* (Paris, 1970–3, no. 79), which represents the top part of the poster that Matisse painted for the window of the Galerie Druet, relates to the central section of the *Le Port d'Abaill* painting. The present drawing might have been executed in connection with this work, possibly in Paris in early 1906, rather than in the summer of 1905 at Collioure.

13 Jeanne Manguin. (1905–06) (p. 147)
Brush, reed pen and ink on white paper
62.2 × 47 ($24\frac{1}{2}$ × $18\frac{1}{2}$)
The Museum of Modern Art, New York.
 Given anonymously

Very few drawings exist in a fully developed Fauve style comparable to that of Matisse's Fauve paintings. They are mostly portraits and figure studies done in brush and reed pen and black ink in a mixed technique of quick lines, dots and summary shading. The portrait of Jeanne Manguin is the most remarkable among them. The sitter was the wife of Henri Manguin,

Matisse's friend and fellow Fauve artist, whom h[e] met at the studio of Gustave Moreau. Although the emphasis is on the decorative quality of the costume rather than on the facial features, which are rendered cursorily, it is an engaging portrait, and the entire composition is expressiv[e] of the personality of this vivacious young woman.

Baltimore, 1971, no. 14
Elderfield, 1978–1, pp. 46–47, 181–82, note 14
Elderfield, 1983, pp. 42–43
Paris, 1975, no. 25

14 *Two Sketches of a Nude Girl Playing a Flute* (stud[y]
for *Bonheur de vivre*). Paris, 1905–06 (p. 146)
Pencil on white paper
34.5 × 21 ($13\frac{5}{8}$ × $8\frac{1}{4}$)
Fogg Art Museum, Harvard University,
 Cambridge, Massachusetts. Gift of Mr an[d]
 Mrs Joseph Kerrigan

Matisse's major undertaking throughout the autumn and winter of 1905–06 was his first large decorative composition of an arcadian landscap[e] with figures, *Bonheur de vivre* (*Joy of Life*, The Barne[s] Foundation, Merion, Pennsylvania; Barr, 1951, p. 320). Begun in October 1905, it was completed i[n] time to be sent as Matisse's only exhibit to the Salon des Indépendants in March 1906. Matisse must have made numerous preparatory drawings, but only a few sketches for single figures are known (Barr, 1951, p. 321). These two are studies for the figure of the goatherd in the right mid-ground of the composition. In the painted version, the sex is changed, the position is reversed, and he is depicted walking among th[e] trees. The drawing is an exploration of one of th[e] various styles used in the composition, and its stress on linearity indicates Matisse's special interest in the drawing style of Ingres (whose work had been exhibited at the Salon d'Automn[e] in 1905).

Baltimore, 1971, no. 9
Barr, 1951, pp. 81–82, 88–92

15 *Seated Nude*. Paris (1906) (p. 148)
Brush and ink on paper
46.3 × 36.8 ($18\frac{1}{4}$ × $14\frac{1}{2}$)
Private collection

In March 1906 in his second one-man show, at th[e] Galerie Druet in Paris, Matisse exhibited his thre[e] Fauve woodcuts for the first time (Fribourg, 1982[,]

nos 349–51). In preparation, he first made brush and ink studies, and the present drawing is one of the two known to exist (the other one being *Seated Woman*, cat. 16). It corresponds closely in size and composition to the print *Seated Nude* (*Nu, le grand bois*, 1906; Fribourg, 1982, no. 349) and illustrates Matisse's interest in an expressive counterpoint of ornamental patterns resulting from the use of a variety of brushstrokes. The large white area of the body is heavily outlined against a boldly patterned background of Neo-Impressionist dots and vigorous rhythmic lines, the whole indicating Matisse's fascination with Van Gogh's drawing. (There had been a retrospective of his work at the Salon des Indépendants in 1905.) The search for a perfect placement of the figure against the back of the chair can be followed in the pencil underdrawing.

Barr, 1951, pp. 98–99
Elderfield, 1978–1, pp. 48–49
Gowing, 1979, pp. 66–68

16 *Seated Woman*. Paris (1906) (p. 148)
Brush and ink on paper
33.3 × 26.9 ($13\frac{1}{8}$ × $10\frac{5}{8}$)
Private collection

This is a study for the woodcut *Seated Nude Asleep* (*Nu, le bois clair*; Fribourg, 1982, no. 351) and is the second of the two existing drawings (see also cat. 15) done in preparation for the artist's first Fauve woodcuts of early 1906, shown at the Galerie Druet in March of that year. It re-emphasizes Matisse's interest in the decorative effects of an overall ornamental pattern and is especially interesting in the bold distortions of the figure, particularly in the area of her right leg.
See also cat. 15, 17

Barr, 1951, pp. 98–99, 322

17 *Standing Nude, Undressing*. Paris (c. 1906) (p. 149)
Brush and ink on paper
75.2 × 34.3 ($29\frac{5}{8}$ × $13\frac{1}{2}$)
Private collection

This work shows stylistic affinities to the two large brush and ink drawings of 1906 which were preparatory studies for Matisse's Fauve woodcuts (cat. 15, 16) first exhibited at the Galerie Druet in March 1906. It might have in fact been intended as a study for another woodcut that was never executed. The massive figure of the woman standing in a pose slightly reminiscent of the bather drying her hair in Matisse's 1904 painting *Luxe, calme et volupté*, is seemingly pulling off her upper garment; the commonly used English title *Standing Nude, Drying Herself* therefore appears incorrect, particularly since the French title, *Femme debout, se déshabillant*, is a more accurate description. The pose finds its parallel in a bronze sculpture, *Standing Nude* (1906; Elsen, 1972, p. 68, fig. 82), and in another line drawing of the same subject (1907–08) at the Musée Matisse, Nice-Cimiez.

Baltimore, 1971, no. 11
Izerghina, 1978, cat. 56
Paris, 1975, no. 23

18 *Marguerite Reading*. Collioure (1906) (p. 150)
Pen and ink on white paper
39.6 × 52.1 ($15\frac{5}{8}$ × $20\frac{1}{2}$)
The Museum of Modern Art, New York.
Acquired through the Lillie P. Bliss Bequest

This portrait of the artist's daughter Marguerite is a preparatory study for his painting *Portrait of Marguerite: La Liseuse* (1906, Musée de Peinture, Grenoble; Barr, 1951, p. 332). In its economy of line it is an excellent example of Matisse's first unshaded continuous line drawings which appeared around 1906. Matisse treated the same subject in the winter of 1905–06 in his painting *Girl Reading (La Lecture)* (Elderfield, 1978–1, pp. 44–45), one of his truly Fauve works.

Baltimore, 1971, no. 13
Elderfield, 1978–1, pp. 46–47
Paris, 1975, no. 22

19 *Head of a Young Sailor*. Collioure (1906) (p. 150)
Pencil on paper
25.4 × 18.4 (10 × $7\frac{1}{4}$)
Art Gallery of Ontario, Toronto. Sam and Ayala Zacks Collection

As Alfred Barr pointed out (Barr, 1951, pp. 93–94), Matisse's figure paintings during 1906–07 display a diversity of styles which can be analysed in two versions of the painting *Young Sailor* (Barr, 1951, pp. 334–35) done in the summer of 1906 at Collioure. The present drawing is a study of the head and hand of the sailor. The model was the artist's son Pierre. It was done in preparation for the first version of the painting, to which it

corresponds almost exactly, especially in the bold contour of the face and neckline and in the shading of the right cheek. The erased pencil lines visible around the outline of the hand indicate the artist's search for a compositionally perfect placement of the hand. The thoughtful mood of the drawing is conveyed with equal intensity in the first painted version but disappears in the second, where it is replaced by more stylized, simplified forms.

Toronto, 1971, no. 106
Baltimore, 1971, no. 12
Barr, 1951, pp. 93—94, 334—35
Paris, 1975, no. 26

20 *Man Reclining.* (c. 1909) (p 151)
Pencil on paper
23.5 × 30.8 $\left(9\frac{1}{4} \times 12\frac{1}{8}\right)$
The Metropolitan Museum of Art, New
York. The Alfred Stieglitz Collection, 1949

This sculpturesque male nude is considered a companion piece to the drawing *Seated Nude Leaning on her Arm* (The Metropolitan Museum of Art, New York; Barr, 1951, p. 323), recently redated to c. 1908 on the grounds of its first publication in the Russian art review *Zolotoe Runo* (*The Golden Fleece*) in mid 1909. Hence *Man Reclining* might also be of a slightly earlier date. It is known to have been first exhibited in Matisse's second American one-man show in February—March 1910 at the Alfred Stieglitz Gallery '291' in New York, and was subsequently reproduced in Stieglitz's publication *Camera Work* in October 1910 (no. XXXII, pl. 31, no. 32). It seems to be one of the last representations of male nudes in Matisse's work. After the execution in 1910 of his second large decorative panel for Shchukin, *Music*, which depicts five male nudes, Matisse's attention focused primarily on the female nude.

Paris, 1973—74, no. 60, pl. 85
Paris, 1975, no. 34

21 *Standing Nude Seen from the Back.* (Issy-les-
Moulineaux, 1909) (p. 151)
Pen and dark brown ink on wove paper
29 × 18.5 $\left(11\frac{3}{8} \times 7\frac{1}{4}\right)$
National Gallery of Canada, Ottawa/Galerie
nationale du Canada, Ottawa

This drawing, in a style reminiscent of Matisse's pen and ink drawings of 1900—03, represents a study for the first of Matisse's group of imposing

life-size reliefs, the *Backs* (I-IV; Elsen, 1972, figs 246, 248, 250, 252) made between 1909 and 1929. Through a system of hatching and cross-hatching the work investigates the relationship of the figure t the ground, in preparation for its three-dimensional rendering. It was probably done in the autumn of 1909 at an intermediate stage whe Matisse was in all likelihood reworking his plaster *Back 0* (Elsen, 1972, fig. 245) into *Back I*. (Comparable drawings are *The Back*, 1909, The Museum of Modern Art, and *Etude d'un nu*, of the same date, National Gallery, Prague.) The dating is corroborated by the presence of the wood-panelled wall of Matisse's new studio at Issy-Les-Moulineaux to which he moved at the beginnin of the autumn of 1909.

Barr, 1951, pp. 141—42
Elderfield, 1978—1, pp. 72—80, 193—95
Elsen, 1972, pp. 180—97
Zürich, 1982—2, cat. 66

22 *Study of Movements for Dance II.* (1909—10) (not
illustrated)
Ink, graphite and crayon on paper
Six drawings: 109.5 × 79.5 $\left(43\frac{1}{8} \times 31\frac{1}{4}\right)$
Private collection

Between the early spring of 1909 and the summer of 1910, Matisse's creative energies were concentrated on the large decorative panels *Dance* and *Music*, commissioned by his Russian patron Sergei I. Shchukin in 1909. The first version of *Dance* — a full-size sketch, *Dance I* (The Museum of Modern Art, New York) — was painted in March 1909 and the final version, *Danc II* (Hermitage, Leningrad) was worked on durin the winter 1909—10 and completed in the summer of 1910, with its composition significantly modified. The present drawings are the only known preparatory studies for *Dance II*, althoug a charcoal drawing at the Musée de Peinture, Grenoble (cat. 23) has also be considered as such. Five other works (two watercolours and three drawings) are related to both *Dance I* and *Dance I* (The Museum of Modern Art, New York, and the Hermitage, Leningrad; see also cat. 23) but ar not preparatory studies.

Elderfield, 1978—1, pp. 54—58, 185—87
Izerghina, 1978, cat. 29, pp. 149—51
Paris, 1975, no. 36

23 *Study for Dance*. Paris (c. 1910) (p. 152)
Charcoal on white paper mounted on card
48 × 65 ($18\frac{7}{8}$ × $25\frac{5}{8}$)
Musée de Peinture, Grenoble. Agutte-
Sembat Bequest 1923

In 1910 Matisse completed the final, second
version of the *Dance* (known as *Dance II*;
Hermitage, Leningrad), one of the two decorative
panels commissioned in 1909 by the Russian
collector Shchukin for the staircase of his house
in Moscow. The present drawing has been
variously attributed, as a study for *Dance I* (1909;
The Museum of Modern Art, New York), and as
a study for *Dance II* because the poses and
movements of the figures relate to both versions.
However, because the movement of the figures
here is much less frantic than in *Dance II*, and the
drawing is executed in a broken line (a
characteristic of later works, e.g. *Girl with Tulips*,
1910, cat. 24), it is possible – as Neff suggests (Neff,
1974, p. 143) – that it is the same charcoal drawing
that Sembat mentioned in 1913 as having been
drawn by Matisse, after *Dance II* was completed,
in a calmer mode than the painting, which the
artist felt was too 'passionate, too dionysiac, too
agitated' (Sembat, 1920, p. 9). A number of other
works related to the *Dance* panels include a
watercolour, *The Dance. Composition No. I* (1909,
Pushkin Museum, Moscow); a pencil study of
the movements for *Dance II* (1909–10, cat. 22); a
watercolour *The Dance* (1911, Musée de Peinture,
Grenoble) painted for Madame Marcel Sembat
after the Hermitage painting, a 1911 pen and ink
drawing (private collection) based on the
composition of *Dance II*, and a pencil study after
the painting *Dance I* (both: The Museum of
Modern Art, New York; all reproduced in
Elderfield, 1978–1, pp. 57, 185–87).

Baltimore, 1971, no. 18
Elderfield, 1978–1, pp. 54–58, 185–87
Grenoble, 1963, no. 133
Izerghina, 1978, cat. 29, pp. 149–51
Neff, 1974, p. 143
———, 1975, pp. 40–44
Paris, 1975, no. 35
Sembat, 1920, p. 9

24 *Girl with Tulips (Jeanne Vaderin)*. Issy-les-
Moulineaux (1910) (p. 153)
Charcoal on paper
73 × 58.4 ($28\frac{1}{4}$ × 23)
The Museum of Modern Art, New York.
Acquired through the Lillie P. Bliss
Bequest

Matisse's mastery in portraiture achieves its
height in this expressive image of a young
woman holding a plant. The model was Jeanne
Vaderin, a young woman then convalescing at
Clamart (near Issy-les-Moulineaux), who also
posed for the oil painting *Girl with Tulips (Portrait of
Jeanne Vaderin)* (1910, Hermitage, Leningrad) and a
series of five sculptured heads of *Jeannette* that
evolved in 1910–13 (Elsen, 1972, figs 168, 171, 173, 175,
177). Since the painting was shown at the Salon
des Indépendants in mid March 1910 as Matisse's
only submission, the drawing was probably
completed at the beginning of that year.

Barr, 1951, p. 131
Elderfield, 1978–1, pp. 64–65
———, 1983, pp. 56–57
Elsen, 1972, pp. 122–34
Izerghina, 1978, cat. 33
Paris, 1975, no. 37

25 *Zorah Seated*. (Tangier, autumn 1912) (p. 155)
Brown oil on canvas
113.6 × 78.7 ($44\frac{3}{4}$ × 31)
Private collection

This drawing demonstrates Matisse's fascination
with exotic, oriental themes. In the winter of
1911–12 and again in the autumn and winter of
1912–13, Matisse made extended visits to Tangier.
During both periods he used the same young
model, Zorah, who posed for several paintings:
Zorah Standing (1912, Hermitage, Leningrad), *Zorah in
Yellow* (1912, private collection, Chicago), and *Zorah
on the Terrace* (1912, Hermitage, Leningrad), the
central panel of the so-called 'Moroccan
triptych' acquired in 1913 by the Russian collector
Morozov. It has been suggested that *Zorah Seated*
might represent the original concept for the
central panel of the triptych, as it is drawn on a
canvas whose dimensions conform to those of
the two side sections, and that it was eventually
replaced by a wider canvas of *Zorah on the Terrace*. A
pen and ink drawing, *Three Girls' Heads, Tangier*
(1912, Isabella Stewart Gardner Museum, Boston),
which constitutes three sketches of Zorah's head,
is probably related to the present work.

Baltimore, 1971, no. 20
Barr, 1951, pp. 145, 154, 159
Izerghina, 1978, cat. 45
Paris, 1975, no. 43

26 *Sergei I. Shchukin*. Paris, 1912 (p.154)
Charcoal on white paper
49.5 × 30.5 (19$\frac{1}{2}$ × 12)
Private collection

This is a preparatory study for an intended
portrait of Matisse's foremost patron and
collector, the Russian merchant, Sergei
Shchukin, whose collection included thirty-nine
Matisses, among them two of his most important
decorative commissions, *Dance* and *Music*.
Marguerite Duthuit recalled that while posing
for his portrait Shchukin received news of his
brother's death, and was obliged to depart for
Moscow. The portrait itself was never executed,
and only this sketch remains. Done in short,
almost violent, strokes, it is a forceful
characterization of the sitter, with particular
emphasis on the area around the eyes. The same
technique can be seen in the *Study of a Nude*, 1912–13
(cat. 27), and also to some degree in the
treatment of the eyes in the *Portrait of André
Rouveyre* (1912, Musée National d'Art Moderne,
Paris; Pompidou, 1979, no. 33).

Baltimore, 1977, no. 19
Barr, 1951, pp. 24, 106
Paris, 1975, no. 40

27 *Study of a Nude*. Paris (1912–13) (p. 156)
(*Etude de femme nue, debout, à mi-corps*)
Charcoal on paper mounted on card
49 × 29 (19$\frac{1}{4}$ × 11$\frac{3}{8}$)
Musée de Peinture, Grenoble. Agutte-
Sembat Bequest 1923

The present study, which shares certain stylistic
characteristics with *Sergei I. Shchukin* (1912, cat. 26),
was drawn from the model Germaine Raynal
who posed for Matisse on numerous occasions in
1912, 1913 and 1914 (see also cat. 28). She was the wife
of the Cubist critic Maurice Raynal and a close
friend of Juan Gris, who also painted her portrait
in 1913. The pose of this drawing is echoed in
Matisse's lithograph *Torso* (1914, Fribourg, 1982,
no. 367). Also, the unconventional compositional
device of placing the figure frontally to fill the
sheet, with the head cut off by the top edge of
the page, can be found later in such drawings as
Elsa Glaser (1914, The Art Institute of Chicago;
Baltimore, 1971, no. 24), *Josette Gris* (1915, private
collection; Paris, 1975, no. 49) and *Study for Portrait of
Sarah Stein* (1915–16, cat. 42).

Grenoble, 1963, no. 134

Paris, 1975, no. 41
Sembat, 1920, p. 5

28 *Reclining Nude*. (Paris, 1914) (p. 157)
Pen and red ink on paper
20.8 × 26.7 (8$\frac{1}{8}$ × 10$\frac{1}{2}$)
Private collection, Switzerland

According to the recollections of Matisse's
daughter Marguerite Duthuit, the model for th[
drawing was also Germaine Raynal (see cat. 27),
the wife of the Cubist art critic Maurice Raynal
and one of the closest friends of Juan Gris. She
had posed for Matisse in the early months of 191[
for the painting *Woman on a High Stool* (The
Museum of Modern Art, New York) and was als[
the subject of several lithographs done during
that year. Since, stylistically, the quality of line
resembles that of the lithographs, particularly
the *Torso* (1914; Fribourg, 1982, no. 367), the presen[
sheet would seem to have been executed within
that year also.

Zürich, 1982–2, no. 69

29 *Yvonne Landsberg*. Paris, July 1914 (p. 158)
Pen and ink on white paper
65 × 50.2 (25$\frac{5}{8}$ × 19$\frac{7}{8}$)
The Museum of Modern Art, New York.
Alva Gimbel Fund

In the spring of 1914 Matisse was commissioned t[
make a portrait drawing of Yvonne Landsberg, a[
young woman of nineteen from a Brazilian
family then living in Paris. Having executed the
commission – apparently a naturalistic full-face
likeness (it has never been published) – Matisse
then asked the sitter to pose for a portrait in oils
which he completed during the spring and
summer of 1914. The painting (*Yvonne Landsberg*,
Philadelphia Museum of Art) is among Matisse'[
most radical of that period and indicates a certa[
discourse with the Cubist idiom. The sittings
took place at Matisse's studio at Quai Saint-
Michel, and in between Matisse made numerou[
drawings and five etchings of Yvonne at rest.
These depict her in a variety of poses, and are
exemplified by this and the four drawings that
follow. These studies show different emphasis o[
the sitter's features and personality. Reputedly,
Yvonne Landsberg was almost morbidly shy and
retiring, tall and graceful but not particularly
pretty because of a receding chin and prominen[
nose. Here, the rendering in quick pen strokes

plays down the latter characteristics. By presenting the sitter in a pose that gives prominence to the figure rather than to the face, and by emphasizing aspects of the dress, he thus conveys her personality through the entire composition. This, as well as cat. 30, seem to be part of the series done during the same session and can be dated to July 1914.

Barr, 1951, pp. 184–85
Elderfield, 1978–1, pp. 96–97
Lavin, 1981, ch. 1

30 *Yvonne Landsberg Smoking.* Paris, July 1914 (p. 158)
Pencil on paper
50.2 × 32.7 ($19\frac{3}{4}$ × $12\frac{7}{8}$)
Pierre Matisse Gallery, New York

See cat. 29.

31 *Mademoiselle Yvonne Landsberg.* Paris, July 1914 (p. 158)
Charcoal on paper
65.5 × 51 ($25\frac{3}{4}$ × $20\frac{1}{8}$)
Private collection

This drawing, from the series of studies related to the oil painting of Yvonne Landsberg, shows her in the pose most closely recalling that of the painting and in fact resembling the early state of the painting, as documented by a recent X-ray (Lavin, 1981, p. 7, fig. 12). It probably followed the preceding sketches.
See also cat. 29.

Lavin, 1981, pp. 6–8

32 *Yvonne Landsberg.* Paris, August 1914 (p. 159, above)
Pencil on paper
51 × 42.5 ($20\frac{1}{8}$ × $16\frac{3}{4}$)
Private collection

According to Barr, the present sheet, inscribed 'August 1914' must have followed the finished version of the painting and might have been done from memory after Yvonne's family departed for Brazil at the outbreak of the First World War in August 1914. It exaggerates the facial features almost to the point of caricature and thereby significantly differs from the other sheets (cat. 29–31), which are rather sympathetic portraits of the young sitter.
See also cat. 29.

Baltimore, 1971, no. 26
Barr, 1951, p. 184

33 *Yvonne Landsberg.* Paris, August 1914 (p. 159, below)
Pencil on tracing paper
28.2 × 21.7 ($11\frac{1}{8}$ × $8\frac{1}{2}$)
The Museum of Modern Art, New York. Gift of The Lauder Foundation, Inc.

This is a tracing from a photograph of the previous, larger drawing (cat. 32). It has been suggested that the original work was scaled down in preparation for eventual reproduction as an etching, hence the repeated signature.
See also cat. 29.

Baltimore, 1971, no. 26
Barr, 1951, p. 184
Elderfield, 1978–1, p. 97

34 *Portrait of Marguerite.* (1915) (p. 160)
Brush and ink on paper
47 × 28 ($18\frac{1}{2}$ × 11)
Collection J. R. Gaines, Lexington, Kentucky

This is one of the later portraits of the artist's daughter Marguerite (see also cat. 11, 18). Although the date sometimes suggested for this work is 1905–06, according to the recollections of the sitter, the drawing was in fact executed at the beginning of the summer in 1915, near Arcachon. The freedom and vivacity of line corroborate the later date, although similar quality of line can also occasionally be found earlier. Moreover, Marguerite, who was born in 1894, would have been only eleven or twelve years old, if the early date were to be accepted. She is clearly quite mature in the present drawing (conceivably around twenty-one), and seems closer in age to her 1916 portrait *Marguerite Matisse. Head with Black Velvet Ribbon* (Matisse family collection; Paris, 1970–3, no. 143).

35 *Portrait of a Girl.* (c. 1915) (p. 161)
Charcoal and crayon on paper
35 × 25.4 ($13\frac{3}{4}$ × 10)
Mr and Mrs Eugene V. Thaw

Matisse must have considered this work an excellent example of his portrait drawing, for he chose to reproduce it in the book *Portraits*, published in 1954 under his own supervision by André Sauret. There it is listed as a portrait of

Cocoly Agelasto, executed in 1915. Although sometimes dated in the late 1920s, it is far more similar in style to drawings done in 1915. The treatment of the nose is comparable to that in the portrait drawing *Greta Prozor* (cat. 44) of winter 1915–16. The tubular treatment of the neck is similar to the device used in the painting *Head, White and Rose* (1915, Musée National d'Art Moderne, Paris). Finally, the rendering of the lock of hair on the girl's left shoulder closely resembles that found in some paintings of Lorette of 1916–17.

Portraits, *1954, p. 30*

36 *Madame Matisse.* Issy-les-Moulineaux (summer 1915) (p. 162)
Crayon on paper
$63 \times 48 \ (24\frac{3}{4} \times 18\frac{7}{8})$
Musée Matisse, Nice-Cimiez

In the autumn of 1914, probably as a result of numerous discussions with Juan Gris, Matisse began to assimilate certain aspects of Cubism. This process affected his drawing slightly later than it did his painting. Among the few known drawings of his Cubist period of 1914–16, the present study illustrates an attempt to incorporate elements of Cubist structure into a conventional naturalistic portrait. Revisions and erasures visible in several areas of the face, hat, and neck, and the grid superimposed on the face, indicate various stages in his analysis of form and its spatial projection, demonstrating his experimentation with the human figure seen in terms of the construction of different planes.

Baltimore, *1971, no. 30*
Carlson, *1971, pp. 38–39*
Paris, *1975, no. 50*

37 *Study for Still-life after de Heem.* 1915 (p. 163)
Graphite on two sheets of paper
$52.3 \times 55.2 \ (20\frac{5}{8} \times 21\frac{3}{4})$
Philadelphia Museum of Art. The Louise and Walter Arensberg Collection

This drawing is one of the three known preparatory studies for Matisse's most complex Cubist painting *Variation on a Still-life by de Heem* of 1915 (The Museum of Modern Art, New York). The subject derives from the artist's own painting of 1893, *Copy after 'The Dessert' by de Heem* (Musée Matisse, Nice-Cimiez). *The Dessert*, of 1640,

was among Matisse's favourite paintings that he copied at the Louvre during his student years in Gustave Moreau's studio. The present drawing depicts a fragment of the central section of the composition. It also repeats a segment of the second, smaller, and more sketchy drawing at the Musée Matisse, Nice-Cimiez, but in a larger and more carefully finished form, conveying the richness of the surfaces and the strict geometric structure of the objects represented. A photograph of a third drawing (location unknown), in the Witt Library, Courtauld Institute, London, entitled *Table à la corbeille de fruit*, shows the portion of the central section of the still-life to the right of this fragment.

Baltimore, *1971, no. 29*
Carlson, *1971, p. 37*

38 *La Coupe de raisin.* (1915) (p. 164)
Pencil on paper
$55 \times 36 \ (21\frac{3}{4} \times 14\frac{1}{4})$
Collection Marshall Cogan, New York

Depictions of fruit or still-lifes with fruit recur frequently among Matisse's subjects, and the present drawing, of a dish of grapes, seems to foreshadow his paintings *Apples* (The Art Institute of Chicago) and *Oranges* (private collection, Paris) of 1916. It is striking in its simplicity, which is enhanced by the frontal placement and lack of any other compositional object.

39 *Still-life with Oriental Bowl.* Issy-les-Moulineaux (autumn 1915) (p. 165)
Pencil on paper
$74 \times 54 \ (29\frac{1}{8} \times 21\frac{1}{4})$
Private collection

This still-life – quite unique in its arrangement of isolated objects – was first exhibited in the winter of 1915–16 at Germaine Bongard's in Paris and was subsequently reproduced in December 1916 in the esoteric art revue *L'Elan* published by Amédée Ozenfant throughout 1915 and 1916. It is generally related to Matisse's 1916 painting *The Gourds* (The Museum of Modern Art, New York) with which it shares compositional relationships and a similar preoccupation with abstract space. The bowl with fruit (without the pineapple) and the sculpture stand, vestiges of which are visible above the bowl, can also be found in the painting

Still-life with a Bust (1916, Barnes Foundation, Merion, Pennsylvania).

Barr, 1951, pp. 189–90
Elderfield, 1978–1, pp. 113, 120
Paris, 1975, no. 47

40 *Vase with Geraniums.* (1915) (p. 162)
Crayon on paper
65 × 48 ($25\frac{5}{8}$ × $18\frac{7}{8}$)
Musée Matisse, Nice-Cimiez

This drawing reveals certain Cubist spatial concerns and explores the relationships of contrasting forms. Comparable treatment of the forms can be found in a 1916–17 painting of the *Trees at Trivaux* (Tate Gallery, London).

Baltimore, 1971, no. 31

41 *Eva Mudocci.* Paris (1915) (p. 167)
Crayon on cream paper
92.6 × 70.5 ($36\frac{1}{2}$ × $27\frac{3}{4}$)
Collection Pierre Matisse

This portrait of the violinist Eva Mudocci is probably the most remarkable of Matisse's drawings. The complex compositional structure demonstrates the artist's discourse with Cubism and his adaptation of Cubist principles into his own idiom. In the winter of 1914–15, being deeply disturbed by the outbreak of the First World War, Matisse tried to find comfort by renewing his interest in music, particularly the Baroque classics; he even began playing the violin again. This drawing may therefore have been made early on in 1915. He made a series of portrait studies of the famous Eva Mudocci, whom Munch had immortalized in his lithograph *Madonna* of 1903. The two other extant drawings of Eva Mudocci (both in private collections, Paris; *Portraits*, 1954, p. 27; Berggruen, 1982, no. 5) are more naturalistic representations of the sitter than the present drawing, where vestiges of earlier, naturalistic depiction are visible only in the erasures around the outline of the face and shoulder on the right side of the picture. The fact that the drawing is composed on three sheets of paper is indicative of the changes in conception and the evolution of the creative process.

Baltimore, 1971, no. 27
Barr, 1951, p. 178
XX siècle, 1970, p. 100

Paris, 1975, no. 51
Portraits, 1954, p. 27

42 *Study for Portrait of Sarah Stein.* Paris, winter 1915–16 (p. 168)
Charcoal on paper
48.5 × 32.1 ($19\frac{1}{8}$ × $12\frac{5}{8}$)
San Francisco Museum of Modern Art. Gift of Mr and Mrs Walter A. Haas

Previously known as *Sketch of Sarah Stein*, this study for the painting *Portrait of Sarah Stein* (1916, San Francisco Museum of Modern Art; Barr, 1951, p. 404) is another key work among Matisse's Cubist drawings. The sitter, the wife of Michael Stein and sister-in-law of Gertrude Stein, was one of Matisse's earliest patrons. She was a close friend, and a pupil at his school of painting, which she helped to organize in 1908. Her carefully taken notes when attending Matisse's class have become an invaluable source of information on Matisse's views on art and his teaching method. The drawing has a certain mask-like quality resulting from the great simplification of means achieved through a highly formalized and schematic vocabulary of form. The unusual placement of the figure, which fills the entire sheet and seems to extend beyond its edge because the upper part of the head is cut off, adds to the monumentality of the composition. This device had been foreshadowed in such earlier drawings as the portraits of *Elsa Glaser* (1914, Art Institute of Chicago; Baltimore, 1971, no. 24) and *Portrait of Josette Gris* (1915, private collection, France; fig. 24).

Barr, 1951, p. 187
Flam, 1973, pp. 14, 41–42

43 *Greta Prozor.* Paris, winter 1915–16 (p. 170)
Pencil on paper
55.5 × 37 ($21\frac{7}{8}$ × $14\frac{9}{16}$)
Musée National d'Art Moderne, Paris. Centre Georges Pompidou

In the winter of 1915–16 Matisse made a series of drawings of Greta Prozor in preparation for her portrait in oils. Daughter of Count Prozor, Greta Prozor was an actress and the wife of the Norwegian art dealer Walter Halvorsen, who was also a pupil at the Académie Matisse. She performed in plays by Ibsen (translated by her father) at the Théâtre de l'Oeuvre of Lugné Poe in Paris. This pencil study of her is the closest to

her final painted portrait (Musée National d'Art Moderne, Paris). The evolution of the drawing can be followed in the pencil lines visible around the outline of the face at her left cheek, shoulder and neck, which indicate that the figure was originally placed lower and more toward the right. Also visible are changes in outline and in the position of the hat. The shadow along the left side of her nose is reminiscent of the Cubist influence present in the *Head, White and Rose* (1915, Musée National d'Art Moderne, Paris), although it is not as strictly geometric. The facial expression and bearing of the torso convey the softness and dignity of the sitter, as well as a sense of her vulnerability and reserve. Three other drawings, one etching and one drypoint of Greta Prozor are also known to exist.

Fourcade, 1983, pp. 102–04
Paris, 1975, no. 53
Pompidou, 1979, no. 34

44 *Greta Prozor.* Paris, winter 1915–16 (p. 169)
Pencil on paper
55 × 36 ($21\frac{5}{8}$ × $14\frac{1}{8}$)
Private collection

This is the most geometricized of the four known studies for the portrait of Greta Prozor. The broad structure of the figure and the economy of its linear vocabulary relate it closely to such works as *Eva Mudocci* (cat. 41) and *Study for Portrait of Sarah Stein* (cat. 42).
See also cat. 43.

Paris, 1975, no. 52
Pompidou, 1979, p. 30

45 *Group of Trees at L'Estaque.* (1916) (p. 166)
Charcoal on paper
62.3 × 47.6 ($24\frac{1}{2}$ × $18\frac{3}{4}$)
Musée National d'Art Moderne, Paris.
 Centre Georges Pompidou

In December 1915, following a short trip to Marseilles with his friend Albert Marquet, Matisse made a brief visit to L'Estaque, a fishing village north of Marseilles. The present sheet is possibly the drawing of pine trees which Matisse described in his letter to Camoin of 19 January 1916 as a depiction of 'the trees along the other side of the road that lead to the restaurant at the jetty.' It is executed in a quasi Cubist idiom, which may have been stimulated by the association of the place with such early Cubist

paintings as Braque's *Road near L'Estaque* (1908, The Museum of Modern Art, New York), *House and Trees* (1908, Kunstmuseum, Bern), and *The Forest, L'Estaque* (1908, Statens Museum for Kunst, Copenhagen).

Paris, 1975, no. 48
Revue de l'art, 1971, p. 19

46 *Portrait of a Woman.* (c. 1916) (p. 170)
Black chalk and pencil over charcoal on vellum
35 × 25.1 ($13\frac{3}{4}$ × $9\frac{7}{8}$)
Department of Prints and Drawings, The Royal Museum of Fine Arts, Copenhagen

This drawing is probably a study of the head of Lorette, the Italian model who posed for Matisse from late 1915 to 1917 and who appears in several compositions and portraits from that time. Barr reports that Matisse had done numerous studies of Lorette's head alone. The present charcoal may be one of those drawn in preparation for the canvas *Two Sisters* (1916, Denver Art Museum), which was modelled after Lorette and her younger sister. The tilt of Lorette's head and her hairstyle in the painting seem to echo those in the drawing. Another, even more beautiful and more resolved drawing in pencil and charcoal (formerly from the same collection of Herbert Melloye, Copenhagen; Sotheby's, London, July 1970, cat. 44) seems to be part of the same series of studies.

Barr, 1951, pp. 191–92, 417

47 *The Plumed Hat.* Nice (c. 1919) (p. 171)
Pencil on off-white wove paper
49 × 37 ($19\frac{3}{8}$ × $14\frac{5}{8}$)
The Baltimore Museum of Art. The Cone Collection, formed by Dr Claribel Cone and Miss Etta Cone of Baltimore, Maryland (BMA 1950.12.58)

Probably the most celebrated group of drawings within Matisse's oeuvre is a suite of works from his early Nice period, *The Plumed Hat*, executed during 1919. It is composed of a score of sheets and four paintings (Schneider, 1982, nos 295–98) depicting the artist's favourite model at the time, nineteen-year-old Antoinette, wearing an extraordinary hat of white feathers and black ribbons that Matisse created himself. Several drawings are preparatory studies for the paintings, the most famous of which is *White

Plumes (1919, Minneapolis Institute of Arts). Others are independent works, occasionally composed as groups within the series, such as the present drawing, which is one of four showing Antoinette in a Jewish robe. Some, such as this one and the following three, are elaborate studies emphasizing the decorative quality of the costume and hat. Others are very simple line drawings. Many of them are reproduced in Matisse's first book on his drawings, *Cinquante dessins*, published in 1920.

Baltimore, 1971, no. 34
Baltimore, 1979, p. 94
Barr, 1951, pp. 206, 428
Cinquante dessins, *1920*
Salinger, 1932, pp. 9–10
Paris, 1975, nos 57–63

48 *A Young Girl, with Plumed Hat, in Profile.* Nice (*c.* 1919) (p. 172)
Pencil on ivory paper
37.2 × 24.7 $(14\frac{5}{8} \times 9\frac{3}{4})$
The Baltimore Museum of Art. The Cone Collection, formed by Dr Claribel Cone and Miss Etta Cone of Baltimore, Maryland (BMA 1950.12.41)

The drawings from *The Plumed Hat* series display a great range of moods in their representation of the subject. Here, Matisse concentrates on the decorative quality of the hat, the flowing rhythm of sinuous line, and the sensuous mouth of the model. The pose, the dress, and the arrangement of the hair relate this drawing to the *White Plumes* painting formerly in the Gothenburg Art Gallery. See also cat. 47.

Baltimore, 1971, no. 35
Barr, 1951, p. 206
Cinquante dessins, *1920, pl. XXX*

49 *Antoinette Wearing Plumed Hat.* Nice (*c.* 1919) (p. 173)
Pen and ink on white paper
26.9 × 36.5 $(10\frac{5}{8} \times 14\frac{3}{8})$
The Art Institute of Chicago. Gift of The Arts Club of Chicago, 1927.1616

This drawing might be considered a study of the decorative qualities of Antoinette's hat, exploring, through the differentiation of brushstrokes, the juxtaposition of the light feathery quality of the plume and the heaviness of the velvet ribbon. It gives the impression of being an overhead close-up view of the hat depicted in cat. 48.
See also cat. 47, 48.

Baltimore, 1971, no. 36
Barr, 1951, pp. 206, 429
Paris, 1975, no. 62

50 *The Plumed Hat.* Nice (1919) (p. 173)
Pencil on ivory wove paper
54 × 36.5 $(21\frac{1}{4} \times 14\frac{3}{8})$
The Museum of Modern Art, New York. Gift of The Lauder Foundation, Inc.

Within *The Plumed Hat* series this drawing is among the most finished and technically accomplished. It is also one of the three published sheets representing Antoinette full-length, seated in an armchair facing the viewer. (The others are a full-length portrait at the Fogg Art Museum, Cambridge; *Cinquante dessins*, 1920, pl. XVII; and a pen and ink study in a private collection in Paris; Paris, 1975, no. 63.)

Barr, 1951, no. 206
Cinquante dessins, *1920, pl. XVI*

51 *Antoinette au chapeau à plumes.* (1919) (p. 172)
Pencil on paper
67 × 49.5 $(26\frac{3}{8} \times 19\frac{1}{2})$
Private collection

See cat. 47.

52 *The Plumed Hat.* Nice, 1919 (p. 175)
Pencil on paper
34.9 × 29.2 $(13\frac{3}{4} \times 11\frac{1}{2})$
Mr William R. Acquavella, New York

This drawing seems to be the closest in pose and composition to the painting *White Plumes* at the Minneapolis Institute of Arts. The thin feathery lines describing the plumes of the hat enhance the mood of delicate sensuousness of the model's face. Another drawing, equally complete, showing Antoinette in an almost identical position but in three-quarter view, is in the collection of the Detroit Institute of Arts (Baltimore, 1971, no. 37).
See also cat. 47.

Barr, 1951, p. 206
Paris, 1975, no. 58

53 *Seated Woman.* Issy-les-Moulineaux (summer 1919) (p. 176)
Pencil on white paper
35.1 × 25.2 (13$\frac{13}{16}$ × 9$\frac{15}{16}$)
Courtauld Institute Galleries. Courtauld Collection, London

For the summer of 1919 Matisse returned from Nice to his studio at Issy-les-Moulineaux. He also brought with him the model Antoinette (cat. 47–52, 54), who posed there for two canvases, the *Black Table* (private collection, Switzerland) and *Tea* (Los Angeles County Museum of Art, Los Angeles, California). The present drawing is a study for the right side of the *Black Table*. The rendering of the model's costume shows the same finished quality and mastery of minute detail that is apparent in the drawings of *The Plumed Hat* suite, and which Aragon compares to the drawing of Ingres.

Aragon, 1971, vol. II, pp. 103–09
Barr, 1951, pp. 196–97

54 *Sleeping Figure (La Gandoura).* (1919) (p. 176)
Pencil on paper
36.4 × 27 (14$\frac{3}{8}$ × 10$\frac{5}{8}$)
Private collection

This drawing of Antoinette at rest explores the subject of the sleeper, in a pose familiar from such earlier paintings as *The Painter and His Model* (1917, Musée National d'Art Moderne, Paris; Pompidou, 1979, no. 11) and *Lorette in Green, in Rose Armchair* (1917, private collection, Switzerland; Paris, 1970–3, no. 146). Here, Antoinette is wearing the *gandoura*, a loosely fitting North African garment, its voluminous folds covering the lower part of her body. She is seated in the same chair as in the *Seated Woman* (cat. 53) which might suggest that the two drawings were done in the same place, at around the same time.

Paris, 1975, no. 56

55 *Tête d'Antoinette.* 1919 (p. 174)
Pencil on paper
40 × 49.5 (15$\frac{3}{4}$ × 19$\frac{1}{2}$)
Private collection

The present sheet was among the works first reproduced in Matisse's book *Cinquante dessins*, published in 1920 (p. XII).
See also cat. 47.

56 *Reclining Model.* (Nice, c. 1919) (p. 177)
Pencil on ivory paper
36.5 × 53.9 (14$\frac{3}{8}$ × 21$\frac{3}{16}$)
Yale University Art Gallery, New Haven, Connecticut. Gift of Edith Malvina K. Wetmore

The present sheet belongs to the group of drawings depicting the model Antoinette reclining against a patterned background of a chaise-longue (cat. 57). It was among the artist's selection of his recent works (1918–20) reproduced in *Cinquante dessins*, published in 1920 (pl. XIX).

Baltimore, 1971, no. 32

57 *Antoinette étendue sur une chaise-longue.* (1919) (p. 174)
Pencil on paper
59 × 67 (23$\frac{1}{4}$ × 26$\frac{3}{8}$)
Private collection

A similar drawing of Antoinette resting in the same chaise-longue is reproduced in *Cinquante dessins*, 1920, pl. XX.
See also cat. 47.

58 *Portrait of Massine.* Monte Carlo, 1920 (p. 178)
Pencil on paper
39 × 28.5 (15$\frac{3}{8}$ × 11$\frac{1}{4}$)
The Art Institute of Chicago. Samuel Mar Purchase Fund. 1972.427

This expressive, meticulously drawn portrait of Léonide Massine, the young Russian dancer and choreographer for Diaghilev's Ballets Russes, w made at the time of Matisse's commission to design costumes and stage sets for Diaghilev's 19 production of *Le Chant du rossignol*. Based on Stravinsky's opera *Le Rossignol*, the ballet was choreographed by Massine, who developed an admiration for Matisse's painting and purchased one of his canvases, *The Gourds* (1916, The Museum of Modern Art, New York). While working on the design, Matisse often consulted Diaghilev an Massine, travelling from Nice to Monte Carlo, and this drawing must have been done during one of those trips. Two other portraits of Massine, also dated 28 April 1920, are known to exist (Paris, Bibliothèque Nationale).

Barr, 1951, pp. 197, 207–08, 412
Paris, 1981, nos 167–69

59 *Open Window at Etretat.* (1920) (p. 179)
Pen and ink
22.8 × 17.5 (9 × 6⅞)
Collection J. R. Gaines, Lexington,
Kentucky

Among Matisse's favourite subjects was the open interior, particularly one flooded with light. His fascination with the motif of the open window began in the 1890s and culminated in the audacious Fauve canvas *The Open Window, Collioure* (1905, Collection Mr and Mrs John Hay Whitney, New York) shown at the famous Salon d'Automne of 1905. There are several representations of this theme during the second decade of the twentieth century, and it becomes one of the most prominent subjects in the 1920s in Nice. The present drawing was executed in the summer of 1920 when, following a trip to London, Matisse spent several weeks at Etretat in Normandy where he painted over thirty canvases, depicting the cliffs, boats on the shore, and various marine still-lifes. Among these, *Interior, 14 July, at Etretat* (1920, Feichenfeldt Collection, Zürich) depicts an open window and emphasizes the interplay of decorative surfaces in a similar way to the present sheet.

Barr, 1951, p. 197

60 *Seated Model with Guitar.* Nice (1922) (p. 181)
Charcoal and estompe on paper
47 × 31.1 (18½ × 12¼)
Art Gallery of Ontario, Toronto. Gift of
Sam and Ayala Zacks

During the 1920s Matisse's favourite drawing medium was charcoal and estompe, which he first used in his academic drawings around 1900 (cat. 5). It allowed him to achieve a remarkable tonal range of blacks, greys and whites, an interesting play of light on objects and a soft background texture. The present drawing is an excellent example of this technique. It was drawn from the model Henriette Darricarrère who began posing for the artist around 1921 and remained his inspiration until 1927. This sheet has been variously placed between 1921 and 1923; however, since the drawing was reproduced in a book published by Faure in 1923 and since during 1922 Matisse executed several compositions on the subject of music-making including the motif of a woman with guitar, the 1922 date for the drawing seems most likely. The composition, with slight changes in the model's dress and pose, is repeated in another drawing (Faure, pl. 54), and with certain variations in the study for the painting *La Robe jaune citron*, both of 1922. The motif of a woman with guitar will return again in the late 1930s and 1940s.

Baltimore, 1971, no. 40
Faure, 1923, pls 44, 53, 54, 66
Paris, 1975, no. 67
Toronto, 1971, no. 107

61 *Reflection in the Mirror.* Nice (1923) (p. 182)
Charcoal on paper
51 × 40.6 (20 × 16)
The Metropolitan Museum of Art, New
York. Robert Lehman Collection

The central theme in the works of the Nice period is the odalisque, lounging and relaxing in an exotic setting, sometimes depicted in the nude, most often semi-dressed in oriental pantaloons and/or ornate robes and veils or headdresses. The present drawing is a study for the painting *Odalisque Reflected in a Mirror* of 1923, at present in the Baltimore Museum of Art (Cone Collection). The same composition, in reverse, is repeated in a related lithograph *Odalisque demi-nue au miroir* of 1923 (Fribourg, 1982, no. 389). The motif of a standing model leaning against a mirror, a window or a wall can be found in a number of other contemporaneous paintings, such as *Odalisque with an Armchair* (1923) and *Odalisque at the Window* (1923), and in lithographs, such as *Standing Odalisque with Fruit Dish* (1924; Fribourg, 1982, no. 399).

Szabo, G. Twentieth-century French Drawings from the Robert Lehman Collection. The Metropolitan Museum of Art, New York, 1981, no. 21

62 *Reclining Model with Flowered Robe.* Nice
(c. 1923–24) (p. 180)
Charcoal and estompe on white laid paper
48 × 62.8 (18⅞ × 24¾)
The Baltimore Museum of Art. The Cone
Collection, formed by Dr Claribel Cone
and Miss Etta Cone of Baltimore,
Maryland (BMA 1950.12.52)

Among the numerous depictions of odalisques and nudes of the 1920s the image of a reclining figure is frequently used. Here the model, Henriette, is portrayed relaxing against a decorative background of chequered upholstery, whose geometric pattern is juxtaposed against

the bold, flowered design of the Spanish shawl covering the figure. The drawing masterfully explores the possibilities of modelling offered by the medium and conveys Matisse's predilection for a profusion of decorative detail, particularly characteristic of the Nice period.

Baltimore, 1971, no. 43
Baltimore, 1979, no. 41
Paris, 1975, no. 69

63 *Young Woman Playing a Violin in Front of a Piano.*
Nice (1924) (p. 182)
Charcoal on paper
31.2 × 47 ($12\frac{1}{4}$ × $18\frac{1}{2}$)
Mr and Mrs Richard Selle, Indiana

This work belongs to a group of drawings of the same motif. The model here is Henriette, who posed for the *Seated Model with Guitar* of 1922 (cat. 60). The other drawings on the theme are: a larger sheet, representing the violinist from a slightly higher viewpoint and wearing a striped dress (Musée National d'Art Moderne, Paris; Pompidou, 1979, no. 38), and a third drawing (Archive of the Musée National d'Art Moderne) on a vertical sheet, depicting the model in three-quarter view from above, seated full length on a stool, also fully visible. A pastel on the same subject, but with the composition in reverse, is in a private collection, USA (Sotheby's, 18 May 1983, no. 48).

Paris, 1975, no. 73
Pompidou, 1979, no. 38

64 *Violinist at the Window.* Nice, 1924 (p. 183)
Charcoal on paper
62.9 × 47.6 ($24\frac{3}{4}$ × $18\frac{3}{4}$)
Private collection, San Francisco

The present sheet is a variation on the theme of a young woman playing a violin (cat. 63), who is now placed standing in front of an open window in the artist's studio. The ambience of the drawing, with the figure of the violinist facing the window and her back turned to the spectator, is reminiscent of the painting *Le Violiniste à la fenêtre* (1917, Musée National d'Art Moderne, Paris; Pompidou, 1979, no. 12). A horizontal version of similar dimensions (formerly in the collection of Pierre Matisse), depicting the head and top part of the young violinist's torso, seems related to this composition.
See also cat. 63.

65 *Still-life.* Nice (1924) (p. 184)
Black chalk on paper
45.1 × 55.1 ($17\frac{3}{4}$ × $21\frac{11}{16}$)
Whitworth Art Gallery. University of Manchester

During 1924–25 Matisse devoted his creative energies largely to still-lifes and studio interiors. His most decorative still-lifes were done in 1924. The present drawing relates closely to the painting *Fruit and Flowers* (1924, private collection, Paris; Barr, 1951, p. 441), for which Matisse had been awarded the first prize at the Carnegie International Exhibition in Pittsburgh in 1927. Here the artist explores the possibilities offered by the medium to create a tonal richness of surface and modelling of form in an otherwise conservative still-life.

Barr, 1951, p. 212

66 *Seated Figure on a Decorative Background.* Nice
(1925–26) (p. 185)
Charcoal on white paper
63 × 48.2 ($24\frac{3}{4}$ × 19)
Private collection

This is a preparatory study for the painting *Decorative Figure on an Ornamental Ground* (Musée National d'Art Moderne, Centre George Pompidou, Paris), which Matisse completed in Nice during the winter of 1925–26. The drawing, although dated 1927, must also have been executed at this time, as stylistic comparison with the painting clearly suggests that the drawing was made first. As Fourcade convincingly suggests (Paris, 1975, no. 74), the 1927 date might have been added by Matisse at the time of the publication of Fels' book, in which it was first reproduced (Fels, 1929, p. 38). Another charcoal drawing, *Buste de femme couchée* dated 1925 (Musée Matisse, Le Cateau; also reproduced in Fels, p. 15) represents the same model, Henriette, against the same background. It shows stylistic affinities with the present sheet in the treatment of the figure, and therefore supports the earlier date of this work.

Baltimore, 1971, no. 41
Paris, 1975, no. 74
Pompidou, 1979, no. 79

67 *Dancer Resting.* Nice (1927) (p.184)
Brush and ink on paper

28 × 73.6 (11 × 29)
Dr and Mrs Martin L. Gecht

In 1927 the theme of a ballet dancer dressed in a
tutu appears briefly in Matisse's work. It was
possibly inspired by the artist's renewed contact
with Diaghilev's Ballets Russes on the occasion of
the new version of the ballet *Le Rossignol*. Matisse
designed the sets and costumes for the original
production in 1920, and they were reused in 1927.
This drawing belongs to a group of works which
includes at least two paintings: *Dancer Standing,
Harmony in Grey* (1927, private collection, Paris;
Schneider, 1982, pl. LXII); *Ballet Dancer* (1927,
Baltimore Museum of Art, Cone Collection;
Barr, 1951, p. 447), and a portfolio of ten
lithographs, executed in 1927 for the Editions de la
Galerie d'Art Contemporain, Paris (Fribourg,
1982, nos 436–45, 447, 450). The lithograph *Sleeping
Dancer on a Couch* (Fribourg, no. 438) from that
portfolio is particularly close in composition to
the present sheet.

58 *The French Window (La Porte-fenêtre)*. Nice, 1928
 (not illustrated)
 Charcoal and estompe on paper
 63 × 48 (24¾ × 19)
 Private collection

In this drawing of the window of his apartment
on Place Charles Félix, Matisse returns to one of
the favourite subjects of his earlier years: an
interior, brightly lit through half-closed shutters.
He had previously treated this subject in such
paintings as *Interior with a Violin* (1917–18, Statens
Museum for Kunst, Copenhagen; Barr, 1951,
p. 421) and again in 1919 in *French Window at Nice*
(Barnes Foundation, Merion, Pennsylvania; Barr,
1951, p. 425). He would explore it again in his *Girl in
Yellow Dress* (1929–31, Baltimore Museum of Art;
Barr, 1951, p. 455). Here, the mood created by the
play of light on the panes and frame of the
window becomes the main subject of the picture.
The atmosphere of indolence and nostalgia is
enhanced by the emptiness of the foreground
and the deep perspective created by the pattern
of light and shadow on the floor. The half-open
shutters protect the interior from the invasion of
the outside world, but at the same time allow
limited contact with it.

Paris, 1975, no. 80

69 *Odalisque and Tabouret*. Nice, 1928 (p.186)
 Pencil on white paper
 95.6 × 56 (37⅝ × 22⅟₁₆)
 The Metropolitan Museum of Art, New
 York. Bequest of Susan Vanderpoel Clark,
 1967

The most characteristic images in Matisse's
works of the mid and late 1920s are the
representations of odalisques, as single figures or
in groups of two or three, seated or reclining
against a decorative background of pillows or
oriental chairs. This drawing was done from a
Persian model who posed for the artist in 1928,
1929 and 1932 (cat. 71, 73) and was the subject of
several drawings and numerous lithographs,
such as *Odalisque assise à la jupe de tulle* (1929;
Fribourg, 1982, no. 453). Here he uses the same
elements, the Moorish chair and stool, which
were reversed in the lithograph. The drawing is
placed on the lower part of a folded sheet of
paper, possibly because of the deckled bottom
edge which adds to the decorative quality of the
composition. A painting, *Odalisque with Green Foliage*
(1929; Besson, 1945, pl. LIV), repeats the
composition of the present sheet, without the
stool, as does another drawing, of 1929, where the
figure, again in the same pose, faces to the right.

Baltimore, 1971, no. 47

70 *The Three Friends*. Nice, 1928 (p. 185)
 Pen and ink on paper
 37.4 × 50.3 (14¾ × 19¾)
 Musée National d'Art Moderne, Paris.
 Centre Georges Pompidou

Matisse's fascination with the exotic finds its
expression in 1928 in a number of drawings and
canvases of languorous, sensuous women – in
groups of two or three – depicted in profusely
decorated surroundings. They are the direct
descendants of Delacroix's imagined harem
scenes and the odalisques of Ingres. This drawing
belongs stylistically within a group of free and
open pen and ink line drawings of the late 1920s
that explore a flowing arabesque, describing the
central group, and the interplay of decorative
patterns. The three models, the decorative
brazier (at upper left), and the patterned
background reappear in several drawings of the
series as well as in paintings.

Pompidou, 1979, no. 39

71 *La Persane*. Nice, 1929 (p. 187)
 Pencil on paper
 $56 \times 28 \left(20\frac{1}{8} \times 11\right)$
 Private collection, Zug, Switzerland

Matisse's pencil drawings of odalisques from
1928–29, unlike his free pen and ink drawings
(cat. 70), are dense and meticulously rendered,
showing his academic training. This sheet seems
to be a continuation of the subject in the
drawing *Odalisque and Tabouret* (cat. 69), and it uses
the same model in an oriental headdress and the
Moorish chair. Here, she is seated in a pose
conventionally associated with ceremonial
portraiture. In Matisse's own work there are
many precedents for this pose, such as *Yvonne
Landsberg* (1914), *Greta Prozor* (1915–16), or several
drawings and canvases of Spanish women of 1923.
Here, however, the model's daring *décolletage*
somewhat contradicts the innocent expression of
her face and of her hands modestly clasped in
her lap. Besides the present sheet there are
several drawings and lithographs of a woman
with a veil; particularly close is *La Persane* (1929;
Fribourg, 1982, no. 446).

Paris, 1975, no. 83

72 *'Quelle soie aux baumes de temps'*. Nice (1931–32)
 (p. 188)
 Pencil on paper
 $31.7 \times 24.1 \left(12\frac{1}{2} \times 9\frac{1}{2}\right)$
 Kasmin Ltd, London

In 1930 the Swiss publisher Albert Skira invited
Matisse to illustrate a new edition of Mallarmé's
Poésies. The volume was finally published in
October 1932 and contained twenty-nine etchings
by Matisse from 1931–32. Matisse made numerous
preparatory drawings, and the present sheet is
among the studies illustrating one of the
sonnets, and corresponds to its first stanza:

> Quelle soie aux baumes de temps
> Où la chimère s'exténue
> Vaut la torse et native nue
> Que, hors de ton miroire tu tends!

Another drawing for the same sonnet (Baltimore
Museum of Art, Cone Collection, 1934, pl. 94)
shows a second variation of the pose, which is
different again from the final etched version
(Mallarmé, *Poésies*, p. 147; Fribourg, 1982, no. 262).

Aragon, 1943, p. 20
Barr, 1951, pp. 244–46

73 *The Lamé Robe*. Nice, 1932 (p. 189)
 Pencil on white paper
 $32.4 \times 25.4 \left(12\frac{3}{4} \times 10\right)$
 Yale University Art Gallery, New Haven,
 Connecticut. Gift of Stephen C. Clark

The oriental subject that so fascinated Matisse
1928–29 (cat. 69, 71) returns in this highly finished
drawing of the same Persian model who posed
for the numerous lithographs and drawings of
the late 1920s. The motif of the Persian dress can
also be found in such contemporaneous oil
paintings as the *Persian Robe* (1931) and *Girl in a
Persian Costume* (1932; both Barr, 1951, p. 468).

Baltimore, 1971, no. 53

74 *Portrait of Dr Claribel Cone*. Nice (1933–34)
 (p. 190)
 Pencil on paper
 $31.4 \times 24.8 \left(12\frac{3}{8} \times 9\frac{3}{4}\right)$
 The Baltimore Museum of Art. The Cone
 Collection, formed by Dr Claribel Cone
 and Miss Etta Cone of Baltimore,
 Maryland (BMA 1950.12.66)

Among the serious collectors of Matisse's work
from its early stages were two American sisters
from Baltimore: Dr Claribel and Miss Etta Cone.
They were introduced to Matisse's work in the
early 1900s by Michael and Sarah Stein and they
bought their first Matisse painting in 1906. This is
one of the three preparatory studies for the
posthumous portrait drawing (cat. 75) of the
older sister, Dr Claribel Cone, who was one of
the few women of her era to obtain a medical
degree. It was commissioned by Etta Cone after
Dr Cone's death on 20 November 1929, probably
in mid December 1930, when Matisse was a guest
at the Cone home during one of his trips to the
United States. Existing correspondence (cf.
Baltimore, 1971, no. 54) establishes that the
portrait was not executed until some time
between July 1933 and August 1934. Matisse's
original conception of the portrait was of a fairly
naturalistic and conventional depiction of a half
length seated figure leaning on a book, as is
shown by the three pencil studies (Cone
Collection, 1934, pls 95 a–c) preceding the final
charcoal version (cat. 75). Since the artist
reputedly worked from memory and from a
photograph given to him by Etta Cone as an *aid*
mémoire for the portrait, it seems likely that the
initial pose was based on that of the photograph.
In the final version it was altered to concentrate

on the face alone. The present drawing is generally considered to be the second state of the portrait. However, when compared with the other two preparatory sketches (Cone Collection, 1934, pls 95 a, c), it seems that this might actually be the third state, because of its use of a more synthetic line to describe the figure, and a more generalized, linear treatment of the eyes and nose, overlaid on an erased, more naturalistic, underdrawing.

Paris, 1975, no. 86
Cone Collection, 1934, pl. 95

75 Dr Claribel Cone. Nice (1933–34) (p. 191)
Charcoal and estompe on white paper
59.1 × 40.6 ($23\frac{1}{4}$ × 16)
The Baltimore Museum of Art. The Cone Collection, formed by Dr Claribel Cone and Miss Etta Cone of Baltimore, Maryland (BMA 1950.12.71)

This is the final, fourth state of the posthumous portrait drawing of Dr Claribel Cone (see cat. 74). The conception of the portrait is radically changed and the pose of the figure in three-quarter view facing right has been altered to one which is almost full face, slightly turned from right to left, and with only a suggestion of the shoulders. By concentrating on the face only, which boldly confronts the viewer, and by highlighting its 'architecture', the portrait conveys the determination and the strong personality of the subject which are not apparent in the other three drawings.

Baltimore, 1971, no. 54
Barr, 1951, p. 247
Cone Collection, 1934, pl. 95

Faun and Nymph. Nice (1935) (p. 192)
Charcoal on paper
55.5 × 62 ($21\frac{7}{8}$ × $24\frac{3}{8}$)
Private collection

In 1935 Matisse executed illustrations for the new edition of James Joyce's Ulysses published by the United Editions Club of New York. Having read the novel and noted the analogy of its structure with Homer's Odyssey, Matisse suggested illustrations corresponding to the episodes based on the subjects from the antique legend rather than the modern story. He then made several variations on the six subjects, each etching

preceded by preparatory drawings. This sheet relates to the drawings for the first etching on the subject of Calypso, a nymph on whose island Odysseus was prisoner for seven years. The composition, although in reverse, is the closest to the first study. The same relationship of the two figures reappears in another Ulysses illustration, The Blinding of Polyphemus, in the drawing Bataille de femmes (cat. 77), in the later painting Nymph in the Forest (1935/6–1941, private collection, Paris; Los Angeles, 1966, no. 74) and the drawing Nymph and Faun with Pipes (1940/1–43, cat. 100). There exists another related drawing of Faun and Nymph (Steingrim Laursen Collection, Copenhagen) where the partial figure of the nymph is placed in a reversed position. The subject of faun and nymph had already been part of Matisse's iconography in 1908–09 with the painting Nymph and Satyr (Hermitage, Leningrad; Izerghina, 1978, no. 22).

Baltimore, 1971, no. 56
Barr, 1951, pp. 249–50
Paris, 1975, no. 89

77 Bataille de femmes. Nice, 1935 (p. 192)
Charcoal on paper
65.5 × 50 (25 × $18\frac{7}{8}$)
Ohara Museum of Art, Kurashiki, Japan

This drawing, by virtue of its subject matter, composition, size, and title, seems to relate to Matisse's illustration for Joyce's Ulysses (see cat. 76). However, it appears to be even closer, in the compositional relationship of the two female figures, to the central section of the second version of the Barnes murals, Dance II (1932–33, Barnes Foundation, Merion, Pennsylvania), which depicts in a tripartite composition a frenzied Dionysiac dance of women as if paired in combat, than it is to the farandole of the Shchukin panel Dance (1910) by which it is supposed to be inspired. It could either be a charcoal study for the composition of the central lunette, and would therefore have been executed around 1932–33, or could relate to Matisse's mythological compositions of about 1935 (cat. 76), in which case it could even be a preparatory study for La Verdure (Nymph in the Forest, 1935/6–41, private collection, Paris; Los Angeles, 1966, no. 74).

Barr, 1951, pp. 243–44, 462–65
Cahiers d'art, 1935, nos 1–4, pp. 13–15

78 *Study for Pink Nude*. Nice, 1935 (p. 193)
Charcoal on paper
48.3 × 67.8 (19 × 26⅝)
Private collection

In 1935 Matisse painted a canvas that was
unusually abstract: *Pink Nude*. He documented
the evolution of that painting in a series of
twenty-two photographs and made, before and
during the course of painting, between 1 May and
30 October 1935, numerous charcoal studies from
the model. The present sheet is one of the studies
related to the first state of the painting, done
before Matisse simplified the naturalistic
contours of the figure to make them more
geometrical and before he eliminated
foreshortening and flattened the space by
suppressing the diagonal of the limbs. The pose,
in modified form, goes back to such early work
as the painting *Blue Nude* (1907, Baltimore
Museum of Art).

Baltimore, 1971, no. 55
Barr, 1951, pp. 247–49, 472–73
Russell, 1969, pp. 134–35

79 *Reclining Nude in the Studio*. Nice, 1935 (p. 194)
Pen and ink on paper
45.1 × 56.8 (17¾ × 22⅜)
Mr and Mrs Nathan L. Halpern, New York

This sheet belongs to a group of large pen and
ink drawings done in 1935–37. The series explores
the subject of a model reclining against a
decorative background. It incorporates the motif
of a reflected mirror image and signals the
presence of the artist himself by including the
edge of his sketch pad, his hand or part of his
silhouette. Using unshaded line drawing Matisse
investigates here the flowing arabesque, the
figure-ground relationship, and the whiteness of
the paper as the source of light and colour
projected against a profusely patterned
background. The expressive possibilities of a thin
unshaded black line against the whiteness of the
sheet were revealed to Matisse in 1931 while
working on the etchings for Mallarmé's *Poésies*.
The 1935–37 drawing series seems to be a further
development of that interest. Several of these
drawings, the present sheet included, were
published by Christian Zervos in a special issue of
Cahiers d'art in 1936.

Baltimore, 1971, no. 57

Barr, 1951, pp. 250–51
Cahiers d'art, nos 3–5, 1936, p. 85

80 *Nude with Necklace Reclining on Flowered Quilt*.
Nice, 1935 (p. 195)
Pen and ink on paper
45 × 55 (17¾ × 21¾)
Waddington Galleries Limited, London

The present work is another example from the
1935–37 series of line drawings of a model reclining
in the studio against a profusely ornamented
background (see also cat. 79, 85). In its
composition, the background elements and the
use of the same model, this drawing is
particularly close to the *Reclining Nude in the Studio*
(cat. 79), a reclining nude of 1935 reproduced in
Cahiers d'art (nos 3–5, 1936, p. 89), and *Nude with
Necklace* (1935, Collection Dina Vierny, Paris; Paris
1975, no. 91). They all share the same sensibility of
line, the same luminous space, and what Matisse
defined as 'a perspective of feeling'.

81 *Model Resting on her Arms*. Nice, 1936 (p. 197)
Pencil on paper
43.8 × 50.8 (17¼ × 20)
The Baltimore Museum of Art. The Cone
Collection, formed by Dr Claribel Cone
and Miss Etta Cone of Baltimore,
Maryland (BMA 1950.12.49)

This drawing reproduces, in reverse, the pose
previously used in two canvases of 1935: *The Dream*
(Musée National d'Art Moderne, Paris;
Pompidou, 1979, no. 19) and *Blue Eyes* (Baltimore
Museum of Art; Barr, 1951, p. 471), and
corresponds closely to the latter in composition
and mood. It also relates directly to a smaller 1935
drawing, *Study for Blue Eyes*, first reproduced by
Roger Fry in his book on Matisse, published in
1935 (pl. 58). The same motif of the nude with
head on her arms, but shown full length leaning
against the chair, is repeated in a number of
charcoal drawings (Fry, 1935, pl. 58; Barr, 1951,
p. 470) and lithographs (Barr, 1951, p. 470).

Baltimore, 1971, no. 58
Barr, 1951, pp. 247, 470–71
Paris, 1975, no. 92
Pompidou, 1979, no. 19

82 *Standing Nude, Seen from the Back*. Nice, (1936)
(p. 196)
Charcoal on paper

51.8 × 38.3 $\left(20\frac{5}{16} \times 15\frac{1}{16}\right)$
Private collection

In this work Matisse reintroduces the motif of a standing model with hands on her head, which he had originally used, in a frontal view, in his 1906 sculpture *Standing Nude, Arms on Head* (Elsen, 1972, p. 68, fig. 82). Later, in 1950, he would again return to it, asking his current model Katia to assume the pose for the sculpture *Standing Nude* (1950; Elsen, 1972, p. 213). The present drawing, striking in its beautiful modelling of form, was included by Claude Roger-Marx in his portfolio of Matisse's drawings, published in 1939.

Paris, 1975, no. 96
Roger-Marx, 1939, pl. 17

83 *Lady with Necklace (Embroidered Blouse)*. Nice, 1936 (p. 198)
 Pen and ink on white paper
 54 × 45 $\left(21\frac{1}{4} \times 17\frac{3}{4}\right)$
 Fogg Art Museum, Harvard University, Cambridge, Massachusetts. Bequest of Meta and Paul J. Sachs

Among numerous line drawings in pen and ink done in 1936, Matisse executed a group of works depicting a model wearing an embroidered Rumanian blouse and a necklace. A selection of these drawings, including the present sheet, appeared in the special issue of *Cahiers d'art* of 1936 devoted to Matisse's drawings. The subject seems to be a continuation of Matisse's interest in oriental themes, which emerged first in the 1920s, and expresses his fascination with the interplay of ornamental patterns, which will persist until 1940 (cat. 84, 91, 95, 96) in both drawings and paintings.

Cahiers d'art, nos 3–5, 1936, pp. 120–29
Paris, 1975, no. 94

84 *The Rumanian Blouse*. Nice, 1937 (p. 199)
 Pen and black ink on white wove paper
 63 × 50 $\left(24\frac{13}{16} \times 19\frac{11}{16}\right)$
 The Baltimore Museum of Art. The Cone Collection, formed by Dr Claribel Cone and Miss Etta Cone of Baltimore, Maryland (BMA 1950.12.57)

This is a further elaboration on the theme of the Rumanian blouse, which culminated in the painted version finished in October 1940 (Musée National d'Art Moderne, Paris; Pompidou, 1979, p. 21). From Aragon's photographic documentation (Pompidou, 1979, pp. 76–79) we know that the pose of the sitter in the early stages of the painting corresponds to that in the present drawing except that she is facing in the opposite direction. Here, as in the early stages, Matisse masterfully organizes diverse ornamental patterns into a lively and complex composition. See also cat. 83.

Baltimore, 1971, no. 60
Baltimore, 1979, no. 42
Paris, 1975, no. 98
Pompidou, 1979, no. 21

85 *Artist and Model Reflected in a Mirror*. Nice, 1937 (p. 200)
 Pen and black ink on paper
 61.2 × 40.7 $\left(24\frac{1}{8} \times 16\frac{1}{16}\right)$
 The Baltimore Museum of Art. The Cone Collection, formed by Dr Claribel Cone and Miss Etta Cone of Baltimore, Maryland (BMA 1950.12.51)

The theme of the artist and his model and their reflected images, which was treated in some line drawings of 1935 (cat. 79), returns in this composition. It is one of the rare instances in which the artist's presence becomes clearly apparent, and asserts the importance of the creator. The line, seemingly spontaneous and free, yet rationally controlled, creates a vigorous decorative background design and, through variation of contour, conveys differentiation of planes. The arabesque defining the model's form brings out the luminous power of space enclosed by line and also activates the space. The whiteness of the paper, which suggests the volumes of the body through the linear articulation of unshaded surface, generates light.

Baltimore, 1971, no. 62

86 *Reclining Nude with Arm behind Head*. Nice, 1937 (p. 203)
 Charcoal on paper
 38.1 × 48.3 (15 × 19)
 The Baltimore Museum of Art. The Cone Collection, formed by Dr Claribel Cone and Miss Etta Cone of Baltimore, Maryland (BMA 1950.12.50)

Matisse had treated the subject of the nude with arms raised behind her head on many occasions, in almost every medium, but never is the pose as

contrived and unnatural as in this drawing. Another drawing, seemingly from the same series but with both hands behind the head and legs drawn towards the torso, is in a private collection in New York (Paris, 1975, no. 102).

Baltimore, 1971, no. 61

87 *Self-portrait*. Nice, 1937 (p. 201, above)
 Charcoal on paper
 $25.5 \times 20.5 \left(10 \times 8\frac{1}{16}\right)$
 Musée National d'Art Moderne, Paris.
 Centre Georges Pompidou

In 1937 Matisse executed a group of three self-portrait drawings in charcoal, and charcoal and estompe, all of which are very close in spirit, conveying his image as a rather stern reflective personality, a reserved and isolated man. This drawing, relatively small in size, seems, in fact, to be a close-up view of the face depicted in the Baltimore *Self-portrait* (cat. 88). It was first reproduced in the Roger-Marx portfolio of Matisse's drawings in 1939. The forceful draughtsmanship and the shaded charcoal medium add to the powerful expression of this and the other works.

Paris, 1975, no. 100

88 *Self-portrait*. Nice, 1937 (p. 201, below)
 Charcoal and estompe on paper
 $47.3 \times 39.1 \left(18\frac{11}{16} \times 15\frac{7}{8}\right)$
 The Baltimore Museum of Art. The Cone
 Collection, formed by Dr Claribel Cone
 and Miss Etta Cone of Baltimore,
 Maryland (BMA 1950.12.61)

See cat. 87.

Baltimore, 1971, no. 59
———, 1979, no. 43

89 *Woman in a Taffeta Dress*. Nice, 1937 (p. 202)
 Charcoal on paper
 $61 \times 40.7 \left(24 \times 16\right)$
 Private collection

The present sheet, as well as the slightly larger *Woman Seated, in a Taffeta Dress* (cat. 90), seem to belong to the same series of charcoal drawings depicting, according to Barr, 'figures esthetically passive, static and casually naturalistic.' They might also relate to the charcoal and estompe preparatory studies for the decoration over a mantelpiece designed for the apartment of

Nelson Rockefeller in New York, executed in November–December 1938 (cf. Paris 1975, no. 104, 105, 106; *Cahiers d'art*, 1939, pp. 14, 15, 17), although here the pose is much less dynamic than in the Rockefeller drawings. The stiffness of the pose and the emphasis on the decorative quality of the voluminous dress recall the composition of the painting *Lady in Blue* of 1937 (private collection Philadelphia). A similarly posed model, but facing in the opposite direction, was the subject of the drawing *The White Jabot* (charcoal, 1930; Besson, 1945, pl. 23) and reappears in the painting *Michaela* of 1943 (private collection, New York; Barr, 1951, p. 491).

90 *Woman Seated, in a Taffeta Dress*. Nice, 1938
 (p. 202)
 Charcoal on paper
 $67 \times 40.5 \left(23\frac{7}{8} \times 15\frac{7}{8}\right)$
 Private collection

This later version of the motif of a woman in a taffeta dress slightly modifies the pose of the model in the preceding drawing (cat. 89) and shows her seated in a different type of armchair.

91 *Seated Woman in a Rumanian Blouse*. Nice, 1938
 (p.209)
 Charcoal on paper
 $66 \times 51 \left(26 \times 20\right)$
 Mr William R. Acquavella, New York

The fascination with the decorative designs of the Rumanian peasant blouse that resulted in a number of drawings in 1936–37 (cat. 83, 84, 95, 96) continues in this work of December 1938. Here Matisse not only concentrates on the intricacies of the ornamental pattern of the blouse which merges with the decorative motif of the armchair, but also explores the figure-ground relationship by including a few ornamental designs on the wall behind the model. This drawing, along with another study of a model in an oriental blouse done in February 1939, was included among the selection reproduced in *Cahiers d'art* in 1939 (nos 1–4). The play of the decorative blouse against a profusely patterned background recurs in a painting, *Dancer Resting*, of 1939 (The Toledo Museum of Art, Toledo, Ohio Besson, 1945, no. 43).

Paris, 1975, no. 107

92 *Reclining Nude Seen from the Back*. Nice, 1938
 (p. 204)

Charcoal on paper
60 × 81 $(23\frac{5}{8} × 31\frac{7}{8})$
Private collection

During the summer months of 1938 Matisse made
a sequence of charcoal drawings of reclining
nudes, both front and back views (cat. 93). Several
of these, including the present sheet, were first
reproduced in the special number of *Cahiers d'art*
in 1939. Done in what Matisse considered to be his
'exploratory' medium, which enabled him 'to
consider simultaneously the character of the
model, the human expression, the quality of
surrounding light, atmosphere and all that can
only be expressed by drawing', these are studies
of various states of the same subject, his attempts
to solve different artistic problems. Modifications
of this pose of a reclining nude resting on elbow
and thigh can be studied, first with his 1905
sculpture of *Reclining Figure with Chemise*,
continuing with particular strength in the 1920s
and 1930s, and occasionally in the early 1940s. In
the present drawing, the emphasis is on the
exploration and articulation of curves, boldly
sweeping the composition and defining the space
occupied by the figure. The searching quality of
the draughtsmanship can be followed in
numerous erased lines visible around the
contours of the body.

Baltimore, 1971, no. 63
Cahiers d'art, nos 1–4, 1939, p. 11
Paris, 1975, no. 104

3 *Reclining Nude.* Nice, 1938 (p. 205)
Charcoal on paper
60.5 × 81.3 $(25\frac{5}{8} × 31\frac{7}{8})$
The Museum of Modern Art, New York.
Purchase

This drawing belongs to the same series as the
Reclining Nude Seen from the Back (cat. 92). It is,
however, in complete opposition to it in its
exploration of the frontal pose and its
articulation of angular forms rather than curves.
Three other drawings seem directly related: a
more naturalistic work, dated June 1938, which
could be considered an earlier state of this
composition (*Le Point*, 1939, pp. 13–109); *Nude Study*
(fig. 54, p. 120) reproduced in *Cahiers d'art* in 1939
(p. 10); and a study of the torso, also included in
Cahiers d'art (p. 12) in 1939.

Flderfield, 1983, pp. 166–67

94 *Dancer Resting in an Armchair.* Nice, 1939 (p. 208)
Charcoal on paper
64 × 47.7 $(25\frac{3}{16} × 18\frac{3}{4})$
National Gallery of Canada, Ottawa/Galerie
nationale du Canada, Ottawa

The present work is one of three known
preparatory studies for the painting *Dancer Resting*
(1940, The Toledo Museum of Art, Toledo, Ohio;
Pompidou, 1979, p. 124, fig. a). One of the others,
almost identical, in charcoal and estompe, is in
the collection of the Musée National d'Art
Moderne, Paris (Pompidou, 1979, no. 41); and the
third, a pen and ink study, which is much more
naturalistic in the depiction of the figure and
thus closer in composition to the final painting
than the two charcoals, is photographically
documented in the archive of the Galerie
Bernheim-Jeune in Paris (Pompidou, 1979, p. 124,
fig. b). Here, as in the drawing in the Musée
National d'Art Moderne, the figure appears
monumental, and the treatment of the
composition in terms of a series of semicircular
forms, echoed in the shapes of the armchair and
the arrangement of the dancer's arms and
thighs, enhances that monumentality.

Pompidou, 1979, no. 41

95 *Young Woman Sleeping in Rumanian Blouse.* Nice,
1939 (p. 206)
Charcoal on paper
37 × 47 $(14\frac{9}{16} × 18\frac{1}{2})$
Mr Julian J. Aberbach

Between December 1939 and November 1940
Matisse devoted more than forty modelling
sessions, some documented by photographs
(*L'Art de France*, 1963, no. 3, pp. 338–39), to painting
Sleeping Woman or *The Dream* (private collection,
Paris; Los Angeles, 1966, cat. no. 81, p. 111). He had
executed numerous studies of the sleeper in
preparation for it, and the present sheet as well
as *Woman Sleeping at the Corner of the Table* (cat. 96)
belong to this group. Here, the sitter's position is
the reverse of that in the final painting. Two
other drawings of the sleeper, in a position close
to this composition, but wearing a sleeveless top
rather than the decorative blouse, are known to
exist (cf. Paris, 1975, nos 113, 114). The pose of the
sleeper is a variation on that previously explored
in the 1935 drawings related to the paintings *The
Dream* and *Blue Eyes* of 1936 (cat. 81) as well as in the
paintings themselves. It also continues the artist's

interest in the ornamental quality of the Rumanian blouse, itself the subject of various drawings (cat. 83, 84, 91).

Paris, 1975, no. 111

96 *Woman Sleeping at the Corner of the Table.* Nice, 1939 (p. 207)
Charcoal on paper
60.4 × 40.7 ($23\frac{3}{4}$ × 16)
Collection Dr and Mrs Arthur E. Kahn

This is another study for the painting *Sleeping Woman* of 1940 (see cat. 95). Done in December 1939, it is quite close compositionally to the final painted version, although it differs slightly in viewpoint and shows greater emphasis on the decorative quality of the blouse and skirt. In its pose it also foreshadows the sleeper in the painting *Sleeping Woman with Violet Table* (1940; Besson, 1945, pl. 46). Matisse documented the process of painting the *Sleeping Woman* in a series of thirteen photographs, and the present drawing recalls the fifth and eighth states (*L'Art de France*, 1963, no. 3, pp. 338–39).

Paris, 1975, no. 112

97 *Young Woman in a 'Fishnet' Dress (Jeune femme assise en robe de résille).* Nice, 1939 (p. 209)
Charcoal on paper
65 × 50 ($25\frac{1}{2}$ × $19\frac{3}{4}$)
Collection Ernst Beyeler, Basel

During the late 1930s and throughout the 1940s Matisse frequently used the motif of a figure seated at a table, either looking at the viewer or deeply lost in thought. This drawing of March 1939 resembles, in method of execution and subject, a group of charcoal drawings from 1938 which includes the *Seated Woman with Right Arm Leaning on an Armchair* (Graindorge Collection, Belgium), various representations of women in taffeta dresses, and the studies for the Rockefeller mantelpiece decoration (Paris, 1975, nos 104–06). It also shows affinities, in the pose and the fishnet patterned dress, to the right-hand figure of the painting *Conservatory* (1937–38, private collection, USA; Barr, 1951, p. 478).

98 *Portrait: Dancer ('The Buddha').* Nice, 1939 (p. 211)
Charcoal on paper
60.5 × 40 ($23\frac{7}{8}$ × $15\frac{3}{4}$)
Musée Matisse, Nice-Cimiez

This powerful drawing, with monstrously exaggerated features and tulip-shaped face, is quite unique in Matisse's oeuvre. It seems to relate to a smaller and much less distorted portrait drawing, *Asiatic Lady* (1939, private collection; Los Angeles, 1966, no. 191), and could be considered a more abstract and bolder versio[n] of the lower part of the same face and neck. It might have been executed at the time or shortl[y] after Matisse completed his costume and stage sets for Massine's symphonic ballet *Rouge et noir*, first performed in 1939, where the flamelike form[s] describing the eyes of the Buddha appear on the costumes of the dancers. The features of the fac[e] also seem to echo, in an exaggerated form, thos[e] of the sculpted head in the painting *Ochre Head* (1937, private collection, New York; Barr, 1951, p. 477). The stiff, tubular neck and the semicircular lines surrounding the head bring t[o] mind a similar treatment of forms in certain works of 1914–16: the painting *Yvonne Landsberg* (cat. 29–33) and the drawing *Head of a Woman* (1916 private collection, Copenhagen).

99 *Still-life.* Nice, 1939 (p 210)
Charcoal on paper
50 × 65.5 ($19\frac{7}{8}$ × $25\frac{7}{8}$)
Rosengart Collection, Lucerne

During the late 1920s and 1930s Matisse concentrated on the human figure as his main subject, occasionally including still-lifes as part [of] the composition. Toward the end of the 1930s h[e] returned to the subject matter of still-lifes of fruit and flowers, as in this sheet from Novemb[er] 1939. This interest was developed in his *Themes an[d] Variations* series of 1941–42 (cat. 113–19).

Zürich, 1982, no. 79

100 *Nymph and Faun with Pipes.* Nice (1940/41–43) (p. 212)
Charcoal on canvas
153 × 165.5 ($60\frac{1}{4}$ × $65\frac{1}{8}$)
Private collection

This large composition resumes, in a monumental form, the subject of the 1935 drawing *Faun and Nymph* (cat. 76) and another 1935 drawing on this theme (Baltimore, 1971, p. 156, fig. a). Stylistically, the simplified forms, and the economy and quality of the contour line defining them, seem to echo those used in the etchings for Joyce's *Ulysses*. Photographs of

Matisse's apartment, taken in 1940 or 1941 and 1942, show this drawing in yet another state, in progress, hanging on the wall.
See also cat. 76.

Aragon, 1971, vol. I, pp. 31, 137
Baltimore, 1971, no. 68
Paris, 1975, no. 143

101 *Still-life, Fruit and Pot.* Nice, 1941 (p. 210)
Pen and ink on paper
52 × 40 (20½ × 15¾)
Musée National d'Art Moderne, Paris.
 Centre Georges Pompidou

This composition belongs among the group of very fine pen and India ink drawings which are related to the paintings *Still-life with Magnolia* (1941, Musée National d'Art Moderne, Paris; Pompidou, 1979, no. 24). The same objects, which were part of Matisse's daily environment and were documented photographically by Aragon (Aragon, 1971, vol. I, pp. 89, 218–19, 248–49), reappear in similar groupings in the series G of his *Themes and Variations* (1941), in the drawing *Still-life with Melon* of 1941 (Rosengart Collection, Lucerne), and in later still-lifes of 1944 and 1949. A number of the sheets related to the present one were exhibited in November 1941 at the Galerie Louis Carré in Paris.

Paris, 1975, no. 117
Pompidou, 1979, no. 43

102 *Reclining Nude.* Nice, 1941 (p.213)
Red chalk on paper
38.4 × 57.2 (15½ × 20½)
Private collection

Within Matisse's oeuvre, drawings in coloured media are relatively rare. Here he again takes up the theme of a reclining nude sleeper, previously explored in numerous charcoal drawings of 1939, many of which were reproduced in the special issue of *Cahiers d'art* in 1939. Dina Vierny, who was a favourite model of Maillol, posed for this drawing.

Cahiers d'art, nos 1–4, 1939, pp. 10–14

103 *Themes and Variations. Series F, dessin du thème.*
 Nice, 1941 (p. 214)
Charcoal on paper
40 × 52 (15¾ × 20½)
Musée de Peinture, Grenoble

The years 1941–42 were for Matisse a period in which his drawing flourished. He made a large group of drawings in crayon, pen and ink, and pencil which were published in 1943 as a portfolio, *Dessins: Thèmes et variations*, with a preface by Louis Aragon. The portfolio contained 158 drawings, divided into 17 sequences or themes, marked A to P, each containing 3 to 19 variations. The sequences developed the themes which preoccupied Matisse throughout his creative life: the female figure, still-life, flowers and fruits. The title Matisse chose for the portfolio indicated both the purpose and the process of executing the drawings. Each theme undergoes several variations, providing the artist with an opportunity to make the composition either more concise and simpler, or more elaborate. The first drawing of each series – its *dessin du thème* – is generally executed in charcoal and followed by variations in pen or crayon. The group of drawings (cat. 104–12), for which this is the *dessin du thème*, was executed in October 1941 and develops the subject of a woman reclining in an armchair. The pose is among those frequently used by Matisse at that time, in such works as the painting *Sleeping Woman* (1940), the drawing of 1941 *Femme dans un intérieur* (charcoal and estompe, October 1941, private collection, Paris), and a charcoal of a reclining woman of November 1941 (Malingue, 1949, no. 19). The same model, in poses analogous to those of series F, seems to have been used by Matisse for his illustrations for *Pasiphaë* by Henri de Montherlant, in 1944. The *Themes and Variations* were considered by Matisse to be of great importance in his oeuvre; he donated this sequence to the Musée de Peinture at Grenoble and distributed some of the other sequences of the series to several French museums: Bordeaux, Montpellier and Saint-Etienne.

Grenoble, 1963, no. 135
Paris, 1975, no. 119
Thèmes et variations, 1943

104 *Themes and Variations, F2.* Nice (October) 1941
 (p. 215, above left)
Pen and ink on paper
52 × 40 (20½ × 15¾)
Musée de Peinture, Grenoble

This is the second sheet, or the first variation, on the theme in the F series. The pose of the model was later taken up with remarkable exactness in the linocut *Fraîchie sur des lits de violettes*, one of the

illustrations for Henri de Montherlant's *Pasiphaë* done in 1944.
See also cat. 103.

Grenoble, 1963, no. 136
Pasiphaë, 1944, p. 27
Paris, 1975, no. 120
Thèmes et variations, 1943

105– *Themes and Variations, F3–F5.* Nice (October)
107 1941 (p. 215, above right, below left, below right)
Pen and ink on paper
$52 \times 40 \ (21 \times 15\frac{3}{4})$
Musée de Peinture, Grenoble

See cat. 103.

Grenoble, 1963, nos 137–39
Paris, 1975, nos 121–23
Thèmes et variations, 1943

108– *Themes and Variations, F6–F10.* Nice (October)
112 1941 (pp. 216–17)
Crayon on paper
$40 \times 52 \ (15\frac{3}{4} \times 20\frac{1}{2})$
Musée de Peinture, Grenoble

See cat. 103.

Grenoble, 1963, nos 139–44
Paris, 1975, nos 124–28
Thèmes et variations, 1943

113 *Themes and Variations. Series M, Study of Flowers and Fruit, M1.* Nice, 1942 (p. 218)
Charcoal on paper
$40.6 \times 52 \ (16 \times 20\frac{1}{2})$
Musée des Beaux-Arts, Bordeaux

This sequence of seven studies of still-lifes of fruit and flowers illustrates the diversity of subjects in the *Themes and Variations* series. The changes in medium and in compositional arrangement allow the viewer to follow the development of form and rhythm of line – the process which Matisse described as 'a cinematography of the sentiments of an artist' ('une cinématographie des sentiments d'un artiste'). The M series, as well as the A, G, H, J and N bis, all utilize the theme of fruit and flowers.
See also cat. 103.

Barr, 1951, p. 268
Marseilles, 1974, no. 75
Thèmes et variations, 1943

114 *Themes and Variations. Series M, Study of Flowers and Fruit, M2.* Nice, 1942 (p. 219, above)
Pen and ink on paper
$49 \times 61 \ (19\frac{1}{4} \times 24)$
Musée des Beaux-Arts, Bordeaux

See cat. 113.

Barr, 1951, p. 268
Marseilles, 1974, no. 75
Thèmes et variations, 1943

115– *Themes and Variations. Series M, Study of Flowers and Fruit, M3–7.* Nice, 1942 (p. 219, below; pp. 220–21)
119 Pencil on paper
$49 \times 60 \ (19\frac{1}{4} \times 23\frac{5}{8})$
Musée des Beaux-Arts, Bordeaux

See cat. 113.

Barr, 1951, p. 268
Marseilles, 1974, no. 75
Thèmes et variations, 1943

120 *Branch of a Judas-tree.* Nice, 1942 (p. 222)
Charcoal on paper
$25.2 \times 39.4 \ (9\frac{5}{16} \times 15\frac{1}{2})$
Mr John Rewald, New York

Some of the floral motifs reminiscent of those used in the *Themes and Variations* series M (cat. 113–19) were also used by Matisse in the illustrations and vignettes for the *Florilège des amours de Ronsard*, commissioned by Skira in late 1941. This study of leaves relates to the vignette motif used on p. 20 of the Ronsard volume. Similar floral forms will subsequently appear in several of Matisse's late cut-outs.

Paris, 1975, no. 142

121 *Portrait of Louis Aragon.* Nice, 1942 (p. 223)
Pen and ink
$52.5 \times 40 \ (20\frac{5}{8} \times 15\frac{3}{4})$
Fondation Capa, Sutton Manor Arts Centre, Hampshire

In March 1942 Matisse made a series of drawings of the French writer Louis Aragon who at that time lived in Nice and who in 1943 wrote an introduction to Matisse's portfolio of drawings, *Thèmes et variations* (see cat. 103). The portrait suite organized according to the principle of the *Then and Variations* series, with four *dessins du thème* in charcoal (Aragon, 1971, vol. I, p. 171, vol. II, pp. 15,

48, 49) and thirty-three variations in pen and ink (Aragon, 1971, vol. II, pp. 50–54). They represent a cinematic sequence of front, three-quarter and profile views of the sitter. According to Aragon, all the drawings completed within the same period in 1942 were later mistakenly inscribed by Matisse 'March, 1943.'

Aragon, 1971, vol. I, pp. 170–71; vol. II, pp. 47–54

122 *Ballerina Seated in an Armchair*. Vence, 1944
(p. 227)
Charcoal on paper
61 × 45 (24 × 18¼)
Mrs William R. Acquavella, New York

Naturalistic depictions of dancers resting in diverse poses, which had been frequent in Matisse's oeuvre in the second half of the 1920s, particularly as subjects of drawings and lithographs, returned in the early 1940s, as in this charcoal of September 1944. Another charcoal drawing, *Woman in an Armchair* (Moulin, 1968, pl. 46), might be an earlier state of the present sheet. There the nude model is seated in a similar pose with her right foot fully visible and propped on a square form of a carpet or footstool. The painting *Dancer Seated in an Armchair*, of September 1942, is an earlier representation of the theme and is almost identical in pose (I. Grünewald, *Matisse och Expressionismen*, Stockholm, 1944, p. 192).

123 *Baudelaire, Man and the Sea*. Vence, September 1944 (p. 224)
Charcoal on paper
52.4 × 39 (20½ × 15⅜)
Art Gallery of Ontario, Toronto. Sam and Ayala Zacks Collection

In 1944 Matisse began the illustrations for a new edition of Baudelaire's *Les Fleurs du mal*, published in 1947. The volume comprises thirty-three photo-lithographic reproductions made from the original drawings. The present drawing faces the four-stanza poem (no. XIV) from the first section of the *Fleurs du mal* entitled 'Spleen et Idéal', and illustrates the first six lines. The monumental image, which is almost a later statement on the subject of the *Young Sailor* of 1906 (cat. 19) and realized in bold, simple lines, manifests the diversity of Matisse's drawing style of the time. A large group of portrait heads drawn in the same style followed in 1945–46, and several of them were reproduced in *Cahiers d'art* (1945–46, pp. 163–96).

Barr, 1951, p. 273
Toronto, 1971, no. 108

124 *Still-life with Fruit*. Vence, September 1944
(p. 225)
Charcoal on paper
40.5 × 52.5 (15¹⁵⁄₁₆ × 20¹¹⁄₁₆)
Private collection, Basel

This drawing, also known as *Apples on a Table* (*French Drawing of the Twentieth Century*, New York 1955, no. 29) is contemporaneous with the illustration to Baudelaire's *Fleurs du mal* (cat. 123). It shares with the latter the same monumental quality of image, the boldness of line, and the method of execution. It also recalls numerous pictures of apples or oranges done around 1916 where the compositional elements are arranged loosely and the image extends beyond the edges of the support.

Bielefeld, 1982, no. 69

125 *Amaryllis*. Vence, 1945 (p. 226)
Charcoal on paper
53 × 40 (20⅞ × 15¾)
Fondation Capa, Sutton Manor Arts Centre, Hampshire

Matisse's interest in depicting plants and flowers continued throughout the 1940s. This drawing seems to be a further development of the motif used in the M series of *Themes and Variations* (1941–42, cat. 113–19).

126 *Jackie*. Vence, 1947 (p. 228)
Charcoal on paper
56 × 38 (22 × 15)
Private collection

The model for this suite of ten portrait drawings was Matisse's grand-daughter, Jacqueline Matisse. Here the artist again applied the principle used in the *Themes and Variations* series (cat. 103–19) and repeated in *Portrait of Louis Aragon* (cat. 121). The *dessin du thème* in charcoal, executed as a 'constructed' portrait in the manner of Matisse's portraits of 1914–16, is followed by nine variations which, done in cursory line drawing, capture the character and personality of the model. A similar quality of drawing can be found in *Portrait of Mme Ida Chagall* of January 1948 (Collection Mme I. Meyer-Chagall, Paris; J. Cassou, *Le Dessin au XXème siècle*, Lausanne, 1951, pl. 30.)

Pompidou, 1979, nos 46–47

127 *Jackie I*. Vence, 1947 (p. 229)
Conté crayon on white paper
52.5 × 40.2 $\left(20\frac{1}{2} \times 15\frac{3}{4}\right)$
Private collection

See cat. 126.

128 *Jackie II*. Vence, 1947 (p. 229)
Conté crayon on white paper
52.5 × 40.2 $\left(20\frac{1}{2} \times 15\frac{3}{4}\right)$
Private collection

See cat. 126.

129 *Jackie III*. Vence, 1947 (p. 229)
Conté crayon on white paper
52.5 × 40.2 $\left(20\frac{1}{2} \times 15\frac{3}{4}\right)$
Private collection

See cat. 126.

130 *Jackie IV*. Vence, 1947 (p. 229)
Conté crayon on white paper
52.5 × 40.2 $\left(20\frac{1}{2} \times 15\frac{3}{4}\right)$
Private collection

See cat. 126.

131 *Jackie V*. Vence, 1947 (p. 230)
Conté crayon on white paper
52.5 × 40.2 $\left(20\frac{1}{2} \times 15\frac{3}{4}\right)$
Musée National d'Art Moderne, Paris.
Centre Georges Pompidou

See cat. 126.

132 *Jackie VI*. Vence, 1947 (p. 230)
Conté crayon on white paper
52.5 × 40.2 $\left(20\frac{1}{2} \times 15\frac{3}{4}\right)$
Private collection

See cat. 126.

133 *Jackie VII*. Vence, 1947 (p. 230)
Conté crayon on white paper
52.5 × 40.2 $\left(20\frac{1}{2} \times 15\frac{3}{4}\right)$
Musée National d'Art Moderne, Paris.
Centre Georges Pompidou

See cat. 126.

134 *Jackie VIII*. Vence, 1947 (p. 230)
Conté crayon on white paper
52.5 × 40.2 $\left(20\frac{1}{2} \times 15\frac{3}{4}\right)$
Private collection

See cat. 126.

135 *Jackie IX*. Vence, 1947 (p.231)
Conté crayon on white paper

52.5 × 40.2 $\left(20\frac{1}{2} \times 15\frac{3}{4}\right)$
Private collection

See cat. 126.

136 *Dahlias and Pomegranates*. Vence, 1947 (p. 232)
Brush and ink on white paper
76.2 × 56.5 $\left(30 \times 22\frac{1}{4}\right)$
The Museum of Modern Art, New York.
Abby Aldrich Rockefeller Fund

In 1947–48 Matisse concentrated on a series of large brush and black ink drawings which, in subject matter as well as in scale and expressive power, are closely related to his contemporaneous paintings of large interiors at Vence. Th drawings depicting either still-lifes or interiors with fruit and flowers (cat. 137–39) are conceive according to the principle of juxtaposition of black and white: white acquires its luminous quality through the value of black, and the whole composition becomes colouristically expressive. Thirteen of these works were first presented in the exhibition of Matisse's recent works of 1947–48 at the Musée National d'Art Moderne in Paris, in June–September 1949. This composition is among the least dense of the sequence, and seems almost to be a close-up vie of the still-life arranged on the table in *Dahlias, Pomegranates and Palm Trees* (cat. 137).

Baltimore, 1971, no. 71
Elderfield, 1978–1, pp. 152, 155

137 *Dahlias, Pomegranates and Palm Trees*. Vence, 19 (p. 233)
Brush and ink on paper
76.2 × 56.5 $\left(30 \times 22\frac{1}{4}\right)$
Musée National d'Art Moderne, Paris.
Centre Georges Pompidou

This is one of the more elaborate compositions the monumental drawings done in thick brush and India ink. It repeats the grouping of object on the table from *Dahlias and Pomegranates* (cat. 13 and also includes a close-up view of the palm tree visible through the window. This motif wi reappear in another drawing of the series, *Composition with Window and Palm Tree* (1948, private collection, France; Paris, 1975, no. 149).
See also cat. 136.

Berggruen, 1983, no. 13
Paris, 1975, no. 148
Pompidou, 1979, no. 47

138 *Still-life with Pineapple.* 1948 (p. 234)
Brush and ink on white paper
104.1 × 74 (41 × 29⅛)
Private collection

This is another in the group of Matisse's bold black and white drawings of interiors with still-lifes of fruits and flowers, which he made during the years 1947 and 1948 in Vence (cat. 136–40). In its composition the drawing relates closely to a painting, *Pineapple*, of early 1948 (Alex Hillman Family Foundation, New York), which constitutes one of the six compositions in Matisse's last series of paintings. Details such as the vase of flowers and the decorative fruit bowl on the table set against the window, with the tree visible outside, repeat the motifs of earlier drawings of the series such as *Still-life with Fruit and Flowers* (1947, Detroit Institute of Arts) and *Still-life with Medlars* (1947, private collection, France).

Baltimore, 1971, no. 72

139 *Composition with Standing Nude and Black Fern.*
Vence, 1948 (p. 235)
Brush and ink on paper
105 × 75 (41⅜ × 29¾)
Musée National d'Art Moderne, Paris.
Centre Georges Pompidou

Among the group of large brush and ink drawings a few also included a female figure, as in the present sheet, where the large black form of the fern at left is counterbalanced by the whiteness of the human form and part of the table with fruit at right. Another, horizontal sheet, much less contrapuntal in the use of black and white, includes some of the same compositional elements: the table with fruit bowl and the same model seated to the right of the table (L.-E. Aström, *Henri Matisse*, Stockholm, 1953, pl. 37). An oil painting, *Interior with Black Fern*, 1948 (Otto Preminger Collection, New York; Zürich, 1982–1, no. 93), one of the six paintings from the series of his large interiors, also takes up the compositional elements present in this drawing but does not directly relate to it.

Pompidou, 1979, no. 48

140 *Model in the Studio.* Vence, 1948 (p. 236)
Brush and ink on paper
56 × 76 (22 × 29⅞)
Private collection

This drawing reunites many compositional elements previously used in the bold black and white drawings (cat. 139), such as the tree visible through the window and the standing model. Its subject relates it to the series of Matisse's late paintings of large interiors. It also continues the theme of the model in the studio, frequently explored in both paintings and drawings during the 1920s and 1930s.

141 *Fig Leaves.* Vence, 1948 (p. 237)
Charcoal on white paper
52.5 × 48 (20⅝ × 18⅞)
Musée Matisse, Nice-Cimiez

Plants and flowers were always an important part of Matisse's environment. They were frequently subjects in his work of the 1940s (cat. 120, 125, 136–39), and later figured prominently among the motifs of his paper cut-outs. Fascinated with the diversity of forms to be found in a single leaf, he studied them in drawing, as in the present sheet, investigating the characteristic form of the leaves.

Baltimore, 1971, no. 73

142 *Head of St Dominic.* Vence–Nice, (1948–49)
(p. 238)
Charcoal on painted plaster on canvas
132 × 108 (52 × 42½)
Collection Pierre Matisse

In 1948 Matisse began work on the decoration for the Chapel of the Rosary for the Dominican nuns at Vence, completed in June 1951. For one of the ceramic murals, opposite the transept windows (on the right of the main altar and in a recess to the left of a large mural of the *Virgin and Child*), Matisse designed a full-size figure of St Dominic. He made innumerable studies for the figure as well as the head, including the present work. The model for the figure was Father M. A. Couturier, a Dominican from Paris, and artistic advisor for the decorations at the church at Assy (Haute-Savoie), for which during the same year Matisse had also executed a half-length figure of St Dominic, closely related to the present work. The Vence mural was also preceded by several, much smaller, preliminary sketches in pen and ink (Barr, 1951, p. 522; Paris, 1975, no. 152), some of which are at the Musée Matisse (Nice-Cimiez). Subsequently, Matisse also made a lithograph of

the head of St Dominic (*c*.1950; Fribourg, 1982, no. 553).

Barr, 1951, pp. 261, 280, 514—23
Paris, 1975, no. 152
Chapelle du Rosaire, *1951*

143 *Study of Hands.* Nice, 1949 (p. 238)
Charcoal on paper
40.5 × 26 ($15\frac{15}{16}$ × $10\frac{1}{4}$)
Musée Matisse, Nice-Cimiez

When working on the figure of St Dominic for the Chapel of the Rosary in Vence, Matisse had also executed various preparatory studies of the hands of the saint (most of them now at the Musée Matisse). Among them is the present study of clasped hands drawn after the Isenheim altarpiece by Matthias Grünewald, whose work Matisse investigated thoroughly while considering the themes for the murals of the chapel. Here, the gesture of the hands recalls that of the imploring Virgin in the Crucifixion panel. Several other drawings of hands, such as the study of St Dominic's left hand holding the Bible (Barr, 1951, p. 283), use the gestures of figures in the same altarpiece as the source of inspiration.

Barr, 1951, p. 282

144 *Study for The Entombment.* Nice, 1949 (p. 240, above)
Charcoal on paper
45 × 57 ($17\frac{3}{4}$ × $22\frac{1}{2}$)
Musée Matisse, Nice-Cimiez

For the east wall of the nave of the Rosary Chapel, directly opposite two apse windows behind the main altar, Matisse designed a large ceramic mural representing, in a single composition, the fourteen Stations of the Cross. The present drawing and the three sheets that follow (cat. 145–47), are studies for the figure of Christ in the last, or fourteenth, Station of the Cross: the Entombment. The four drawings record different stages in the evolution of the figure and allow us to follow both conceptual and formal changes in the treatment of the subject. The original conception of the body may have been inspired by Matisse's own c. 1895 copy of the seventeenth-century painting *Dead Christ* by Philippe de Champaigne (Barr, 1951, p. 293). Subsequently, the quite naturalistic depiction was simplified and geometricized (cat. 147). In

later states the direction in which the body faced was reversed, and remained thus in the mural itself. The changes in the position of the body can be particularly appreciated in the third of the exhibited sheets (cat. 146).

145 *Study for The Entombment.* Nice, 1949 (p. 240, below)
Charcoal on paper
48 × 63 ($18\frac{7}{8}$ × $24\frac{3}{4}$)
Musée Matisse, Nice-Cimiez

See cat. 144.

146 *Study for The Entombment.* Nice, 1949 (p. 241, above)
Charcoal on paper
48 × 63 ($18\frac{7}{8}$ × $24\frac{3}{4}$)
Musée Matisse, Nice-Cimiez

See cat. 144.

Baltimore, 1971, no. 74

147 *Study for The Entombment.* Nice, 1949 (p. 241, below)
Charcoal on paper
48 × 63 ($18\frac{7}{8}$ × $24\frac{3}{4}$)
Musée Matisse, Nice-Cimiez

See cat. 144.

Baltimore, 1971, no. 75

148 *Study for the Virgin and Child.* Nice, 1949 (p. 239)
Charcoal
52.5 × 40.5 ($20\frac{5}{8}$ × 16)
Musée Matisse, Nice-Cimiez

This is one of the preparatory studies for the mural of the *Virgin and Child* placed on the north wall of the nave in the Chapel of the Rosary at Vence. Besides the present work, Matisse made a number of pen and ink studies of the two figures and another, larger, charcoal with the *Virgin and Child* in a slightly modified pose, placed against a decorative floral background, which was slightly altered in the final version of the mural. All studies are at the Musée Matisse at Nice-Cimiez.

Chapelle du Rosaire, *1951*

149 *The Necklace.* Nice, 1950 (p. 237)
Brush and ink on white wove paper
52.8 × 40.7 ($20\frac{7}{8}$ × $16\frac{1}{8}$)
The Museum of Modern Art, New York.
 The Joan and Lester Avnet Collection

Following the bold black and white drawings in heavy ink-loaded brush and India ink, Matisse executed innumerable calligraphic brush and ink portrait-heads and nudes, such as *The Necklace* (also known as *Nude with a Necklace*) of May 1950. A number of other drawings may have been done from the same model and around the same time, such as *Torso, Back View* (May 1950, private collection, Paris; Barr, 1951, p. 509), *Seated Nude with Arms Raised* (1952; Paris, 1950, p. 24), *Portrait* (1950, Collection Dina Vierny, Paris; Paris, 1975, no. 153), portrait of *Mme Monique Mercier* (1951; *Portraits*, 1954, p. 78), and another frontal view of the model's face and neck with an indication of beads around the neck. All share the same stylistic characteristics – an energetic, heavy contour line, activating the space and evoking volume, and a mask-like facial quality.

Elderfield, 1978–1, p. 153
Paris, 1975, no. 154
The Museum of Modern Art, New York, The Treasury of Modern Drawing, 1978, p. 32

150 *Tree*. Nice, December 1951 (p. 243)
Brush, black ink and white gouache on cream paper
150 × 150 (59 × 59)
Musée Matisse, Nice-Cimiez. Donation Jean Matisse. Dépôt de l'Etat
Not shown in New York

Among Matisse's works of 1951–52 are several large studies of trees or, as he described them, his personal 'signs for trees', in the manner of Chinese artists. The drawings included here are part of a group of plane trees done in preparation for the ceramic mural completed in March 1952 for the house of Matisse's friend, the publisher Tériade. A decade earlier, in 1941, Matisse had made some twenty-one studies of trees (Aragon, 1971, vol. I, p. 109) visible from his apartment window in Nice-Cimiez. He had extensively discussed the method of their execution in his letter to André Rouveyre in 1942 and subsequently in his statement to Aragon in 1943, in which he stressed the patient study of 'how the mass of the tree is made, then the tree itself, the trunk, the branches, the leaves', and emphasized the necessity to find his own 'sign for the tree' which would convey the emotion inspired in him by the sight of the tree.

Aragon, 1971, vol. I, pp. 108–11
Baltimore, 1971, nos 76, 77

Fourcade, 1972, pp. 166–70
Flam, 1973, pp. 94–95
Paris, 1975, nos 157–58

151 *Tree*. Nice, December 1951 (p. 242)
Brush, black ink and white gouache on tan paper
158 × 120 ($62\frac{1}{4}$ × $47\frac{1}{4}$)
Private collection

See cat. 150.

152 *Blue Nude I*. Nice, 1952 (p. 244)
Cut and pasted paper, prepainted with gouache
116 × 78 ($45\frac{11}{16}$ × $30\frac{3}{4}$)
Collection Ernst Beyeler, Basel
Not shown in New York

This is one of four paper cut-outs in the series of *Blue Nudes* executed in April 1952. Originally entitled *Bathers (Baigneuses)* they were possibly produced for inclusion in the larger work then in progress, *The Parakeet and the Mermaid*. A sketchbook documenting the preparatory studies for *The Parakeet and the Mermaid*, published in 1955 (*Henri Matisse. Carnet de dessins*, text by Jean Cassou, Paris, Huguette Berès, Berggruen et Cie), includes several sketches of the poses developed in the *Blue Nude* series.

Elderfield, 1978–2, pp. 26–29, pl. 32
St Louis, 1977, pp. 211–13, no. 167

153 *Blue Nude IV*. Nice, 1952 (p. 245)
Painted, cut and pasted paper, charcoal
103 × 74 ($40\frac{1}{2}$ × $29\frac{1}{8}$)
Musée Matisse, Nice-Cimiez. Donation Jean Matisse. Dépôt de l'Etat
Not shown in New York

Although designated as *Blue Nude IV*, this work was actually begun as a study for the three other cut-outs, *Blue Nudes I–III*, but was finished only after they were completed. It is the most elaborate figure study among Matisse's cut-outs.

Elderfield, 1978–2, pp. 26–29, pl. 35
St Louis, 1977, p. 217, no. 170

154 *Blue Nude, The Frog*. Nice, 1952 (p. 246)
Cut and pasted paper, prepainted with gouache
141 × 134 ($55\frac{1}{2}$ × $52\frac{3}{4}$)
Collection Ernst Beyeler, Basel
Not shown in New York

Unlike the monochrome series *Blue Nude I–IV*, this work presents the blue nude in an unusual frontal position, against a brilliant yellow background.

Elderfield, 1978–2, p. 29
Moulin, 1968, p. 35 (pl. VI)
St Louis, 1977, p. 230, no. 180

155 *Acrobats*. Nice, 1952 (p. 247, above left)
Brush and ink on paper
105.5 × 74.5 $\left(41\frac{1}{2} \times 29\frac{3}{8}\right)$
Musée Matisse, Nice-Cimiez. Donation Jean
 Matisse. Dépôt de l'Etat
Not shown in New York

In the last group of six large brush and ink drawings Matisse explores the subject of acrobats – a subject which had fascinated him since the 1930s. In 1931–32 he executed a series of lithographs of *Movements for the Dance*, originally intended to illustrate a text by Colette (Fribourg, 1982, nos 580–88, pp. 165–67), where the poses and the summary treatment of the figures anticipate those of the Acrobats. The four drawings included in the exhibition are part of the series which contained three double images (of which this is one) and three single figures in profile view (cat. 156–58), all conceptually related to the contemporaneous large paper cut-out *Acrobats* (cat. 159). According to Fourcade the pose of the figures derives from a charcoal drawing of a kneeling figure in three-quarter back view (*Derrière le miroir*, no. 46, May 1952, p. 3).

Paris, 1970, no. 214, A
Paris, 1975, nos 159–61

156 *Acrobat*. Nice, 1952 (p. 247, above right)
Brush and ink on paper
105.5 × 74.5 $\left(41\frac{1}{2} \times 20\frac{3}{8}\right)$
Private collection

See cat. 155.

Baltimore, 1971, no. 80
Paris, 1975, no. 159

157 *Acrobat*. Nice, 1952 (p. 247, below left)
Brush and ink on paper
105.5 × 74.5 $\left(41\frac{1}{2} \times 20\frac{3}{8}\right)$
Private collection

See cat. 155.

Paris, 1975, no. 161

158 *Acrobat*. Nice, 1952 (p. 247, below right)
Brush and ink on paper
105.5 × 74.5 $\left(41\frac{1}{2} \times 20\frac{3}{8}\right)$
Private collection

See cat. 155.

Baltimore, 1971, no. 79
Paris, 1975, no. 160

159 *Acrobats*. Nice, 1952 (p. 248)
Blue paper cut-out, paper and charcoal
 mounted on canvas
213 × 209.5 $\left(83\frac{7}{8} \times 82\frac{1}{2}\right)$
Private collection
Not shown in London

In 1952 Matisse produced his largest number of important paper cut-outs, among them the present work, which was developed at the same time as the seminal *The Parakeet and the Mermaid*, and was accompanied by six large brush and ink drawings (cat. 155–58). The pose of the figures evolved out of the exuberant position of the blue dancer in one of the single-figure cut-outs, *La Chevelure* (1952), and is a variation on poses of acrobats in the brush and ink drawings. The process of composition can be followed in the right part of the panel where the figure, composed on five sheets of paper, shows the charcoal underdrawing. The superimposition of the cut-out form over the charcoal drawing results in the suggestion of movement.

Baltimore, 1971, no. 81
Elderfield, 1978–2, p. 29
St Louis, 1977, pp. 222–23

LIST OF ILLUSTRATIONS IN THE TEXT

Dimensions are given in centimetres and inches, height × width × depth. Dates are enclosed in parentheses when they have not been verified.

41 × 53 (16⅛ × 20⅞). Musée National d'Art Moderne, Paris. Centre Georges Pompidou. Gift of the artist.

29 *Seated Nude with Arms Raised* (c. 1922). Charcoal and estompe on white paper, 61 × 49.5 (24 × 19½). Collection of the Art Institute of Chicago. The Wirt D. Walker Fund.

30 *Large Seated Nude* (1922–25). Bronze, 84 (33). Private collection.

31 AUGUSTE RENOIR: *Portrait of Ambroise Vollard as a Toreador*, 1917. Oil on canvas, 103 × 83.2 (40½ × 32¾). Nippon Television Network Corp.

32 Matisse in his studio in Place Charles Félix, Nice, c. 1926.

33 *Seated Figure on a Decorative Background* (1925). Charcoal on white paper, 81.5 × 66.5 (32⅛ × 26⅛). Private collection. (See cat. 66.)

34 *Decorative Figure on an Ornamental Ground* (1925–26). Oil on canvas, 130.2 × 97.5 (51¼ × 38⅜). Musée National d'Art Moderne, Paris. Centre Georges Pompidou.

35 *Fruit and Bronze*, 1910. Oil on canvas, 89 × 116.5 (35 × 45⅞). The Pushkin Museum of Fine Arts, Moscow.

36 *Seated Odalisque with Flowers and Fruit against an Ornamental Ground* (1927). Pen and ink on paper, 27.5 × 38 (10¹³⁄₁₆ × 15). Private collection. Photo: Musées Nationaux.

37 *Seated Nude*, 1929. Drypoint, 14.7 × 10 (5¹³⁄₁₆ × 3¹⁵⁄₁₆). The Museum of Modern Art, New York. Purchase.

38 *Study for The Rape of Europa* (1929). Charcoal on paper mounted on canvas, 102.5 × 153 (41⅜ × 10¼). Private collection.

39 *Nude from the Back* (1927). Pencil on paper, 29.7 × 23 (11⅝ × 9). Private collection.

40 Charles Baudelaire, 1855. Gelatin silver print by Daniel Masclet from the collodion negative by Nadar. Courtesy International Museum of Photography at George Eastman House, Rochester (New York).

41 *Charles Baudelaire* (1931–32). Pencil on ivory paper, 31.6 × 23.7 (12⁷⁄₁₆ × 9¼). The Baltimore Museum of Art: The Cone Collection, formed by Dr Claribel Cone and Miss Etta Cone of Baltimore, Maryland.

42 *Charles Baudelaire*, 1932. Etching, 30.5 × 22.9 (12 × 9). From Stéphane Mallarmé, *Poésies* (Paris, 1932). The Museum of Modern Art, New York. Abby Aldrich Rockefeller Fund.

43 *Faun and Nymph* (1930–32). Etching, 30.1 × 24.1 (11⅞ × 9½). From Stéphane Mallarmé, *Poésies* (Paris, 1932). The Museum of Modern Art, New York. Abby Aldrich Rockefeller Fund.

44 *Nymph and Satyr*, 1909. Oil on canvas, 89 × 117.2 (34 × 46⅛). The State Hermitage Museum, Leningrad.

45 *Dance II* (1932–33). Oil on canvas, 357.1 × 1513.5 (140½ × 596). Photograph © copyright by The Barnes Foundation, Merion, Pennsylvania.

46 *The Toboggan*. Pochoir plate, 33 × 30.1 (13 × 11⅞). From *Jazz* (Paris, 1947). The Museum of Modern Art, New York. Gift of the artist.

47 *Study for Bataille de femmes*. From James Joyce, *Ulysses* (New York, 1935). The Museum of Modern Art, New York. The Louis E. Stern Collection.

48 *Bataille de femmes*. Soft ground etching, 28.1 × 21.7 (11¹⁄₁₆ × 8½). From James Joyce, *Ulysses* (New York, 1935). The Museum of Modern Art, New York. The Louis E. Stern Collection.

49 *Study for The Blinding of Polyphemus*. From James Joyce, *Ulysses* (New York, 1935). The Museum of Modern Art, New York. The Louis E. Stern Collection.

50 *The Blinding of Polyphemus*. Soft ground etching, 26.9 × 21 (10⅝ × 8¼). From James Joyce, *Ulysses* (New York, 1935). The Museum of Modern Art, New York. The Louis E. Stern Collection.

51 *Nymph and Faun with Pipes* (1935). Charcoal on canvas, 153 × 167 (60¼ × 65¾). Musée Matisse, Nice-Cimiez.

52 Matisse in his studio, 1940/41, working on *Nymph in the Forest* (c. 1935–1942/43), with the unfinished *Nymph and Faun with Pipes* (c. 1940/41–43; cat. 100) in the background.

53 *The Conservatory* (1938). Oil on canvas, 74 × 61 (29 × 23⅞). Private collection, USA.

54 *Nude Study*, 1938. Charcoal on paper, 61 × 80 (24 × 31⅜). Private collection.

55 *Dormeuse*, 1940. Lead pencil on paper, 40.5 × 52.5 (15¹⁵⁄₁₆ × 20⅝). Private collection.

56 *The Dream*, 1940. Oil on canvas, 81 × 65 (32 × 25⁹⁄₁₆). Private collection, Paris.

57 Matisse's studio at Cimiez with *Themes and Variations* pinned on the wall, c. 1943.

58 Matisse drawing on the wall of his apartment at the hotel Le Régina, Nice, 1⁵ April 1950.

59 The Chapel of the Rosary, Vence.

60 *Tree*, 1952. Brush, black and white ink over charcoal on paper, 160 × 284 (63 × 112) Private collection.

61 *Tree*, 1952. Painted and enamelled ceramic, 160 × 284 (63 × 112). Collection E Tériade. Photo: Hélène Adant.

62 The dining room in Matisse's apart ment at the hotel Le Régina, Nice, 1952 Photo: Hélène Adant.

63 Matisse's studio at the hotel Le Régina Nice, c. 1953. Photo: Hélène Adant.

CHRONOLOGY

1869 31 December: Henri Emile Benoît Matisse born at Le Cateau-Cambrésis (département du Nord) in the house of his grand-parents; shortly thereafter the family returns to Bohain-en-Vermandois (département de l'Aisne).

1882—87 Studies at the Lycée Saint-Quentin.

1887—88 Studies law in Paris; returns to Saint-Quentin to become a clerk in a law office.

1889 Attends morning classes (drawing from casts) at the Ecole Quentin Latour (Saint-Quentin).

1890 Begins painting, while convalescing from appendicitis.

1891—92 Abandons law and becomes a student under Bouguereau at the Académie Julian in Paris to prepare for the competition for entry to the Ecole des Beaux-Arts.
 February: takes the entrance examination and fails.

1892 Draws from the antique at the Cour Yvon at the Ecole des Beaux-Arts; begins (unofficially) in Gustave Moreau's class. Evening classes at the Ecole des Arts Décoratifs (where he meets Albert Marquet).

1893 Works with Gustave Moreau and begins copying at the Louvre, at Moreau's suggestion.

1894 Makes numerous copies at the Louvre. Birth of daughter Marguerite.

1894—95 Winter: prepares again for the entrance examination to the Ecole des Beaux-Arts, and passes.

1895 March: officially enters Gustave Moreau's class at the Ecole des Beaux-Arts. Meets Manguin, Piot, Bussy, Rouault. Begins to paint outdoors in Paris. Moves to 19 quai Saint-Michel. Summer in Brittany.

1896 Salon de la Société des Beaux-Arts accepts 4 of his paintings. Elected an Associate Member of the Société Nationale. Second stay in Brittany; visits Belle-Ile.

1897 Discovers Impressionism through the Caillebotte Bequest shown at the Musée du Luxembourg. Exhibits the painting *La Desserte* at the Salon de la Nationale. Works in Brittany where he meets the painter John Russell (sees 2 drawings by Van Gogh, one of which he buys).

1898 Marries Amélie Parayre of Toulouse. Spends honeymoon in London where on Pissarro's advice he studies Turner. Spends six months in Corsica, then the next six months in Toulouse and Fenouillet.

1899 Returns to Paris after one year abroad. Birth of son Jean. Works under Cormon who has succeeded Moreau at the Beaux-Arts; asked to leave the

school. For a few months attends classes at the Académie E. Carrière (wh[e]
he meets André Derain). Evening sculpture classes at the Ecole Commun[e]
de la Ville de Paris (rue Etienne Marcel). Exhibits for the last time at the Sa[l]
de la Nationale. Purchases Cézanne's painting *Three Bathers*, a plaster bust [of]
Henri Rochefort by Rodin, head of a boy by Gauguin and a second draw[ing]
by Van Gogh.

1900 Winter: works at the studio of La Grande Chaumière under Bourdelle.
Financial hardship. Paints exhibition decorations at the Grand Palais for t[he]
Exposition Universelle. Continues to study sculpture in the evenings. Bir[th]
of son Pierre.

1901 Late winter rest in Villars-sur-Ollon, Switzerland. Exhibits at the Salon [des]
Indépendants. Sees Van Gogh's retrospective at Galerie Bernheim-Jeu[ne].
Meets Maurice Vlaminck.

1902 Exhibits at Galerie Berthe Weill with his friends from the Atelier Gusta[ve]
Moreau. One-year stay in Bohain with wife and children.

1903 Foundation of the Salon d'Automne where Matisse exhibits along with [his]
friends, including Camoin, Manguin, Rouault, Puy and Derain. Gaugui[n]
retrospective takes place. Sees exhibition of Islamic art at the Pavillon [de]
Marsan. First attempts at engraving.

1904 First one-man show with Ambroise Vollard, Paris.
Summer: Saint-Tropez with Paul Signac and H. E. Cross.
Sends 13 works to the Salon d'Automne.

1905 *Luxe, calme et volupté* exhibited at the Salon des Indépendants and bought [by]
Signac. First summer stay in Collioure (with André Derain). Meets
Maillol who introduces him to Daniel de Monfried, 'guardian' of t[he]
Gauguin collection.
October: famous 'Fauve' Salon d'Automne; the Steins begin to buy his wo[rk].
Takes a studio in the Couvent des Oiseaux, rue de Sèvres, Paris.

1906 March: one-man show at the Galerie Druet, Paris, including drawings a[nd]
woodcuts.
Late spring: visit to Biskra, Algeria.
Summer: Collioure.
Exhibits at the Salon d'Automne. Claribel and Etta Cone start buying [his]
work. Develops interest in African art. *Bonheur de vivre* exhibited at the Sal[on]
des Indépendants and bought by Leo Stein. Meets Picasso at the Stei[ns].
Returns to Collioure for the winter.

1907 *Blue Nude* exhibited at the Salon des Indépendants.
Mid June – mid July: Collioure.
Mid July – mid August: Padua, Florence, Arezzo and Siena.
Autumn: back in Collioure. Exchanges paintings with Picasso who [is]
working on *Les Demoiselles d'Avignon*. Admirers organize a school (Acadé[mie]
Matisse) in rue de Sèvres, Paris, where he teaches.

1908 Moves to boulevard des Invalides where his studio and school are a[lso]
established. Visits Bavaria (to Munich with Hans Purrmann).
First exhibition in the US at Alfred Stieglitz's 'Little Galleries of the Pho[to]
Secession' ('291'), New York; shows drawings, watercolours and prints.
Exhibits at the Salon d'Automne.
December: 'Notes d'un peintre' published in *La Grande Revue*, vol. 52, pp. 24–
The Russian collector S. I. Shchukin starts buying his work.

1909	Shchukin commissions *Dance* and *Music*.

1909 Shchukin commissions *Dance* and *Music*.
February: visits Cassis (in the south of France).
Spring: back in Paris for the Salon des Indépendants.
June–September: Cavallière (near Saint-Tropez).
September: moves to Issy-Les-Moulineaux (south west of Paris), where he builds a studio. Loses interest in his school. First contract with the Galerie Bernheim-Jeune.
December: second visit to Germany; meets Paul Cassirer. Begins *The Serpentine* and *Back I*.

1910 First exhibition at Galerie Bernheim-Jeune.
Second exhibition at Gallery '291' in New York.
Late summer: travels to Munich to see an exhibition of Islamic art. Brief stay in Paris for the Salon d'Automne where he exhibits *Dance* and *Music*.
November–January 1911: travels to Spain; paints in Seville.

1911 End January: back in Paris.
Stays in Issy until May. Exhibits at the Salon des Indépendants.
June–September: Collioure.
Autumn: visits Moscow for installation of the Shchukin decorations; studies Russian icons.
December–April 1912: first trip to Tangier.

1912 Spring: back in Issy for summer. First exhibition exclusively organized for his drawings and sculptures at Gallery '291' in New York.
Exhibits at the Salon des Indépendants. Danish collectors and I. A. Morosov in Moscow begin to buy his work.
Autumn–late February 1913: second trip to Tangier.

1913 April: returns to Paris for his one-man show at Galerie Bernheim-Jeune.
Summer: Issy, with a short visit to Collioure and Cassis.
By November: back in his old studio at 19 quai Saint-Michel. Participates in the Armory Show in New York.

1914 Stays at quai Saint-Michel until the summer.
August: spends one month in Issy. Rejected from military service, having volunteered to be drafted after the war declaration in August 1914.
First half of September: joins his family, travelling to the south of France (Toulouse and Bordeaux).
Mid-September–early October: Collioure, where he has extended discussions with Juan Gris. Back in Paris, quai Saint-Michel, for the Salon d'Automne. Remains there until spring 1915.

1915 Stays in Paris until the spring, with a short visit to Arcachon, near Bordeaux.
Summer and autumn: Issy. The model Laurette begins posing for him.
Late November: short trip to Marseilles with Marquet, followed by brief stay at L'Estaque, north of Marseilles.
December: returns to his studio on quai Saint-Michel.

1916 Stays in Paris until the spring.
Summer: Issy, with short trips to L'Estaque and Marseilles.
Winter: Paris, with a short trip to L'Estaque.

1917 January–May: first winter in Nice staying at the Hôtel Beau Rivage.
Summer: back in Issy.
Autumn: Paris, quai Saint-Michel.
Winter: Nice. Visits Renoir at Cagnes.

1918	Spring: moves to an apartment on the promenade des Anglais, then to V des Alliès, both in Nice. Summer: Paris and Cherbourg. Autumn: back in Nice, at the Hôtel de la Méditerranée. Visits Renoir Cagnes and Bonnard at Antibes. Exhibits with Picasso at Galerie P Guillaume.
1919	May: exhibition at Galerie Bernheim-Jeune. Antoinette begins posing. Summer and autumn: Issy. November–December: exhibits at the Leicester Galleries, London.
1920	Early summer: visit to London then a few weeks in Etretat, Norman Works on the ballet *Le Chant du rossignol* by Diaghilev. Constant travelling fro Nice to Monte Carlo to consult Diaghilev on the project. Publication of *Cinquante dessins par Henri Matisse* supervised by the art Exhibition of his recent 1919–20 works at Galerie Bernheim-Jeune.
1921	Summer: Etretat. Autumn: back in Nice, taking an apartment on Place Charles Félix. Fr now on, half of the year in Nice and the other half in Paris until the ea 1930s. The painting *Odalisque au pantalon rouge* is bought by the state for the Musée Luxembourg. Henriette Darricarrère begins posing.
1922	Focuses on lithography. Begins work on *Large Seated Nude*, completed in 19
1923	Makes numerous charcoal drawings.
1924	Exhibitions, notably at the Brummer Galleries, New York, and Copenhagen.
1925	Visits Italy. Is made 'Chevalier de la Légion d'Honneur'. Exhibition at Gale des Quatre Chemins, Paris, on the occasion of their publication of W. George's book on Matisse's drawings.
1927	Awarded First Prize at the Carnegie International Exhibition in Pittsbu Exhibition of drawings and lithographs at Galerie Bernheim-Jeune.
1929	Concentrates on numerous drypoints, prints and lithographs.
1930	Leaves for Tahiti via New York and San Francisco, visiting the Barr Foundation at Merion, Pennsylvania, as well as Miss Etta Cone in Baltimo Commissioned by Albert Skira to illustrate Mallarmé's poems. Important retrospective at Galerie Thannhauser in Berlin. December: returns to the US.
1931	Series of important retrospectives in Paris (Galerie Georges Petit), Ba (Kunsthalle), New York (The Museum of Modern Art), the last t including numerous drawings. Concentrates on the illustration to M larmé. Accepts Dr Barnes's commission to paint murals for the walls of t Foundation.
1932	Completes the first version for the Barnes mural. Begins work on a seco version after an error in the dimensions. Publication of Mallarmé's *Poés* with 29 etchings. Exhibition at Pierre Matisse Gallery, New York, of the drawings chosen by Matisse for the 1920 publication *Cinquante dessins*.
1933	Installs the second version of the murals in the Barnes Foundation. Holiday in Italy (Venice and Padua).
1934–35	Focuses on the series of engravings for *Ulysses* by James Joyce.
1935	Makes a design for Beauvais Tapestry. Mme Lydia Delectorskaya, Matiss secretary, begins acting as his assistant and model.

1936	Exhibition of Matisse's recent works at Paul Rosenberg's gallery, Paris. Special issue of *Cahiers d'art* includes an important series of ink drawings by Matisse.
1937	Massine invites him to design the scenery and costumes for the ballet *Rouge et noir* by the Ballets Russes of Monte Carlo. Participates in the exhibition *Maîtres de l'art indépendant* at the Petit Palais, Paris.
1938	Moves to the hotel Le Régina in Cimiez, near Nice. First *gouache découpée* (cut-out), a medium which he had previously used in preliminary works for Barnes decoration.
1939	Summer: works at Hôtel Lutétia in Paris. September: leaves Paris after declaration of the Second World War. October: returns to Nice. Special issue of *Cahiers d'art*, illustrating a series of his charcoal drawings.
1940	Stays until the spring at the Hôtel Lutétia, then moves to boulevard Montparnasse. May: moves to Bordeaux, then to Ciboure (near Saint-Jean de Luz). Legal separation from Madame Matisse.
1941	Begins illustrating *Florilège des amours*. Spring spent in hospital in Lyons recovering from two intestinal operations. Works in bed on a series of drawings, *Themes and Variations* (continuing through 1942). Exhibition of his drawings and charcoals at Galerie Louis Carré, Paris.
1942	Exchanges paintings and drawings with Picasso. Works on the illustrations for *Poèmes* by Charles d'Orléans. Louis Aragon visits.
1943	Air raid at Cimiez. June: moves to villa 'Le Rêve' in Vence. Publication of *Thèmes et variations* preceded by the text 'Matisse-en-France' by Louis Aragon. Begins the paper cut-outs for *Jazz*.
1944	Participates in the Salon d'Automne exhibition in celebration of the Liberation. Illustrations for Baudelaire's *Les Fleurs du mal*.
1945	Summer: returns to Paris. Series of exhibitions, including important retrospective at the Salon d'Automne. Recent drawings at Pierre Matisse Gallery in New York, then at Galerie Maeght in Paris.
1946	Illustrates the letters of Marianna Alcaforado. A documentary film shows Matisse working.
1947	Publication of *Jazz* (Tériade), and of *Les Fleurs du mal*, illustrated by Matisse.
1948	Retrospective at the Philadelphia Museum of Art. Begins designs and decorations for the Dominican Chapel at Vence, and a figure of St Dominic for the church at Assy. Publication of *Florilège des amours* by Ronsard.
1949	Returns to the hotel Le Régina in Cimiez. Exhibition of cut-outs at Pierre Matisse Gallery, New York. Exhibition at the Musée National d'Art Moderne, Paris. Retrospective in Lucerne, Musée des Beaux-Arts.
1950	Exhibition at Galeries des Ponchettes, Nice, and at the Maison de la Pensée Française, Paris. Publication of *Poèmes* by Charles d'Orléans with lithographs by Matisse. Receives highest prize at the 25th Venice Biennale.
1951	25 June: consecration of the chapel at Vence. Matisse retrospective at The Museum of Modern Art, New York. Publication of Alfred Barr's monograph *Matisse, His Art and His Public*. Works on cut-outs and large brush drawings.

1952	Inauguration of the Musée Matisse at Le Cateau-Cambrésis. Exhibition recent drawings and the *Blue Nude* series at Galerie Maeght, Paris.
1953	Exhibition of cut-outs at Galerie Berggruen and of sculpture (organized the Arts Council) at the Tate Gallery, London.
1954	3 November: Matisse dies in Nice and is buried at Cimiez.

MAJOR EXHIBITIONS CONTAINING DRAWINGS

Exhibitions are listed chronologically, according to the abbreviated form in which they appear in the Catalogue. For a more complete exhibition list, see the catalogues Matisse. Dessins, sculptures, Musée National d'Art Moderne, Centre Georges Pompidou, Paris, 1975, and Henri Matisse. Das Goldene Zeitalter, Kunsthalle Bielefeld, Bielefeld, 1981.

Paris 1901	20 April–21 May. *Société des Artistes Indépendants*, Grandes Serres de l'Exposition Universelle.
Paris 1904	1–18 June. *Exposition des oeuvres du peintre Henri Matisse*, Galerie Ambroise Vollard (1 drawing).
Paris 1905	18 October–25 November. *Société du Salon d'Automne*, Grand Palais des Champs Elysées (3 drawings).
Paris 1906	19 March–7 April. *Exposition Henri Matisse*, Galerie Druet.
Paris 1907–1	20 March–30 April. *Société des Artistes Indépendants*, Serres du Cours-la-Reine (2 drawings).
Paris 1907–2	1–22 October. *Société du Salon d'Automne*, Grand Palais des Champs Elysées (2 drawings).
Berlin 1907	December. *Vierzehnte Ausstellung der Berliner Secession, Zeichnende Kunst* (8 drawings).
New York 1908	6–25 April. *An Exhibition of Drawings, Lithographs, Watercolours, and Etchings by M. Henri Matisse*, The Little Galleries of the Photo-Secession.
Paris 1908	1 October–8 November. *Société du Salon d'Automne*, Grand Palais des Champs Elysées (6 drawings).
Berlin 1908	December 1908–January 1909. *Henri Matisse*, Paul Cassirer.
Moscow 1909	24 January–28 February. *La Toison d'Or. Zolotoye Runo* (9 drawings).
Paris 1910–1	14–22 February. *Exposition Henri Matisse*, Galerie Bernheim-Jeune (26 drawings).
New York 1910	27 February–20 March. *An Exhibition of Drawings and Photographs of Paintings by Henri Matisse*. The Little Galleries of the Photo-Secession (at least 24 drawings).
Paris 1910–2	17–28 May. *Nus*, Galerie Bernheim-Jeune (4 drawings).
London 1910	8 November 1910–15 January 1911. *Manet and the Post-Impressionists*, Grafton Galleries (12 drawings).
New York 1912	14 March–6 April. *An Exhibition of Sculpture (the first in America) and Recent Drawings by Henri Matisse*, The Little Galleries of the Photo-Secession (12 drawings).
London 1912	5 October–31 December. *Second Post-Impressionist Exhibition*, Grafton Galleries (11 drawings).
New York 1913	15 February–15 March. *International Exhibition of Modern Art*, The Armory of the Sixty-ninth Infantry (3 drawings).

Paris 1913	14–19 April. *Exposition Henri Matisse. Tableaux du Maroc et sculptures*, Gal Bernheim-Jeune (at least 6 drawings).
New York 1915	20 January–27 February. *Henri Matisse Exhibition*, Montross Gallery (5 drawin
Paris 1918	23 January–15 February. *Oeuvres de Matisse et de Picasso*, Galerie Paul Guillaur
Paris 1919	2–16 May. *Oeuvres récentes de Henri Matisse*, Galerie Bernheim-Jeune.
London 1919	November–December. *Pictures by Henri Matisse*, Leicester Galleries (3 drawin
New York 1924	25 February–22 March. *Exhibition of Works by Henri Matisse*, The Gallerie Joseph Brummer (6 drawings).
Paris 1924	6–10 May. *Exposition Henri Matisse*, Galerie Bernheim-Jeune.
Paris 1925–1	1–20 January. *Dessins d'Henri Matisse et aquarelles de P. Signac et d'H. E. Cross*, Gal Bernheim-Jeune.
Paris 1925–2	13–28 November. *Henri Matisse – Peintures – Dessins*, Aux Quatre Chemins.
Paris 1927	24 January–4 February. *Exposition Henri Matisse. Dessins et lithographies*, Gal Bernheim-Jeune.
London 1928	January. *Drawings, Etchings and Lithographs by Henri Matisse*, The Leicester Galle (16 drawings).
Paris 1929	7–25 November. *Exposition de peintures et dessins de Henri Matisse*, Galerie Portique.
Berlin 1930	15 February–19 March. *Henri Matisse*, Galerien Thannhauser (54 drawings).
Basel 1931	9 August–15 September. *Henri Matisse*, Kunsthalle (28 drawings).
New York 1931	3 November–6 December. *Henri Matisse Retrospective Exhibition*, The Museum Modern Art (37 drawings).
New York 1932–1	22 November–17 December. *Henri Matisse. Exhibition of Fifty Drawings (Cinqu dessins)*, Pierre Matisse Gallery (49 drawings).
New York 1932–2	3–30 December. *Poésies de Stéphane Mallarmé. Eaux-fortes originales de Henri Mat* Marie Harriman Gallery. (Also included the preparatory studies for the seri
San Francisco 1936	11 January–24 February. *Henri Matisse. Paintings, Drawings, Sculpture*, San Franci Museum of Art.
London 1936	February. *Exhibition of Drawings and Lithographs by Henri Matisse*, The Leices Galleries (52 drawings).
Paris 1936	2–30 May. *Exposition d'oeuvres récentes de Henri Matisse*, Paul Rosenberg.
Paris 1937	1–29 June. *Oeuvres récentes de Henri Matisse*, Paul Rosenberg.
Lucerne 1937	*Henri Matisse*, Galerie Rosengart (34 drawings).
New York 1938	15 November–10 December. *Henri Matisse. Paintings, Drawings of 1918 to 1938*, Pie Matisse Gallery (9 drawings).
New York 1941	15 April–3 May. *Drawings by Matisse. Small Pictures by French Painters*, Pierre Mati Gallery (12 drawings).
Paris 1941	10–30 November. *Henri Matisse. Dessins à l'encre de chine, fusains (oeuvres récent* Galerie Louis Carré (at least 33 drawings).
New York 1944	February. *Modern Drawings*, The Museum of Modern Art (17 drawings).
New York 1945	30 October–17 November. *Henri Matisse Recent Drawings*, Pierre Matisse Gall (22 drawings).
Paris 1945	7–29 December. *Henri Matisse. Peintures – Dessins – Sculptures*, Galerie Maeght drawings).
Liège 1947	*Henri Matisse. Dessins*, A.P.I.A.W., (49 drawings).
Philadelphia 1948	*Henri Matisse. Retrospective Exhibition of Paintings, Drawings and Sculpture.* Organized collaboration with the artist. Philadelphia Museum of Art (86 drawings).
New York 1949	February. *Henri Matisse. Paintings, Papiers Découpées, Drawings – 1945–1948*, Pie Matisse Gallery.

Paris 1949	June–September. *Henri Matisse, oeuvres récentes, 1947–1949*, Musée National d'Art Moderne (22 brush drawings).
Lucerne 1949	9 July–2 October. *Henri Matisse*, Musée des Beaux-Arts (60 drawings).
Nice 1950	January–March. *Henri Matisse*, Galerie des Ponchettes (23 drawings).
Paris 1950	5 July–24 September. *Henri Matisse. Chapelle, peintures, dessins, sculptures*, Maison de la Pensée Française (32 drawings).
New York 1951	13 November 1951–13 January 1952. *Henri Matisse*, The Museum of Modern Art. Travelling exhibition to Cleveland, Chicago and San Francisco (18 drawings).
Marseilles 1951	7–29 December. *Henri Matisse*, Galerie Mouillot (28 drawings).
Stockholm 1951	31 December 1951–31 January 1952. *Henri Matisse. Thèmes et variations, Le Rêve, La Chapelle*, Konstsalongen Samlaren (32 drawings).
Paris 1952	May. *Dessins récents de Henri Matisse*, Galerie Maeght (62 drawings).
New York 1952	8 October 1952–4 January 1953. *Les Fauves*, The Museum of Modern Art. Travelling exhibition (14 drawings).
New York 1953	10–28 February. *The Sculpture of Henri Matisse*, Curt Valentin Gallery (24 drawings).
Rotterdam 1954	16 April – 8 June. *Matisse, Bronzen, Tekeningen, Schilderijen, Schetsen*, Museum Boymans van Beuningen (122 drawings).
Cone Collection 1954	*The Cone Collection*, Richmond, Virginia, Museum of Fine Arts.
New York 1955	24 January–19 February. *Selections from the Cone Collection*, Knoedler Galleries (9 drawings).
Houston 1955	18 September–16 October. *Matisse, Sculptures, Paintings and Drawings*, Museum of Fine Arts (122 drawings).
Boston 1955	1–30 November. *Matisse Bronzes and Drawings*, Museum of Fine Arts (131 drawings).
Jerusalem 1955	*Collection Ayala and Sam Zacks. Art français du vingtième siècle*, Musée National Bezalel. Travelling exhibition (4 drawings).
Toronto 1956	*A Selection from the Ayala and Sam Zacks Collection: Nineteenth and Twentieth Century Paintings and Drawings*, The Art Gallery of Toronto. Travelling exhibition (4 drawings).
Liège 1958	3 May–31 July. *Apollon, Collection Theodor Ahrenberg*, Musée des Beaux-Arts (24 drawings).
Paris 1958–1	May–July. *Chefs-d'oeuvre de Henri Matisse*, Galerie Bernheim-Jeune (18 drawings).
Paris 1958–2	June. *Henri Matisse. Dessins et sculptures inédites*, Galerie Berggruen (15 drawings).
New York 1958–1	25 November–20 December. *Henri Matisse. Sculpture, Drawings*, Fine Art Associates.
New York 1958–2	December 1958–January 1959. *Matisse. Drawings and Sculpture*, Pierre Matisse Gallery (26 drawings).
Zürich 1959	14 July–12 August. *Henri Matisse. Das plastische Werk*, Kunsthaus (51 drawings).
Hamburg 1959	3 September–15 November. *Französische Zeichnungen des XX Jahrhunderts*, Kunsthalle (27 drawings).
Geneva 1959	4 December 1959–29 January 1960. *Le Livre illustré par Henri Matisse: dessins, documents*, Galerie Gérald Cramer (20 drawings).
Aix-en-Provence 1960	9 July–31 August. *Matisse*, Pavillon de Vendôme (37 drawings).
Berne 1960	15 December 1960–31 January 1961. *Henri Matisse. Das Illustrierte Werk, Zeichnungen und Druckgraphik*, Klipstein und Kornfeld (27 drawings).

Albi 1961	11 July–11 September. *Henri Matisse*, Musée Toulouse-Lautrec (77 drawings)
Marseilles 1962	26 June–1 September. *Gustave Moreau et ses élèves*, Musée Cantini (8 drawings)
Stockholm 1962	*Dessins de Henri Matisse*, Konstsalongen Samlaren.
Saint-Quentin 1964	*Les Elèves de l'Ecole La Tour*, Chambre de Commerce (16 drawings).
Beverly Hills 1965	April–May. *Matisse Drawings*, P. N. Matisse Gallery (18 drawings).
Los Angeles 1966	5 January–27 February. *Henri Matisse Retrospective*, UCLA Art Gallery. Sho subsequently in Chicago and Boston (83 drawings).
London 1967	21 April–27 May. *Henri Matisse. Drawings*, Victor Waddington (37 drawings).
New York 1967	9 September–12 November. *Drawings from the Alfred Stieglitz Collection*, T Metropolitan Museum of Art (6 drawings).
Baltimore 1967	15 October 1967–14 January 1968. *French Illustrated Books of the Nineteenth and Twent Centuries*, The Baltimore Museum of Art.
Chicago 1967	November. *Matisse Drawings*, Holland Gallery.
London 1968	11 July–8 September. *Matisse*, Hayward Gallery.
Toronto 1969	12–30 April. *Henri Matisse Drawings*, The Gerald Morris Gallery.
Moscow 1969	April. *Matisse: peintures, sculpture, oeuvre graphique, lettres*, The Pushkin Museum Fine Arts (51 drawings).
Saint-Paul 1969	July–September. *A la rencontre de Matisse*, Fondation Maeght (64 drawings).
Paris 1970–1	10 February–10 March. *Chefs-d'oeuvre de Henri Matisse*, Galerie Bernheim-Jeu (10 drawings).
Paris 1970–2	23 April–1 June. *Matisse*, Galerie Dina Vierny (21 drawings).
Paris 1970–3	April–September. *Henri Matisse, exposition du centenaire*, Grand Palais drawings).
Bordeaux 1970	2 May–1 September. *Hommage à Henri Matisse*, Musée des Beaux-Arts drawings).
Darmstadt 1970	15 August–11 November. *Sonderausstellung Gustav Klimt – Henri Matisse*, Mathild höhe (82 drawings).
Copenhagen 1970	10 October–29 November. *Matisse. En Retrospektiv udstilling*, Statens Museum Kunst (16 drawings).
New York 1970	*Four Americans in Paris*, The Museum of Modern Art. Travelling exhibition drawings).
Baltimore 1971	12 January–21 February. *Matisse as a Draughtsman*, The Baltimore Museum of A (80 drawings).
Jerusalem 1971	Autumn. *Henri Matisse. Prints and Drawings from a Swiss Private Collection*, The Isr Museum – Barbara and Isidore M. Cohen Gallery (7 drawings).
New York 1972	24 February–8 May. *The Sculpture of Matisse*, The Museum of Modern A Shown subsequently in Minneapolis and Berkeley (19 drawings).
London 1972	6–29 July. *Henri Matisse, Drawings*, Victor Waddington (19 drawings).
Chicago 1973	15 September – 11 November. *Twentieth Century Drawings from Chicago Collecti Museum of Contemporary Art (5 drawings).
College Park 1973	7 November–21 December. *Twentieth Century Masterpieces from the Musée de Greno University of Maryland Art Gallery (18 drawings). Travelling exhibition.
Marseilles 1974	15 June–15 September. *130 dessins de Matisse*, Musée Cantini.
Toronto 1974	16 November–4 December. *Henri Matisse. An Exhibition of Drawings and Sculpt David Mirvish Gallery (10 drawings).
Paris 1974	22 November 1974–22 January 1975. *Dessins du Musée National d'Art Mode 1890–1945*, Musée National d'Art Moderne (7 drawings).

New York 1974	*Seurat to Matisse: Drawing in France. Selections from the Collection of The Museum of Modern Art*, The Museum of Modern Art (12 drawings).
London 1975	24 March–25 April. *Matisse, Light and Colour in Line Drawing*, Thomas Gibson Fine Art Ltd (7 drawings).
Paris 1975	29 May–7 September. *Matisse. Dessins, sculpture*, Musée National d'Art Moderne, Centre Georges Pompidou.
St Louis 1977	10 September 1977–12 March 1978. *The Paper Cut-outs of Henri Matisse*, St Louis Art Museum. Travelling exhibition.
New York 1978	26 October 1978–30 January 1979. *Matisse in the Collection of The Museum of Modern Art*, The Museum of Modern Art.
New York 1979	24 August–8 October. *Matisse and Master Drawings from the Baltimore Museum of Art*, The Solomon R. Guggenheim Museum.
Pompidou 1979	*Oeuvres de Henri Matisse (1869–1954)*, Musée National d'Art Moderne, Centre Georges Pompidou (20 drawings).
Paris 1980	*Matisse. Dessins*, Galerie Dina Vierny.
Paris 1981	18 March–21 June. *Henri Matisse. Donation Jean Matisse*, Bibliothèque Nationale (29 drawings).
Tokyo 1981	20 March–17 May. *Matisse*, The National Museum of Modern Art (34 drawings).
Cannes 1981	31 March–27 June. *Henri Matisse. Dessins, lithographies, sculpture, collage, 1906–1952*, Galerie Herbage (24 drawings).
Tours 1981	July. *Henri Matisse. Dessins*, Musée des Beaux-Arts de Tours.
Bielefeld 1981	18 October–13 December. *Henri Matisse. Das Goldene Zeitalter*, Kunsthalle (55 drawings).
San Francisco 1982	17 February–24 March. *Henri Matisse. An Exhibition of Drawings*, John Berggruen Gallery (41 drawings).
Paris 1982	9 June–20 July. *Album Matisse. 33 dessins de 1905 à 1950*, Galerie Dina Vierny.
Fribourg 1982	10 June–5 September. *Henri Matisse. Gravures et lithographies*, Musée d'Art et d'Histoire Fribourg.
Zürich 1982–1	15 October 1982–16 January 1983. *Henri Matisse*, Kunsthaus. (Shown subsequently in Düsseldorf, Städtische Kunsthalle.)
Zürich 1982–2	29 October 1982–16 January 1983. *Nabis und Fauves*, Kunsthaus.
Berggruen 1983	April–May. *Matisse. Dessins au pinceau*, Galerie Berggruen (29 drawings).

SELECT BIBLIOGRAPHY

This bibliography includes only those works which are referred to in the Catalogue, as well as the major monographs on the artist which discuss drawings. They are listed alphabetically, according to the abbreviated form in which they appear in the Catalogue. For a more complete list of references, see the catalogues *Matisse. Dessins, sculptures*, Musée National d'Art Moderne, Centre Georges Pompidou, Paris, 1975, and *Matisse as a Draughtsman*, Baltimore Museum of Art, Baltimore, 1971.

ARAGON 1943 Louis Aragon, 'Matisse-en-France', *Henri Matisse. Dessins: Thèmes et variations*, Paris, Martin Fabiani, 1943.

ARAGON 1971 Louis Aragon. *Henri Matisse. Roman*, Paris, Gallimard, 1971, 2 vols. (English edition: *Henri Matisse. A Novel*, London, Collins, 1972.)

BALTIMORE 1971 *Matisse as a Draughtsman*. Baltimore, The Baltimore Museum of Art, 1971. (Introduction and catalogue notes by V. I. Carlson.)

BALTIMORE 1979 The Baltimore Museum of Art. *Master Drawings and Watercolors from the Nineteenth and Twentieth Centuries*, New York, The American Federation of Art, 1979. (Text by V. I. Carlson.)

BARR 1951 Alfred Barr. *Matisse, His Art and His Public*, New York, The Museum of Modern Art, 1951 (with bibliography). Reprinted London, Secker and Warburg, 1975.

BERGGRUEN 1983 *Matisse. Dessins au pinceau*, Paris, Galerie Berggruen, 1983.

BESSON 1945 Georges Besson. *Matisse*, Paris, Les Editions Braun, 1945.

BIELEFELD 1981 *Henri Matisse. Das Goldene Zeitalter*, Bielefeld, Kunsthalle, 1981 (with bibliography).

CAHIERS D'ART 1935 *Cahiers d'art*, 1935, nos 1–4, Paris.

CAHIERS D'ART 1936 'Dessins de Matisse', *Cahiers d'art*, 1936, nos 3–5, Paris.

CAHIERS D'ART 1939 'Dessins récents de Henri Matisse', *Cahiers d'art*, 1939, nos 1–4, Paris.

CAHIERS D'ART 1945–46 *Cahiers d'art*, 1945–46, Pa pp. 162–96.

CARLSON 1971 Victor I. Carlson. 'Some Cubist Drawi by Matisse', *Arts Magazine*, 45, March 1971, New Yc pp. 37–39.

CHAPELLE DU ROSAIRE 1951 *Chapelle du Rosaire des Do nicaines de Vence par Henri Matisse*, Vence, 1951.

CINQUANTE DESSINS 1920 *Cinquante dessins par Henri Mati* Paris, Galerie Bernheim-Jeune, 1920.

CONE COLLECTION 1934 *The Cone Collection of Baltim Maryland – Catalogue of Paintings, Drawings, Sculpture of Nineteenth and Twentieth Centuries*, Baltimore, Etta Co 1934. (Foreword by George Boas.)

CONE COLLECTION 1955 *Cone Collection. A Handbook wi Catalogue of Paintings and Sculpture*, Baltimore, T Baltimore Museum of Art, 1955. Revised edition, 19

DUTHUIT 1949 Georges Duthuit. *Les Fauves*, Gene Editions des Trois Collines, 1949. (English edition: *Fauves*, New York, Wittenborn, Schultz, Inc., 1950.)

ELDERFIELD 1972 John Elderfield. 'Matisse Drawings a Sculpture', *Artforum*, 11, 1 September 1972, Los Ange pp. 77–85.

ELDERFIELD 1978–1 John Elderfield. *Matisse in the Collec of The Museum of Modern Art*, New York, The Museum Modern Art, 1978.

ELDERFIELD 1978–2 John Elderfield. *The Cut-outs of H Matisse*, New York, George Braziller, 1978, Lond Thames and Hudson, 1979.

ELDERFIELD 1983 John Elderfield. *The Modern Drawing: Works on Paper from The Museum of Modern Art*, New Yo The Museum of Modern Art, 1983.

ELSEN 1972 Albert E. Elsen. *The Sculpture of Henri Mati* New York, Harry N. Abrams Inc., 1972.

FAURE 1923 Elie Faure, Jules Romains, Charles Vildr Léon Worth, *Henri Matisse*, Paris, Georges Crès, 1923.

FELS 1929 Florent Fels. *Henri Matisse*, Editions Chroniques du Jour, Paris, 1929.

FLAM 1973 Jack D. Flam. *Matisse on Art*, London, Phaid 1973 (with select bibliography). Reprinted 1978.

FOURCADE 1972 Dominique Fourcade, ed. *Henri Matisse. Ecrits et propos sur l'art*, Paris, Hermann, 1972.

FOURCADE 1983 Dominique Fourcade. 'Greta Prozor', *Cahiers du Musée National d'Art Moderne, Centre Georges Pompidou*, Paris, Musée National d'Art Moderne, Centre Georges Pompidou, 1983, no. 11, pp. 101–07.

FRY 1935 Roger Fry. *Henri Matisse*, Paris, Editions des Chroniques du Jour, New York, 1935.

GEORGE 1925 Waldemar George. *Dessins de Henri Matisse*, Paris, Editions des Quatre Chemins, 1925.

GOWING 1979 Lawrence Gowing. *Henri Matisse*, London, Thames and Hudson, 1979, New York and Toronto, Oxford University Press, 1979.

GRENOBLE 1963 Musée de Peinture et de Sculpture, Grenoble. *Dessins modernes*, Paris, Editions des Musées Nationaux, 1963.

IZERGHINA 1978 A. N. Izerghina. *Henri Matisse: Paintings and Sculpture in Soviet Museums*, Leningrad, Aurora Art Publishers, 1978.

JACOBUS 1972 John Jacobus. *Henri Matisse*, New York, Harry N. Abrams Inc., 1972.

LAVIN 1981 Maud Lavin. 'An Analysis of Henri Matisse's 1914 Portrait of Mlle Yvonne Landsberg', unpublished MA thesis, University of Pennsylvania, 1981.

LE POINT 1939 *Le Point*, no. XXI, July 1939, Paris.

LOS ANGELES 1966 Los Angeles, UCLA Art Gallery. *Henri Matisse Retrospective*, 1966. (Introductory texts by Jean Leymarie, Herbert Read and William S. Lieberman.)

MALINGUE 1949 Maurice Malingue. *Matisse dessins*, Paris, Editions des Deux Mondes, 1949.

MARSEILLES 1974 *130 dessins de Matisse*, Marseilles, Musée Cantini, 1974.

MOULIN 1968 Raoul-Jean Moulin. *Henri Matisse dessins*, Paris, Editions Cercle d'Art, 1968.

NEFF 1974 John Hallmark Neff. 'Matisse and Decoration 1906–1914', unpublished PhD dissertation, Cambridge, Harvard University, 1974.

NEFF 1975 John Hallmark Neff. 'Matisse and Decoration. The Shchukin Panels', *Art in America*, vol. 63, July-August 1975, New York, pp. 38–48.

NEW YORK 1972 *The Sculpture of Henri Matisse*, New York, The Museum of Modern Art, 1972. (Introduction by Alicia Legg.)

PARIS 1970 *Henri Matisse – Exposition du Centenaire*, Grand Palais, Paris, Réunion des Musées Nationaux, 1970. (Introduction by Pierre Schneider.)

PARIS 1973–74 *Dessins français du Metropolitan Museum of Art, New York – de David à Picasso*, Paris, Musée du Louvre, 1973–74.

PARIS 1975 *Matisse – dessins, sculpture*, Musée National d'Art Moderne, Paris, 1975. (Introduction by D. Fourcade, catalogue notes by D. Fourcade and I. Monod-Fontaine.)

PASIPHAË 1944 Henri de Montherlant. *Pasiphaë*, Paris, Martin Fabiani, 1944. Reprinted Paris, 1981.

POMPIDOU 1979 *Oeuvres de Henri Matisse*, Paris, Collections du Musée National d'Art Moderne, Centre Georges Pompidou, 1979. (Text by I. Monod-Fontaine.)

PORTRAITS 1954 *Portraits par Henri Matisse*, Monte Carlo, André Sauret, 1954.

ROGER-MARX 1939 Claude Roger-Marx. *Dessins de Henri Matisse*, Paris, Les Editions Braun, 1939.

RUSSELL 1969 John Russell. *The World of Matisse, 1869–1954*, New York, Time-Life Books, 1969.

ST LOUIS 1977 *Henri Matisse – Paper Cut-outs*, St Louis, The St Louis Art Museum, 1977.

SALINGER 1932 Margareta Salinger. 'White Plumes with Variations', *Parnassus*, IV, December 1932, New York, pp. 9–10.

SCHNEIDER 1982 Pierre Schneider, M. Carra, X. Deryng. *Tout l'oeuvre peint de Henri Matisse 1904–1928*, Paris, Flammarion, 1982.

SEMBAT 1920 Marcel Sembat. *Henri Matisse*, Paris, Editions de la Nouvelle Revue Française, 1920.

THÈMES ET VARIATIONS 1943 *Dessins: Thèmes et variations*, Paris, Martin Fabiani, 1943. (Introduction by L. Aragon.)

TORONTO 1971 *A Tribute to S. J. Zacks from the Sam and Ayala Zacks Collection*, Toronto, Art Gallery of Ontario, 1971.

XXe SIÈCLE 1970 'Homage to Henri Matisse', *XXe siècle*, New York, Tudor Publishing Company, 1970.

ZÜRICH 1982–1 *Henri Matisse*, Zürich, Kunsthaus, 1982, Düsseldorf, Städtische Kunsthalle, 1982.

ZÜRICH 1982–2 *Nabis und Fauves*, Zürich, Kunsthaus, 1982.

NOTES TO THE TEXT

Wherever possible, references for quotations from Matisse and for works cited but not illustrated are made to the following sources, which are given in abbreviated form:

Barr: Alfred H. Barr, Jr. *Matisse: His Art and His Public* (New York: The Museum of Modern Art, 1951).

Baltimore: *Matisse as a Draughtsman*. Introduction and catalogue by Victor I. Carlson (Baltimore: The Baltimore Museum of Art, 1971).

Elsen: Albert E. Elsen. *The Sculpture of Matisse* (New York: Abrams, 1972).

Flam: Jack D. Flam. *Matisse on Art* (London: Phaidon, 1973).

Fourcade: Dominique Fourcade. *Henri Matisse. Écrits et propos sur l'art* (Paris: Hermann, 1972).

Fribourg: *Henri Matisse, 1869–1954. Gravures et lithographies*. Catalogue by Margrit Hahnloser-Ingold (Fribourg: Musée d'Art et d'Histoire, 1982).

Paris: *Henri Matisse. Dessins et sculpture*. Introduction by Dominique Fourcade; catalogue by Dominique Fourcade and Isabelle Monod-Fontaine (Paris: Musée National d'Art Moderne, Centre Georges Pompidou, 1975).

CHAPTER 1 (pp. 19–43)

1 Matisse, *Portraits*, 1954, in Fourcade, pp. 177–78; trans. Flam, pp. 151–52.
2 Maurice Raynal et al., *History of Modern Painting*, vol. II (Geneva: Skira, 1950), p. 28.

3 See Barr, pp. 13, 293, 529 n. 4 reference to the single drawing can be dated with some certaint this period. On Matisse's acad training in general, see Barr, pp. 1 Flam, pp. 18–19; Gaston Diehl, *Matisse* (Paris: Pierre Tisné, 1954), Frank Anderson Trapp, 'The Pain of Henri Matisse: Origins and I Development' (Ph.D. disserta Harvard University, 1952); J. W. Cowart, '"Ecoliers" to "Fau Matisse, Marquet and Manguin D ings, 1890–1906' (Ph.D. disserta Johns Hopkins University, 1972), w Matisse's student drawings catalogued and illustrated.
4 See Barr, p. 14, and E. Tériade, ' isse Speaks', 1952, in Flam, p. 131.
5 Matisse, 'Henri Matisse vous p 1950, in Fourcade, pp. 315–16; tr Flam, p. 125.
6 Matisse, radio interview, 194 Barr, p. 563.
7 Matisse, 'Divagations', 1937, in F cade, p. 157; trans. Flam, p. 77.
8 Letter to Henry Clifford, 14 ruary 1948, in Flam, p. 121, and for following quotation.
9 Matisse, *Jazz*, 1947, in Fourc p. 237; trans. Flam, p. 112.
10 Raymond Escholier, *Henri M* (Paris: Floury, 1937), p. 30. See Jacques Guenne, 'Entretien avec H Matisse', 1925, in Fourcade, p. 79; tr Flam, p. 54.
11 André Verdet, 'Entretiens Henri Matisse', 1952, in Fourcade, p trans. Flam, p. 145. Matisse mad similar statement to Henry Cliffor 1948 (note 8, above) and on ano occasion attributed the remark Michelangelo (Louis Aragon, *Matisse. A Novel*, trans. Jean Stew

London: Collins, 1972; vol. I, p. 140).
Matisse may, in fact, have been think-
ing of a statement by Gauguin: 'To
know how to draw does not mean to
draw well.' (*Racontars de Rapin*, 1902.
Quoted in Ronald Pickvance, *The Draw-
ings of Gauguin*; London: Hamlyn, 1970;
p. 5.)

12 Jacques Guenne, 'Entretien avec
Henri Matisse', 1925, in Fourcade, p. 79;
trans. Flam, p. 54.

13 Matisse, *Portraits*, 1954, in Fourcade,
p. 178; trans. Flam, p. 151.

14 Barr, p. 3 n. 15A. Barr, however,
conflates the titles of these two works.
See *Cent chefs-d'oeuvre du Musée de Lille*
(Lille: 1970), cat. 77 and 78.

15 See Barr, p. 15, and Flam, p. 156
n. 23.

16 Georges Rouault, 'Lettres de
Georges Rouault à André Suarès', *L'Art
et les artistes*, Paris, n.s., vol. XIII, nos.
65–69 (March–July 1926), p. 221, quoted
in Frank Anderson Trapp, 'The Atelier
Gustave Moreau', *Art Journal*, London,
vol. XXII, no. 2 (Winter 1962–63), p. 93.

17 He did not do particularly well,
however, achieving a score of only 37
out of a possible 100. See Flam, p. 156
n. 24.

18 'Lettres de Georges Rouault',
p. 242, quoted in Trapp, p. 93.

19 Idem.

20 Letter to Henry Clifford, 14 Feb-
ruary 1948, in Flam, p. 121.

21 Diehl, *Matisse* (note 3, above), p. 11.
It was not, of course, really revolu-
tionary for Moreau to have his stu-
dents copy in the Louvre, but part of
standard academic practice. So was his
recommendation (discussed later) that
they sketch in the streets. See Alfred
Boime, *The Academy and French Painting in
the Nineteenth Century* (London: Phaidon,
1971), pp. 34–35, 42–43, 47ff., 122–132.

22 'Henri Matisse', 1907, in Fourcade,
p. 56; trans. Flam, p. 32.

23 'Notes d'un peintre', 1908, in Four-
cade, p. 49; trans. Flam, p. 38, where
Matisse also writes: 'I do not insist
upon all the details of the face, on
setting them down one-by-one with
anatomical exactitude.'

24 'Henri Matisse', 1907, in Fourcade,
p. 55; trans. Flam, p. 31.

25 E. Tériade, 'Matisse Speaks', 1951, in
Fourcade, p. 115; trans. Flam, p. 131.

26 Lawrence Gowing, *Matisse* (Lon-
don: Thames and Hudson, 1979), p. 10.

27 Letter to Henry Clifford, 14 Feb-
ruary 1948, in Flam, p. 120.

28 Léon Degand, 'Matisse à Paris',
1945, in Fourcade, p. 301; trans. Flam,
p. 103.

29 Clara T. MacChesney, 'A Talk
with Matisse', 1912, in Flam, p. 51.

30 Gaston Diehl, 'Avec Matisse le
classique', 1943: trans. Flam, p. 170 n. 12.

31 This and the following statements
by Matisse to his students derive from
'Notes by Sarah Stein', 1908, in Barr,
pp. 550–52.

32 Jacques Guenne, 'Entretien avec
Henri Matisse', 1925, in Fourcade,
pp. 85–86; trans. Flam, p. 56 (and p. 163
n. 24 for the correct Courbet
quotation).

33 Idem, in Fourcade, p. 81; trans.
Flam, p. 54.

34 Idem.

35 See Paris, cat. 7, 8; Jean Guichard-
Meili, *Matisse* (Paris: Fernand Hazan,
1967), fig. 2; *Matisse. Dessins au pinceau*
(Paris: Berggruen, 1983), cat. 2. The
extant Matisse drawings of this kind
seem mostly to date around 1900. Some
comparable works by Marquet have
been placed as late as 1904 (see *Albert
Marquet*; Bordeaux: Galerie des Beaux-
Arts, 1975; cat. 97–100). All such works
in ink from 1900 onward probably owe
something to the 'Japanese' calli-
graphic style of Bonnard's drawings
(see John Elderfield, *The 'Wild Beasts':
Fauvism and its Affinities*; New York: The
Museum of Modern Art, 1976; p. 23). A
1902 Matisse ink sketch of Notre Dame
(Paris, cat. 12) was drawn on the verso
of a Bonnard exhibition announce-
ment.

36 Barr, pp. 38, 98.

37 Jacques Guenne, 'Entretien avec
Henri Matisse', 1925, in Fourcade, p. 83;
trans. Flam, p. 55.

38 A comparable drawing to this has
been dated 1899–1900, when Matisse was
working with Carrière. See *Dessins mod-
ernes: Grenoble, Musée de Peinture et de
Sculpture* (Paris: Musées Nationaux,
1963), cat. 129.

39 See Gowing, *Matisse* (note 26,
above), pp. 38–43, 69–105, for an impor-
tant discussion of this aspect of
Matisse's work, 1900–10.

40 'Notes by Sarah Stein', 1908, in
Barr, p. 550. Carlson draws especial
attention to this aspect of the drawing
(Baltimore, cat. 2).

41 Raymond Escholier, *Matisse, ce vivant* (Paris: Fayard, 1956), pp. 161–62; and for the following quotations. Elsen, who discusses this incident (p. 15), suggests it took place in 1898. The following year, when Matisse was back from his wedding trip and had returned to drawing, seems more likely.

42 Paris, cat. 1 (dated '3 janvier 1899') appears to be Matisse's first portrait. This year of his thirtieth birthday was an important one for Matisse in the general re-evaluation of his art. (He had begun his career as an artist exactly ten years earlier; subsequent re-evaluations would take place at regular ten-year intervals.) Matisse's whole art shifts in direction in 1899. Also that year, he acquired his Cézanne *Bathers*, which was to be an important touchstone for him until he gave it to the City of Paris in 1935.

43 See note 1, above.

44 This paragraph derives from the author's *The Modern Drawing* (New York: The Museum of Modern Art, 1983), p. 146.

45 'Notes by Sarah Stein', 1908, in Barr, p. 550 (and pp. 551–52 for a different version of the same advice).

46 Ibid., p. 551.

47 E. Tériade, 'Propos de Henri Matisse', 1933, in Fourcade, p. 126; trans. Flam, p. 66.

48 Matisse, *Portraits*, 1954, in Fourcade, p. 176; trans. Flam, p. 151.

49 Aragon, *Henri Matisse* (note 11, above), vol. I, p. 135.

50 Idem.

51 See Elderfield, *Matisse in the Collection of The Museum of Modern Art* (New York: The Museum of Modern Art, 1978), p. 28.

52 Paris, cat. 1.

53 Cf. *Nude in the Studio*, 1899 (Elderfield, *The 'Wild Beasts'* [note 35, above] p. 22, where comparable paintings are discussed) and *Self-portrait as an Etcher*, 1903 (Fribourg, cat. 1).

54 Matisse, 'La Chapelle du Rosaire', 1951, in Fourcade, p. 258; trans. Flam, p. 128.

55 Jean Puy, 'Souvenirs', *Le Point*, Paris, no. 21 (July 1939), p. 22.

56 'Notes by Sarah Stein', 1908, in Barr, p. 552.

57 There was an important Van Gogh exhibition at the Bernheim-Jeune Gallery in 1901. One specific Van Gogh influence is traced in Henry Geldzahler, 'Two Early Matisse Drawings', *Gazette de Beaux-Arts*, Paris, no. (November 1962), pp. 497–505.

58 See Adrien Chappuis, *The Drawings of Paul Cézanne. A Catalogue Raisonné* (Greenwich, Conn.: New York Graphic Society, 1973), pp. 12–13.

59 Idem.

60 This paragraph is adapted from the author's *The Modern Drawing* (note 44, above), p. 20.

61 'The Drunken Boat: The Revolutionary Element in Romanticism', Northrop Frye, ed., *Romanticism Reconsidered* (New York: Columbia University Press, 1963), p. 9.

62 Ibid., p. 10.

63 Jacques Guenne, 'Entretien avec Henri Matisse', 1925, in Fourcade, p. ; trans. Flam, p. 55.

64 'Eye and Mind', in *The Primacy of Perception* (Evanston, Ill.: Northwestern University Press, 1964), p. 164.

65 'The poet has always been supposed to be imitating nature, but if the model of his creative power is in his mind, the nature that he is to imitate is now inside him, even if it is also outside.' (*Romanticism Reconsidered* [note 61, above] p. 13.)

66 Georges Duthuit, *The Fauvist Painters* (New York: Wittenborn, Schultz, 1950), p. 24.

67 Escholier, *Matisse, ce vivant* (note above), p. 140.

68 See note 53, above.

69 See note 51, above.

70 Charles W. Millard, 'Matisse in Paris', *The Hudson Review*, New York, vol. 23, no. 3 (Autumn 1970), p. 542.

71 'Notes by Sarah Stein', 1908, in Barr, p. 551.

72 Escholier, *Matisse, ce vivant* (note above), p. 18.

73 Ibid., p. 163.

74 Guichard-Meili, *Matisse* (note above), p. 168.

75 Clement Greenberg, 'Matisse in 1966', *Bulletin of The Museum of Fine Arts, Boston*, vol. LXIV, no. 336 (1966), p. 73.

76 'Matisse's Sculpture: The Grasp and the Seen', *Art in America*, New York, vol. LXIV, no. 4 (July–August 1976) p. 65; and for the following quotation.

77 Escholier, *Matisse, ce vivant* (note above), pp. 163–64. Matisse links his use of the arabesque to Renaissance artists. This comparison derives from a statement

ment by Cézanne quoted in Emile Bernard's 'Paul Cézanne', *L'Occident*, Paris, July 1904, pp. 17–30, an article which Matisse must surely have known. It is translated in Judith Wechsler, ed., *Cézanne in Perspective* (Englewood Cliffs, N.J.: Prentice-Hall, 1975), pp. 39–45. See also below and note 87 for another important Matisse derivation from the same article.

78 'Notes by Sarah Stein', 1908, in Barr, p. 551.

79 Gowing, *Matisse* (note 26, above), p. 33.

80 Matisse, 'La Chapelle du Rosaire', 1951, in Fourcade, p. 257; trans. Flam, p. 128.

81 Matisse watercolours are extremely rare. In 1912, Matisse told an interviewer that he used neither watercolour nor pastel (Flam, p. 51). Apart from the Collioure watercolours (see Baltimore, cat. 5–7), the few other Matisse works in this medium are mostly studies after important paintings.

82 This drawing was made on the same occasion as a painting by Derain of this subject, of which Mme Matisse made a tapestry version. See Elderfield, *The 'Wild Beasts'* (note 35, above), pp. 41–42.

83 An X-ray of the 1905 painting *View of Collioure* shows that Matisse began this work with a most carefully drawn linear framework, which the broken colour units subsequently fractured. See A. Izerghina, *Henri Matisse. Paintings and Sculptures in Soviet Museums* (Leningrad: Aurora, 1978), p. 127.

84 See Elderfield, *Matisse in the Collection of The Museum of Modern Art* (note 51, above), pp. 36–39. We know that Matisse produced *Luxe, calme et volupté* after cartoon (see Paris, cat. 30). It is therefore tempting to see the *Le Port d'Abaill* drawing also as a cartoon for the 1905–06 painting since it is identical in size to it (*Henri Matisse: Exposition du centenaire*; Paris: Réunion des Musées nationaux, 1970; cat. 59). Yet, its ink medium and broad treatment hardly seem appropriate to a cartoon (cf. Paris, cat. 30, the only extant cartoon we know). Indeed, its drawing seems abstracted from that in the painting rather than vice versa. Jean Matisse, the artist's son, apparently claimed that it was traced from the painting.

The painting itself was first shown at Matisse's Galerie Druet exhibition of March–April 1906 (see Elderfield, ibid., p. 180 n. 6). We know that Matisse painted a poster for that exhibition (*Exposition du centenaire*, cat. 79), showing a view of sailboats at Collioure similar to those at the centre of *Le Port d'Abaill*. Another oil on board, close to the style of that poster, shows the complete harbour view (Richard J. Wattenmaker, *The Fauves*; Toronto: Art Gallery of Ontario, 1975; p. 18), and may well have been made in the same context. Our drawing, if it is indeed a tracing, could likewise belong to this sequence of works. A study of a boat at Collioure (Paris, cat. 17) would seem to prepare for the painting; likewise, two of that 1905 summer's watercolours (Baltimore, cat. 5, 6); and even, conceivably, an ink study of a horse (*Matisse. Dessins au pinceau* [note 35, above], cat. 2), though this could equally belong to the c. 1900 period to which studies of this kind are usually assigned.

85 Letter of 2 August 1971 from Marguerite Duthuit (Archives of The Museum of Modern Art). The multiple contours and dense shading around the face generally relate this drawing to the woodcut studies and other early 1906 works discussed below.

86 This letter is quoted in *Henri Matisse: Exposition du centenaire* (note 84, above), cat. 55.

87 See note 77, above. It seems reasonable to assume that Matisse, having read Cézanne's words while struggling with Neo-Impressionism in 1904, should return to them in 1905 when thinking about that style's limitations.

88 Fauvist debts to Neo-Impressionism are studied in Catherine C. Bock, *Henri Matisse and Neo-Impressionism, 1898–1908* (Ann Arbor, Mich.: UMI Research Press, 1981), ch. IV: 'Second Divisionist Period'.

89 Recorded by Gaston Diehl, in Fourcade, p. 93.

90 Hilton Kramer, 'Those Glorious "Wild Beasts"', *New York Times*, 4 April 1976.

91 This paragraph is adapted from the author's *The Modern Drawing* (note 44, above), p. 42.

92 For the woodcuts, see Fribourg, cat. 349–51, and Riva Castleman's dis-

cussion of them in Elderfield, *Matisse in the Collection of The Museum of Modern Art* (note 51, above), pp. 48–50.

93 Van Gogh's work had been exhibited along with Seurat's at the Salon des Indépendants in spring 1905, an exhibition that Matisse helped to hang. This afforded Matisse an excellent opportunity to evaluate the limitations he was finding in Neo-Impressionism.

94 Bernice Rose, *A Century of Modern Drawing* (London: British Museum Publications, 1982), p. 17.

95 The woodcuts were apparently made by Mme Matisse. See Castleman (note 92, above).

96 Rose, *A Century of Modern Drawing* (note 94, above), p. 17.

97 Fribourg, cat. 352–64.

98 Gowing, *Matisse* (note 26, above), p. 55.

99 Barr, p. 53.

100 Charles Estienne, 'Entretien avec M. Henri-Matisse', 1909, in Fourcade, p. 60; trans. Flam, p. 48, and for the following quotations.

CHAPTER 2 (pp. 44–73)

1 'Eye and Mind', in *The Primacy of Perception* (Evanston, Ill.: Northwestern University Press, 1964), p. 185.

2 Matisse, 'Notes d'un peintre', 1908, in Fourcade, p. 45; trans. Flam, p. 37, and for the following quotations.

3 Ibid., in Fourcade, p. 43; trans. Flam, p. 36.

4 Ibid., in Fourcade, p. 51; trans. Flam, p. 39.

5 Matisse, 'Notes d'un peintre sur son dessin', 1939, in Fourcade, p. 163; trans. Flam, p. 82.

6 Matisse, *Jazz*, 1947, in Fourcade, p. 238; trans. Flam, p. 112.

7 Matisse, 'Notes d'un peintre', 1908, in Fourcade, p. 51; trans. Flam, p. 39.

8 Gaston Diehl, 'Les nourritures terrestres de Matisse', 1945; trans. Flam, p. 167.

9 Quoted by Pierre Schneider, 'The *Bonheur de vivre*: A Theme and Its Variations', lecture at The Museum of Modern Art, New York, 30 March 1976.

10 E. Tériade, 'Constance du Fauisme', 1936, in Fourcade, p. 129; trans. Flam, p. 74.

11 Matisse, 'Notes d'un peintre', 19 in Fourcade, p. 43; trans. Flam, p. 36.

12 Clara T. MacChesney, 'A Ta with Matisse', 1912, in Flam, p. 51.

13 Idem.

14 André Verdet, 'Entretiens av Henri Matisse', 1952; trans. Flam, p. 14

15 Matisse, 'Notes d'un peintre', 19 in Fourcade, pp. 42–43; trans. Fla p. 36, and for the following quotation

16 'Everything that is not useful the picture is, it follows, harmful. work of art must be harmonious in entirety: any superfluous detail wou replace some other essential detail the mind of the spectator.' (See note above.)

17 Marguette Bouvier, 'Hen Matisse chez lui', 1944; trans. Fla p. 97. Cf. 'Notes by Sarah Stein', 1908, Barr, p. 551.

18 Matisse, 'Notes d'un peintre', 19 in Fourcade, p. 50; trans. Flam, p. 38.

19 Ibid., in Fourcade, pp. 43–44; tra Flam, p. 36.

20 'Yes, indeed. I believe my role is provide calm ...' See Georges Ch bonnier, 'Entretien avec Henri M isse', 1950; trans. Flam. p. 140.

21 Idem.

22 See note 11, above.

23 See Paris, cat. 30.

24 Jean Puy, 'Souvenirs', *Le Po* Paris, July 1939, p. 36. Quoted after Ba p. 91.

25 A more abstracted version of t piper appears, together with the tw central reclining figures for *Bonheur vivre*, in a drawing published in *130 des de Matisse* (Marseilles: Musée Canti 1974), cat. 9.

26 Matisse, *Jazz*, 1947, in Fourca p. 237; trans. Flam, p. 112, and for t following quotation. References to own use of a plumb line app regularly in Matisse's statements his art. In his 'Über Henri Matiss *Werk*, Zürich, vol. 33, no. 6 (June 194 pp. 185–92, Hans Purrmann refers Matisse using not only a plumb li but also a system of lines drawn on t studio wall behind the model, anc mirror, as drawing aids.

27 See Riva Castleman's discussion these works in John Elderfield, *Mat in the Collection of The Museum of Modern*

(New York: The Museum of Modern Art, 1978), pp. 48–50.

28 'Rodin and Matisse: Differences, Affinities and Influences', unpublished ms., 1982.

29 Elsen, p. 20.

30 See Chapter 1, note 86.

31 In 1945, Matisse compared Gauguin and Van Gogh, and observed that, like Ingres and Delacroix, both were concerned with 'arabesques and colour'. Hence, both were useful to the creation of Fauvism. The influence of Gauguin, however, was 'more direct ... Gauguin himself seems to come straight out of Ingres' – Ingres, with his almost compartmentalized and distinct colour'. (Trans. Flam, p. 102.) In 1936, he told Tériade that 'expression by colour' was characteristic of modern art in general, 'to which has been added, with what is called Fauvism and the movements which have followed it, expression by design; contours, lines and their direction.' (Trans. Flam, p. 73.) While Matisse's art does shift in direction in 1906, it does so, this suggests, only to give greater importance to the designing or drawing of colour, which had been the aim of Fauvism. To look now to Gauguin and Ingres rather than to Van Gogh and Delacroix is not to turn to something entirely new but simply to a calmer union of drawing and colour.

32 Schneider, 'The *Bonheur de vivre*: A Theme and Its Variations' (note 9, above), quoting from letter to Signac, July 1905.

33 See Frank A. Trapp, 'Art Nouveau Aspects of Early Matisse', *Art Journal*, London, vol. XXVI, no. 1 (Autumn 1966), pp. 2–8.

34 A group of thirty-one Manets were included in the 1905 Salon d'Automne. Although Matisse spoke of preferring Ingres' to Manet's line at this time, it is difficult to believe that Manet did not have an effect on his post-Fauve style. Even the flattened 1906 Fauve woodcuts suggest the influence of Manet. The relation of Manet and Matisse has been studied by Dominique Fourcade, in 'Matisse et Manet?', *Bonjour Monsieur Manet* (Paris: Musée National d'Art Moderne, Centre Georges Pompidou, 1983), pp. 25–32.

35 See the drawings in Derain's Fauve sketchbook, on which the definitive study is now Michael Parke-Taylor, 'André Derain: les copies de l'Album fauve', *Cahiers du Musée National d'Art Moderne*, Paris, no. 5 (1980), pp. 363–77.

36 Bernice Rose, *A Century of Modern Drawing* (London: British Museum Publications, 1982), p. 18.

37 Georges Charbonnier, 'Entretien avec Henri Matisse', 1950, in Fourcade, p. 200; trans. Flam, p. 141.

38 See Paris, cat. 28, 29.

39 Barr, p. 82.

40 *Sincerity and Authenticity* (Cambridge, Mass.: Harvard University Press, 1971), p. 139.

41 I am indebted here to Vladimir Nobokov's study of Proust in his *Lectures on Literature* (New York: Harcourt, Brace, Jovanovich, 1980), pp. 207–49, from which, unless otherwise noted, the quotations from Proust derive.

42 'The Drunken Boat: The Revolutionary Element in Romanticism', in Northrop Frye, ed., *Romanticism Reconsidered* (New York: Columbia University Press, 1963), pp. 20–21.

43 'Henri Matisse', 1907, in Fourcade, p. 55; trans. Flam, p. 32.

44 'Notes d'un peintre', 1908, in Fourcade, p. 46; trans. Flam, p. 37.

45 Charles Estienne, 'Entretien avec M. Henri-Matisse', 1909, in Fourcade, p. 60; trans. Flam, p. 48. Relevant to what follows here is the fact that Matisse referred in 1907 to various forms of 'primitive' art under the common term 'les écritures plastiques' (Fourcade, p. 56).

46 André Verdet, 'Entretiens avec Henri Matisse', 1952, trans. Flam, p. 142.

47 Clara T. MacChesney, 'A Talk with Matisse', 1912, in Flam, p. 52. 'Notes by Sarah Stein', 1908, in Barr, p. 550.

48 Matisse, 'Notes d'un peintre', 1908, in Fourcade, p. 50; trans. Flam, p 38.

49 See Barr, p. 357, for the painting and, for this comparison, John Golding, *Matisse and Cubism* (Glasgow: University of Glasgow Press, 1978), p. 6.

50 For Japanese influence, see Robert Roess, 'Matisse and Torii Kiyonaga', *Arts Magazine*, New York, vol. 55, no. 6 (February 1981), pp. 164–67. Possible Egyptian sources could well be the sculptures that Derain also copied in the Louvre. (See Parke-Taylor, 'André Derain' [note 35, above] pp. 363–77.)

51 Matisse, 'Notes d'un peintre', 1908,

in Fourcade, p. 45; trans. Flam, p. 37.

52 See Golding, *Matisse and Cubism* (note 49), p. 10.

53 J. Tugendhold, 'The Salon d'Automne', *Apollon*, Leningrad, no. 12 (1910), p. 31, quoted in Albert Kostenev-ich, '*La Danse* and *La Musique* by Henri Matisse: A New Interpretation', *Apollo*, London, n.s., vol. 100, no. 154 (December 1974), p. 512.

54 'Henri Matisse', 1907, in Fourcade, p. 56; trans. Flam, p. 32.

55 See *Raoul Dufy* (London: Arts Council of Great Britain, 1983), p. 74.

56 'Looking at Life with the Eyes of a Child', 1954, in Flam, p. 148.

57 Barr, p. 162.

58 For a discussion of *Dance I* and references to the considerable litera-ture on both paintings, see Elderfield, *Matisse in the Collection of The Museum of Modern Art* (note 27, above), pp. 54–58.

59 'Matisse and Decoration: The Shchukin Panels', *Art in America*, New York, vol. 63, no. 4 (July–August, 1975), p. 44.

60 Elsen, p. 186.

61 This paragraph is adapted from the author's *The Modern Drawing* (New York: The Museum of Modern Art, 1983), p. 56.

62 Matisse, *Portraits*, 1954, in Fourcade, pp. 179–81; trans. Flam, pp. 152–53, for this and the following quotations.

63 E.g., Baltimore, cat. 17.

64 E.g., Elderfield, *Matisse in the Collec-tion of The Museum of Modern Art* (note 27, above), pp. 57, 186 (fig. 32); Paris, cat. 42; Baltimore, cat. 22a, b.

65 Fribourg, cat. 23, 52.

66 Fribourg, cat. 55–58, 365–72. Ger-maine Raynal was also the subject of the charcoal *Standing Nude* (cat. 25). This drawing is usually dated *c.* 1912–13 for its relation to the Shchukin charcoal (see Paris, cat. 41). Matisse may well have used this model in 1912–13 as well as in 1914. Paris, cat. 41, is correct in stating that the 1914 lithographs are in a different spirit to the drawing. Never-theless, Fribourg, cat. 367 (1914) is com-parable to it, and a case is to be made for placing the drawing at the later date.

67 Fribourg, cat. 24, 25, 32, 45.

68 For details of the Landsberg com-mission, see Barr, pp. 184–85; Maud Lavin, 'An Analysis of Henri Matisse's 1914 Portrait of Mlle Yvonne Lands-

berg', M.A. thesis (Philadelphia: U[niv]versity of Pennsylvania, 1981).

69 'Notes d'un peintre', 1908, in Fo[ur]cade, p. 45; trans. Flam, p. 37.

70 Barr, p. 184.

71 Discussed by Lavin (note [68], above).

72 'Notes by Sarah Stein', 1908[, in] Barr, p. 551.

73 Barr, p. 185.

74 Barr, p. 184.

75 Lavin (note 68, above) sugg[ests] that this drawing preceded comple[tion] of the painting and therefore pr[oves] that the painting's inscribed constr[uc]tional lines were premeditated. [The] question seems incapable of res[olu]tion; however, the drawing does se[em] to me to post-date the painting. It [is] not an uncommon practice for Ma[tisse] to make summarizing drawings of [this] kind (especially on this small sc[ale]) after important works. The constr[uc]tional lines in the drawing do not se[em] to have been intuitively discovered [but] based on an existing model, the pa[int]ing itself.

76 E. Tériade, 'Matisse Speaks', 195[?] Flam, p. 132.

77 Danièle Giraudy, ed., 'Corresp[on]dance Henri Matisse – Cha[rles] Camoin', *Revue de l'art*, Paris, no[. ?] (1971), p. 17.

78 'Notes by Sarah Stein', 1908[, in] Barr, p. 551.

79 Barr, p. 402.

80 The painting is analysed in El[der]field, *Matisse in the Collection of The Mus[eum] of Modern Art* (note 27, above), pp. 105[?] from which the following is derive[d].

81 Barr, p. 392.

82 Benedetto Croce, *Guide to Aesth[etics]* (South Bend, Indiana: Regne[ry/] Gateway, 1965), p. 23.

83 E. Tériade, 'Matisse Speaks', [195?] Flam, p. 134.

84 Frank Trapp, 'Form and Sym[bol] in the Art of Matisse', *Arts Maga[zine]*, New York, vol. 49, no. 9 (May 19[?]) pp. 56–58.

85 Golding, *Matisse and Cubism* ([note] 49, above), p. 4, and *passim* for a brilli[ant] survey of Matisse's relationship [to] Cubism.

86 See John Golding, *Cubism. A Hi[story] and an Analysis, 1907–1914* (New Yo[rk:] Harper and Row, 1968), p. 87.

87 See note 83, above.

88 The *Gourds* is illustrated in B[arr]

o. 412. The *Still-life with Plaster Bust*, though often dated to 1912, is certainly later, as evidenced by its relation to this drawing. In *Matisse in the Collection of The Museum of Modern Art* (note 27, above), I suggested a *c*. 1915 date for the painting (p. 192 n. 16). However, Jack Flam has evidence (to be published in his forthcoming monograph on Matisse) that *Jeannette V*, shown in the painting, dates to 1916, which should therefore be the date of the painting too.

39 See Elderfield, *Matisse in the Collection of The Museum of Modern Art* (note 27, above), p. 112, where the work is discussed.

40 See Barr, p. 406.

41 Matisse, 'Notes d'un peintre', 1908, in Fourcade, p. 47; trans. Flam, p. 37.

42 While this drawing does seem to belong with the other 1915 still-lifes, its vertical banding could make it a 1916 work, since that was the date when Matisse's paintings achieved that compositional form.

43 Clement Greenberg, *Art and Culture* (Boston: Beacon, 1961), p. 102.

44 Matisse, 'Notes d'un peintre', 1908, in Fourcade, p. 49; trans. Flam, p. 38.

45 E. Tériade, 'Matisse Speaks', 1951: Flam, p. 134.

46 Those for Greta Prozor are reproduced in Dominique Fourcade's fine study of the painting of this subject: *Greta Prozor. Henri Matisse'*, *Cahiers du Musée National d'Art Moderne*, Paris, no. 11 (1983), pp. 101–07. For the other Eva Mudocci sheets, see the catalogue entry (no. 40) on our work.

47 Raymond Escholier, *Matisse, ce vivant* (Paris: Fayard, 1956), p. 113.

48 Matisse, 'Notes d'un peintre', 1908, Fourcade, p. 45; trans. Flam, p. 37.

CHAPTER 3 (pp. 74–100)

1 *Cinquante dessins par Henri Matisse* (Paris: Bernheim-Jeune, 1920).

2 Matisse visited Renoir regularly in 1917 and 1918 and began to refer to him as equal in importance to Cézanne. See Dominique Fourcade, 'Autres Propos de Matisse', *Macula*, Paris, no. 1 (1976), pp. 100–06 for texts by Matisse and an important discussion by Fourcade on Matisse and Renoir. Numerous Renoir prototypes exist for the pose and treatment of this drawing.

3 Francis Carco, 'Conversation avec Matisse', 1941; trans. Flam, pp. 85–86.

4 These great drawings and their associated paintings are referred to in virtually all the studies of Matisse's career, but await the study they deserve. The best general appreciation of the drawings is Margaretta Salinger, 'White Plumes with Variations', *Parnassus*, New York, vol. 4 (December 1932), pp. 9–10. A crucial interview with Matisse, just after their completion, appears in Ragnar Hoppe, *Städer och Konstnärer, resebrev och essäer om Kunst* (Stockholm: Albert Bonniers, 1931), a section of which is translated into English in John Elderfield, *Matisse in the Collection of The Museum of Modern Art* (New York: The Museum of Modern Art, 1978), pp. 121–22, and the whole interview, with useful annotations by Dominique Fourcade, in *Macula*, Paris, no. 1 (1976), pp. 93–95. This interview took place in June 1919 at Matisse's Paris studio on the quai Saint-Michel, which seems to raise doubts as to whether the Plumed Hats were made in Nice, since we know that Matisse, exceptionally, brought his model north for the summer (Barr, p. 544, n. 8 to p. 206). However, the ex-Gothenburg (stolen) painting, *White Plumes* (illus. Louis Aragon, *Henri Matisse. A Novel*, trans. Jean Stewart; London: Collins, 1972; vol. II, p. 107), shows a Nice interior behind the model. (I am grateful to Jack Flam for this observation.) Since the hat was an intuitive creation by Matisse himself, it is reasonable to assume that all of the Plumed Hat works were made at Nice. One drawing of a Plumed Hat subject has been dated to the early 1930s and characterized as a preliminary study for the 'Apparition' etching (Fribourg, cat. 237) of Matisse's Mallarmé illustrations (*The Cone Collection of Baltimore, Maryland. Catalogue of Paintings, Drawings, Sculpture of the Nineteenth and Twentieth Centuries*; Baltimore: Etta Cone, 1934; pl. 85, right). The etching is certainly a remembrance of the Plumed Hat series. If the drawing is indeed a study for it, then it is yet another – and quite astonishing – example of Matisse's power of recall.

5 Ragnar Hoppe, interview of June 1919 (note 4, above).

6 Paris, cat. 57.

7 'Eye and Mind', *The Primacy of Perception* (Evanston, Ill.: Northwestern University Press, 1964), p. 184.

8 Paris, cat. 60.

9 See note 4, above.

10 Martin Turnell, 'People in Proust', reprinted from his *The Novel in France*, in Irving Howe, ed., *The Idea of the Modern* (New York: Horizon, 1967), p. 249.

11 Barr, p. 206.

12 Clement Greenberg, *Matisse* (New York: Abrams, 1953), commentary to pl. 14.

13 Aragon, *Henri Matisse* (note 4, above), vol. II, p. 109.

14 Paris, cat. 59.

15 Barr, p. 430. This work was made at Issy.

16 Barr, p. 427.

17 Lawrence Gowing, *Matisse* (London: Thames and Hudson, 1979), pp. 142–43.

18 Aragon, *Henri Matisse* (note 4, above), vol. II, p. 109.

19 See Elderfield, *Matisse in the Collection of The Museum of Modern Art* (note 4, above), p. 212 n. 18.

20 Matisse, 'Notes d'un peintre sur son dessin', 1939, in Fourcade, p. 162; trans. Flam, p. 82.

21 A drawing by Matisse showing a very similar figure to these was illustrated in Georges Duthuit, *Les Fauves* (Geneva: Trois Collines, 1949), p. 218, where it is improbably dated *c.* 1902. Another (undated) appears in Marcel Sembat, *Matisse et son oeuvre* (Paris: Nouvelle Revue Française, 1920), p. 6.

22 Hannah Arendt, *The Human Condition* (Chicago and London: The University of Chicago Press, 1958), p. 57.

23 Barr, p. 426.

24 Gowing, *Matisse* (note 17, above), p. 117.

25 E. Tériade, 'Matisse Speaks', 1951, in Flam, p. 133.

26 See note 24, above.

27 John Russell, *The World of Matisse* (New York: Time-Life, 1969), p. 129.

28 See Barr, pp. 207–08.

29 Barr, p. 373.

30 A frequently repeated phrase. See, for example, 'Le Chemin de la couleur', 1947, in Fourcade, p. 204; trans. Flam, p. 116.

31 Idem.

32 E. Tériade, 'Visite à Henri Matisse', 1929, in Fourcade, p. 99; trans. Flam, p. 59, and for the following quotation.

33 E. Tériade, 'Matisse Speaks', 1951, in Flam, p. 135.

34 Danièle Giraudy, ed., 'Correspondance Henri Matisse – Charles Camoin', *Revue de l'art*, Paris, no. 1 (1971), p. 21.

35 Ragnar Hoppe, interview of June 1919 (note 4, above).

36 Matisse, 'Notes d'un peintre sur son dessin', 1939, in Fourcade, p. 160; trans. Flam, p. 81.

37 See Clement Greenberg, 'Detached Observations', *Arts Magazine*, New York, vol. 51, no. 4 (December 1976), pp. 86–89, for a discussion of 'light' and 'heavy' modelling.

38 Pierre Schneider, 'Matisse's Sculpture. The Invisible Revolution', *Art News*, New York, vol. 71, no. 1 (March 1972), p. 70.

39 Baltimore, cat. 38, while noting the relationship of the drawing to *Large Seated Nude*, dates it *c.* 1920, without explanation. A *c.* 1922 date would seem the earliest.

40 See Baltimore, cat. 38, for details of some of these works.

41 See note 2, above.

42 Danièle Giraudy, ed., 'Correspondance Henri Matisse – Charles Camoin' (note 34, above), p. 21.

43 Raymond Escholier, *Matisse, ce vivant* (Paris: Fayard, 1956), pp. 163–64.

44 Matisse, observations on painting, 1945; trans. Flam, p. 101.

45 Jacques Guenne, 'Entretien avec Henri Matisse', 1925, in Fourcade, p. 83–84; trans. Flam, p. 55.

46 Georges Duthuit, *Les Fauves* (note 21, above), 1949, in Fourcade, p. 84, n.

47 Clement Greenberg, *Art and Culture* (Boston: Beacon, 1961), p. 98.

48 Letter to Raymond Escholier, November 1936, in Fourcade, pp. 133–; trans. Flam, p. 75.

49 Baltimore, cat. 43.

50 Charles W. Millard, 'Matisse in Paris', *The Hudson Review*, vol. 23, no. (Autumn 1970), p. 542.

51 Letter of 14 February 1948, in Flam, p. 121.

52 E. Tériade, 'Visite à Henri Matisse', 1929, in Fourcade, p. 96; trans. Flam, p. 59.

53 Elderfield, *Matisse in the Collection of The Museum of Modern Art*, p. 130.

Aragon, *Henri Matisse* (note 4, ‹ove), vol. I, p. 61.

The Human Condition (note 22, ‹ove), p. 52.

Ibid., p. 50.

Ibid., p. 72.

The nymph and faun subject appears in the early 1930s and is ‹scussed in Chapter 4.

See Paris, cat. 82. The painting is ‹w in the National Gallery of Art, ‹nberra, Australia. The drawing has ‹en dated 1928 (*Cahiers d'art*, Paris, nos. ‹, 1931, p. 89).

Elsen, p. 152.

André Verdet, 'Entretiens avec ‹nri Matisse', 1952, in Fourcade, ‹. 57–58; trans. Flam, p. 146.

Letter of 14 February 1948, in Flam, 121.

E. Tériade, 'Visite à Henri Matisse', ‹9, in Fourcade, p. 96; trans. Flam, 59.

Escholier, *Matisse, ce vivant* (note 43, ‹ove), p. 168.

Jean Guichard-Meili, *Matisse* ‹ris: Fernand Hazan, 1967), p. 168.

These sculptures are reproduced ‹Elsen, pp. 154, 156, 158, 160, 163, 164, 168, ‹. In *Matisse in the Collection of The ‹seum of Modern Art* (note 4, above), ‹. 78, 80, I associated *Back IV* with ‹ttisse's work on the Barnes com-‹ssion and therefore suggested a 1931 ‹te for the sculpture. The association ‹relevant but the date is a mistake. ‹e Barnes commission, and indeed ‹ general abstraction of Matisse's ‹rk in the early 1930s, builds on what ‹d already been achieved in the later ‹ns.

Escholier, *Matisse, ce vivant* (note 43, ‹ve), p. 36.

Clement Greenberg, 'Matisse in ‹', *Bulletin of The Museum of Fine Arts,* ‹on, vol. LXIV, no. 336 (1966), p. 73.

E. Tériade, 'Entretien avec ‹iade', 1930, in Fourcade, p. 102; trans. ‹m, p. 60.

APTER 4 (pp. 101–34)

E. Tériade, 'Visite à Henri Matisse', ‹; 'Entretien avec Tériade', 1930, in ‹rcade, pp. 92–112; trans. Flam, ‹58–64, for the following quotations ‹ess otherwise noted.

2 André Verdet, 'Entretiens avec Henri Matisse', 1952; trans. Flam, p. 145.

3 Matisse, *Jazz*, 1947, in Fourcade, p. 239; trans. Flam, p. 113.

4 Matisse, 'Rôle et modalités de la couleur', 1945, in Fourcade, p. 201; trans. Flam, p. 100.

5 Hannah Arendt, *The Human Condition* (Chicago and London: The University of Chicago Press, 1958), pp. 139–44.

6 'Notes d'un peintre', 1908, in Fourcade, p. 42; trans. Flam, p. 34.

7 Arendt, *The Human Condition* (note 5, above), pp. 169–70; and for the following quotations.

8 See note 1, and for the following quotations.

9 See Barr, pp. 244–46; Baltimore, cat. 48–51; Fribourg, cat. 235–63.

10 Matisse, 'Comment j'ai fait mes livres', 1946, in Fourcade, p. 211; trans. Flam, p. 107.

11 See Baltimore, cat. 54; Paris, cat. 86.

12 This drawing was published in 1934 as the second of the three studies (*The Cone Collection of Baltimore, Maryland. Catalogue of Paintings, Drawings, Sculpture of the Nineteenth and Twentieth Centuries*; Baltimore: Etta Cone, 1934; pl. 95b) and has subsequently been accepted as such (cf. Paris, cat. 86). However, stylistic comparison of the three studies would tend to suggest that it is the third. It is certainly the most abstracted and synthetic of the three.

13 Barr, p. 247.

14 Barr, p. 336.

15 See John Elderfield, *Matisse in the Collection of The Museum of Modern Art* (New York: The Museum of Modern Art, 1978), p. 110.

16 Ibid., p. 170.

17 Mallarmé, letter to Charles Morice, n.d., in *Mallarmé: Selected Prose, Poems, Essays, and Letters*, trans. Bradford Cook (Baltimore: The Johns Hopkins Press, 1956), p. 105.

18 Barr, p. 243. Barr's account of the Barnes commission (pp. 241–44), is still the most useful. However, we now know from Matisse's letters to Simon Bussy that, after the second version of *Dance* was completed and installed at Merion, Matisse then reworked the first version. The terms 'first version' and 'second version', as used here, should therefore be understood to refer to the order in which they were begun.

19 See John Hallmark Neff, 'An Early Ceramic Triptych by Henri Matisse', *The Burlington Magazine*, London, no. 114 (December 1972), pp. 848–53.

20 E.g., *Pastoral*, c. 1906 (Barr, p. 319); *Head of a Faun*, 1907 (Elsen, p. 121); the *Nymph and Faun* painting (location unknown) shown in *The Red Studio* (Barr, p. 162).

21 Barr, pp. 472–73.

22 Barr, pp. 249–50; Fribourg, cat. 217–23. Two to five pencil studies for each of the illustrations were reproduced in the book along with the final etchings themselves.

23 Raymond Escholier, *Matisse, ce vivant* (Paris: Fayard, 1956), p. 119.

24 Baltimore, cat. 68.

25 Idem.

26 Barr, p. 30, reproduces this photograph with an August 1941 date; the December 1940 date is given by Louis Aragon, *Henri Matisse. A Novel*, trans. Jean Stewart (London: Collins, 1972), vol. I, p. 31.

27 See Paris, cat. 89; *Henri Matisse* (Zürich: Kunsthaus, 1982), cat. 82.

28 The date of this photograph comes from Aragon, *Henri Matisse* (note 26, above), vol. I, p. 137.

29 It is difficult to be sure whether this drawing should be dated to the period of the second Barnes mural (c. 1932–33) for its relationship to the central lunette there or should be placed with the other known mythological drawings of the mid 1930s.

30 Leo Steinberg, 'Picasso's Sleepwatchers', *Other Criteria* (New York: Oxford University Press, 1972), p. 101.

31 A. Izerghina, *Henri Matisse. Paintings and Sculptures in Soviet Museums* (Leningrad: Aurora, 1978), p. 182, top right; Barr, p. 482; Isabelle Monod-Fontaine, *Oeuvres de Henri Matisse (1869–1954)* (Paris: Collections du Musée National d'Art Moderne, n.d.), p. 124, fig. a (the drawing appears in the 1940 painting, *Dancer Resting*).

32 Barr, pp. 253–54. Matisse's interest in mythological subjects at this time was such that, according to Massine, 'Matisse proposed doing a ballet on a classical subject, "Diana", for which he himself had fashioned the plot.' (*The Yale Literary Magazine*, New Haven, vol. CXXIII; Fall 1955, p. 24). One of Matisse's cut-out designs for *Rouge et noir* used the nymph and faun theme, and a draw-

ing for the curtain that of Her[c] and Antaeus. The former image revised for a *Verve* cover in 1945, again for 'The Toboggan' in *Jazz*. (*Matisse. Paper Cut-Outs*; The St Loui[s] Museum and The Detroit Institu[te] Arts, 1977; cat. 4, 7, 8, 13, 17).

33 See Barr, p. 493, for the [] (nymph and faun) version of this [w] and Aragon, *Henri Matisse* (not[e] above), vol. I, p. 286 for the fin[al] version.

34 Danièle Giraudy, ed., 'Corres[pon]dance Henri Matisse – Ch[arles] Camoin', *Revue de l'art*, Paris, [] (1971), p. 34.

35 Escholier, *Matisse, ce vivant* (no[te] above), p. 95.

36 Flam, pp. 72–73.

37 E. Tériade, 'Constance du f[auv]isme', 1936, in Fourcade, pp. 12[] trans. Flam, p. 74.

38 Matisse, 'La Chapelle du Ros[aire]' 1951, in Fourcade, pp. 257–58; t[rans.] Flam, p. 128.

39 Letter to Raymond Escholie[r,] November 1936, in Fourcade, pp. 13[] trans. Flam, p. 75.

40 Matisse, 'Rôle et modalités [de la] couleur', 1945, in Fourcade, p. 201; t[rans.] Flam, p. 99.

41 André Verdet, 'Entretiens [avec] Henri Matisse', 1952; trans. Flam, p. []

42 Jack D. Flam, 'Some Observat[ions] on Matisse's Self-Portraits', *Arts M[aga]zine*, New York, vol. 49, no. 9 (May [1975]) pp. 50–52.

43 Lawrence Gowing, *Matisse* ([Lon]don: Thames and Hudson, [1979]), pp. 154–57.

44 See note 1, above.

45 Matisse, *Portraits*, 1954, in Fourc[ade,] p. 176; trans. Flam, p. 151.

46 Martin Turnell, 'People [in] Proust', reprinted from his *The No[vel in] France*, in Irving Howe, ed., *The Idea [of the] Modern* (New York: Horizon, [1967],) p. 249.

47 'Henri Matisse', 1907, in Fourc[ade,] p. 55; trans. Flam, p. 31.

48 E. Tériade, 'Constance du f[auv]isme', 1936, in Fourcade, p. 129; tr[ans.] Flam, p. 74.

49 Turnell, in *The Idea of the M[odern]* (note 46, above), p. 255.

50 Matisse, 'Looking at Life with [the] Eyes of a Child', 1954, in Flam, p. 149[.]

51 Maurice Merleau-Ponty, 'M[eta]physics and the Novel', *Sense and []*

...se (Evanston, Ill.: Northwestern ...niversity Press, 1964), pp. 29–30; and ...r the following quotations from this ...thor.

Aragon, *Henri Matisse* (note 26, ...ove), vol. I, p. 234.

Brendon Prendeville, 'Theatre, ...anet and Matisse. The Nietzschean ...nse of Time in Art', *Artscribe*, London ...ctober 1978), p. 33.

Matisse, 'Notes d'un peintre sur ...n dessin', 1939, in Fourcade, ...159–63; trans. Flam, pp. 81–82; and ... the following quotations, unless ...herwise noted.

See note 40, above.

Lydia Delectorskaya, 'Thèmes et ...riations et un album didactique', ...published ms. (Archives of The ...useum of Modern Art).

See Baltimore, cat. 58. However, ... suggestion made there that the 1935 ...awing was revised to actually ...ome the 1936 work, when an ad-...ional strip of paper was added to the ... of the sheet, cannot be true since ... horizontal dimensions of the two ...rks are different.

Fribourg, cat. 602–14.

The other drawing is Paris, cat. 102.

Pierre Schneider, 'Matisse's Sculp-...e: The Invisible Revolution', *Art ...ws*, New York, vol. 71, no. 1 (March ...), p. 70.

Matisse refers to this in Henry de ...ntherlant, 'En écoutant Matisse', ...; trans. Flam, p. 78.

See Paris, cat. 111.

Aragon, *Henri Matisse* (note 26, ...ve), vol. I, p. 112.

Barr, p. 267.

'Correspondance Matisse – Bon-...d, 1925–46', *La Nouvelle Revue Française*, ...s, vol. XVIII, no. 211 (1 July 1970), ...2. Cf. also Paris, cat. 111.

Fourcade, p. 188.

Ibid., p. 190.

The whole set was published in ...by Martin Fabiani, Paris, with a ...thy text, 'Matisse-en-France', by ...gon, which could possibly give the ...ression that the drawings were ...e with publication in mind. (Ma-...began working on his drawings ...he *Florilège des amours de Ronsard* at the ...e time, which initiated a new ...od of involvement with illustrated ...s.) It is clear, however, that they ... not so conceived. Lydia Delector-skaya has pointed out (see note 56, above) that Matisse decided to publish these drawings because his work in general was less accessible due to the disruptions of the war, and this parti-cular body of work was, he felt, of the greatest importance.

69 See note 54, above.

70 See note 56, above, and Aragon, *Henri Matisse* (note 26, above), vol. I, pp. 234–36; also for the following quotations.

71 Aragon, *Henri Matisse* (note 26, above), vol. I, p. 129.

72 Flam, p. 73.

73 *Florilège des amours de Ronsard* (Paris: Skira, 1948), pp. 92, 111.

74 *Henri Matisse* (note 26, above), vol. I, p. 75; and for the following quotation.

75 Ibid., p. 140.

76 'Notes d'un peintre', 1908, in Four-cade, p. 45; trans. Flam, p. 37.

77 Francis Carco, 'Conversation avec Matisse', 1941; trans. Flam, p. 84.

78 Reference was made earlier to Matisse's consistently artistic response to the difficulties of the war years. The year 1944 was especially painful. Both Mme Matisse and Marguerite were active in the French underground movement. In 1944 they were captured. Mme Matisse was imprisoned for six months. Marguerite was tortured and sent off to Germany in a prison train bound for the camp at Ravensbruck. She managed to escape. Mme Matisse was released. And Matisse, meanwhile, was drawing ballerinas. 'What are we to make', asked Clement Greenberg, 'of this apparent distance of Matisse's from the terrible events of his time and his place?' His answer was that it was something to celebrate. 'It's as though he set himself early on against the cant, the false feeling and falsely ex-pressed feeling that afflict the dis-cussion of art in our culture.' ('Matisse in 1966', *Bulletin of The Museum of Fine Arts, Boston*, vol. LXIV, no. 336, 1966, pp. 66–76). Matisse refused the rhetor-ical, the polemical and the propagan-dist. 'There are two ways of expressing things,' he had written in 1908: 'one is to show them crudely, the other is to evoke them through art.' (Trans. Flam, p. 37). If only for his fidelity to that belief, Matisse is important for art today, especially today.

79 Aragon, *Henri Matisse* (note 26, above), vol. I, p. 110.

80 'Rôle et modalités de la couleur', 1945, in Fourcade, p. 201; trans. Flam, p. 100.

81 Letter to Henry Clifford, 14 February 1948; Flam, p. 121.

82 'Exactitude is not Truth', 1948; Flam, p. 117.

83 'On Modernism and Tradition', 1935; Flam, p. 72.

84 Maria Luz, 'Témoignage', 1952, in Fourcade, p. 248; trans. Flam, p. 137.

85 *Henri Matisse. Paper Cut-Outs* (note 32, above), p. 219.

86 See note 84, above.

87 Aragon, *Henri Matisse* (note 26, above), vol. I, p. 109.

88 Marguette Bouvier, 'Henri-Matisse chez lui', 1944; trans. Flam, pp. 96–98.

89 Fourcade, pp. 166–70.

90 Aragon, *Henri Matisse* (note 26, above), vol. I, p. 93; and p. 95 for the following quotation.

91 See note 84, above.

92 Letter to André Rouveyre, 22 February 1948, in Fourcade, p. 243.

93 André Verdet, 'Entretiens avec Henri Matisse', 1952, in Fourcade, p. 250; trans. Flam, p. 147.

94 'This afternoon', Matisse wrote in a letter of 31 March 1943, 'I was out of bed from three to half past seven. I have been working in colour, and I have the conviction of having witnessed the great breakthrough in colour which I had been waiting for, analogous to that which I had made in drawing last year.' (Quoted by Pierre Schneider in *Henri Matisse. Exposition du Centenaire*; Paris: Réunion des Musées Nationaux, 1970; p. 46).

95 See note 84, above.

96 Aragon, *Henri Matisse* (note 26, above), vol. II, p. 207.

97 *Henri Matisse: Oeuvres récentes, 19* (Paris: Museé National d'Art Mode 1949), p. 21.

98 Gowing, *Matisse* (note 43, ab pp. 178, 181; Fribourg, cat. 291ff.

99 Matisse, 'Le noir est une coul 1946, in Fourcade, p. 203; trans. F p. 106.

100 Matisse, 'La Chapelle du Ros. 1951, in Fourcade, p. 258; trans. F p. 128.

101 Aragon, *Henri Matisse* (not above), vol. I, p. 112.

102 Barr, p. 293.

103 Letter to Alexandre Romm February 1934, in Fourcade, p. 147; t Flam, p. 69.

104 Georges Charbonnier, 'Entre avec Henri Matisse', 1950, in Four p. 266; trans. Flam, p. 140.

105 Elderfield, *Matisse in the Collec The Museum of Modern Art* (not above), pp. 162, 226.

106 André Verdet, 'Entretiens Henri Matisse', 1952; trans. Flam, p

107 See note 4, above.

108 Aragon, *Henri Matisse* (not above), vol. I, p. 195.

109 These famous sentences by and Pater, and much other rele material on the subject of the da and the mask, are discussed in F Kermode's brilliant study, *Ror Image* (London: Routledge and K Paul, 1957).

110 Barr, p. 36.

111 'Notes d'un peintre', 1908 Fourcade, p. 52; trans. Flam. p. 39.

112 Matisse, 'Looking at Life with Eyes of a Child', 1953, in Flam, p. 14

113 Merleau-Ponty, *Sense and Non-* (note 51, above), p. 30.

114 See note 11 to Chapter 1, abov

115 Matisse, *Portraits*, 1954, in Four pp. 176–78; trans. Flam, p. 151–52, an the following quotations.

PHOTOGRAPHIC ACKNOWLEDGMENTS

Bérard: pp. 137, 162 above, 162 below, 211, 237 above, 238 ow, 239, 240 above, 240 below, 241 above, 241 below, 243, 247 above left.
y M. Elkind: p. 206.
aujour: p. 228.
queline Hyde: pp. 159 above, 165 below, 169, 172 right, above, 174 below, 176 above, 192 below, 196, 204, 247 ve right.
Maison IFOT: pp. 156, 214, 215, 216, 217.
ler: p. 139.
o E. Nelson: p. 194.
Pollitzer: pp. 138 below, 140, 145 above, 149, 154, 155, 167, 222.
hael Tropea: p. 184 above.